OBSESSED WITH™

STAR TREK®

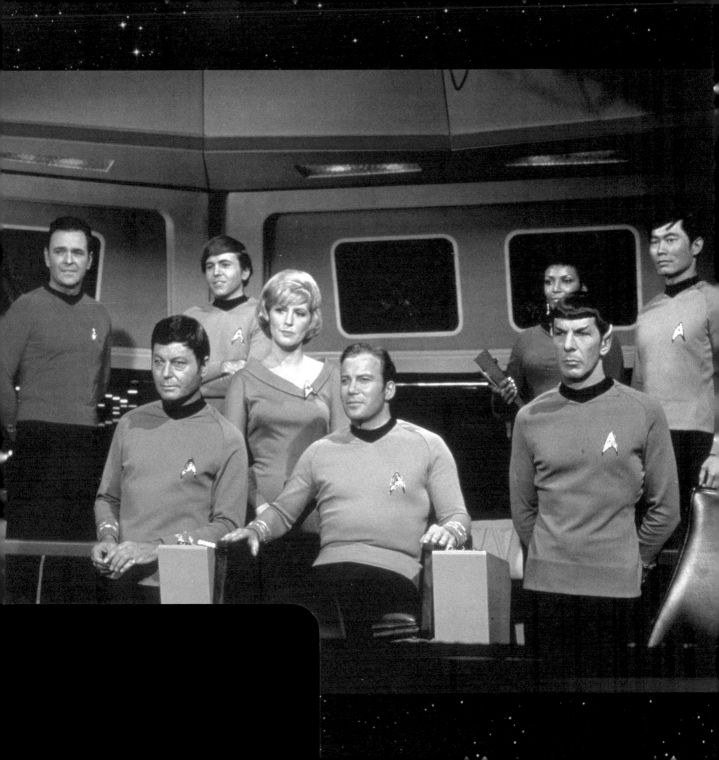

OBSESSED WITH™

STAR TREK®

TEST YOUR KNOWLEDGE OF THE STAR TREK UNIVERSE

By Chip Carter

CHRONICLE BOOKS

SAN FRANCISCO

Library of Congress Cataloging-in-Publication Data available.

ISBN: 978-1-4521-0171-2

Manufactured in China

Produced by becker&mayer! LLC, Bellevue, Washington
www.beckermayer.com

Design: Katie Stahnke, Gabriel Stromberg
Editorial: Amelia Riedler, Amy Wideman
Image Research: Jessica Eskelsen
License Acquisition: Josh Anderson
. Production Coordination: Leah Finger
Product Development: Peter Schumacher

10 9 8 7 6 5 4 3 2 1

Chronicle Books LLC
680 Second Street
San Francisco, CA 94107

www.chroniclebooks.com

www.startrek.com

CONTENTS

HOW TO USE THE MODULE

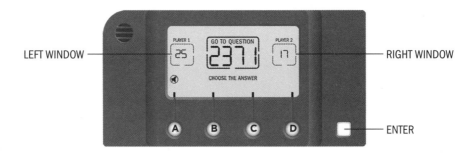

LEFT WINDOW — PLAYER 1 | GO TO QUESTION | PLAYER 2 — RIGHT WINDOW

CHOOSE THE ANSWER

A B C D ☐ — ENTER

To turn on the module, press the ENTER button.

CHOOSING THE GAME MODE

The module will automatically start in **Random Question** mode. To switch between the **Random Question** and **Question Select** game modes, hold down ENTER and press **D**. The module will ask you to SELECT THE GAME MODE. Press **B** for **Question Select**, or **C** for **Random Question** mode.

• In **Random Question** mode, a question number will appear automatically. Turn to that question in the book and read it. The module will ask you to CHOOSE THE ANSWER.

Select your answer by pressing the corresponding button beneath **A**, **B**, **C**, or **D**. The display window and accompanying sound will notify you whether you are CORRECT or INCORRECT. If you are incorrect, the module will display the correct answer.

The module will then randomly select another question.

• In **Question Select** mode, press ENTER to accept the question number displayed, or enter the number of the question you wish to answer by pressing **A** for each 1,000 digit, **B** for each 100, **C** for each 10, and **D** for the single digit. For example, if you would like

to answer question number 2138, you would press **A** twice, **B** once, **C** three times, and **D** eight times. Press ENTER to enter the question. The module will ask you to CHOOSE THE ANSWER. If you are incorrect, the module will display the correct answer.

The module will then automatically advance to the next question in sequence. To accept that question, press ENTER. To answer a different question, enter the corresponding question number using the **A**, **B**, **C**, and **D** buttons as above.

CHOOSING THE NUMBER OF PLAYERS

After you choose the game mode, the module will then ask you to SELECT THE NUMBER OF PLAYERS. Press **A** for a 1-PLAYER game, or **D** for a 2-PLAYER game. For 2-PLAYER mode, each player will alternate selecting and answering questions as above, according to the game mode. PLAYER 1 or PLAYER 2 will flash to signal which player's turn it is.

SCORING

• In **1-PLAYER** mode, after the player answers each question, the module will flash the number of CORRECT answers in the LEFT WINDOW out of the total number of QUESTIONS answered in the RIGHT WINDOW, followed by the percentage correct in the RIGHT WINDOW.

• In **2-PLAYER** mode, the LEFT WINDOW displays PLAYER 1's number of CORRECT questions out of the total number of questions, and the resulting percentage correct. PLAYER 2's score appears in the RIGHT WINDOW.

ADDITIONAL FUNCTIONS

The module will turn off after 45 seconds idle or by holding down ENTER for three seconds. It can be awakened by pressing the ENTER button.

When the module is turned back on, it will automatically remember the score, question number, and game mode of the last game played. To reset the score, hold down ENTER and press **D**.

To mute the sound effects, hold down ENTER and press **A**. An icon will signal whether the speaker is on ◁ or off ⊗.

BATTERIES

The module includes three AG-13 button-cell batteries. If the module does not turn on, you may need to replace the batteries through the compartment door on the side of the module.

CHAPTER 1
THE FIVE-YEAR MISSION

STAR TREK: THE ORIGINAL SERIES

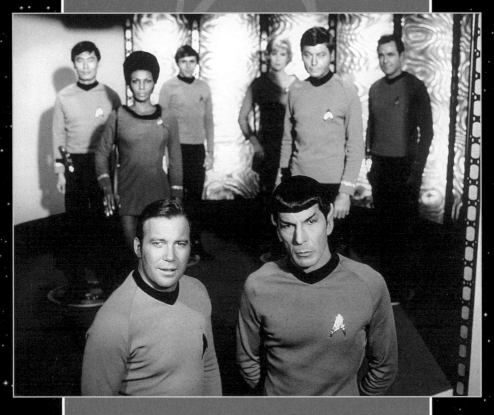

1. What is Captain Kirk's middle name?
 A. Thomas C. Tiberius
 B. Romulus D. Augustus

2. What planet is Spock's mother from?
 A. Rigel C. Beta III
 B. Earth D. Andoria

3. What technology on board the *U.S.S. Enterprise* does Dr. McCoy distrust the most?
 A. Transporter C. Diagnostic
 B. Warp D. Duotronic

4. What is Chief Engineer Scott's first name?
 A. Alastair C. Montgomery
 B. Ewen D. Douglas

5. What is the registry number of the *U.S.S. Enterprise?*
 A. NCC-1657 C. NCC-1701
 B. NCC-1709 D. NCC-176

6. What division do uniforms with blue tunics represent?
 A. Operations C. Science
 B. Command D. Recreation

7. In the episode "The Man Trap," what substance did the M-113 creature drain from humans?
 A. Magnesium C. Potassium
 B. Zinc D. Salt

LEFT The crew of the *U.S.S. Enterprise*.

8. In the episode "The Corbomite Maneuver," what is the name of the beverage that Balok offered his *Enterprise* guests?

A. Bloodwine **C.** Fizzbin
B. Tranya **D.** Kaferian apple juice

9. Who is the young man the alien Thasians raised and gifted with incredible powers?

A. Robert Tomlinson **C.** Charlie Evans
B. Tom Nellis **D.** Lee Kelso

10.

11. What is the illegal substance Harry Mudd used to enhance the characteristics of the women he was carrying?

A. Romulan ale **C.** Venus drug
B. Omicron Ceti spores **D.** Mahko root

12. What is the name of the First Federation ship commanded by Balok?

A. *Thasian* **C.** *Miri*
B. *Corbomite* **D.** *Fesarius*

13. What was the name of the seven-foot-tall android servant of the Old Ones on the planet Exo III?

A. Rayburn **C.** Korby
B. Ruk **D.** Andrea

14. How was the Psi 2000 virus spread?

A. Through telepathy **C.** Through contact with water
B. Through the air **D.** Through a transporter

15. What do the children of Miri's planet call adults?

A. Foolies **C.** Grups
B. Herberts **D.** Onlies

16. What device did the Tantalus V penal colony use to treat the criminally insane?

A. Alpha-wave inducer **C.** Cortical stimulator
B. Neural neutralizer **D.** Neural calipers

10.

On September 8, 1966, NBC aired the first episode of *Star Trek* and changed pop culture forever. Never before had a television show created such a fervent fan base. Trekkers, as the fans came to be known, were so loyal to the show that when NBC announced the show's cancellation after the second season, they flooded the network with over a million protest letters. NBC had to air a televised announcement telling fans the show had been renewed and to please stop writing the network.

It all became possible because of a former police sergeant and journeyman television writer, Gene Roddenberry. He had pitched a show to NBC about exploring the frontiers of space, much as the hit western *Wagon Train* depicted the expansion of the Wild West. He got the green light to make the pilot for *Star Trek*, but NBC ultimately rejected the filmed episode as "too cerebral." NBC wanted more action, more adventure. Roddenberry went back to the drawing board and filmed a second pilot (shown at right), featuring a different captain and crew, but still included one pointy-eared alien officer.

Who was the only actor to appear in both *Star Trek* pilots?

A. Jeffrey Hunter
B. William Shatner
C. Leonard Nimoy
D. James Doohan

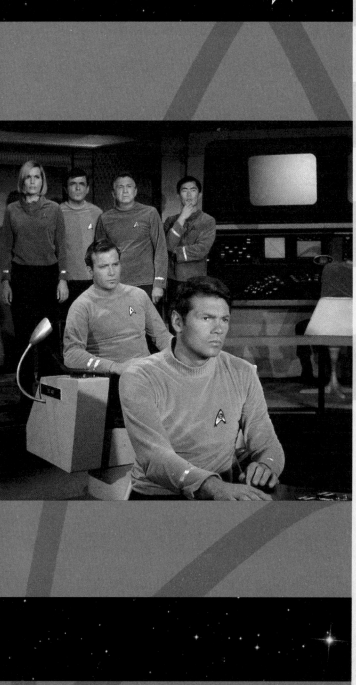

17. What instrument does Spock play?

 A. Harpsichord **C.** Lirpa

 B. Vulcan lyre **D.** Sitar

18. What dangerous mental powers do the Talosians possess?

 A. Pyrokinesis **C.** Illusion

 B. Telekinesis **D.** Teleportation

19. Actor Mark Lenard portrayed the first Romulan commander encountered by the *Enterprise* and later played which famous Vulcan?

 A. Surak **C.** Sarek

 B. Stonn **D.** Sybok

20. What is Dr. McCoy's first name?

 A. Lawrence **C.** William

 B. David **D.** Leonard

21. An accidental overdose of what drug drove Dr. McCoy into a paranoid state?

 A. Masiform D **C.** Cyalodin

 B. Cordrazine **D.** Stokaline

22. Who is the social worker Kirk fell in love with when he was stranded in time in the 1940s?

 A. Nancy Hedford **C.** Edith Keeler

 B. Janice Lester **D.** Carolyn Palamas

23. Who is the bully from Kirk's Starfleet Academy days who liked to play practical jokes on him?

 A. Gary Mitchell **C.** Finnegan

 B. Ben Finney **D.** Tyree

24. What literary character did Dr. McCoy first see on the "Shore Leave" planet?

 A. The Mad Hatter **C.** The White Rabbit

 B. Peter Pan **D.** Don Juan

25. What is the Prime Directive?

A. Members of Starfleet are not to interfere with the natural development of pre-warp cultures

B. Members of Starfleet are never to visit the planet Talos IV

C. If a captain is mentally incapacitated, the medical officer should relieve him or her of duty

D. Members of Starfleet must destroy all life on an entire planet if it is hostile

26. Who was the captain of the *U.S.S. Enterprise* prior to Kirk taking command?

A. Robert April

B. Christopher Pike

C. Matt Decker

D. Morgan Tracy

27.

Halfway into the first season of *Star Trek*, the writing staff ran into a familiar problem for weekly television shows: they were out of viable scripts. Creator Gene Roddenberry was faced with finding a quick solution or shutting down production on his fledgling series. He decided to write a show around the footage shot for the rejected pilot. This not only provided a way to recoup some of the expensive production costs of that first pilot, but it kept the season on schedule.

He crafted an episode that followed up on Spock's past service on the *U.S.S. Enterprise* and his loyalty to his prior commander. Not only did this give Starfleet and the ship a sense of history and depth, but the episode, "The Menagerie," became *Star Trek*'s first two-part, feature-length episode. The reused footage was seen by the crew on the ship's viewscreen as a mysterious transmission of recorded events from thirteen years earlier.

Who did Spock (shown at right) reveal was transmitting the recorded events?

28. The advanced Metreon race forced Captin Kirk to fight a representative of which species in the episode "Arena"?

A. Rigelian

B. Orion

C. Gorn

D. Andorian

29. Which character is a Shakespearean actor who Captain Kirk suspected was the mass murderer "Kodos the Executioner"?

A. Thomas Leighton

B. Kevin Riley

C. Anton Karidian

D. Patrick Stewart

30. Who served as chief medical officer during Captain Pike's command of the *U.S.S. Enterprise*?

A. Dr. Elizabeth Dehner

B. Dr. Mark Piper

C. Dr. M'Benga

D. Dr. Phillip Boyce

31. Who is the genetically engineered "superman" the crew of the *U.S.S. Enterprise* discovered in the episode "Space Seed"?

A. Clark Kent

B. Trelane

C. Khan

D. Charlie X

32. What is the virtual weapon that "destroyed" the *U.S.S. Enterprise* during the Eminiar-Vendikar war?

A. Disintegration station

B. Sonic disruptors

C. Tricobalt satellite

D. Photon torpedo launcher

A. The Orion slave girl

B. Vina

C. Commodore Mendez

D. The Talosians

33. In his manor on Gothos, where was the mechanical source of Trelane's powers located?

A. In the harpsichord
C. Behind the tapestry
B. In the statues
D. Behind the mirror

34. What is the name of the silicon-based life form encountered by the miners on Janus VI?

A. Excalbian
C. Horta
B. Melkotian
D. Metron

35. What type of emotions destroyed the Omicron Ceti III spores?

A. Peaceful
C. Intense
B. Mixed
D. Suppressed

36. What type of radiation destroyed the gelatinous Denevan neural parasites?

A. Gamma
C. Ultraviolet
B. X-rays
D. Delta

37. Which of Captain Kirk's former girlfriends was appointed as his prosecutor during his court-martial?

A. Nancy Crater
C. Carol Marcus
B. Lenore Karidian
D. Areel Shaw

38. What are the robed enforcers on the planet Beta III called?

A. Archons
C. Absorbers
B. Lawgivers
D. Heads

39. The slingshot method of time travel was first shown in which episode?

A. "All Our Yesterdays"
C. "Amok Time"
B. "Tomorrow Is Yesterday"
D. "The City on the Edge of Forever"

40. What is the name of Captain Kirk's older brother, who died during a parasite infestation on Deneva?

A. William
C. Leonard
B. Peter
D. Sam

41. Which famous 1960s science fiction author wrote the episode "Amok Time"?

A. Theodore Sturgeon
B. Kurt Vonnegut Jr.
C. Harlan Ellison
D. Ray Bradbury

42. What was the name of the scientist who created an interdimensional corridor to the antimatter universe?

A. Dr. Leighton
B. Ayelborne
C. Trelane
D. Lazarus

43. In the *Star Trek* original series, which episode featured the first appearance of the Klingons?

A. "Day of the Dove"
B. "A Private Little War"
C. "Errand of Mercy"
D. "The Trouble with Tribbles"

44.

45. What is the name of the irresistible mating urge Vulcans experience every seven years?

A. *Kolinahr*
B. *Plak-tow*
C. *Pon farr*
D. *Fal-tor-pan*

46. In the episode "Metamorphosis," what 200-year-old pioneer of Earth's space program did Kirk encounter?

A. Captain Jonathan Archer
B. Stephen Hawking
C. Zefram Cochrane
D. Buzz Aldrin

47. What is the first manifestation of Apollo's power?

A. Lightning strikes members of the landing party
B. A hand-shaped energy field
C. Scotty falls in love
D. Winds blow in space

48. Which of these computers did Captain Kirk *not* destroy by confronting it with the contradictions of its own programming?

A. Landru
B. Nomad
C. M-5
D. Atavachron

49. Who did Nomad think Captain Kirk was?

A. Vaal
B. Jackson Roykirk
C. Dr. Daystrom
D. The mirror universe Kirk

44.

As Vulcans know, humans have preconceived notions. Anything that does not fit in with their pre-established belief system is considered wrong, evil, or monstrous.

In the episode "The Devil in the Dark," the human miners of Janus VI send a distress call simply to have Starfleet come and get rid of the creature terrorizing them and delaying production. It took logic and a Vulcan mind-meld to deduce what the true situation was—that the creature was a silicon-based life form and it only attacked the miners because they were haphazardly destroying strange mineral growths that were actually the creature's eggs (shown at right).

The situation was further resolved when the creature communicated by etching a message in English on the cavern floor with the acid from its body.

What was its message?

A. "I Am Alive"
B. "Phone Home"
C. "No Kill I"
D. "Live Long and Prosper"

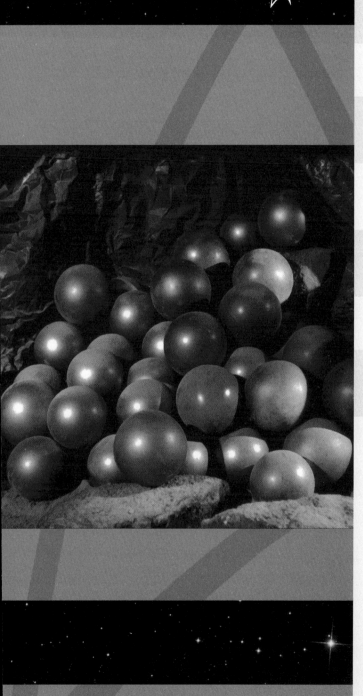

50. What are the standard-issue personal punishment devices equipped on board the *I.S.S. Enterprise*?

A. Tantalizers

B. Agonizers

C. Screamers

D. Neural Rippers

51. Who was the "Captain's Woman" on the mirror universe *Enterprise*?

A. Lieutenant Uhura

B. Lieutenant Mira Romaine

C. Lieutenant Marlena Moreau

D. Lieutenant Marla McGivers

52. What sophisticated computer made the natives of Gamma Trianguli VI immortal?

A. Akuta

B. Sayana

C. Vaal

D. Jahweh

53. In "The Doomsday Machine," who was the sole survivor of the *U.S.S. Constellation*?

A. Commodore José Mendez

B. Commodore Robert Wesley

C. Commodore Matt Decker

D. Captain Harris

54. What were the names of the extragalactic life-forms who created a "haunted" castle on Pyris VII?

A. Norman and Alice

B. Nancy and Zefram

C. Sylvia and Korob

D. Shras and Thelev

55. What was the name of Harry Mudd's shrewish wife?

A. Ruth

B. Janice

C. Stella

D. Edith

56. What kept Zefram Cochrane alive for more than 150 years?

A. A lifetime of warp travel

B. Sakuro's Disease

C. The mysterious alien called the Companion

D. The Atavachron

57. What was the name of Spock's father?

A. Stonn

B. Sarek

C. T'Pau

D. Surak

58. What was the real race of the spy on board the *U.S.S. Enterprise* during the "Journey to Babel"?

A. Tellerite
B. Andorian
C. Orion
D. Vulcan

59. Which actress, also known for playing Catwoman in the 1960s *Batman* television series, played Eleen in the episode "Friday's Child"?

A. Lee Meriwether
B. Eartha Kitt
C. Julie Newmar
D. Michelle Pfeiffer

60. Who is the only crewman unaffected by accelerated aging after visiting the colonists on Gamma Hydra IV?

A. Spock
B. Commodore Stocker
C. Chekov
D. McCoy

61. Why is Vulcan blood green?

A. It is iron-based
B. It is sulfur-based
C. It is copper-based
D. It is methane-based

62. What did the Jack the Ripper entity feed on?

A. Blood
B. Fear
C. Quadrotriticale
D. Circuitry

63. What is unusual about tribble procreation?

A. They don't procreate
B. They do not breed in captivity
C. They are born pregnant
D. They gestate for years

64. Who said, "I didn't mean to say that the *Enterprise* should be hauling garbage. I meant to say that it should be hauled away as garbage"?

A. Koloth
B. Korax
C. Kor
D. Arne Darvin

65. Who was the unscrupulous entrepreneur who sold tribbles?

A. Harry Mudd
B. Cyrano Jones
C. Trelane
D. Korax

66. What is the horned, white, apelike creature that is native to the planet Neural called?

A. *mahko*
B. Mugato
C. Tyree
D. Krell

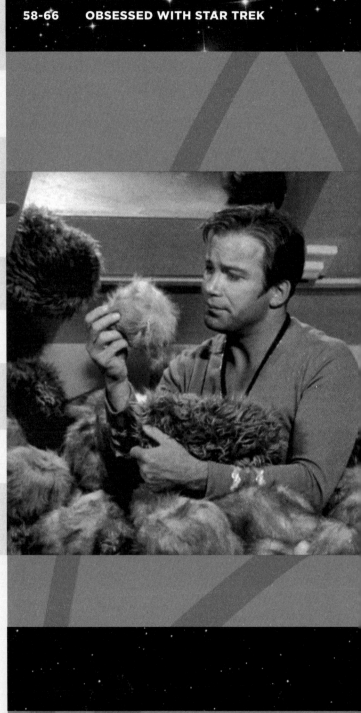

71.

Furry, cuddly, and constantly emitting a soothing purr, tribbles (shown at left with Kirk) instantly made fans and most of the *Enterprise* crew happy in their first appearance in the episode "The Trouble with Tribbles." It was only after the tribbles began to eat and multiply, and eat and multiply, consuming a whole compartment of much-needed grain, that the trouble with tribbles really began.

Known for its humor, the episode also stands out for its character interplay and the continuity with the first season's Organian Peace Treaty. Tribbles would remain one of the most popular and iconic aliens of *Star Trek*, appearing again and again in merchandise, books, comics, and other episodes. But it was the final disposition of a space station full of tribbles that got the last laugh.

Where did the tribbles infesting the *U.S.S. Enterprise* end up after Scotty beamed them off the ship?

A. Space Station K-7
B. Klingon ship
C. Cyrano Jones's ship
D. Into space

67. Who kidnapped Kirk, Uhura, and Chekov from the *Enterprise* and pitted them against other thralls in gladiatorial contests?
A. The Quatloos
B. Kloog
C. Galt
D. The Providers

68. What was the card game Kirk "taught" the Iotians?
A. Kronk
B. Shralk
C. Fizzbin
D. Supernova

69. Who said, "I'd advise youse to keep dialin' Oxmyx"?
A. Spock
B. Kirk
C. McCoy
D. Krako

70. What episode featured the threat of a giant space amoeba?
A. "Amok Time"
B. "The Omega Glory"
C. "The Immunity Syndrome"
D. "A Piece of the Action"

71.

72. Which cultural observer violated the Prime Directive by recreating a Nazi society on the planet Ekos?
A. Captain Merik
B. Captain Tracey
C. John Gill
D. Isak

73. Who was the leader of the Kelvans from the Andromeda galaxy?
A. Kelinda
B. Rojan
C. Hanar
D. Tomar

74. Who designed the computers on board the *U.S.S. Enterprise*?
A. Dr. Elizabeth Dehner
B. Dr. M'Benga
C. Dr. Richard Daystrom
D. Dr. Carter

75. What is the first ship the M-5 destroys?

- **A.** *U.S.S. Lexington*
- **B.** *Wotan*
- **C.** *U.S.S. Excalibur*
- **D.** *U.S.S. Defiant*

76. Who was First Citizen Merikus?

- **A.** The proconsul, Marcus
- **B.** Dr. McCoy
- **C.** Captain Merik
- **D.** Flavius Maximus

77. What was the name of Gary Seven's feline companion?

- **A.** Terri
- **B.** Isis
- **C.** Roberta
- **D.** Beta-5

78. How was Dr. McCoy able to replace Spock's brain?

- **A.** He used Vulcan techniques
- **B.** He cloned a piece of Spock's brain
- **C.** The Eymorg's Great Teacher enhanced his skills
- **D.** He used remote control

79. Who said, "Military secrets are the most fleeting of all. I hope that you and I exchanged something more permanent"?

- **A.** Spock
- **B.** Subcommander Tal
- **C.** Romulan commander
- **D.** Kirk

80. What "disease" does McCoy diagnose Kirk with when they arrive on Miramanee's planet?

- **A.** Dilithium fever
- **B.** Stockholm syndrome
- **C.** Tahiti syndrome
- **D.** Montezuma's revenge

81. What was the name of the noncorporeal creature the children summoned in "And the Children Shall Lead"?

- **A.** Medusa
- **B.** Gorgon
- **C.** Hydra
- **D.** Cyclops

82.

83. What does IDIC stand for?

- **A.** Internal Deliberations end Intrusive Conflicts
- **B.** Infinite Diversity in Infinite Combinations
- **C.** Iterations Develop Inherent Cohesiveness
- **D.** I Desire Intuitive Coherence

82.

Not as brash as Klingons, nor as logical as their Vulcan cousins, the Romulans are nevertheless formidable enemies.

In "The Enterprise Incident," Captain Kirk became more and more irrational, and ultimately ordered the ship into Romulan territory for no apparent reason. Immediately, the *Enterprise* was surrounded by Romulan ships.

Kirk and Spock met with the Romulan commander (shown at right), who had little to say to Kirk but was fascinated with the first officer. She invited Spock to dinner and appealed to him both logically and emotionally that he would be better served by joining the Romulan cause. And, initially, it seemed he agreed with her.

An enraged Kirk then attacked his first officer, who used the "Vulcan death grip" on Kirk, apparently killing him. His body was beamed back to the *Enterprise*. When revived, the captain explained to McCoy and Scotty that he and Spock were actually acting under orders from Starfleet.

What were those orders?

- **A.** To kidnap a Romulan commander
- **B.** To steal a cloaking device
- **C.** To start a secret branch of Starfleet Intelligence
- **D.** To reunify the Vulcans and Romulans

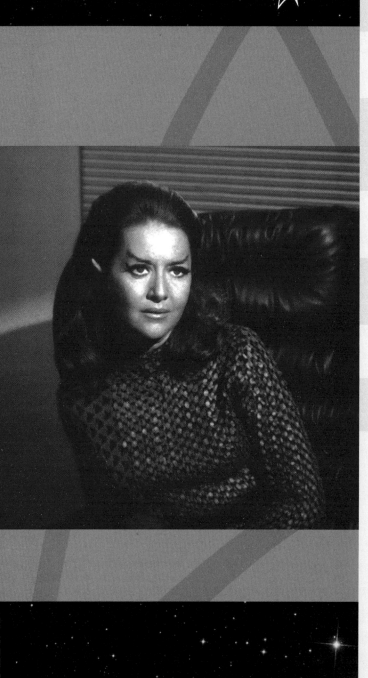

84. What was Dr. Miranda Jones's secret?

A. She was deaf C. She was blind

B. She was Vulcan D. She was blonde

85. What infamous American frontier scenario did the Melkotians force Kirk and his landing party to recreate?

A. Assassination of Jesse James C. Gunfight at the OK Corral

B. Buffalo Bill's Wild West show D. The Alamo

86. How did the *Enterprise* crew and Klingons drive away the noncorporeal Beta XII-A entity?

A. They had belligerent thoughts C. They laughed and had peaceful thoughts

B. They used advanced disruptor weaponry D. They used intra-ship beaming

87. What fatal disease did Dr. McCoy contract in "For the World Is Hollow and I Have Touched the Sky"?

A. Kironide deficiency C. Vegan choriomeningitis

B. Xenopolycythemia D. Rigelian fever

88. What race of beings had ships that could create a web of energy to trap other vessels?

A. Elasians C. Scalosians

B. Tholians D. Andorians

89. Which episode featured the first interracial kiss on network television?

A. "Wink of an Eye" C. "Day of the Dove"

B. "Plato's Stepchildren" D. "Elaan of Troyius"

90. What was the name of the Queen of the Scalosians?

A. Philana C. Elaan

B. Deela D. Mara

91. What did Dr. McCoy nickname the mute empathic woman they encountered in the Minarian star system?

A. Jewel C. Ruby

B. Sapphire D. Gem

92. What do the tears of Elasian women do to men?

A. Cause them to marry the woman

B. Cause them to love the woman

C. Cause them to hate the woman

D. Cause them to fear the woman

93. Who played Marta, the Orion—an actress better known for her role as Batgirl in the 1960s *Batman* television series?

A. Yvette Mimieux

B. Madge Blake

C. Yvonne Craig

D. Lee Meriwether

94. How long had Bele been chasing Lokai before they encountered the *U.S.S. Enterprise*?

A. 500 years

B. 5,000 years

C. 50,000 years

D. 5,000,000 years

95. Who was the lieutenant in charge of the Memory Alpha equipment transfer who fell in love with Scotty?

A. Mira Romaine

B. Nancy Hedford

C. Angela Martine

D. Uhura

96. Which famous Earth figure did Flint *not* claim to have been in the episode "Requiem for Methuselah"?

A. Brahms

B. Moses

C. Alexander the Great

D. Leonardo daVinci

97. What U.S. president did aliens replicate to fight alongside Kirk and Spock in "The Savage Curtain"?

A. Franklin Delano Roosevelt

B. John F. Kennedy

C. George Washington

D. Abraham Lincoln

98. What was the last episode that aired of the original series?

A. "All Our Yesterdays"

B. "Turnabout Intruder"

C. "The Savage Curtain"

D. "The Way to Eden"

99.

100. During "The Man Trap," who said, "It's a mystery, and I don't like mysteries. They give me a bellyache, and I've got a beauty right now"?

A. Dr. McCoy

B. Captain Kirk

C. Spock

D. Mr. Sulu

99.

In the episode "The City on the Edge of Forever" an accidental overdose drove Dr. McCoy mad and he ran through a time portal ending up in Earth's past—and thus changed all of Earth's history from that point on. His actions inadvertently erased all of Starfleet's history. Stranded at the eye of the storm was the only remnant of the original Earth: the small landing party of the *U.S.S. Enterprise*.

Kirk and Spock went after McCoy (shown at right), but the price Kirk would pay for correcting the time line would carry a devastating personal cost.

What did Kirk have to do to ultimately save history?

A. He killed one of his best friends

B. He let his family die

C. He let the woman he loved die

D. He killed his own ancestor

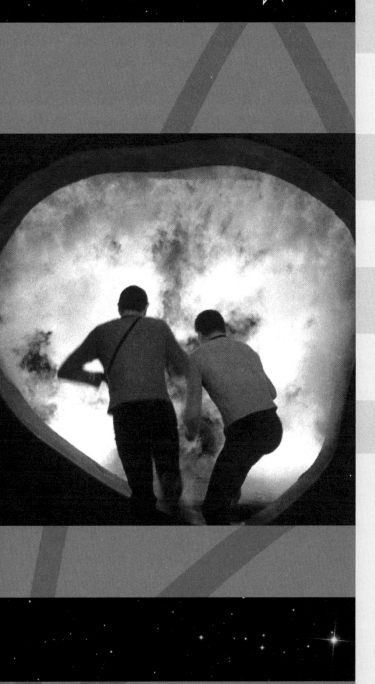

101. What Irish ballad did the Psi 2000 virus cause Lieutenant Riley to sing over and over again?

A. "Mother Macree"
B. "Danny Boy"
C. "Irish Eyes Are Smiling"
D. "I'll Take You Home Again, Kathleen"

102. When Charlie Evans controlled his mind, which line of poetry did Spock *not* recite?

A. "As I pondered, weak and weary ..."
B. "Tiger, tiger, burning bright ..."
C. "Saturn rings around my head ..."
D. "In truth, there is no beauty ..."

103. Where did Kirk plan to strand his best friend, Gary Mitchell, whose psionic powers had gone beyond control?

A. Cestus III
B. Taurus II
C. Rigel XII
D. Delta Vega

104. In the episode "The Enemy Within," how cold did the planet Alfa 177 get at night?

A. Minus 300 degrees Fahrenheit
B. Minus 250 degrees Fahrenheit
C. 32 degrees Fahrenheit
D. 40 degrees Fahrenheit

105. What alias did Harry Mudd use when he first encountered the crew of the *U.S.S. Enterprise*?

A. Charlie Evans
B. Norman
C. Richard Daystrom
D. Leo Francis Walsh

106. More famous for playing Lurch from *The Addams Family,* whom did actor Ted Cassidy play in the episode "What Are Little Girls Made Of?"

A. Dr. Crater
B. Dr. Korby
C. Ruk
D. Lieutenant Rayburn

107. Whom did Miri have a crush on?

A. Spock
B. McCoy
C. Kirk
D. Scotty

108. What episode first showed Spock performing a Vulcan mind-meld?

A. "Miri"
B. "Conscience of the King"
C. "Dagger of the Mind"
D. "What Are Little Girls Made Of?"

109. How did the producers make the Talosians seem even more alien?

A. Women played the roles of the male aliens

B. They used colored lights to distort the look of the aliens' faces

C. The aliens appeared as figures from history

D. They used puppets

110. In the episode "The Menagerie," why didn't Vina want to come back to the *Enterprise* and live with humans?

A. She loved the Talosians

B. Talosians had improperly restructured her body

C. She was half-Talosian

D. She hated humans

111. A Romulan attack interrupted whose wedding during the episode "Balance of Terror"?

A. Uhura and Spock's

B. Chapel and Korby's

C. Scotty and Romaine's

D. Martine and Tomlinson's

112. What type of radiation stranded the Galileo 7 shuttlecraft on the planet Taurus?

A. Dilithium

B. Cosmic

C. Ionic

D. Delta

113. Actor William Campbell portrayed both Trelane from "The Squire of Gothos" and which Klingon captain?

A. Kor

B. Koloth

C. Korax

D. Kang

114. Why did reptilian aliens destroy a Federation base on Cestus III?

A. The base attacked them

B. The base invaded their territory

C. They thought it was a Klingon base

D. There was no reason

115.

116. How did Spock discover proof of computer tampering in the episode "Court-Martial"?

A. He found irregular sensor readings

B. He beat the computer at chess repeatedly

C. He used a white-sound masking device

D. He reconstructed the memory banks

115.

As fascinating as it was for viewers in the 1960s to see the technology of the future and landscapes of exotic alien places (Metron alien from an uncharted planet shown at right), sometimes the crew needed to be outside on some Earth-like world where real trees and real rocks (along with plaster and papier-mâché ones) could lend another dimension of reality to the show.

In the eternal sunshine and wide range of geography of Southern California, location filming was easily accessible—and good if you needed something that looked just a little bit alien. One park, just a forty-five-minute drive north of Hollywood, is well known not only for its distinctive triangular rock summit but also for its numerous *Star Trek* scenes (and almost as many homages and parodies). One of the most iconic scenes is the battle in "Arena," where Kirk fought a reptilian creature with only weapons he had at hand.

What is the name of the park?

A. Sun Valley

B. Vasquez Rocks

C. Antelope Valley

D. Huntington Gardens

117. What was Landru's process for controlling the natives of Beta III called?

 A. Harvesting **C.** Absorbing

 B. Assimilating **D.** Collecting

118. What portrait of a famous historical leader did Lieutenant Marla McGivers *not* have in her quarters?

 A. Napoleon Bonaparte **C.** Richard the Lion-Hearted

 B. Alexander the Great **D.** Abraham Lincoln

119. Which Federation ambassador overrode Kirk's adherence to the Eminian Union's warning to stay away from Eminiar IV?

 A. High Commissioner Ferris **C.** Robert Fox

 B. Sarek **D.** Gav

120. Who is the botanist who fell in love with Spock and later reconnected with him on Omicron Ceti III?

 A. Christine Chapel **C.** Leila Kalomi

 B. Rayna Kapec **D.** Amanda Grayson

121. How many Organians does Kor "kill" in order to threaten the council to turn Spock and Kirk over to him?

 A. 100 **C.** 200

 B. 150 **D.** 800

122. Which actress—famous for her role in the nighttime soap opera *Dynasty*—played Kirk's lover in "The City on the Edge of Forever"?

 A. Linda Evans **C.** Emma Samms

 B. Diahann Carroll **D.** Joan Collins

123. What legendary science fiction author wrote the episode "The City on the Edge of Forever?"

 A. Ray Bradbury **C.** Isaac Asimov

 B. Robert Bloch **D.** Harlan Ellison

124. What protected Spock from being blinded by a medical experiment during the mission to Deneva?

 A. His Vulcan extra eyelid **C.** VISOR

 B. Sensor web **D.** Retnax-5

125. What is the most common Vulcan greeting?

A. "Peace be with you." C. "We are of the Body."

B. "Live long and prosper." D. "Jolan tru."

126. Who was the only person who ever turned down a seat on the Federation Council?

A. T'Pau C. Gav

B. Sarek D. Shras

127. In what object was the "god" Apollo's power source located on Pollux IV?

A. Urn C. Temple

B. Lyre D. Statue

128. What sort of storm caused the transporter malfunction that sent Kirk's landing party into the mirror universe?

A. Solar C. Thunder

B. Ion D. Cosmic

129. Who did the mirror-Kirk assassinate to gain command of the *I.S.S. Enterprise*?

A. Spock C. Captain Pike

B. Captain April D. President of Earth

130. Who is the Security Chief of the *I.S.S. Enterprise*?

A. Spock C. Chekov

B. Sulu D. Uhura

131. What biblical figure did Spock ironically compare Captain Kirk to, after the mission on Gamma Trianguli VI?

A. Adam C. God

B. Cain D. Satan

132. Landon and Chekov's actions inspire two of the natives of Gamma Trianguli VI to do what?

A. Join Starfleet C. Tell on them

B. Kiss D. Procreate

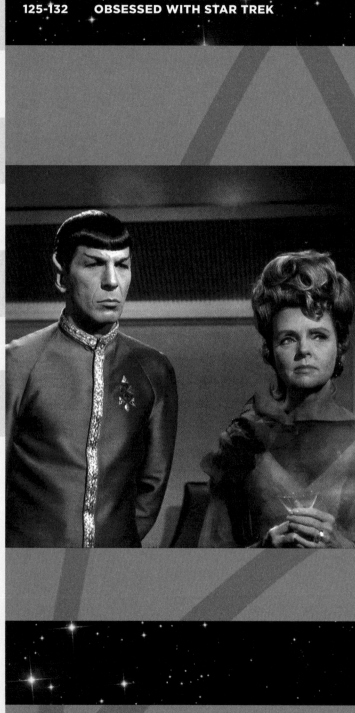

141.

By the second season, Mr. Spock had proven to be the breakout character of the show. "I grok Spock" T-shirts were everywhere and Leonard Nimoy received an astonishing amount of fan mail. So, for fans hungry for more Vulcan lore, the episode "Journey to Babel" allowed everyone to meet Spock's parents.

His mother, the warm and witty Amanda (shown at left with Spock, left), and his father, the coldly logical Sarek, came aboard the *Enterprise* for an ambassadorial conference, and the tension between Spock and his father was instantly noticeable. Kirk learned of the rift between the two over Spock's choice of Starfleet as a career. Things didn't get any better as Sarek became the prime suspect in a murder investigation, then suffered a near-fatal heart attack, as the true murderer wounded Kirk. But it wasn't until Spock chose to donate his rare blood type for his father's recovery that the two Vulcans' animosity thawed.

For how long had Spock and his father not spoken before the events of "Journey to Babel"?

A. Ten years
B. Twelve years
C. Eighteen years
D. Fifty years

133. Whose fatal sacrifice gives Kirk the idea of how to destroy the planet-killer in "The Doomsday Machine"?
A. Edith Keeler's
B. Matt Decker's
C. Yeoman Rand's
D. Ben Finney's

134. What cured Assistant Federation Commissioner Nancy Hedford of Sakuro's disease?
A. Transporters
B. Merging with the Companion
C. Plasma ray bombardment
D. Warp field exposure

135. What common Vulcan pet did Spock have as a child?
A. *Katra*
B. Jolan Tru
C. *Plomeek*
D. *Sehlat*

136. What natural substance did Dr. McCoy discover that cures hyper-accelerated aging in the episode "The Deadly Years"?
A. Acidophilus
B. Melinomium
C. Histamines
D. Adrenaline

137. On what ship did Captain Kirk first serve?
A. *U.S.S. Hood*
B. *U.S.S. Constellation*
C. *U.S.S. Farragut*
D. *U.S.S. Excalibur*

138. What is the vampiric cloud creature of Tycho IV composed of?
A. Tritanium
B. Dikronium
C. Quadrotriticale
D. Antimatter

139. How did Spock force the Jack the Ripper entity out of the computer in the episode "Wolf in the Fold"?
A. Made it compute pi to the last digit
B. Fed it illogical instructions
C. Rebooted it
D. Mind-melded with it

140. Who said, "I was not aware, Mr. Baris, that twelve Klingons constitutes a swarm"?
A. Spock
B. Captain Koloth
C. Kirk
D. Cyrano Jones

141.

142. Who was the drill thrall who taught Kirk to fight on Triseklion, as he taught her to love?

A. Galt
B. Lars
C. Shahna
D. Kloog

143. Before the *U.S.S. Enterprise*, what was the last Federation ship to visit Sigma Iotia II?

A. *U.S.S. Intrepid*
B. *U.S.S. Horizon*
C. *U.S.S. Exeter*
D. *U.S.S. Beagle*

144. What was the only Federation ship crewed almost entirely by Vulcans?

A. *U.S.S. Hood*
B. *U.S.S. Intrepid*
C. *U.S.S. Potemkin*
D. *U.S.S. Lexington*

145. What is the only cure for the bite of the mugato?

A. Teer
B. Mahko root
C. Scalosian water
D. Masiform D

146. Who said, "Oblivion together does not frighten me, beloved" in the episode "Return to Tomorrow"?

A. Sargon
B. Thalassa
C. Kirk
D. McCoy

147. Whom did the Ekosians try to intimidate and conquer in the episode "Patterns of Force"?

A. Zetarans
B. Zeons
C. Andromedans
D. Sigma Iotians

148. What type of exotic energy does the galactic barrier contain?

A. Ionic
B. Negative
C. Neural
D. Gamma

149. What is the name of Gary Seven's multipurpose tool that is disguised as a pen?

A. Sonic Screwdriver
B. Servo
C. Beta-6
D. IDIC

150. What was the only *Star Trek* original series episode to feature the Vulcan IDIC symbol on a medallion Spock wore?

A. "Spectre of the Gun"
B. "Is There in Truth No Beauty?"
C. "Spock's Brain"
D. "And the Children Shall Lead"

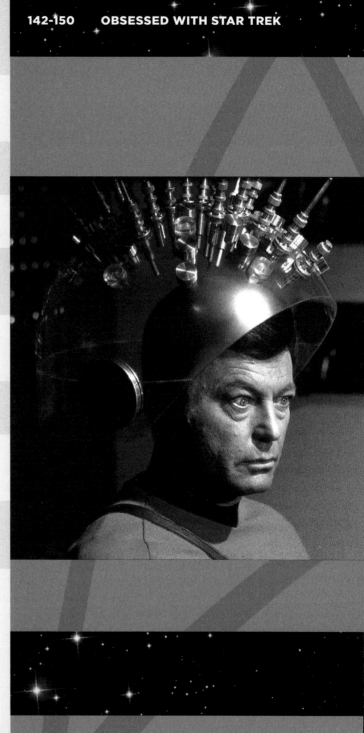

156.

When a beautiful alien stole Spock's physical brain to run her planet's computer system, it began a bizarre race against time for the *Enterprise* crew to find the missing brain and return it. The strange dichotomy of the female Eymorgs' technology complicated matters. The Eymorgs themselves possessed only a primitive intelligence, but the one who stole the brain was advanced enough to perform a complicated surgical procedure.

Dr. McCoy (shown at left) theorized that the Eymorgs' dependence on the computer to provide everything they needed atrophied their intellectual capabilities. Nevertheless, to save Spock, McCoy had to link up with their computer in an attempt to gain the knowledge he needed to replace Spock's missing brain. While the *Enterprise* crew was interrogated, a line was spoken that would become an ironic science-fiction idiom.

Who uttered the immortal words, "Brain and brain! What is brain?"

A. Spock
B. Luma
C. Kara
D. The Morg guard

151. Who said, "What can I do, Captain? You know we're always supposed to maintain good relations with the natives" in the episode "The Apple"?
A. Chekov
B. Scotty
C. Sulu
D. McCoy

152. What is the only episode to feature a female Klingon?
A. "Day of the Dove"
B. "The Savage Curtain"
C. "Let That Be Your Last Battlefield"
D. "The Way to Eden"

153. Whom did McCoy marry while stricken with a fatal illness?
A. Natira
B. Mara
C. Philana
D. Sylvia

154. What was the sister ship of the *U.S.S. Enterprise* that was locked in "interphase" between two universes?
A. *U.S.S. Potemkin*
B. *U.S.S. Defiant*
C. *U.S.S. Excalibur*
D. *U.S.S. Intrepid*

155. Who was the one member of the Platonians who did *not* have their psychokinetic powers?
A. Parmen
B. Eraclitus
C. Alexander
D. Philana

156.

157. What was the cause of the Scalosians' hyper-acceleration?
A. Solar flare radiation
B. Hard water fumes
C. Warp field radiation
D. Volcanic radiation

158. What chess phrase did Kirk and Scotty use as code to prevent unauthorized transport while orbiting the Elba II asylum?
A. "Bishop takes knight."
B. "Pawn to king six."
C. "Queen to queen's level three."
D. "Check and mate."

159. What actor—best known for playing the Riddler in the 1960s *Batman* television series—played the black-and-white-skinned alien Bele?
A. Frank Gorshin
B. John Astin
C. Burgess Meredith
D. Cesar Romero

160. What was the consequence of the Gideons making themselves immortal?

A. Sterility
B. Madness
C. Higher taxes
D. Overpopulation

161. What was the name of the commander of the Kalandan station, whose image is replicated by the outpost's computer?

A. Rayna
B. Odona
C. Losira
D. Lokai

162. What did the *Enterprise* crew discover would kill the noncorporeal Zetarians after they lived in the vacuum of space for millennia?

A. Light
B. Oxygen
C. Intense atmospheric pressure
D. Gravity

163. In "The Way to Eden," what slang name for bureaucratic officials did Dr. Sevrin's followers continually call Captain Kirk?

A. Ralph
B. Fred
C. Basil
D. Herbert

164. Who was the founder of the Klingon Empire?

A. Kang
B. Kor
C. Korax
D. Kahless

165. Who fell in love with Spock while stranded in Sarpeidon's Ice Age, but could not return to the future due to her changed cellular structure?

A. Zora
B. Zarabeth
C. Rayna
D. Mara

166. What is the mineral only found on Ardana?

A. Lithium
B. Zenite
C. Radan
D. Pergium

167. What is the only antidote for Rigelian fever?

A. Ritalin
B. Ryetalyn
C. Saurian brandy
D. Stokaline

168. What is the name of Spock's pet?

A. Selek
B. I-Chaya
C. L-langon
D. Surak

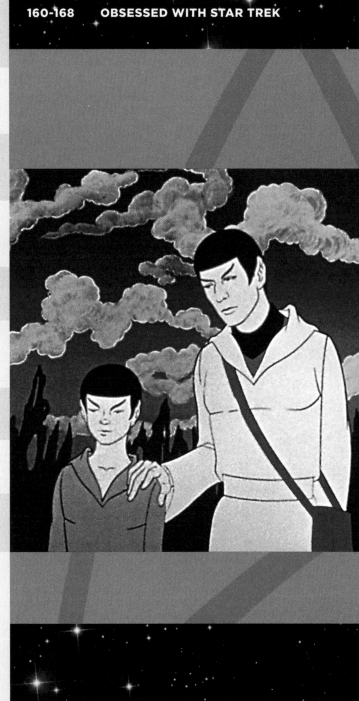

174.

"Yesteryear" (shown at left) was one of the first *Star Trek* animated series episodes; it aired on September 15, 1973. It was written by D.C. Fontana, who also penned "Journey to Babel," another chapter in Spock's family background. In "Yesteryear," the Guardian of Forever from the original series sent Spock into his past on Vulcan to discover a change in his own history that threatened his present existence.

By interacting with his father and younger self, Spock discovered a difficult decision his younger self had to make in order to save his later self's personal time line. During its production, this animated episode became controversial because the network did not want the original ending, fearing children would be upset. However, Roddenberry insisted on Fontana's ending, an uncompromising portrayal of a young child facing difficult life choices.

What did Spock have to change to correct his time line?

A. Confront his father about Starfleet
B. Choose the Vulcan way and let his suffering pet die
C. Save his younger self during the *kahs-wan* ordeal
D. Find out who his cousin Selek really is

169. What is the name of Spock's hometown on Vulcan?
A. Sha-ka-ree
B. Vulcanopolis
C. ShiKahr
D. Vulcania

170. Which crew member did *not* beam down as part of the all-female landing party in the *Star Trek* animated series episode, "The Lorelei Signal"?
A. Nurse Chapel
B. Lieutenant Uhura
C. Lt. M'Ress
D. Lt. Davison

171. In the animated sequel "More Tribbles, More Troubles," both the characters of Captain Koloth and Cyrano Jones returned, but who was the only actor to reprise his role from the original series?
A. William Campbell
B. Stanley Adams
C. Mark Lenard
D. Roger C. Carmel

172. What is the name of the creature the Klingons genetically engineered to hunt and eat tribbles?
A. Glommer
B. Korax
C. I-Chaya
D. Devisor

173. What is the dominant life-form on the planet Phylos?
A. Vulcans
B. Intelligent clones
C. Intelligent plant life
D. Intelligent marine life

174.

175. In "The Magicks of Megas-Tu," the Megans claim to have visited Earth and been persecuted during which historical period?
A. Crusades
B. Nazi Germany
C. Salem witch trials
D. Roman Empire

176. The animated episode "Once Upon a Planet" is a sequel to which original series episode?
A. "For the World Is Hollow and I Have Touched the Sky"
B. "The Ultimate Computer"
C. "Assignment: Earth"
D. "Shore Leave"

177. What does Mudd's love potion do to people when it wears off?

A. Makes them forget who the loved one is

B. Turns them into rock creatures

C. Causes the lovers to despise each other for a few hours

D. Makes them ugly

178. What caused the *U.S.S. Enterprise* crew to shrink in height?

A. Reductive rays

B. Terratin's soil

C. Nucleonic fission

D. Spiroid epsilon waves

179. What do the inhabitants of the temporal pocket dimension in the episode "The Time Trap" call their prison?

A. Rura Penthe

B. Fantasia

C. Elysia

D. Elba II

180. During the mission to the planet Argo, which of the *Enterprise* crew were transmuted into water-breathers?

A. Bones and Scotty

B. Kirk and Bones

C. Kirk and Spock

D. Sulu and Chekov

181. What is the artifact known as the Soul of the Skorr?

A. Crystalline egg worshipped by Skorrians

B. Brain patterns of a religious leader preserved in a sculpture

C. Book containing all of the original religious texts

D. Dilithium belt thought to gift antigravity flight to the wearer

182. In "The Pirates of Orion," production difficulties gave the Orions what color skin instead of their traditional green?

A. Red

B. Purple

C. Blue

D. Tan

183. Honorary commander Ari bn Bem from Pandro is what type of life-form?

A. Immortal

B. Amphibian

C. Colony Creature

D. Avian

184. While infected by the energy cloud in "The Practical Joker," what does the *U.S.S. Enterprise* computer send out to decoy the Romulan vessel?

A. An asteroid

B. Laughing gas

C. An inflatable fake *U.S.S. Enterprise*

D. Holographic snowstorms

187.

The final episode of the *Star Trek* animated series in October 1974 was the last adventure of the *U.S.S. Enterprise* crew until *Star Trek: The Motion Picture* was released in 1979.

Delving into the legacy of the *U.S.S. Enterprise* (shown below), Kirk and his crew escorted a retiring Commodore Robert April, first-ever captain of the *Enterprise*, to Babel for one last

185. What type of planets with oxygen-nitrogen atmospheres does Starfleet classify as able to support humanoid life?

A. Class-M

B. Class-L

C. Class-D

D. Class-J

186. What ethnicity was Ensign Dawson Walking Bear?

A. Chinese American

B. Native American

C. African American

D. Japanese American

187.

mission. An encounter with a visitor from a negative universe sent the *Enterprise* into a strange backwards dimension where they began to grow younger at an exponential rate. Soon, the crew realized, they would be too young to return to their rightful universe.

What was the mandatory retirement age for Starfleet officers before the events of this episode?

A. 65

B. 75

C. 85

D. 147

188. After a transporter accident split Kirk into good and evil duplicates, what did the evil Kirk ask Dr. McCoy to give him to drink?

A. Antarean brandy

B. Tranya

C. Whiskey

D. Saurian brandy

189. Which medical archaeologist was Nurse Chapel engaged to before he disappeared for five years?

A. Dr. Simon Van Gelder

B. Dr. Tristan Adams

C. Dr. Roger Korby

D. Dr. Thomas Leighton

190. When do the children of Miri's world contract the disease that kills their parents?

A. Infancy

B. Puberty

C. Middle age

D. Old age

191. How many years before the episode "Balance of Terror" did the Romulan War take place?

A. 10 years

B. 100 years

C. 500 years

D. 1,000 years

192. What name do Klingons and Romulans call their spacecraft?

A. Cutters

B. Warbird

C. Bird-of-Prey

D. Galleons

193. What type of radiation did the Omicron Ceti III spores immunize the colonists against?

A. Cathode

B. Berthold

C. Ionic

D. Delta

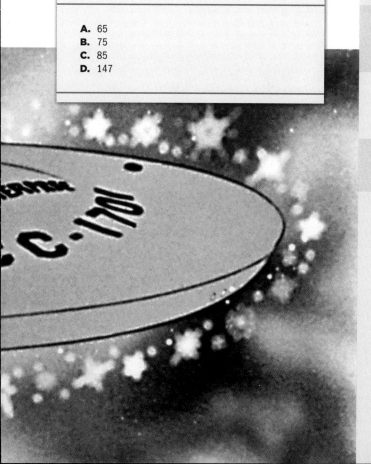

194. Who said, "Curious how often you humans manage to obtain that which you do not want"?

A. Kor

B. Spock

C. Trefayne

D. Ayelborne

195. During "Errand of Mercy," what device did the Klingons use to interrogate Spock?

A. Neural neutralizer

B. Psycho-tricorder

C. Mind-sifter

D. Romulan mind-probe

196. To avoid Klingon notice, what does Spock pose as while on Organia?

A. Organian council member

B. Romulan ambassador

C. Vulcan trader

D. Klingon serf

197. How did Kirk and Spock travel into the past to stop McCoy from changing history in "The City on the Edge of Forever"?

A. Atavachron

B. Guardian of Forever

C. Slingshot effect

D. Temporal instability

198. What is the name for the elevator that crewmen use to get from deck to deck on board the *Enterprise*?

A. Jefferies Tube

B. People mover

C. Turbolift

D. Vertical corridor

199. What is different about the computer voice aboard the *Enterprise* in the mirror universe?

A. It speaks in binary code

B. It is male

C. It is emotional

D. There is no voice

200. In the episode "The Changeling," which bridge officer did Nomad "kill," then repair?

A. Uhura

B. Scotty

C. Spock

D. Chekov

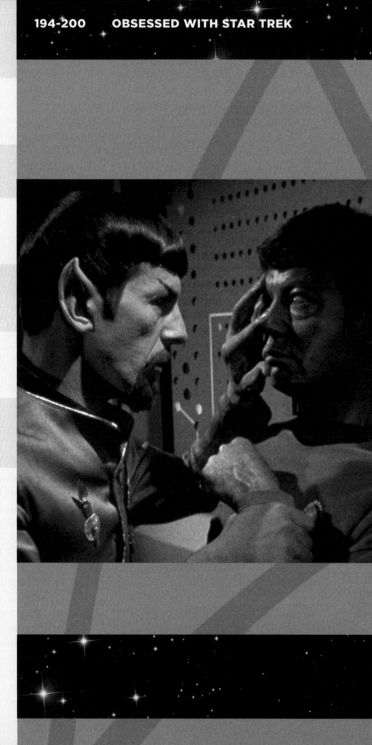

204.

In the episode "Mirror, Mirror," Kirk and his landing party were beamed up from a planet and into an alternate universe where an evil empire held sway instead of the Federation. The mirror Kirk's standard procedure for civilizations that don't give him what he wants is to obliterate their cities one by one.

As the good Kirk and his crew tried to escape, they had to avoid being killed by evil duplicates of their shipmates as well as staying one step ahead of a ruthless and curious Spock (shown at left with McCoy, right). Kirk discovered that his counterpart had a mysterious superweapon that kept him in power because it allowed him to make his enemies disappear via remote control.

What is the name of the weapon?

A. Agony booth
B. Neural neutralizer
C. Tantalus field
D. Ultimate nulllifier

201. Who designed the original *U.S.S. Enterprise*'s distinctive saucer shape and engines?

A. Gene Coon
B. Matt Jefferies
C. D.C. Fontana
D. Bob Justman

202. Who designed the female costumes for the original series?

A. Bob Mackie
B. William Ware Theiss
C. Gene Coon
D. Fred Feinberger

203. What is the only crime punishable by death, according to Starfleet regulations?

A. General Order No. 3, mutiny
B. General Order No. 1, breaking the Prime Directive
C. General Order No. 7, visiting Talos IV
D. General Order No. 24, destroying a planet

204.

205. During Kirk's battle with Spock in the episode "Amok Time," what does McCoy tell the Vulcans he is injecting Kirk with?

A. Cordrazine
B. Tri-ox compound
C. Plomeek
D. Kironide

206. In which episode did Ensign Chekov first appear?

A. "Amok Time"
B. "Journey to Babel"
C. "The Changeling"
D. "Who Mourns for Adonais?"

207. What does the Vulcan word *kroykah* mean?

A. Stop
B. Fight
C. Challenge
D. Honor

208. Which Vulcan weapon is shaped like a curved axe on one end and a rounded cudgel on the other?

A. *Ahn-woon*
B. *Kal-if-fee*
C. *Plomeek*
D. *Lirpa*

209. What is Captain Kirk's serial number?

 A. K32759-013
 B. SC937-0176CEC
 C. J54T578K235
 D. 11001001

210. What does a Code One Alert from Starfleet signal?

 A. Invasion or war
 B. Temporal instability
 C. Discovery of Omega particles
 D. Breaking of the Prime Directive

211. What station other than Communications did Lieutenant Uhura often take over during emergency situations?

 A. Navigation
 B. Helm
 C. Science
 D. Command

212. What standard-issue equipment did Mr. Scott use to power the fuel-less *Galileo 7* while stranded on Taurus II?

 A. Communicators
 B. Tricorders
 C. Phasers
 D. Scanners

213. What change to the opening credits was made at the beginning of the second season?

 A. DeForest Kelley's name was added
 B. The theme music was extended
 C. A female soprano vocal was added
 D. All answers are correct

214. Which *Star Trek* actor was to first wear each uniform in each division color: red, gold, and blue?

 A. Leonard Nimoy
 B. George Takei
 C. Eddie Paskey
 D. Nichelle Nichols

215. What was Nancy Crater's affectionate nickname for her old flame Dr. McCoy?

 A. Magnolia
 B. Plum
 C. Sugar
 D. Bones

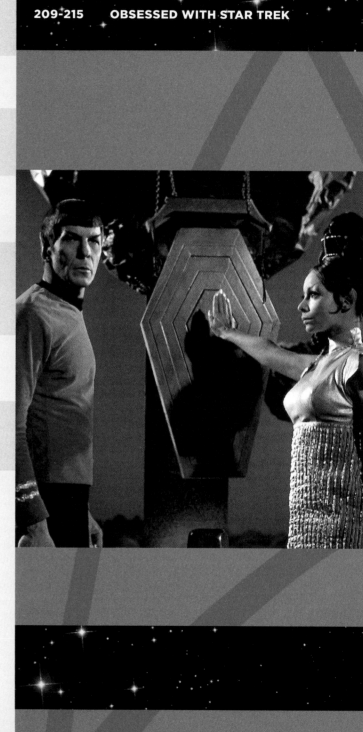

220.

Living on an arid desert planet and steeped in centuries of tradition and logic, the Vulcans often seem cold-blooded. However, as their marriage customs show, their emotions and passions run deep. The term for a wedding ceremony in Vulcan literally translates as both "marriage" and "challenge." If a wife does not want a mate for any reason, she can choose a defender to fight and win her from her betrothed.

When the irresistible Vulcan mating urge struck Spock, he became irrational and was compelled to return to his home planet to his wife T'Pring (shown at left with Spock, left). He defied orders to do so, coming into conflict not only with his logical upbringing, but his duty as a Starfleet officer.

During Spock's absence from the planet, T'Pring became involved with another man, and when Spock returned, he learned that she did not want to be "the consort of a legend." Her logical solution was to force the ancient rite of challenge and choose a champion—one she knew would free her to live as she preferred.

Who did T'Pring choose as her champion?

A. T'Pau
B. Kirk
C. Stonn
D. McCoy

216. *Star Trek* creator Gene Roddenberry made his only (and uncredited) appearance in the episode "Charlie X" as who?
A. The floating Thasian head
B. Voice of the galley chef
C. Sam
D. Kirk's stunt double

217. What was the nickname Sulu gave to his unusual purring plant in the *Enterprise* botany lab?
A. Gertrude
B. Beauregard
C. Audrey
D. Seymour

218. How many episodes did Yeoman Rand appear in?
A. Eight
B. Thirteen
C. Forty-seven
D. Seventy-nine

219. Which famous 1960s author wrote the episode "Shore Leave," in which the *Enterprise* crew encounters a planet where every thought can come true?
A. Theodore Sturgeon
B. Isaac Asimov
C. Harlan Ellison
D. Robert Bloch

220.

221. What type of radioactive element, used for energy throughout the Galaxy, is mined on Janus VI?
A. Pergium
B. Corbomite
C. Tricobalt
D. Bertholium

222. Which lieutenant insisted his colleagues be given a burial despite the danger of the giant creatures on Taurus II in the episode "The Galileo Seven"?
A. Latimer
B. Boma
C. Gaetano
D. Kelowitz

223. Who designed the tribble props?
A. Bob Justman
B. Gene Roddenberry
C. Wah Chang
D. David Gerrold

224. Who wrote the main title theme song?

A. Jerry Goldsmith C. Alexander Courage
B. Howard Shore D. James Horner

225. On the Richter scale of cultures, how did the Federation initially classify Organia?

A. A C. D-
B. B D. F

226. The production model for the *Botany Bay* was reused as which freighter in "The Ultimate Computer" episode?

A. *Thor* C. *U.S.S. Valiant*
B. *Freya* D. *Wotan*

227. What planet do the Federation and Klingons both claim and want to develop per the Organian Peace Treaty?

A. Burke's Planet C. Gerrold's Planet
B. Sherman's Planet D. K-7

228. What did Kirk and Spock do when they "put the bag" on Krako?

A. Kidnapped him C. Confined him
B. Provided information about him D. Influenced him by force

229. What form of radiation did Spock have the nuclear electronics lab generate to negate Apollo's force field?

A. Celebium C. Berthold rays
B. M-rays D. Delta

230. Who said, "Crazy way to travel, spreading a man's molecules across the universe"?

A. Ensign Garrovick C. Dr. McCoy
B. Lt. Chekov D. Nurse Chapel

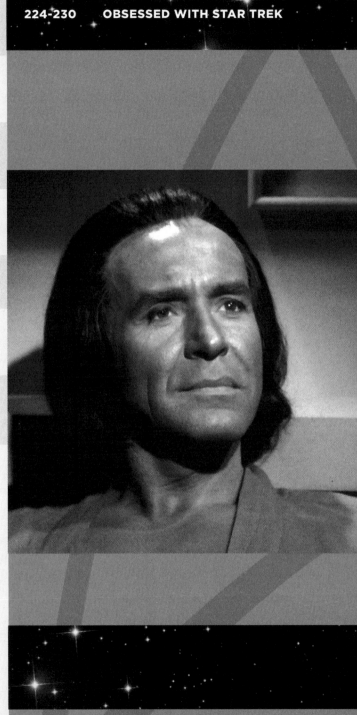

231. One ounce of antimatter has the equivalent explosive force of how many cobalt bombs?

A. 100 **C.** 100,000
B. 10,000 **D.** 1,000,000

232. What is the name of the alien probe that Nomad joins with to upgrade itself?

A. Tan-Ru **C.** M-5
B. Omega **D.** Landru

233. What did McCoy discover about Apollo?

A. He was a symbiotic host **C.** He was a silicon-based life-form
B. He had a mysterious extra organ in his chest **D.** He was a cybernetic organism

234. What was the name of the mission that Kirk's girlfriend from the 1930s ran?

A. Five-Year Mission **C.** The Good Samaritan Mission
B. The Army of Salvation **D.** Twenty-First Street Mission

235. Though not seen on-screen until *Star Trek: The Next Generation*, an emergency saucer separation was mentioned and performed off-screen in which original series episode?

A. "Bread and Circuses" **C.** "Arena"
B. "The Apple" **D.** "All Our Yesterdays"

236.

Neither a monster nor a psychopath, Kirk's nemesis, Khan Noonien Singh (shown at left), believes he deserves to rule because he is better than all other humans. And he is. Genetically engineered, Khan is the strongest and smartest of his kind—a race of modified humans created during the Eugenics Wars.

Khan also possesses a magnetic charisma that makes others unable to refuse him. He can charm, parry, and debate with unshakable confidence.

His allure caused the ship's historian to fall in love with him. Ultimately, her loyalty to her ship forced her to aid Kirk so he might be able to best Khan in a fight. However, Khan's influence over the crew member was strong, and rather than discipline her, Kirk allowed her to go into exile with Khan.

Who was the crew member who fell in love with Khan?

A. Carolyn Palamas
B. Tonia Barrows
C. Marla McGivers
D. Marlena Moreau

237. In the episode "By Any Other Name," what vitamin compound does McCoy give Spock, telling the Kelvans that it is a cure for Rigelian Kassaba fever?

A. Rigelian vitamin D **C.** Retlaw
B. Stokaline **D.** Kironide

238. What nickname does Yeoman Landon call Chekov that no one else ever uses?

 A. Ivan **C.** Big Red
 B. Pav **D.** Tovarisch

239. Which *Starsky and Hutch* actor played Makora in the episode "The Apple"?

 A. Paul Michael Glaser **C.** Antonio Fargas
 B. David Sool **D.** Bernie Hamilton

240. Melvin Belli, the lawyer/actor who appeared in the episode "And the Children Shall Lead," was also known as legal counsel to which 1960s assassin?

 A. Lee Harvey Oswald **C.** James Earl Ray
 B. Jack Ruby **D.** Sirhan Sirhan

241. What does Bele possess that protects him from weapons fire?

 A. Dense skin tissue **C.** Natural force field
 B. Ability to create illusions **D.** Energy-absorbing powers

242. What kind of sword does Scotty use in "Day of the Dove"?

 A. Claymore **C.** Katana
 B. Rapier **D.** Cutlass

243. What is the library planetoid that stores all of the Federation's scientific and cultural information?

 A. Memory Alpha **C.** Talos IV
 B. Sarpedion **D.** Guardian of Forever

244. Who said, "Uncontrolled power will turn even saints into savages. And we can all be counted on to live down to our lowest impulses"?

 A. Spock **C.** Alexander
 B. McCoy **D.** Parmen

248.

In 1968, as the second season wound down, executive producer Gene Roddenberry knew the show was on the brink of cancellation due to low ratings. He decided to make the last episode of the second season into a "backdoor" pilot—Hollywood lingo for an episode of an existing television show to potentially start a new series or spin-off—about a scientifically advanced secret agent in the 1960s.

In the second season finale "Assignment: Earth," the *Enterprise* crew traveled back in time and met the enigmatic Gary Seven, a human raised by aliens who came to Earth to protect humanity from itself.

In addition to Seven's human assistant, Roberta Lincoln, and his computer, Beta 5, he was also helped on his mission by a being that appeared to be able to transform from cat to woman (shown at left).

What was this feline creature known as?

A. Isis
B. Beta 6
C. Terri
D. Mara

245. The common radan stones in Elaan's ceremonial necklace turned out to be the raw form of what necessary engine component?
A. Pergium
B. Antimatter
C. Dilithium crystals
D. Ionic spheres

246. What is the one limitation of the Vian energy transfer devices?
A. They need frequent recharging
B. They can only respond to one owner's thought patterns
C. They cannot affect organic material
D. They cause great pain to the user

247. What was the disease in Captain Kirk's blood that the Gideons took to try to infect their population?
A. Vegan choriomeningitis
B. Xenopolycythemia
C. Rigelian flu
D. Sakuro's disease

248.

249. The tiny model of the *U.S.S. Enterprise* used in the episode "Catspaw" was donated to which museum or collector?
A. Smithsonian
B. Science Fiction Museum
C. New York Museum of History
D. A private collector

250. Horror writer Robert Bloch did *not* pen which of the following episodes?
A. "Catspaw"
B. "The Savage Curtain"
C. "Wolf in the Fold"
D. "What Are Little Girls Made Of?"

251. Which director tied with Joseph Pevney for helming the most episodes in the original series (fourteen each)?
A. Vince McEveety
B. Gene Coon
C. Ralph Senensky
D. Marc Daniels

252. What does a Collar of Obedience do?
A. Makes the wearer see what the Providers wish
B. Give pain to the wearer
C. Subdue the wearer's will
D. Instills obedience in all who see the wearer

253. The second crewman to beam down in "The Man Trap" was named after which 1960s science fiction author (and friend of the episode's writer, George Clayton Johnson)?

A. Isaac Asimov

B. Robert Heinlein

C. Kurt Vonnegut Jr.

D. Theodore Sturgeon

254. How many episodes did regular extra Eddie Paskey appear in as the ubiquitous crewman Lieutenant Leslie?

A. Fifty-seven

B. Forty-seven

C. Thirty-seven

D. Twenty-seven

255. What is name of the leader on the planet Capella IV?

A. Seer

B. First

C. Teer

D. Deem

256. What is Ensign Chekov's first name?

A. Piotr

B. Dolph

C. Ivan

D. Pavel

257. Who is the captain of the *U.S.S. Farragut*?

A. Captain Tracey

B. Capt. Merik

C. Capt. Garrovick

D. Commodore Decker

258.

259. Which of Dr. Sevrin's followers is the child of a Federation ambassador?

A. Adam

B. Irina

C. Tongo Rad

D. Hadley

260. Before his breakdown, Captain Garth was a pivotal figure in which Federation conflict?

A. Cheron border wars

B. Orion Gambit

C. Romulan War

D. Battle of Axanar

258.

If ever there was a need for the Prime Directive, it was to help the impressionable and imitative people of Sigma Iotia II.

The planet was visited by a Federation ship nearly 100 years prior to the events of the episode "A Piece of the Action." At that time, a ship's crew member accidentally left a book behind—and the Sigma Iotians repatterned their entire culture after it. Responding to a 100-year-old radio signal, the *Enterprise* crew arrived on the planet and discovered that the Sigma Iotian culture was now structured similarly to the mobs of the 1920s on Earth.

To blend in, Kirk and Spock took on roles as gang members (shown at right). Despite being captured several times, the pair ended up taking peaceful control of the planet on behalf of the Federation, guiding the Sigma Iotians into a less violent society.

However, McCoy accidentally left behind a standard piece of equipment on the planet, meaning the trouble may not have ended with their visit.

What was this piece of Starfleet technology?

A. Hypospray

B. Communicator

C. Phaser

D. Tricorder

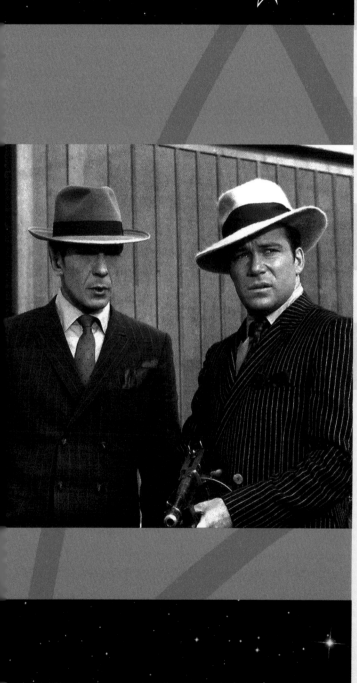

261. What is the name of the cloud city on Ardana?

A. Stratos C. Aeiros

B. Bespin D. Cumulus

262. What book was accidentally left on Sigma Iotia II that changed the planet's entire society?

A. *War and Peace* C. *Little Caesar*

B. *Chicago Mobs of the Twenties* D. *They're a Weird Mob*

263. What is the name of Tyree's wife?

A. Kalinda C. Nona

B. Ann D. Thlassa

264. Who said, "Risk is our business"?

A. Scotty C. Dr. McCoy

B. Kirk D. Sulu

265. What did the human crew members need in order to act as host bodies for the last three members of Sargon's race?

A. Dikronium C. Metabolic reduction formula

B. Dilithium D. Vulcan mind-melds

266. Who played Gary Seven's assistant?

A. Madeline Kahn C. Jane Wyman

B. Barbara Babcock D. Teri Garr

267. How did Scotty describe the potent beverage he acquired on Ganymede?

A. "It's, uh, it's Romulan." C. "It's, uh, it's strong."

B. "It's, uh, it's green." D. "It's, uh, it's illegal."

268. In the episode "By Any Other Name," McCoy used suggestions and stimulants to make which Kelven believe he was sick?

A. Kelinda C. Hanar

B. Rojan D. Tomar

269. What killed the "space hippies" when they landed on Eden?

A. Ultrasonic music
B. Eating plants filled with a powerful acid
C. Bureaucracy
D. The "Man"

270. What rendered McCoy's antidote to Rigelian fever inert?

A. Delta radiation
B. Saurian brandy
C. Necrotic tissue contamination
D. Irillium impurities

271. How long had the immortal Flint lived?

A. 60 years
B. 600 years
C. 6,000 years
D. 60,000 years

272. Where was Lieutenant Mira Romaine born?

A. Earth
B. Memory Alpha
C. Martian Colony III
D. Vulcan

273. What killed the crew of the *U.S.S. Exeter*?

A. Phaser on overload
B. Faulty blood analyzer unit
C. The ship self-destructed
D. A virus

274. What American credo do the Yangs recite, even though time and lingual shifts have mangled the original words?

A. "The Star-Spangled Banner"
B. "Preamble" to U.S. Constitution
C. "Home of the Brave"
D. "Pledge of Allegiance"

275. What is unique about the M-5 computer unit?

A. It is biological
B. It is programmed with its creator's memory engrams
C. It does *not* need a power source
D. It can predict the future

276. What type of internal combustion engine vehicle was advertised on the planet 892-IV?

A. Jupiter 8
B. Centurion
C. Apollo
D. StarRider

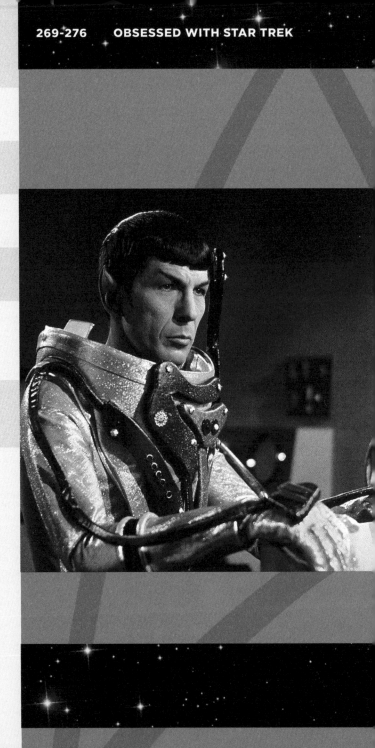

277. What does "condition green" mean?

A. The Prime Directive has been broken

B. An Earth-type culture has been discovered

C. The captain is being relieved of duty

D. The landing party is endangered

278.

278.

In the episode "The Tholian Web," Captain Kirk was caught between dimensions, and the *Enterprise* was trapped in a mysterious "energy cage" while searching for a missing sister ship.

Not knowing Kirk's whereabouts, the crew declared their captain dead. In addition, the crew's nervous systems were jeopardized due to the energy cage, causing them to act erratically. Running out of options, McCoy and Spock (shown at left) watched a recording of Kirk's last orders, instructing the two to work together—a difficulty in their present mental state. Despite their frictions, they managed to rescue the still-living Kirk and used the aliens' weapon to free the ship from its trap by discovering what caused the crew's mental degradation.

What Klingon nerve gas formed the basis of the nerve blocker that counteracted the effects of the energy web on the crew?

A. Theragen

B. Stokaline

C. Cyalodin

D. Vertazine

279. What is the Romulan Right of Statement?

A. The right to announce an intended betrothal

B. The right of a condemned criminal to explain his or her actions and motives

C. The right to approach the Romulan Senate and speak

D. The right to understand Romulan currency transactions

280. What was the date of the shootout at the OK Corral?

A. October 26

B. December 25

C. July 15

D. July 4

281. Kang's wife held what position on his ship?

A. Science officer

B. First officer

C. Chief medical officer

D. Chief engineer

282. What drink of Kirk's was spiked with the Scalosian water?

A. Romulan ale

B. Antarean brandy

C. Coffee

D. Fizzbin

283. How did Marta die?

A. Poisoned from the atmosphere

B. Overdosed on drugs

C. Stabbed by an Andorian

D. Blown up by Garth

284. What is Bele's title?

A. High Commissioner of Decontamination Procedures

B. Minister of Equality and Segregated Affairs

C. Chief Officer of the Commission of Political Traitors

D. Chief Inspector of External Intelligence

285. Which Gideon was infected with the disease from Kirk's blood first?

A. Hodin

B. Odona

C. Krodak

D. An unnamed Gideon

286. Who is the High Advisor of the Planet Council on Ardana?

A. Stratos

B. Plasus

C. Mavig

D. Tongo Rad

287. What is Plasus's daughter's name?

A. Vanna

B. Droxine

C. Anka

D. Midro

288. Who is the librarian on Sarpeidon?

A. Mr. Atoz

B. Zarabeth

C. Zora

D. Yarnek

289. Why does Janice Lester resent Captain Kirk?

A. She feels he betrayed her

B. He no longer loves her

C. He took the credit for her discovery

D. He represents the fact that Starfleet didn't allow female captains

290. In the animated series, who is the felinoid communications officer who often substitutes for Lieutenant Uhura?

A. Lt. Arex

B. Lt. M'Ress

C. Lt. Clayton

D. Lt. Markel

291. Who had to command the *U.S.S. Enterprise* when the crew reverted into children while in the negative universe?

A. Commodore April

B. Mr. Spock

C. Sarah April

D. Karla Five

292. Who was the first medical officer aboard the *Enterprise*, who designed many of the instruments now used in sick bay?

A. Dr. M'Benga

B. Dr. Boyce

C. Sarah April

D. Dr. Piper

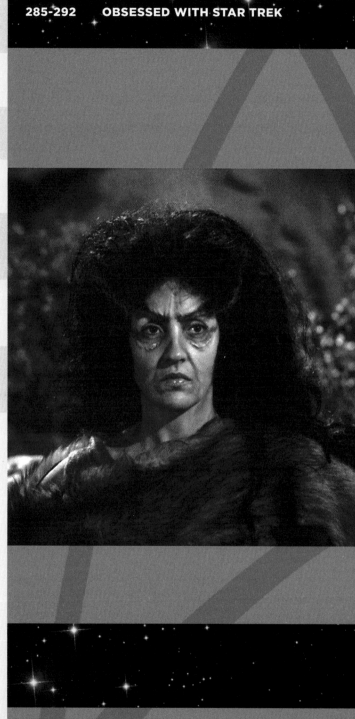

295.

In the episode "The Savage Curtain," the rock-based life-forms of the planet Excalbia had vastly different ethics than the species of the *U.S.S. Enterprise* they encountered. The Excalbians kidnapped Kirk and Spock and damaged the *Enterprise*'s warp engines. The Starfleet officers were forced to join other heroes from galactic history to battle some of the greatest villains in a fight to the death—all so that the Excalbians could learn about philosophies such as "good" and "evil."

To raise the stakes, the Excalbians made a deal that if the "good" side did not win, then the *Enterprise* would be destroyed by its already damaged antimatter engines. Opposing them were some of the worst villains in Federation history: Genghis Khan, Kahless, the father of the Klingon Empire, twenty-first-century despot Colonel Green, and Zora of Tiburon (shown at left).

What were Zora's contributions to the annals of galactic evil?

A. A despotic empire
B. The seduction and murder of her powerful husband
C. Cruel scientific experiments on humanoids
D. Her overthrow of the Tiburon Federation

293. What speed did Karla Five's ship achieve while in the positive universe?
A. Warp 36
B. Warp 10
C. Warp -10
D. Only subwarp speeds

294. Which episode won the show's only Emmy for Outstanding Entertainment Children's Series?
A. "The Counter-Clock Incident"
B. "How Sharper Than a Serpent's Tooth"
C. "Albatross"
D. "Jihad"

295.

296. Which cast member contributed to the script for the animated series episode "The Infinite Vulcan"?
A. Walter Koenig
B. Leonard Nimoy
C. James Doohan
D. Majel Barrett

297. According to Spock, which British fantasy author was his mother quite fond of?
A. C.S. Lewis
B. Lewis Carroll
C. J.R.R. Tolkien
D. Mark Twain

298. What is the only alien race in any *Star Trek* series *not* specifically created for the show?
A. Phylosians
B. Aquans
C. Orions
D. Kzinti

299. In "The Time Trap," what is the mysterious region of space known as the place where numerous starships have disappeared?
A. Delta Triangle
B. Delta Quadrant
C. Wormhole
D. Space Sargasso

300. Which episode first revealed James T. Kirk's middle name?
A. "The Trouble with Tribbles"
B. "Obsession"
C. "BEM"
D. "Court-Martial"

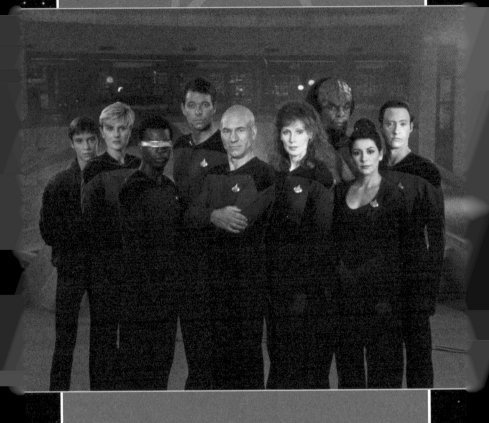

301. Who was the first Klingon to serve in Starfleet?

 A. K'Ehleyr
 C. K'mpec
 B. Worf
 D. Kurn

302. What scientific advance allowed blind Chief Engineer Geordi La Forge to see?

 A. VISOR
 C. Retnax-5
 B. Radar
 D. Retinal imaging scans

303. What was the registry number of the *Enterprise* when Captain Picard took command?

 A. NCC-2893
 C. NX-2000
 B. NCC-9754
 D. NCC-1701-D

304. What class of ship was the *U.S.S. Enterprise* in *Star Trek: The Next Generation*?

 A. *Ambassador* class
 C. *Excelsior* class
 B. *Galaxy* class
 D. *Oberth* class

305. The larger size of the twenty-fourth century *U.S.S. Enterprise* allows it to include what in its crew complement?

 A. Ferengi traders
 C. Families
 B. Holographic life-forms
 D. Noncorporeal life-forms

306. What is the name of the station on Deneb IV where the *U.S.S. Enterprise*-D completed its first mission?

 A. Farpoint
 C. Deneb One
 B. Deep Space 12
 D. Risa

307. What part of speech does the android Data almost never use?

 A. Prepositions
 C. Contractions
 B. Adverbs
 D. Gerunds

LEFT The crew of *The Next Generation*.

308. What does Picard say to order the ship into warp drive?

- **A.** "Head out"
- **B.** "Bon voyage"
- **C.** "Engage"
- **D.** "Let's go"

309. What unofficial naval term does Captain Picard call Commander Riker?

- **A.** Bosun
- **B.** Number One
- **C.** Boomer
- **D.** Jack

310. What actor played the irritating and all-powerful entity, Q?

- **A.** Armin Shimerman
- **B.** John deLancie
- **C.** Whoopi Goldberg
- **D.** Jonathan Frakes

311. Which original series character made a poignant and surprise cameo in *The Next Generation* as the new ship readied for her maiden voyage?

- **A.** Admiral James T. Kirk
- **B.** Ambassador Spock
- **C.** Admiral Leonard McCoy
- **D.** Captain Montgomery Scott

312. What is the Ferengi word that most closely means "captain"?

- **A.** Nagus
- **B.** Tog
- **C.** Broctor
- **D.** DaiMon

313. Half-Betazoid Deanna Troi was not fully telepathic, but she did possess which of the following mental abilities?

- **A.** Clairvoyance
- **B.** Illusions
- **C.** Empathy
- **D.** Telekinesis

314. What was the name of Data's cat?

- **A.** B-4
- **B.** Spot
- **C.** Watson
- **D.** Spike

315. Whose husband was killed while serving under Captain Picard's command of the *U.S.S. Stargazer*?

- **A.** Dr. Katherine Pulaski
- **B.** Dr. Beverly Crusher
- **C.** Lieutenant Deanna Troi
- **D.** Lieutenant Tasha Yar

316. What fictional detective does Data admire?

- **A.** Sherlock Holmes
- **B.** Dixon Hill
- **C.** Mickey Spillane
- **D.** Hercule Poirot

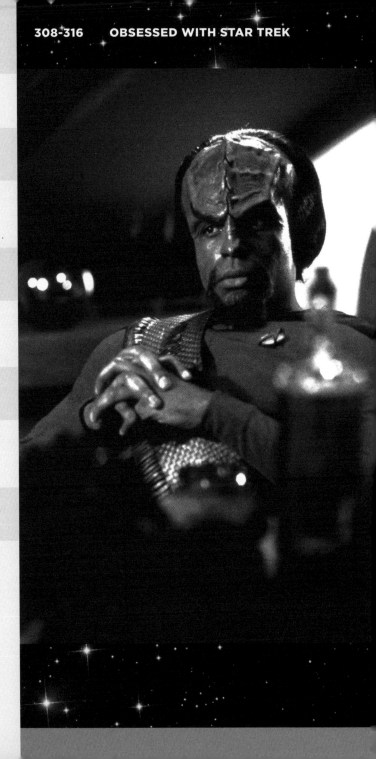

322.

Despite Worf's (shown at left) weekly presence on the bridge of the *U.S.S. Enterprise*, and the notion that the Federation and the Klingon Empire had buried the hatchet and were now (uneasy) allies, the popular aliens were not seen until nearly the end of the first season. In "Heart of Glory," Worf took center stage as a pair of rogue Klingons forced him to question where his loyalties lay: with Starfleet or his Klingon heritage?

The episode established the groundwork for many story arcs to come: arcs that would stretch beyond *The Next Generation* and into the films and *Deep Space Nine* as well. The show also named the colony where Worf was born and rescued after a Romulan attack.

What was the name of the Klingon colony world?

A. Khitomer
B. Omicron Theta
C. Qo'noS
D. Moab IV

317. "The Naked Now" is an homage to what *Star Trek* original series episode?
A. "This Side of Paradise" **C.** "Bread and Circuses"
B. "Wink of an Eye" **D.** "The Naked Time"

318. What was true about the first episode of *Star Trek: The Next Generation* that was not true of the original series' first broadcast?
A. It aired in syndication **C.** It was shot in high definition
B. Gene Roddenberry had nothing **D.** It didn't feature a ship called
to do with the production *Enterprise*

319. What card game did the bridge crew often play?
A. Poker **C.** Parisses Square
B. Bridge **D.** War

320. Where was Dr. Crusher during the second season?
A. On Caldos IV **C.** On sabbatical
B. Head of Starfleet medical **D.** On Risa

321. In *Star Trek: The Next Generation*, what division did a red tunic signify?
A. Operations **C.** Command
B. Science **D.** Civilian

322.

323. What Klingon dish is best served alive?
A. Revenge **C.** *gagh*
B. Blood pie **D.** Targ

324. How does Picard order his favorite beverage?
A. "Tea, Risa blend" **C.** "Tea, Earl Grey, hot"
B. "Cappuccino, large, iced" **D.** "Coffee, black, one sugar"

325. What is the curved, dual-bladed sword Klingons use?

A. *bat'leth*

B. *d'k tahg*

C. *kligat*

D. *mek'leth*

326. What is the highest warp speed possible for a *Galaxy*-class starship, barring help from Q-type entities?

A. 8

B. 9

C. 10

D. 14.1

327. What is the name of Dr. Crusher's teenage son?

A. Leslie

B. Eugene

C. Wesley

D. Alexander

328. What is the Betazoid word that means "beloved"?

A. Rixx

B. Muktok

C. Mok'bara

D. *imzadi*

329. What is the recreation room on *Galaxy*-class starships that allows 3-D immersion into an environment?

A. Rec Deck

B. Interior Illusion Chamber

C. Holodeck

D. Battle Bridge

330. What serves the food and drink on starships?

A. Replicators

B. Food fabricators

C. Nanite chefs

D. Particle fountains

331. What is the name of the medical area aboard a starship?

A. Infirmary

B. Sick bay

C. Bio Care

D. Triage

332. What phrase did Captain Picard use to indicate he wanted something done?

A. "Make it so."

B. "Get to it."

C. "Engage."

D. "Face front."

333. What was *Star Trek* creator Gene Roddenberry's nickname?

 A. "Big Gene" **C.** "Great Bird of the Galaxy"

 B. "Wes" **D.** "Mean Gene"

334. How does Lwaxana Troi affectionately refer to her daughter?

 A. "Darling" **C.** "Little one"

 B. "My holy ring" **D.** "My sacred chalice"

335.

While exploring the dangers of space, the assumption is that not everyone will survive. In the original series, Kirk and Spock made it back to the ship every episode, except for one feature film where Spock died, but even then he later came back to life. Meanwhile, numerous red-shirted crewmen met their maker due to everything from poisoned flowers to giant Neanderthal-like creatures.

But viewers got a shock before the first season of *Star Trek: The Next Generation* was even finished—one of the bridge crew was permanently killed in action. (Actress Denise Crosby had asked to leave the show to pursue other opportunities. She would return to guest-star as an alternate time line version of herself as well as a surprising villain.)

What killed Crosby's character, Lieutenant Yar, in the episode "Skin of Evil" (funeral shown at left)?

 A. A Romulan attack

 B. Gangs from her home colony

 C. Armus

 D. An ancient weapons system

336. What is "traditional" about Betazoid wedding ceremonies?

 A. The women wear wigs that are small caged animals **C.** The vows are telepathic

 B. All participants are nude **D.** They are performed on a mental plane

337. What was the name of Data's android daughter?

 A. Lore **C.** Lal

 B. Kamala **D.** Leah

338. What is the Klingon unit of measurement for distance?

 A. Jellicoe **C.** *hur'q*

 B. Mogh **D.** Kellicam

339. What is Captain Picard's first name?

 A. Jean-Luc **C.** Rene

 B. Robert **D.** Valjean

340. What was the name of Data's evil twin brother?

 A. B-4 **C.** Datum

 B. Lal **D.** Lore

341. What is Commander Riker's middle name?

 A. Tiberius **C.** Timothy

 B. Thomas **D.** Terrance

342. What is the name of Dr. Crusher's late husband?

A. Ian C. Eugene
B. Jack D. Andrew

343. Who took over for Dr. Crusher as chief medical officer of the *Enterprise* during the second season?

A. Dr. Noonien Soong C. Dr. Quaice
B. Dr. Pulaski D. Nurse Ogawa

344. What term replaced "landing party" in the twenty-fourth century?

A. Away Team C. Mission specialists
B. Beamers D. Redshirts

345. How many Federation legal experts did it take to draft the Treaty of Armens with the Sheilak Corporate?

A. 57 C. 372
B. 128 D. 412

346. Who became security chief after Tasha Yar?

A. Data C. Worf
B. La Forge D. Wesley

347. What striking fashion accessory is Guinan *never* without during the first six seasons?

A. Earrings C. Necklace
B. Hat D. Gloves

348. What cosmic entity is Guinan less than fond of, having met him several centuries ago?

A. Traveler C. Trelane
B. Q D. Apollo

349. Just how old *is* Guinan, anyway?

A. 100 C. About 500
B. 300 D. Never ask a lady's age

352.

The second season of *The Next Generation* brought several changes to the show. Dr. Crusher left the ship and Dr. Katherine Pulaski came aboard as chief medical officer. Chief of Operations Miles O'Brien began to make his presence better known. And a new bartender, the enigmatic Guinan, became a sympathetic ear to many of the crew.

However, one of the new crew members could *not* accept that Commander Data was anything more than a machine, and was therefore incapable of going beyond his programming and unworthy of being considered a true life-form. The new crew member challenged Data to demonstrate his reasoning skills in a holodeck simulation (shown at left with La Forge, far left, and Pulaski, middle). The android's battle with the computer became dangerous for him and everyone on the ship—but ultimately, Data and his crew mates defeated the threat.

Who was the crew member who instigated Data's battle of wits with the computer?

A. Guinan
B. Nurse Ogawa
C. Dr. Pulaski
D. Chief O'Brien

350. What was the name of the lounge on the *Enterprise* where Guinan tended bar?

A. Tex's
B. Ten-Forward
C. Starboard Lounge
D. Guinan's

351. What did Q often call Mr. Worf?

A. Imp
B. Mr. Bumpy
C. The growler
D. Microbrain

352.

353. What house did the Klingon sisters Lursa and B'Etor belong to?

A. Mogh
B. Martok
C. Duras
D. K'mpec

354. Which member of Data's family did actor Brent Spiner *not* portray?

A. Lore
B. Lal
C. Dr. Noonien Soong
D. B-4

355. What did Worf call "a warrior's drink"?

A. Coffee
B. Bloodwine
C. Prune juice
D. Raktajino

356. What was Worf's younger brother's name?

A. Duras
B. Mogh
C. K'mpec
D. Kurn

357. Who was the Academy Award–winning actress who played Guinan?

A. Meryl Streep
B. Whoopi Goldberg
C. Demi Moore
D. Sally Field

358. Who was the adventurous archaeologist Picard was attracted to?

A. Vash
B. Professor Galen
C. Marla Aster
D. Janice Lester

359. What is the network connecting the Borg drones together called?

A. The Net
B. The Collective
C. The Hive
D. The Feed

360. What episode featured the first appearance of Deanna Troi's mother, Lwaxana?

A. "Haven"
B. "The Big Goodbye"
C. "Where Silence Has Lease"
D. "The Battle"

361. What was Lwaxana Troi's nickname for Worf?

A. Lieutenant UniBrow
B. Mr. Woof
C. *bat'leth* breath
D. Lt. Targ

362. What is the name of Worf's son?

A. Mogh
B. Nikolai
C. Alexander
D. Kurn

363. What is the energy weapon commonly used by Starfleet personnel?

A. Disruptors
B. Energy Whips
C. Phasers
D. Photon ray

364. Aside from a starship tactic, the "Picard Maneuver" also referred to what?

A. Locutus's fighting tactics
B. Patrick Stewart's on-screen habit of adjusting his tunic
C. Picard's negotiation ploys
D. Patrick Stewart's convention anecdotes

365. How do Borg ships travel vast distances?

A. Subspace waves
B. Tachyon bridge
C. Transwarp conduits
D. Positronic path

366.

366.

Worf's life was forever changed when a former love, Federation emissary K'Ehleyr (shown at right), arrived on board to deal with a Klingon sleeper ship, the *T'Ong*, whose crew didn't know that they were no longer at war with the Federation.

Worf's and K'Ehleyr's passion reignited during the mission. Worf wanted K'Ehleyr to take the Klingon oath of marriage, but the half-Klingon K'Ehleyr didn't believe in "that Klingon nonsense." She later revealed that her feelings for Worf were so strong that they scared her and made her unable to commit to him.

But their relationship was strained, both personally and professionally. They were so combative with each other, it almost jeopardized their ability to complete the mission.

How did Worf and K'Ehleyr ultimately manage to avoid a confrontation with the *T'Ong*?

A. By pretending to be in command of the *Enterprise*
B. By pretending to be the Klingon Royal Family
C. By threatening to destroy their ship
D. By giving them commands from the Chancellor

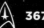

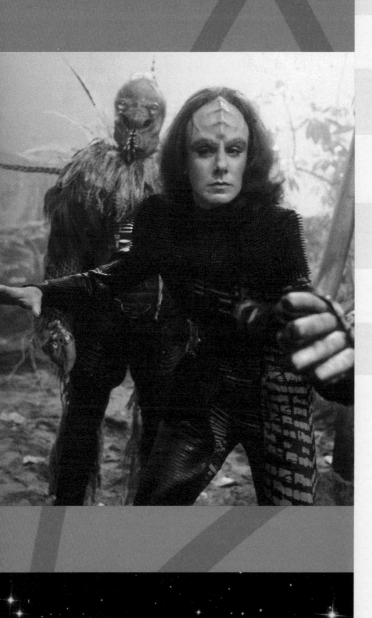

367. Who was responsible for the Crystalline Entity's attack on the Omicron Theta colony world?

A. Dr. Noonien Soong **C.** Juliana Soong

B. Lore **D.** Raymond Marr

368. What is the governmental structure on Angel One?

A. Democracy **C.** Oligarchy

B. Matriarchy **D.** Patriarchy

369. What was the name of the extremely lifelike hologram that Riker nearly fell in love with?

A. Viola **C.** Soprano

B. Concerto **D.** Minuet

370. What was the name of the computer that provided everything the Aldeans needed?

A. Custodian **C.** Bynar

B. Radue **D.** Caretaker

371. What aliens referred to humans as "ugly bags of mostly water?"

A. Benzites **C.** The photoelectric microbrain from Velara III

B. Zaldans **D.** Bynars

372. What did Admiral Quinn suspect was happening within Starfleet?

A. Conspiracy **C.** Stagnation

B. Complacency **D.** It was too big to fail

373. Who introduced Dr. Crusher to her future husband?

A. Captain Picard **C.** Gregory Quinn

B. Dr. Dalen Quaice **D.** Walker Keel

374. Who was Counselor Troi's *imzadi*?

A. Will Riker **C.** Devinoni Ral

B. Worf **D.** Aaron Conor

375. Where did Captain Picard first meet Vash?

 A. Professor Galen's class **C.** Risa

 B. Loren III **D.** At a lecture hall

376. Who assumed control of the *Star Trek* franchise after Gene Roddenberry's death?

 A. Ron Moore **C.** Majel Barrett

 B. Brannon Braga **D.** Rick Berman

377. What caused Riker and Worf's animosity in the anti-time future?

 A. Troi's death **C.** Troi's choice of husband

 B. Worf's loss of station **D.** Riker's promotion to admiral

378. In "The Defector," which Shakespearean play does Data perform that Picard later quotes during the episode?

 A. *Henry V* **C.** *Romeo & Juliet*

 B. *Richard II* **D.** *Titus Andronicus*

379. Who was responsible for bouncing Picard back and forth through time in "All Good Things..."

 A. The *Enterprise*-D itself **C.** Q

 B. Picard from the future **D.** Locutus's dormant nanoprobes

380. What is the name of the resort planet known for its tropical climate and the natives' open sexuality?

 A. Risa **C.** Galorndon Core

 B. Turkana IV **D.** Argus Array

381. What was the name of Commander Riker's transporter duplicate?

 A. Kyle **C.** Thaddius

 B. Thomas **D.** Jonathan

382. Where is Starfleet Academy located?

 A. San Francisco **C.** Idaho

 B. Van Nuys **D.** Tycho City

383. What was the first twenty-fourth century appearance of the Romulans called?
- **A.** "Conspiracy"
- **B.** "Skin of Evil"
- **C.** "The Neutral Zone"
- **D.** "The Child"

384. What two species from the Beta Renner system were applying for admission to the Federation in 2364?
- **A.** Bandi and Klingon
- **B.** Anticans and Selay
- **C.** Bynars and Jaradans
- **D.** Ferengi and Edo

385.

In the episode "Cause and Effect," it appeared that the *Enterprise* might be destroyed—perhaps indefinitely. Caught in a temporal causality loop, no one on the ship was aware they had been repeating the same actions over and over again ... until Dr. Crusher's (shown at left) persistent feeling of déjà vu forced her to investigate further.

The crew deduced a way to send a message to themselves to signal the correct course of action that would break the ship out of the temporal loop. The problem was that the message had to be very short and be implanted in Data's brain as a sort of "post-hypnotic suggestion."

What did the chosen message of "3" signify?

- **A.** Commander Riker's rank pips
- **B.** Win at poker
- **C.** The number of times they have been destroyed
- **D.** How many hours they have left before repeating the cycle

386. What is the purpose of the Klingon Death Ritual?
- **A.** To prepare the warriors for battle
- **B.** To warn the dead a Klingon warrior is coming
- **C.** To bond with the family of a fallen warrior
- **D.** To delegate rightful heirs

387. How was the Quazulu VIII virus that attacked the *U.S.S. Enterprise* crew while orbiting Angel 1 transmitted?
- **A.** By transporter beam
- **B.** By touch
- **C.** By smell
- **D.** By thought

388. Where was the *U.S.S. Enterprise*-D constructed?
- **A.** Utopia Planitia
- **B.** Drydock
- **C.** Starbase 74
- **D.** San Francsico

389. What weapons did the Ferengi use in their first appearance that were never again seen on *The Next Generation*?
- **A.** *Oo-mox*
- **B.** Energy torpedoes
- **C.** Energy Whips
- **D.** Ferengi disruptors

390. What department deals with astronomy and star mapping aboard a starship?

A. Stellar cartography
B. Astrology
C. Starbase
D. Observation deck

391.

391.

In the episode "Sarek," the crew excitedly prepared for the arrival of Spock's father, the legendary Ambassador Sarek (shown at right), for his final mission before retirement. Almost immediately, however, something seemed to be wrong. Sarek's aides and wife tried to isolate him. But when Sarek attended a concert in his honor, Picard noticed the Vulcan shedding a tear.

392. What was the name of the starship engineer whose holographic likeness Geordi began to fall in love with?

A. Leah Brahms
B. Nuria
C. Rishon Uxbridge
D. Marla Aster

393. Who was the Borg that Geordi managed to isolate from the rest of the Collective?

A. Locutus
B. Hugh
C. One of Three
D. Crosis

When members of the crew were beset by violent emotions, Dr. Crusher suggested it may be due to the ambassador, who was suffering from a rare and embarrassing Vulcan genetic condition that telepathically projected his emotions onto others. Forced to confront the ambassador on the eve of his greatest triumph, Picard learned that the increasingly erratic Sarek was not even aware of his illness. Nonetheless, with Picard's help, the ambassador managed to succeed in the delicate negotiations.

394. What was Ambassador Spock's true purpose on Romulus?

A. Reunify the Vulcan and Romulan people
B. Overthrow the Senate
C. Save his father's life
D. Mind-meld with Sela

How did Picard help the famed Vulcan ambassador?

395. How did Q repay a debt to Picard?

A. By playing matchmaker with Vash
B. Giving him Q-powers
C. Making him the "real" Robin Hood
D. Letting him uncover an archaeological find

396. What was the result of Q's encounter with Vash?

A. She nearly killed him
B. She stole his powers
C. She traveled with him for a time
D. He married her

397. Lieutenant Barclay suffered from what condition that made the real world seem unimportant to him?

A. Bendii syndrome
B. Holoaddiction
C. Protomorphosis syndrome
D. Teplan blight

A. Took over the negotiations for him
B. Contacted his estranged son
C. Mind-melded to stabilize his condition
D. Gave him a blood transfusion

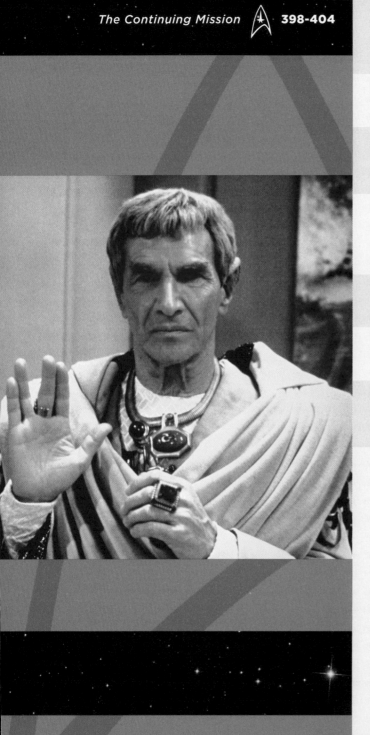

398. Poor, hypochondriacal Barclay wrongly believed he suffered from what technology-based syndrome?

A. Transporter shock **C.** Transporter psychosis
B. Terellian death syndrome **D.** Phaser poisoning

399. Ironically, which department did Lieutenant Barclay work in?

A. Security **C.** Engineering
B. Medical **D.** Weapons

400. Actor Dwight Schulz played Lieutenant Reginald Barclay, but was also known for playing which character on *The A-Team*?

A. "Faceman" Peck **C.** "Howling Mad" Murdock
B. B.A. Baracus **D.** John "Hannibal" Smith

401. What does the pattern buffer of a transporter do?

A. Prevents unauthorized matter from mingling **C.** "Draws" a picture of the person being transported
B. Temporarily stores the matter stream **D.** Targets the destination point

402. Who was the transporter chief aboard the *U.S.S. Enterprise*?

A. Barclay **C.** O'Brien
B. Ogawa **D.** Shelby

403. How long was Scotty trapped in the transporter beam?

A. 75 years **C.** 175 years
B. 100 years **D.** 181 years

404. Which original *U.S.S. Enterprise* crew member never appeared with the *U.S.S. Enterprise* (NCC-1701-D) crew?

A. McCoy **C.** Spock
B. Scotty **D.** Uhura

405. Why did Lwaxana Troi fire her valet before Mr. Homm?

 A. He wasn't telepathic

 B. He stole the Sacred Chalice of Rixx

 C. His thoughts about her became too erotic

 D. He wasn't able to perform his duties

406. Why did the Bynars need the *Enterprise*?

 A. They needed to test holographic upgrades

 B. They needed to reboot their planetary computer

 C. They needed to escape a supernova

 D. They needed to fight Klingons

407. Whom did Chief O'Brien marry?

 A. Alyssa Ogawa

 B. Robin Lefler

 C. Keiko

 D. Leah Brahms

408.

409. Who was the captain of the *U.S.S. Enterprise* (NCC-1701-C)?

 A. Richard Castillo

 B. Rachel Garrett

 C. Tasha Yar

 D. John Harriman

410. Who sensed the time line was not right in "Yesterday's *Enterprise*"?

 A. Tasha Yar

 B. Wesley Crusher

 C. Data

 D. Guinan

411. What episode showed Wesley Crusher's "promotion" to acting ensign?

 A. "The Last Outpost"

 B. "Where No One Has Gone Before"

 C. "Haven"

 D. "Code of Honor"

412. Combadges contain what valuable metal?

 A. Silver

 B. Latinum

 C. Gold

 D. Bronze

413. What rock legend had a cameo as one of the fishlike Antidean delegates?

 A. Stevie Nicks

 B. Lindsay Buckingham

 C. Mick Fleetwood

 D. John Fleetwood

408.

Though ratings had been growing in recent episodes, no one was prepared for the sudden burst of popularity the show would enjoy at the end of the third season. With the reappearance of the Borg and the first true cliff-hanger ending in *Star Trek* history (notwithstanding the *Star Trek* original series episode "The Menagerie," split due to its length), *The Next Generation* had truly arrived.

In "The Best of Both Worlds," a possible Borg incursion into Federation space had been identified and the ambitious Lieutenant Commander Shelby came aboard to help determine if the Borg were behind the disappearance of the New Providence colony. As Riker dealt with Shelby's aggressive personality, and his own uncertainty about passing up command of a ship of his own for the third time in a row, the unthinkable happened: Captain Picard was kidnapped by the Borg.

A rescue attempt was thwarted and the Borg headed straight for Earth. It seemed nothing could get worse ... until an assimilated Jean-Luc Picard (shown at right) appeared on the screen, claiming to speak for the Borg and stating that resistance was futile.

What was the name given to Picard's Borg alter ego?

 A. First Speaker

 B. One of Seven

 C. Borg King

 D. Locutus

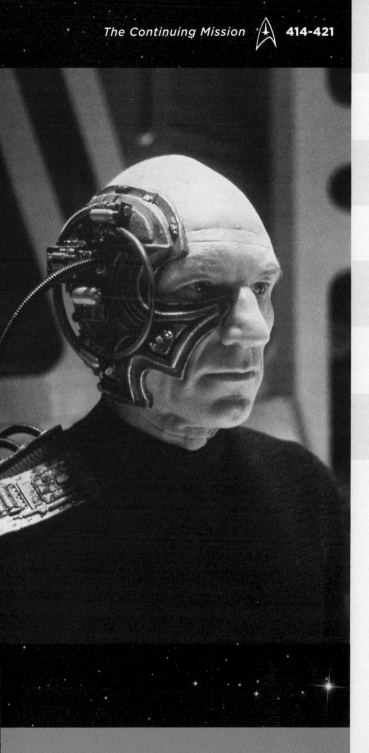

414. What scientific hobby did Picard almost give up a Starfleet career for?

A. Archaeology

B. Quantum physics

C. Astrometry

D. Vintner

415. What was the name the production crew gave the Australian lionfish in Captain Picard's tank?

A. Gene

B. Tiberius

C. Stanley

D. Livingston

416. What was the first episode to feature Picard's holonovel program starring hard-boiled private investigator Dixon Hill?

A. "Skin of Evil"

B. "The Big Goodbye"

C. "The Emissary"

D. "Haven"

417. What artificial organ does Picard have?

A. Heart

B. Lung

C. Kidney

D. Liver

418. Which second-season episode contained an homage to the *Star Trek* original series episode "The Deadly Years"?

A. "Loud as a Whisper"

B. "The Outrageoius Okona"

C. "The Schizoid Man"

D. "Unnatural Selection"

419. Who was the first Starfleet officer to serve aboard a Klingon vessel in a new exchange program?

A. Commander Riker

B. Lieutenant Data

C. Troi

D. Dr. Crusher

420. What did the Klingon *R'uustai* ceremony do?

A. Made one an adult warrior

B. Declared war on an enemy

C. Bonded two individuals as brothers

D. Married two individuals

421. What is the name of the Betazoid female midlife cycle that quadruples sex drive?

A. Phase

B. Vapors

C. *imzadi*

D. Pause

422. How many of the Omicron Theta colonists' memories and journals were downloaded into Data?

A. 47
B. 216
C. 411
D. 532

423. What instrument does Data play?

A. Banjo
B. Trombone
C. Drums
D. Violin

424. What fictional character does the holodeck imbue with consciousness in order to "defeat" Data in a challenging mystery?

A. Sherlock Holmes
B. Professor Moriarty
C. Robin Hood
D. Albert Einstein

425. Who said, "Then let me just say that ... our relationship is beyond friendship—beyond family. And I will let him go. And you must do the same. There can only be one captain—and that is now your chair"?

A. Doctor Crusher
B. Guinan
C. Troi
D. Admiral Hanson

426. What was the name of the insectoid race whose language Picard was having difficulty mastering for a diplomatic mission in "The Big Goodbye"?

A. Jarada
B. Pakled
C. Tarellian
D. Edo

427. Whom did Data first tell where his off switch was located?

A. Wesley
B. Dr. Crusher
C. Geordi
D. Spot

428. The Cerebus II natives developed an herb- and drug-based treatment that reversed what?

A. Spacesickness
B. All disease
C. Intelligence
D. Aging

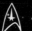

430.

The fourth season of *The Next Generation* became known for its many family-themed episodes. Old and new family members appeared: father figures and real fathers, evil twins and holographic wives, and in the middle, a wedding and love in a holodeck simulation of Sherwood Forest.

Over the past seasons, the show had built up a mythology concerning the crew's lives beyond the shipboard adventures, and two episodes during the fourth season cemented it: "Brothers" and "Family." In "Brothers," Data was reunited with his creator as well as his brother, Lore.

"Family" focused on Picard and Worf's reunions with their own families (Picard and family shown at left). Worf's adopted parents visited the ship to comfort their son after his dishonor on the Klingon home world; and on Earth, Picard struggled with the memory of how everything he stood for had been violated by the Borg and questioned whether he could remain in Starfleet.

Who helped Picard deal with the emotional aftershocks of being captured by the Borg?

A. Counselor Troi
B. Dr. Crusher
C. His brother, Robert
D. His nephew, Rene

429. Why did Karnas of Mordan want revenge on Admiral Jameson?

A. Jameson stole his wife
B. Jameson supplied his enemies with weapons
C. Jameson had become immortal
D. Jameson took him out of power

430.

431. What damaged the ozone layer and in turn caused the Aldeans to become sterile?

A. Their computer
B. Their plant life
C. Their children
D. Their defense shield

432. What weakens the microbrain of Velara III?

A. Light
B. Darkness
C. Water
D. Sand

433. What was Commander Riker's father's name?

A. Thomas
B. Kyle
C. Ethan
D. Jean-Luc

434. What was the holographic game the Zakdorn were masters of?

A. Strategema
B. Risk
C. Three-dimensional chess
D. Ktarian game

435. What was the only "clip show" during the run of *The Next Generation*?

A. "Peak Performance"
B. "Shades of Gray"
C. "Pen Pals"
D. "Time Squared"

436. What was Dixon Hill's preferred drink?

A. Scotch, neat
B. Rye and ginger
C. Martini
D. Vodka tonic

437. K'Ehleyr was only half-Klingon. What race was her mother?

A. Romulan **C.** Human

B. Betazoid **D.** Tellarite

438. Who said, "I am not a merry man"?

A. Worf **C.** Data

B. Riker **D.** Picard

439. Who was the captain of the *U.S.S. Hood*?

A. Benjamin Maxwell **C.** Edward Jellico

B. Robert DeSoto **D.** Erik Pressman

440. Who was Kahless the Unforgettable's brother, whom he fought for twelve days and nights?

A. Mogh **C.** Molor

B. Morath **D.** Lukara

441. How long did Thomas Riker live alone on Nervala IV?

A. Three years **C.** Eight years

B. Six years **D.** Twelve years

442. What alloy is commonly used to construct the hulls of starships and space stations?

A. Adamantium **C.** Kreigarium

B. Duranium **D.** Latinum

443. Who does K'mpec choose to become the arbiter of the Klingon Rite of Succession?

A. Worf **C.** Picard

B. Riker **D.** K'Ehleyr

444. What command was Riker offered just prior to the Borg attack at Wolf 359?

A. *U.S.S. Hood* **C.** *U.S.S. Melbourne*

B. *U.S.S. Defiant* **D.** *U.S.S. Pegasus*

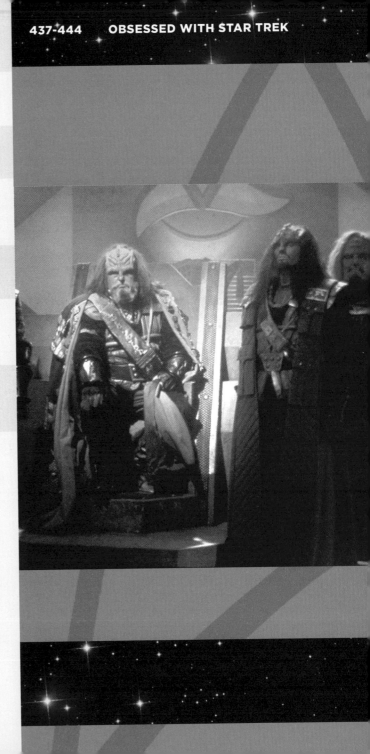

446.

K'Ehleyr, Worf's lover, returned to the *Enterprise* in the fourth-season episode "Reunion," with a surprise: She had borne Worf a son after their last encounter. Worf, dishonored in the Empire during the events of "Sins of the Father," avoided claiming the child as his to prevent his family's humiliation from falling on the boy.

K'Ehleyr also related the news that the leader of the Klingon Empire (K'mpec, shown at left) had been poisoned and asked that Picard investigate who was behind it. Klingon politics turned fatal when K'Ehleyr was murdered. Worf felt honor-bound to avenge her death by killing the only one who could restore Worf's honor among his people. Justice was served, and Worf finally acknowledged his son before sending him to live with his own adoptive parents.

What role did Picard accept in Klingon politics in order to name the new leader of the Klingon Empire?

A. Arbiter of the Rite of Succession
B. *Cha'Dlch*
C. Chancellor of the High Council
D. *gin'tak*

445. What was Tasha Yar's younger sister named?

A. Elizabeth
B. Dalen
C. Nicole
D. Ishara

446.

447. Who killed Worf's mate, K'Ehleyr?

A. Gowron
B. Duras
C. K'empec
D. Lursa

448. In "Future Imperfect," what realization showed Riker that he was not actually missing sixteen years of memories?

A. He knew Picard would not become an ambassador
B. The holographic Minuet was never his wife
C. Everything was too perfect
D. Tomalak was already dead

449. Where did Wesley's "Final Mission" take place before he left for Starfleet Academy?

A. Alpha Onias III
B. Lambda Paz
C. Pentarus V
D. Pentarus III

450. As Wesley was preparing to leave for Starfleet Academy, who told him, "You will be missed"?

A. Data
B. Captain Picard
C. Riker
D. Dr. Crusher

451. What caused Counselor Troi to lose her empathic abilities in "The Loss"?

A. Not practicing her talents enough
B. Overwhelming emotions from two-dimensional life-forms
C. Betazoid "Phase"
D. Overexposure to warp fields

452. Who was the deep-cover Romulan spy uncovered the day of the O'Briens' wedding?

A. Ishara Yar
B. Ambassador T'Pel
C. Admiral Mendak
D. V'sal

453. What episode featured the first appearance of the Cardassians?

A. "The Wounded"
B. "Devil's Due"
C. "First Contact"
D. "Night Terrors"

454. Which recurring *Cheers* actress played a Malcorian who seduced Riker in order to fulfill her dreams of making love to an alien?

A. Rhea Perlman
B. Shelley Long
C. Bebe Neuwirth
D. Kirstie Alley

455. Why was the real Dr. Leah Brahms angry with Geordi?

A. He used her likeness inappropriately in a holodeck program
B. He broke up with her
C. He hit on her despite the fact she was married
D. She thought he was not a good engineer

456. Where did Dr. Brahms graduate from?

A. Vulcan Science Academy
B. MIT
C. Daystrom Institute
D. Starfleet Academy

457. How did Data and Troi free the *U.S.S. Enterprise* from Tyken's Rift?

A. Using Guinan's phaser rifles
B. Venting hydrogen from the bussard collectors
C. Dreaming their way out
D. Contacting the Brattain

458. What kind of light revealed the nonsentient reptilian humanoids of Tarchannen III?

A. Black
B. Ultraviolet
C. Reflected
D. Infrared

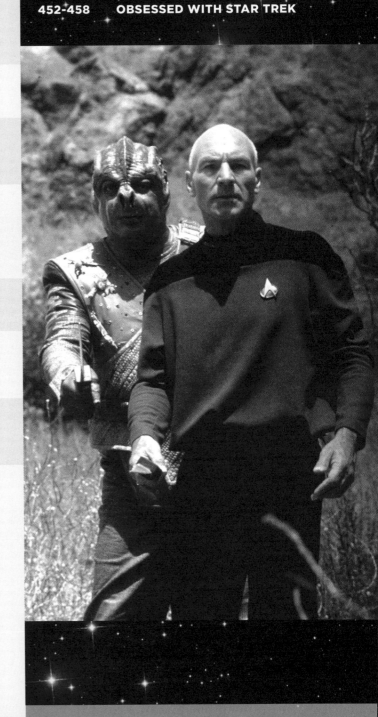

463.

The Federation was frustrated in its efforts to open relations with the alien race known as the "Children of Tama." No amount of futuristic technology seemed to help communicate with the race whose language was not structured on individual words.

In the episode "Darmok," the Federation sent Picard to once again attempt communication with the incomprehensible society—and the Tamaranian captain Dathon (shown at left with Picard, right) instigated a life-or-death situation in an attempt to reach an understanding with the humans.

The episode's unique take on linguistics and the performances of Patrick Stewart and Paul Winfield made it one of the highlights of the fifth season.

What was the concept Dathon was trying to convey to Picard with the phrase "Darmok and Jalad … at Tanagra!"?

459. Who were the benevolent aliens whose probe increased Lieutenant Barclay's intelligence?

A. Cytherians C. Mintakans
B. Malcorians D. Barzan

460. Who ran a theater workshop on board the *Enterprise*?

A. Lieutenant Barclay C. Dr. Crusher
B. Commander Riker D. Data

461. Which crewman hid his or her Romulan ancestry to enter Starfleet?

A. Nurse Ogawa C. Ensign Sito
B. Simon Tarses D. Chief O'Brien

462. What was the "age of resolution"?

A. The voluntary end of life for Kaelon II's natives C. The scientific revolution on Kaeon II
B. The time allotted for Kaelon scientists to finish experiments D. The Betazoid time of marriage

463.

464. Who was "The Host" for the Trill symbiont until Odon's replacement could arrive?

A. Captain Picard C. Data
B. Dr. Crusher D. Commander Riker

465. Which episode marked the first (if shadowy) appearance of Sela?

A. "In Theory" C. "Redemption"
B. "The Mind's Eye" D. "The Host"

466. Who told Riker, "If you can't make the big decisions, Commander, I suggest you make room for someone who can"?

A. Captain Jellico C. Admiral Pressman
B. Commander Shelby D. Sam Lovelle

A. Understanding through shared experience
B. Wounded by a common enemy
C. Brothers at war
D. Join battle fleets together

467. How did the Tamarian people communicate?

 A. Metaphor **C.** Visual cues

 B. Semaphore **D.** Singing

468. What is the Bajoran structure of names?

 A. Given names are not used **C.** Surnames are descriptive

 B. Family names are not used **D.** Surnames precede given names

469. What actress played the bitter Ensign Ro Laren?

 A. Michelle Forbes **C.** Ashley Judd

 B. Nana Visitor **D.** Demi Moore

470. How was the Crystalline Entity destroyed?

 A. Modulating phasers **C.** Photon torpedo barrage

 B. Modulated graviton beam **D.** Alteration of the warp engines' power frequency

471. Who destroyed the Crystalline Entity?

 A. Kila Marr **C.** Lore

 B. Renny Marr **D.** Data

472. What episode saw the birth of Molly O'Brien?

 A. "Silicon Avatar" **C.** "Ensign Ro"

 B. "The Game" **D.** "Disaster"

473. Who delivered newborn Molly O'Brien?

 A. Worf **C.** Wesley Crusher

 B. Dr. Crusher **D.** Data

474. Who played returning ensign Wesley Crusher's love interest in "The Game"?

 A. Taylor Swift **C.** Ashley Judd

 B. Kellie Pickler **D.** Wynona Judd

479.

One of the most talked-about episodes of *The Next Generation*, "Yesterday's Enterprise," opened innocently enough with Worf discovering a new drink in the Ten-Forward lounge. But when a temporal rift opened up and the *U.S.S. Enterprise*-C flew through from twenty years in the past, the entire time line changed.

In the new time line created by the *Enterprise*-C's disappearance from the past, Picard's Federation had been at war for decades with the Klingons. Only one member of Picard's crew sensed that the time line they were experiencing was not the right one: the bartender, Guinan (shown at left). After discovering that the *Enterprise*-C was meant to be lost, a terrible decision lay ahead. The previous *Enterprise*-C crew and one of Picard's crew members were meant to die.

Which of Picard's crew chose to make his or her death mean something by going back in time with the *Enterprise*-C?

A. Tasha Yar
B. Commander Riker
C. Worf
D. Data

475. What were "Lefler's Laws"?
A. Ensign Lefler's "life lessons"
B. Rules of warp field geometry
C. Similar to Planck's constant
D. Part of the Heisenberg uncertainty principle

476. How did Wesley and Data defeat the Ktarian game?
A. They didn't; Lefler did
B. Enzymes from chocolate
C. Optic burst from a palm beacon
D. Trapping it in Data's positronic brain

477. What legendary Federation ambassador died in the episode "Unification"?
A. Lwaxana Troi
B. Sarek
C. Gav
D. Spock

478. What did the Federation fear Ambassador Spock had done?
A. Vulcan ritual suicide
B. Turned traitor
C. Defected to Romulus
D. Gone back in time

479.

480. Who betrayed Spock on Romulus?
A. Omag
B. Jaron
C. Neral
D. Senator Pardek

481. Which of the *Enterprise* crew was able to perform a Vulcan nerve pinch correctly for the first time on Romulus?
A. Worf
B. Geordi
C. Data
D. Tasha Yar

482. What century did the time-traveling Rasmussen claim to be from?
A. twenty-second
B. twenty-seventh
C. thirtieth
D. thirty-first

483. What is the standard Romulan greeting?

A. *Veruul* C. *Tal shiar*
B. *Uhlan* D. *Jolan tru*

484. How would a starship travel via the faster-than-light soliton wave?

A. As energy particles C. By dissipating the wave
B. Riding it like a surfboard D. Effectively swimming through it

485. Which *Enterprise* officer did the sole survivor of the *U.S.S. Vico* imitate after being saved by him?

A. Captain Picard C. Data
B. Lieutenant Worf D. Geordi

486. Who did the noncorporeal Ux-Mal claim to be?

A. The disembodied spirits of the C. Gods
 Essex crew
B. Klingon *jat'yln* D. Borg survivors

487. According to tradition, who must assist in a Klingon's ritual suicide?

A. His eldest son C. His *hegh'bat*
B. His mate D. His commander

488. What was the name of the androgynous race that banned all sexual preference?

A. Mab-Bu C. J'naii
B. Sartaaran D. Lysian

489. Who said, "Primitive? Maybe so, but sometimes, there is a lot to be said for an experience that's ... primitive"?

A. Commander Riker C. Soren
B. Worf D. Geordi

490. What was the clue Data sent himself to break out of the temporal loop in the Typhon Expanse?

A. "Decompress the shuttle bay" C. "Listen to Crusher"
B. "Use tractor beam" D. "Three"

493.

The weekly Tuesday poker game (shown below) grew over seven years for the senior officers. Viewers watched characters' quirks and personality traits emerge through the games. Writer Brannon Braga even managed to work the poker game into a plot point in the critical and fan-favorite episode "Cause and Effect."

Games varied, as did the stakes. Once Dr. Crusher bet the men their beards versus dying her hair brown, though the game was interrupted before a winner could be declared. And games in a science fiction setting also proved difficult to remain fair—especially with a crew

consisting of an android, an empath, and a blind man whose optical aid allowed him to see through most cards. Even the junior officers got in on the action, setting up their own version of the game.

But one senior officer never accepted the standing invitation to play until the last moments of the series finale, and was told by Commander Troi, "You were always welcome."

Who was it?

A. Riker
B. Picard
C. Guinan
D. La Forge

491. What was the name of the elite cadre of Starfleet Academy cadets Wesley was part of?
A. Red Squadron
B. Nova Squadron
C. Hawk Squadron
D. Omega Squadron

492. What was the forbidden flying stunt that killed one of Wesley's friends?
A. Kolvoord Starburst
B. Picard Maneuver
C. Quantum Wave
D. Delta Flyer

493.

494. What Starfleet bad boy did Robert Duncan McNeill play in *Voyager*?
A. Harry Kim
B. Tom Paris
C. Lieutenant Carey
D. Chakotay

495. What was Wesley's punishment for lying about a cadet's death?
A. Expulsion from Starfleet Academy
B. Community service
C. Repeating a year at the Academy
D. Hard labor

496. What was the name of the holodeck program Lwaxana took Alexander to for fun and relaxation?
A. Program 9
B. Risa
C. Parallax Colony
D. Betazed 1

497. How did Lwaxana escape marrying Campio?
A. By adopting Alexander
B. By hiding in the holodeck
C. By appearing nude at their wedding
D. By telepathically embarrassing him

498. What was Kamala?

A. A shapeshifter
B. Elemental aggregate being
C. Supra-psionic
D. Rare empathic metamorph

499. What did Kamala take from her bond with Picard?

A. Rank
B. Sense of duty
C. Intelligence
D. Borg nanoprobes

500. How did Geordi and Data plan to attack the Borg using Hugh?

A. Make him into a bomb
B. Hold him hostage
C. Use a paradoxical program to consume their processing resources
D. Make them all individuals

501. What sent Ro and Geordi out of sync with normal matter after a transporter accident on a Romulan science vessel?

A. Syncopated cloak experiment
B. Chroniton interference with his VISOR
C. Phase cloaking technology
D. Temporal rift

502. How did Picard learn to play a Ressikan flute?

A. Years of practice
B. Living a lifetime in twenty-five minutes under an alien probe's influence
C. Leftover from his implanted Borg knowledge
D. He never learned

503. What nineteenth-century American author did Data encounter when thrown back in time?

A. Nathaniel Hawthorne
B. Henry Thoreau
C. Mark Twain
D. Herman Melville

504. Where is Data's off switch?

A. Left temple
B. Under his wrist
C. Small of his back
D. Top of his spine

505.

505.

One of Starfleet's prime missions is to "seek out new life." In the episode "The Measure of a Man," the search turned inward as a Starfleet commander questioned whether the android Data was a sentient life-form or a piece of equipment.

Commander Bruce Maddox wanted to essentially reverse-engineer Data and create new, invulnerable Starfleet officers. Captain Picard had to find a way to legally prove Data's rights as a life-form.

Ultimately, the question couldn't fully be answered. The hearing (shown at right) heightened when one of Data's shipmates was forced to act for the prosecution and came close to proving his comrade was nothing but a machine. However, the judge agreed with Picard that taking away Data's personal liberties would be equivalent to enslaving him.

Which of Data's friends served as the prosecutor during the hearing?

A. Commander Riker
B. Geordi La Forge
C. Guinan
D. Dr. Crusher

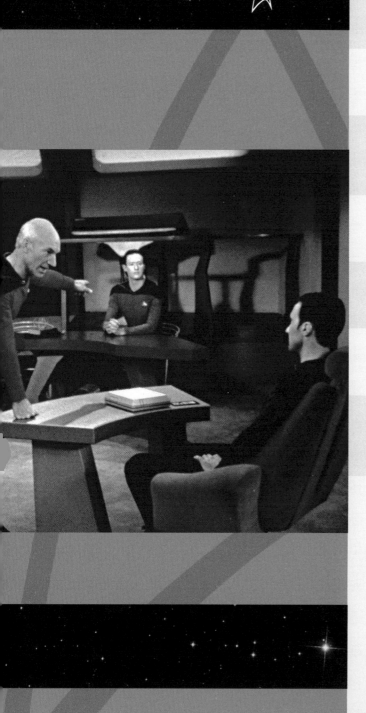

506. What Vulcan member of the *Enterprise* medical staff was often referenced, but seen only once?

A. Dr. Selar
B. Nurse Ogawa
C. Dr. Pulaski
D. Dr. Quaice

507. What life-forms did Lieutenant Barclay see in the transporter after beaming from the *U.S.S. Yosemite*?

A. Lycosans
B. Pattern snakes
C. Quasi-energy microbes
D. Plexers

508. What killed Ambassador Ves Alkar?

A. An out-of-control Counselor Troi
B. His own overwhelming negative energy
C. The Rekag peoples
D. His mother

509. What was the name of the ship Commander Montgomery Scott was discovered on?

A. *U.S.S. Grissom*
B. *U.S.S. Defiant*
C. *U.S.S. Yorktown*
D. *U.S.S. Jenolen*

510. What colossal structure would surround a star and allow life on its interior surface?

A. Starbase
B. Orbital platform
C. Dyson Sphere
D. Life Star

511. With what drink did Scotty drown his sorrows at feeling out of place in the twenty-fourth century?

A. Aldebaran whiskey
B. Synthehol
C. Scotch
D. Milkshakes

512. Who said, "Starship captains are like children. They want everything right now and they want it their way. The secret is to give them what they need, not what they want"?

A. Scotty
B. Riker
C. Troi
D. Crusher

513. What was the name of Data's poem about his cat?

A. "Spot's Sonnet"
B. "Ode to Spot"
C. "Rime of the *Enterprise*-D"
D. "The *Felis catus* Sleeps Tonight"

514. What protects twenty-fourth-century Earth from phenomena like tornados?

A. Polymer shield
B. Hidden Q
C. Weather modification network
D. Atmospheric satellite regulators

515. In the episode "Rascals," after an energy field enveloped a shuttlecraft, who did *not* come back as a child?

A. Picard
B. Keiko
C. Worf
D. Ro

516. What is the last *Star Trek: The Next Generation* episode in which Miles O'Brien chronologically appears?

A. "True Q"
B. "Rascals"
C. "A Fistful of Datas"
D. "Family"

517. Who helped Alexander program his Wild West holodeck simulation?

A. Lieutenant Barclay
B. Data
C. Worf
D. Geordi

518. Why was Picard chosen for the mission to destroy metagenic weapons on Celtris III?

A. He hated Cardassians
B. He understood metagenic weaponry
C. Admiral Jellico was out to get him
D. His experience with theta-band carrier waves

519. Captain Jellico had his own command catchphrase similar to Picard's— what was it?

A. "Get it done."
B. "No excuses."
C. "Make it work."
D. "Now, you lot!"

520.

521. Who accidentally brought Professor Moriarity back after four years in the holodeck's memory storage?

A. Geordi
B. Data
C. Wesley
D. Lieutenant Barclay

520.

In the two-part episode "Chain of Command," Starfleet relieved Picard of command and installed an aggressive and more formal captain on the bridge of the *Enterprise* so that Picard, Worf, and Dr. Crusher could train for an espionage mission.

While trying to uncover the truth about possible meta-genic weapons, Picard was caught by the Cardassians—who proved themselves to be as adept at torture as they were at conversation and administrative organization.

When Riker and the crew tried to convince their new captain to mount a rescue mission for Picard, Riker was relieved of duty and Data promoted to first officer. Picard was finally rescued after he suffered agonizing physical and psychological torture (shown at right) at the hands of the Cardassian Gul Madred. Part of that torture was a number of lights that Madred claimed Picard should see. Picard later admitted to Troi that he was closer to break-ing than anyone knew.

How many lights did Gul Madred insist Picard see?

A. Two
B. Three
C. Four
D. Five

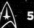

522. Who was Moriarity's newfound (and just as holographical) love?

A. Countess Regina Barthalomew

B. A replica of Dr. Pulaski

C. A holosimulation of the *Enterprise*-D computer

D. A Troi hologram program

523. What was the coalescent organism's final form before Geordi killed it?

A. Aquiel

B. Keith Rocha

C. Maura

D. Morag

524. What is the name of the Romulan secret intelligence division?

A. *D'deridex*

B. Tal Shiar

C. Vinerine

D. Khazara

525. When Q let Picard rectify a past mistake, what kind of officer did Picard become?

A. Anthropology and archaeology officer

B. He never entered Starfleet

C. Lieutenant (junior grade) in astrophysics

D. He never made it past ensign

526. What aliens attacked Picard at the Bonestall Recreation Facility?

A. Nausicaans

B. Muyoans

C. Jurai

D. Andorians

527. Who asked Worf, "Would you like to talk about what's bothering you, or would you like to break more furniture?"

A. Dr. Crusher

B. Counselor Troi

C. Dr. Bashir

D. Commander Riker

528. What information did Jaglom Shrek offer Worf?

A. That the *Enterprise* was in danger

B. That his father was still alive

C. That he was heir to the Klingon Empire

D. That he was half-Romulan

529. Who was the half-Romulan, half-Klingon girl Worf felt attracted to?

 A. Gi'ral **C.** Qa'vaks

 B. Marta **D.** Ba'el

530. What toxic waste were the thieves on the Remmler Array after?

 A. Excessive baryon buildup **C.** Antimatter residue

 B. Trilithium resin **D.** Magnetic corrosion

531. Tim Russ was better known for portraying Tuvok on *Voyager*, but he appeared in "Starship Mine" as who?

 A. Commander Hutchinson **C.** Devor

 B. Satler **D.** Pomet

532. In "The Chase," the recording of the ancient humanoid claimed the Romulan, human, Klingon, and Cardassian races were all what?

 A. Savages **C.** Inferior

 B. Related **D.** Devolving

533. Who wrote the theater play "Frame of Mind"?

 A. Mavek **C.** Beverly Crusher

 B. Data **D.** Jaya

534. How did Riker stay sane while captured and drugged by the Tilonian anarchists?

 A. He focused on the play he was performing in **C.** He focused on his duty

 B. He focused on his love for Troi **D.** He focused on his music

535. Why did Beverly Crusher face court-martial?

 A. She broke the Prime Directive **C.** She broke the Hippocratic oath

 B. She disobeyed a direct order **D.** She performed a forbidden autopsy

536. What was the nickname Dr. Crusher disliked?

 A. "Bones" **C.** "Dr. Mom"

 B. "The Dancing Doctor" **D.** "Dr. Drama"

538.

In "Sins of the Father," Worf (shown at left between a fellow Klingon and Picard) discovered he had a younger brother who wanted Worf's help in keeping their family from being dishonored. The theme of Klingon honor was a mainstay for the series, but nothing would affect Worf as much as discovering his father being named the traitor behind the attacks on his home world that left Worf and his brother orphans.

Unable to accept the dishonor, Worf put his life at risk to challenge the accusations, but even when he discovered the truth that could clear his family name, his troubles were only beginning. To expose the powerful family who had actually betrayed the Empire could cause a civil war.

What did Worf choose to do instead?

A. Kill the Emperor
B. Accept discommendation
C. Resign from Starfleet
D. Kill his brother

537. How was Takaran's internal anatomy unusual for a humanoid?
A. His organs moved around
B. He had no discrete organs
C. All his cells were static
D. He had gaseous blood

538.

539. Who resurrected Kahless the Unforgettable?
A. Clerics of Boreth
B. Worf
C. Gowron
D. Kurak

540. What Klingon beverage are the *Enterprise* replicators unable to produce correctly?
A. Bloodwine
B. Firewine
C. *Warnog*
D. *Raktajino*

541. How did Commander Riker get injured in the episode "Timescape"?
A. Feeding Spot
B. Playing Parrises squares
C. Worf's calisthenics program
D. Romulan attack

542. What did the aliens in "Timescape" try to use the Romulan warp engines for?
A. Break the time barrier
B. Incubate their young
C. Attack the Federation
D. Reset the chronal loop

543. What famous real-life physicist appeared in "Descent" to play cards with Data?
A. Carl Sagan
B. John Barrow
C. Stephen Hawking
D. Roger Penrose

544. What was Data's first emotion?
A. Sadness
B. Anger
C. Joy
D. Fear

545. In command of the *Enterprise* during the Borg attack in "Descent," what experimental technology did Dr. Crusher use to escape the Borg?
A. Metaphasic shielding
B. Transwarp conduit
C. Artificial quantum singularity
D. Positronic phaser lock

546. What was the name of the ship Geordi's mother captained?

A. U.S.S. Wellington

B. U.S.S. Hera

C. U.S.S. Yamato

D. U.S.S. Thomas Paine

547. What famous Broadway actor portrayed Geordi La Forge's father, Commander Edward La Forge?

A. Joel Grey

B. Mandy Patinkin

C. Ben Vereen

D. Gregory Hines

548. What was the weapon Tallera was looking for in the episode "Gambit"?

A. Katric ark

B. The Stone of Gol

C. Tal shaya

D. Ahn-woon

549. What other Vulcan role did actress Robin Curtis portray before Tallera in "Gambit"?

A. Valeris

B. T'pau

C. Saavik

D. Dr. T'Pan

550. What did the Vulcan Isolationist Movement believe?

A. Contact with alien cultures was contaminating them

B. Logic was no longer enough for society to survive

C. Romulans were trying to infiltrate their society

D. Vulcan should be moved to another dimension

551.

The title "Unification" said it all—the episode included the hoped-for unification of two races, the unification of the *Star Trek* original series and *The Next Generation*, and the unification of an estranged father and son.

Leonard Nimoy reprised his iconic role as Spock (shown below with Data, right), even as the Star Trek film franchise starring the characters from the original series was winding down. Airing during the twenty-fifth anniversary of the original series and sadly on the heels of *Star Trek*

551.

552. In his dream, what kind of cake did Data serve his fellow officers?

A. Black forest

B. Golden buttercream

C. Sponge

D. Cellular peptide

553. What was living on the ship and interfering with the warp drive, as well as making Data's dreams a nightmare?

A. Banshees

B. Interphasic creatures

C. Telepathic leeches

D. Core worms

554. What was the name of Troi's father?

A. Patrick

B. Bryan

C. Ian

D. Jonathan

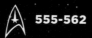
creator Gene Roddenberry's death, the loss was unintentionally echoed on-screen as Spock learned his own father had died.

Two *Star Trek* legends met as Spock and Data compared notes on humanity, Sela's plans for a Romulan invasion of Vulcan were thwarted, and Spock finally connected with his late father.

How did Spock reunite with his father?

A. Holographic message from Sarek
B. Mind-meld with Picard
C. Tachyon beam messaging
D. By holding Sarek's katric urn

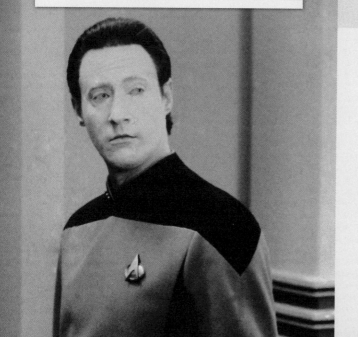

555. Which star of the *Spider-Man* films portrayed Hedril in "Dark Page"?
A. Kirsten Dunst
B. Bryce Dallas Howard
C. Rosemary Harris
D. Donna Murphy

556. In what episode did Dr. Crusher discover Captain Picard was once in love with her?
A. "Dark Page"
B. "Attached"
C. "Force of Nature"
D. "Phantasms"

557. What was the final *Star Trek: The Next Generation* episode to feature Lwaxana Troi?
A. "Sub Rosa"
B. "The Chase"
C. "Thine Own Self"
D. "Dark Page"

558. Who said, "I do not care for telepaths. They make me ... uneasy"?
A. Worf
B. Barclay
C. Geordi
D. Ogawa

559. What was the warp speed limit for Federation ships once the subspace damage was discovered?
A. Warp 2
B. Warp 4
C. Warp 5
D. Warp 6

560. As discovered in "Force of Nature," what were warp field engines doing to subspace?
A. Creating rifts
B. Erasing it
C. Converting it to normal space
D. Closing it off

561. Who did Juliana Tainer claim to be?
A. Data's "mother"
B. Dr. Soong's cousin
C. Dr. Soong's mother
D. Data's wife

562. What did Data discover about Dr. Tainer?
A. She had deactivated Lore
B. She was an android
C. She was part of the Crystalline Entity
D. She did not trust him

563. Who won the *bat'leth* tournament on Forca III?

A. Worf
B. Gowron
C. An unnamed Klingon
D. Kurn

564. In one universe Worf visited in "Parallels," a beaten Captain Riker said what race had taken over Earth?

A. Cardassians
B. Romulans
C. Borg
D. Klingon

565. What rank did Wesley Crusher hold in one of Worf's alternate realities?

A. Doctor
B. Lieutenant
C. Captain
D. Commander

566. How did Worf return from the multiple parallel realities he was experiencing?

A. Inverse warp field
B. Tetryon pulse
C. Antimatter explosion
D. Quantum fissure

567. Who was the captain of the *U.S.S. Pegasus*?

A. Margaret Blackwell
B. Will Riker
C. Erik Pressman
D. Admiral Nechayev

568.

569. Which star of television's *Lost* portrayed Riker's first commanding officer?

A. Matthew Fox
B. Jeff Fahey
C. Terry O'Quinn
D. Josh Holloway

570. What treaty did the development of the technology installed aboard the *U.S.S. Pegasus* violate?

A. Treaty of Algeron
B. The Khitomer Accords
C. Seldonis IV Convention
D. Tomed Peace Treaty

571. Which of the following film stars portrayed Worf's adopted brother, Nikolai Rozhenko?

A. Joe Pesci
B. John Schuck
C. Paul Sorvino
D. Ron Perlman

568.

In "The Pegasus," Commander Riker's loyalty was tested when his first captain, Admiral Eric Pressner (shown at right with Riker, left), came on board with a secretive mission to salvage his old ship—and some of the past came back to haunt Riker as well.

The *U.S.S. Pegasus* had been lost twelve years prior, when the crew nearly mutinied during suspicious tests on board the ship, and a fresh-out-of-the-Academy Riker supported his captain. As Picard dug deeper into the mystery, Riker was unable to provide answers, which jeopardized his place on the *Enterprise*.

When the excavation of the *Pegasus* looked promising, Riker's old captain wanted to reactivate the experiment that had killed the rest of the crew. Riker then had to choose between loyalties and the truth.

What was the forbidden experimental technology on board the *Pegasus*?

A. Multiresonant disruptors
B. Phasing cloak
C. Biogenic weaponry
D. Temporal torpedos

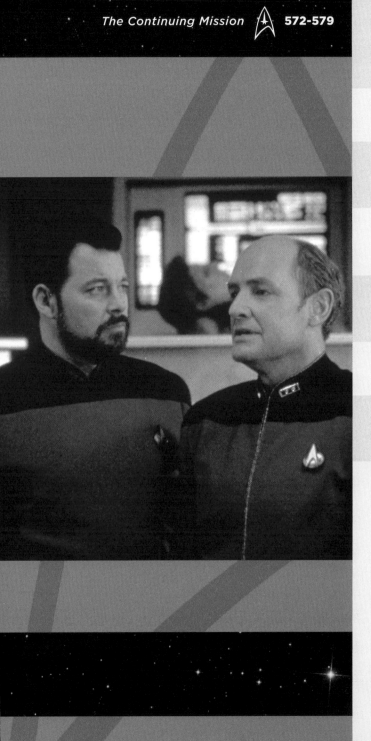

572. How did Nikolai keep the pre-warp Boraalen civilization from knowing they were on a starship?

A. He drugged them
B. He kept them in a replica of their caves on the holodeck
C. He brainwashed them
D. He cryogenically froze them

573. What was Dr. Crusher's grandmother's name?

A. Leslie
B. Beverly
C. Fiona
D. Felisa

574. What was the name of the anaphasic life-form preying on the Howard women's lineage?

A. Vorin
B. Ronin
C. Quint
D. Joret

575. What does PADD stand for?

A. Point And Detect Device
B. Powered Anondyne Directional Detector
C. Personal Access Display Device
D. Primary And Divided Data

576. What Klingon animal made its first appearance in "Where No One has Gone Before"?

A. *Targ*
B. Klingon octopus
C. *Pipius*
D. *Bregit*

577. In what episode did the PADD device first appear?

A. "Haven"
B. "Lonely Among Us"
C. "Justice"
D. "The Naked Now"

578. What was the only thing Mr. Homm ever said aloud while visiting the *Enterprise*?

A. "I'll be back."
B. "Thank you for the drinks."
C. "Nice ship."
D. "I'll take those."

579. Who was Lwaxana's valet before Mr. Homm?

A. Mr. Xelo
B. Gene Roddenberry
C. Mr. Miller
D. Mr. Timicin

580. Who was the writer of the first episode in which Dixon Hill appears, also credited as the author of the *Dixon Hill* novels (as seen on the computer screen)?

A. Brannon Braga
B. Gene Roddenberry
C. Maurice Hurley
D. Tracy Tormé

581. Which martial art was the basis for the illegal move used by Riker's father to beat his son while sparring?

A. Karate
B. *mok'bara*
C. *anbo-jyutso*
D. tal-shiar

582. Who observed, "Whoever said getting there was half the fun never traveled in a class-8 probe"?

A. K'Ehleyr
B. Lwaxana Troi
C. Dr. Leah Brahms
D. Q

583. What was the Tox Uthat?

A. Pleasure device
B. Quantum phase inhibitor
C. Reptilian humanoid
D. Ancient relic

584.

585. What was the native name for the spaceship-sized alien creature dubbed "Tin Man"?

A. Tam
B. Gomtuu
C. Elbrum
D. *horgh'an*

586. Which holodeck program did the recovering Barclay *not* erase?

A. Program 1
B. The Three Musketeers
C. Ten-Forward
D. Program 9

587. What was the first two-part *The Next Generation* episode?

A. "Best of Both Worlds"
B. "Unification"
C. "Redemption"
D. "Gambit"

588. How many Federation ships were destroyed battling the Borg at Wolf 359?

A. 39
B. 76
C. 89
D. 100

584.

Normally more mischievous than deadly, Q returned in the episode "Q-Who" wanting to join the crew of the *Enterprise*. When rebuffed, he demonstrated exactly how much humans exploring space needed him on their side, as he sent the ship hurtling light-years away on a collision course with the menace known as the Borg (male Borg shown at right).

Developed by writer Maurice Hurley and originally envisioned as a race of insectoids, the Borg quickly became the ultimate kind of threat to counter the ideals of the Federation. Their intertwined consciousness, lack of identity, and sheer technological power echoed the changes in the real world with personal computing on the rise and the strange new network called the "Internet" becoming widespread.

How far out would Q send the *Enterprise* to give it what he called "a little bloody nose"?

A. Out of the galaxy
B. Outside space and time
C. 100 parsecs
D. 7,000 light years

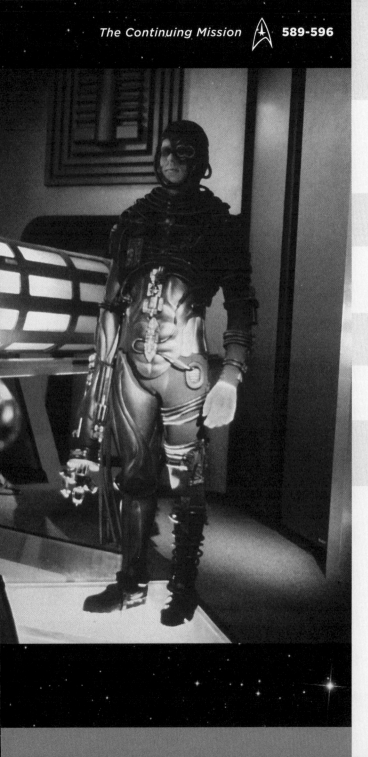

589. Though Commander Shelby clearly wanted Riker's job, what did she end up doing after the battle of Wolf 359?

A. Became science officer aboard the *Enterprise*

B. Retired from Starfleet

C. Joined the task force to reassemble the fleet

D. Transferred to Deep Space 9

590. Why was the episode "Legacy" significant?

A. It marked the 80th episode, breaking the original series run of 79 episodes

B. It featured the return of Tasha Yar

C. It was the twenty-first anniversary of the cancellation of the original series

D. It was Gene Roddenberry's last show as producer

591. What was Sarek's second human wife's name?

A. Perrin

B. Amanda

C. Sarah

D. Diana

592. Whose four-lobed brains are difficult for Betazoids to telepathically read?

A. Romulans

B. Ferengi

C. Vulcans

D. Cardassians

593. What ship did Geordi La Forge previously serve on?

A. *U.S.S. Sutherland*

B. *S.S. Vico*

C. *U.S.S. Merrimack*

D. *U.S.S. Victory*

594. What ship did Lieutenant Barclay previously serve on?

A. *U.S.S. Ramen*

B. *U.S.S. Zhukov*

C. *U.S.S. Rutledge*

D. *U.S.S. Nobel*

595. Who was the admiral who turned a probe of the *Enterprise*'s dilithium explosion into a witch hunt for Picard?

A. Alynna Nechayev

B. Gregory Quinn

C. Savar

D. Norah Satie

596. Who was the *M*A*S*H* star who portrayed Lwaxana's love interest, Timicin?

A. Alan Alda

B. McLean Stevenson

C. Mike Farrell

D. David Ogden Stiers

597. What starship technology was initially thought to harm Trills in their first appearance?

A. The transporter
B. Communicators
C. Replicated food
D. Hyposprays

598. Whom did Data first attempt to have a romantic relationship with?

A. Keiko O'Brien
B. Counselor Troi
C. Lieutenant Jenna D'Sora
D. Guinan

599. Why did Gowron refuse to restore Worf's honor?

A. Kurn tried to kill him
B. Picard wouldn't get involved in a Klingon civil war
C. He was allied with Duras
D. He was really a Romulan spy

600. The Traveler's true name is ...?

A. Unpronounceable by Humans
B. Menyuk
C. Eric
D. Kosinski

601. What is the unit of measure for subspace field stress?

A. Cochrane
B. Zefram
C. Archer
D. Daystrom

602. Who was behind the attempt to assassinate Klingon Governor Vagh?

A. Gowron
B. Lursa and B'Etor
C. Sela
D. Lore

603. Who portrayed Yar's Romulan daughter, Sela?

A. Rosalind Chao
B. Denise Crosby
C. Diana Muldaur
D. Ashley Judd

604. How long prior to the episode "Ensign Ro" was Bajor annexed?

A. One year
B. Forty years
C. Sixty years
D. Eighty years

605. Who did Robin Lefler claim was her first friend?

A. Wesley Crusher
B. A tricorder
C. Dathon
D. Data

606. What Klingon opera did Worf request the musician on Qualor II sing?
- **A.** Aktuh and Maylota
- **B.** K'lodnr Zil
- **C.** Shevok'tah gish
- **D.** Gav'ot toh'va

607. Who did actor Malachi Throne portray in the original series episode "The Menagerie" alongside fellow "Unification" guest star Leonard Nimoy?
- **A.** Captain Pike
- **B.** Jose Tyler
- **C.** Commodore Mendez
- **D.** Dr. Boyce

608. In addition to a character in "The Menagerie," actor Malachi Throne also provided voice-over for which character in the first *Star Trek* pilot?
- **A.** Number One
- **B.** Talosian Keeper
- **C.** Ship's computer
- **D.** Rigelian guard

609. When was Alexander Rozhenko born, according to the Klingon calendar?
- **A.** Year of Kahless, 999
- **B.** 43rd day of *Maktog*
- **C.** *D'k tahg* day
- **D.** During the *Kot'baval* Festival in 2370

610. What is a black cluster?
- **A.** Starfleet's black ops division
- **B.** Twenty-fourth-century musical group
- **C.** Colloquial name for Breen outposts
- **D.** Group of collapsed protostars

611. Who said, "Data, I would like you to make Timothy the best android he can possibly be"?
- **A.** Captain Picard
- **B.** Counselor Troi
- **C.** Dr. Crusher
- **D.** Timothy's mother

612.

613. Which of the Ullians was responsible for telepathically violating the *Enterprise* crew's minds?
- **A.** Tarmin
- **B.** Jev
- **C.** Inad
- **D.** Dr. Martin

612.

At first, Wesley Crusher was the character fans liked the least. He embodied the science-fiction stereotype of the "boy genius who saves the day." *Star Trek* fans reacted negatively to that cliché, despite Wil Wheaton's portrayal. Over the course of the series, both Wheaton and the show's writers found a niche for the character. Wesley's adolescence and unique situation aboard a starship began to make sense.

But no one could have foreseen that Wesley, protégé of the duty-bound Captain Picard, could be involved in a cover-up regarding a fellow cadet's death. In his third year at the Academy, burdened by a sense of loyalty to his squad, Wesley appeared to lie under oath. Picard's old mentor Boothby (shown at left) pointed out to Picard the pressures Wesley's squadron was under. When evidence contradicted Wesley's testimony, Picard offered him a choice: either Wesley could come clean or Picard would tell the board of inquiry what had really happened.

What does "The First Duty" in the episode's title refer to?

- **A.** Loyalty to one's captain
- **B.** Squadron loyalty
- **C.** The truth
- **D.** Family

614. How many members of "The Masterpiece Society" left their colony on Moab IV after the *Enterprise*-D saved it?

A. One
B. Twenty-four
C. Forty-seven
D. Sixty-two

615. Who was named first officer of the *U.S.S. Enterprise*-D while "fighting" the Lysian war?

A. Ensign Ro
B. Kieran MacDuff
C. Counselor Troi
D. Picard

616. Who stepped up to the role of bartender in the episode "Conundrum"?

A. Data
B. Chief O'Brien
C. Nurse Ogawa
D. Alexander

617. What *Cheers* alumni captained the *U.S.S. Bozeman*?

A. Kelsey Grammer
B. Ted Danson
C. George Wendt
D. Woody Harrelson

618. Ray Walston (Starfleet Academy's grizzled and wise gardener, Boothby) was better known to 1960s TV fans as Uncle Martin in what sitcom?

A. *My Favorite Martian*
B. *The Munsters*
C. *The Addams Family*
D. *Bewitched*

619. In "Ethics," whom did Worf designate as Alexander's guardian if he should die?

A. Data
B. Riker
C. Troi
D. Picard

620. Patrick Stewart and Famke Janssen, who played Kamala in "The Perfect Mate," would work together again in a comic book film series—which one?

A. *Spider-Man*
B. *Batman*
C. *Fantastic Four*
D. *X-Men*

621. Who was Guinan's imaginary friend?

A. Q
B. A bunny rabbit
C. A Tarcassian razor beast
D. A Denebian slime devil

622. Who said, "I don't have all the answers! I've never been dead before!"?

A. Geordi La Forge
B. Ensign Ro Laren
C. Mirok
D. Varel

626.

When an alien probe was brought aboard the *Enterprise* and a beam knocked Captain Picard unconscious in "The Inner Light," it caused him to live forty-two years as an entirely different person. The probe contained the history and memories of an entire race, doomed as their sun went nova. The probe survived, seeking to transfer the memories of an entire people to one person who would remember and tell their story.

In under a half hour, Picard lived a lifetime as Kamin, the ironweaver (shown at left with his daughter, right). After he saw the probe launch from his world, he was gently drawn back to reality as the probe completed its transfer.

After his ordeal, the crew inspected the probe and found a box, which they gave to Picard.

What was in the box?

A. His tools
B. A wedding ring
C. Ressikan flute
D. A sash

623. Who played Picard/Kamin's son in "The Inner Light"?
A. Daniel Stewart
B. Brian Bonsall
C. Brent Spiner
D. Daniel Day-Lewis

624. How long had the Kataan people been dead?
A. 100 years
B. 1,000 years
C. 10,000 years
D. 1,000,000 years

625. How did the Devidians feed?
A. Temporal energy
B. Human blood
C. El-Aurian emotions
D. Human neural energy

626.

627. What was the name of O'Brien's pet tarantula?
A. *bat'leth*
B. Carmichael
C. Christina
D. Wilbur

628. Ironically, what was the name of the transport ship Ambassador Ves Alkar used?
A. *Dorian*
B. *Cheron*
C. *Lazarus*
D. *Don Juan*

629. Which "Desperate Housewife" played a Starfleet officer seduced by "The Outrageous Okona"?
A. Felicity Huffman
B. Nicollette Sheridan
C. Eva Longoria
D. Teri Hatcher

630. What shuttlecraft did Picard provide Scotty on an "extended loan"?
A. *Goddard*
B. *Galileo*
C. *El-Baz*
D. *Copernicus*

631. What was the name of Picard's aunt who had a stockpile of miracle "remedies?"
A. Marie
B. Sophia
C. Brigitte
D. Adele

632. What Earth superhero did Q seem to be paraphrasing when he said, "With unlimited power comes responsibility"?
A. Spider-Man
B. Superman
C. Batman
D. Iron Man

633. What led Data to discover the Exocomps' sentience?

 A. Their language **C.** Their sense of self-preservation
 B. Their reproductive habits **D.** Their poetry

634. What powers a Romulan starship's engine?

 A. Artificial black hole **C.** Anti-time particles
 B. Artificial quantum singularity **D.** Phase matter

635. What Romulan honor had Commander Toreth received for a victory over the Klingons?

 A. Sotarek Citation **C.** Romulan Star Cluster
 B. Grankite Order of Tactics **D.** Praetor's Commendation

636. What do Romulan cloaking devices leave off-line when in operation?

 A. Sensors **C.** Standard defense shields
 B. Weapons **D.** Communications

637. To whom did Picard first tell his story of near death in a fight with Nausicaans?

 A. Beverly Crusher **C.** Deanna Troi
 B. William Riker **D.** Wesley Crusher

638. What type of weapon did the Klingon children of Carraya IV use to till soil?

 A. *bat'leth* **C.** *mek'leth*
 B. *gin'tak* **D.** *d'k tahg*

639. Who was the "master of small talk" at the Remmler Array?

 A. Admiral Nechayev **C.** Commander Hutchinson
 B. Dexter Remmick **D.** Admiral Haftel

640. Who was the new chief of stellar sciences officer Picard fell in love with, but granted a transfer off the ship?

 A. Nella Daren **C.** Kelsey
 B. Kiros **D.** Penny Muroc

641. Ironically, how did Picard incapacitate Tim Russ's terrorist character in "Starship Mine"?

 A. Used a laser torch **C.** Used a Vulcan nerve pinch
 B. Knocked him out with a flute **D.** Tied him up

650.

"Relics" married hardcore science fiction concepts with the nostalgia of an old friend who wondered what his place in a new world was. Commander Montgomery Scott (shown at left) was discovered in a transporter beam loop and was brought on board only to wonder if he, like his old ship, was simply a relic in this new generation.

Tensions between Scotty and Geordi depicted the age-old struggle between the benefits of experience versus the desire to escape the shadows of a legacy. To help cope with his sense of isolation, Scotty retreated to a holodeck recreation of the original *Enterprise* bridge. Unfortunately for the production staff, those sets had long ago been torn down.

How did they find a cost-effective way to let Scotty revisit the bridge of his beloved "NCC one-seven-oh-one"?

A. They built a two-dimensional recreation of the bridge
B. Blue-screened matte footage and a rented fan-made replica
C. CGI
D. They built a miniature of the bridge and superimposed footage

642. What Los Angeles Laker Hall of Famer played the "galaxy's tallest Klingon"?
A. Larry Bird
B. James Worthy
C. Kobe Bryant
D. Shaquille O'Neal

643. What did Professor Galen give to his old pupil?
A. Kurlan *naiskos*
B. A recipe for biscuits
C. Prehistoric DNA samples
D. Romulan cloaking device

644. Who did Salome Jens—who also played the leader of the Founders in *Deep Space Nine*—portray in the *Next Generation* episode "The Chase"?
A. Gul Ocett
B. Professor Galen
C. The ancient humanoid
D. Captain Nu'Daq

645. Dr. T'Pan was head of the Vulcan Science Academy for how long?
A. Fifteen years
B. Fifty years
C. One year
D. Thirty years

646. What ship did Commander Riker serve on when he was involved in a transporter duplication?
A. *U.S.S. Hood*
B. *U.S.S. Defiant*
C. *U.S.S. Ghandi*
D. *U.S.S. Potemkin*

647. What was unique about Nervala IV that interfered with transporter functions?
A. It generated a distortion field
B. A Dyson sphere surrounded it
C. It created constant ion storms
D. It was in a state of temporal flux

648. Which real-life astronaut had a cameo in the episode "Second Chances"?
A. Neil Armstrong
B. Buzz Aldrin
C. John Glenn
D. Dr. Mae Jamison

649. The actor who played Geordi's father in "Interface" also played which relative of a LeVar Burton character in the legendary miniseries *Roots*?
A. Brother
B. Son
C. Grandson
D. Father

650.

651. What is the Betazed neurotransmitter involved in telepathy?

A. Psilosynine C. Metafoliates

B. Telecytes D. Ceretonins

652. Who said, "Sometimes a cake is just a cake"?

A. Sigmund Freud C. Data

B. Counselor Troi D. Stephen Hawking

653. What was the first non-unified world to attempt to join the UFP?

A. Hekarus VI C. Kesprytt III

B. Atrea IV D. Calder II

654. What is Dr. Crusher's phobia?

A. Spiders C. Performing

B. Heights D. Snakes

655. As revealed in the episode "Inheritance," how did Dr. Soong transfer his wife's memories to an android?

A. Synaptic scanning C. Memory meld

B. Core dump D. Brain engram download

656. Which cadet from Wesley Crusher's Nova Squadron managed to post on the *U.S.S. Enterprise*-D?

A. Sito Jaxa C. Jean Haja

B. Nick Locarno D. Josh Albert

657. Who is the ambitious lieutenant who tried to ingratiate himself to Riker in "Lower Decks"?

A. Taurik C. Sito Jaxa

B. Sam Lovelle D. Alyssa Ogawa

658. Why did Picard request the Bajoran ensign from "The First Duty" be transferred to the *Enterprise*-D?

A. He felt responsible for her C. He wanted to let her redeem herself

B. He loved her mother D. He was her father

659.

659.

For seven seasons, viewers saw the interactions and daily lives of the *Enterprise*'s senior staff and their visitors, families, and friends. But what was going on among the enlisted crew?

"Lower Decks" shone a light on the junior officers as they hoped for promotions, fell in love, learned from their mentors, and sought out their own paths of exploration among the stars.

As one ensign prepared for a dangerous mission (shown below with Worf, left), she learned to stand up for herself, despite the guilt and self-doubt over events that happened while she was at the Academy. She went on to perform admirably, but was lost during the mission.

Who was the brave ensign?

A. Sito Jaxa
B. Sam Lovelle
C. Taurik
D. Robin Lefler

660. Where did Taurik learn about new warp field configurations?

A. Daystrom Institute
B. Utopia Plantia
C. Jupiter Research labs
D. Tanaline Propulsion Laboratory

661. Who was Nurse Ogawa's boyfriend?

A. Ben
B. Lieutenant Andrew Powell
C. Sam Lovelle
D. Taurik

662. What did the people of Barkon IV call the amnesiac Data?

A. Garvin
B. Talur
C. Mr. Iceman
D. Jayden

663. In "Thine Own Self," who told Counselor Troi, "Congratulations, you just destroyed the *Enterprise*"?

A. Worf
B. Riker
C. Picard
D. Geordi

664. What was inside the rogue comet in the episode "Masks"?

A. An entire civilization
B. A trapped star
C. A D'Arsay archive
D. A renegade Q

665. What was the D'Arsay structure composed of?

A. Fortanium
B. Duranium
C. Ihatium
D. Trilithium resin

666. What subject did Data use during his first attempt at sculpture in "Masks"?

A. Comet
B. PADD
C. Counselor Troi
D. Music

667. What is the rite of passage for a Klingon to go from child to Warrior?

A. *Qapla'*
B. Age of Ascension
C. *Sto-vo-Kor*
D. *R'usstai*

668. What was the date of *Star Trek* creator Gene Roddenberry's death?

A. October 26, 1991
B. December 25, 1991
C. January 1, 1991
D. April 4, 1992

669. Which powerful being did the crew suspect was a member of the Q Continuum, but proved not to be?

A. Traveler
B. Crystalline Entity
C. Ardra
D. Farpoint "space jellyfish"

670. What *LA Law* actor appeared as the second member of the Q Continuum?

A. Harry Hamlin
B. Corbin Bernsen
C. Blair Underwood
D. Jimmy Smits

671. Which 1960s folk singer portrayed one of Picard's old flames in "We'll Always Have Paris"?

A. Michelle Phillips
B. Janis Ian
C. Carole King
D. Janis Joplin

672. What is the significance of the repeated use of number 47 throughout the modern *Star Trek* series?

A. Episode 47 was executive producer Rick Berman's first script
B. Writer Joe Menosky began to include it as a joke in his early scripts
C. It is the unofficial answer to the ultimate question of life
D. It is Gene Roddenberry's birthday (March 7)

673. What is the name of the distinctive computer displays nicknamed after their creator, a designer and technical advisor on the show?

A. Roddenberry Screens
B. Berman Boards
C. Okudagrams
D. Jein Gels

674. Which *Entertainment Tonight* host made a cameo as a Klingon in the episode "The Icarus Factor"?

A. Mary Hart
B. Leeza Gibbons
C. Leonard Maltin
D. John Tesh

675.

676. What is the motto of Starfleet Academy?

A. "Veni, vidi, vici"
B. "Carpe astris"
C. "Ex astris, scientia"
D. "A astris usque ad astris"

675.

On his way back from a *bat'leth* tournament, Worf (shown at right) encountered a rift in dimensions and began quantum shifting from alternate universe to alternate universe. In one, La Forge was killed; in another, a Cardassian member of Starfleet was seen on the *Enterprise* bridge.

To get him home and seal the breach in the universes, preventing even more alternate versions of himself and the *Enterprise* from shifting from one reality to another, Worf underwent a dangerous trip in the shuttlecraft. He returned home, though the experience made him see one relationship in particular differently.

With whom did Worf explore a different type of relationship after his visit through the parallel universes?

A. K'Ehleyr
B. Dr. Crusher
C. Troi
D. Sito Jaxa

677. What was the final stage of the bridge officer examination?

A. Choose to order someone under your command to a certain-death scenario

B. Choose to rescue innocents in the face of certain destruction

C. Choose to destroy the ship rather than face capture

D. Choose to be stranded while crew escapes

678. What did the crew use instead of stardates in the alternate time line of "Yesterday's *Enterprise*"?

A. Gregorian calendar

B. Military dates

C. Warp dates

D. Combat dates

679. Who was the first chief engineer named on the *U.S.S. Enterprise*-D?

A. O'Brien

B. MacDougall

C. Argyle

D. Singh

680. What did Wesley do after he left Starfleet Academy?

A. He explored the galaxy with the Traveler

B. He rejoined the Academy one month later

C. He became a part of Lakanta's tribe

D. He died

681. What science did Lieutenant Walter J. Pierce specialize in?

A. Warp field dynamics

B. Linear warp containment systems

C. Power conduit schematics

D. Variable warp drive design

682. Which cast member directed the seventh-season episode "Genesis"?

A. Gates McFadden

B. Jonathan Frakes

C. Patrick Stewart

D. LeVar Burton

683. What illness accidentally mutated into the de-evolution disease while Barclay was being treated?

A. Terellian death syndrome

B. Urodelean flu

C. Sakuro's disease

D. Irumodic syndrome

684. Which animal did Data's cat Spot revert into while infected with Barclay's protomorphosis syndrome?

A. Saber-toothed tiger

B. Spider

C. Rhesus monkey

D. Iguana

685. Whose body was hidden in the *Enterprise*-D's bulkhead?

A. Daniel Kwan
B. Ensign Calloway
C. Commander Sirol
D. Marla Finn

686.

687. Who was the half-human, half-Napean lieutenant who committed suicide due to violent empathic echoes in the ship's warp coils?

A. Lieutenant Daniel Kwan
B. Lt. William Hodges
C. Ensign Dern
D. Ensign Ranier

688. What planet, ceded to the Cardassians by treaty, was inhabited by descendents of Native Americans?

A. Dorvan V
B. Caldos IV
C. D'Arsay
D. Barkon IV

689. Which warp propulsion scientist was mentioned several times in the seventh season but was never seen?

A. Dr. Selar
B. Dr. M'Benga
C. Dr. Reyga
D. Dr. Vassbinder

690. In Klingon, what is a *gin'tak*?

A. A three-pronged knife
B. A celebration
C. A trusted advisor of a Klingon house
D. A spiritual leader

691. What is a *darsek*?

A. A cup of Klingon juice
B. One unit of Klingon currency
C. An expression of disgust
D. An affectionate term for "son"

692. Which Ferengi nemesis re-sequenced Jason Vigo's DNA?

A. Tol
B. DaiMon Bok
C. Quark
D. Birta

693. What did Picard trade a very old bottle of Saurian brandy for in "Bloodlines"?

A. Stone of Gol
B. Ressikan flute
C. Gorlan prayer stick
D. Kurlan naiskos

686.

After high ratings of *The Next Generation*'s third season finale, the writers developed an epic two-part cliff-hanger for the fourth season finale and fifth season opener. In "Redemption" (shown below), Picard was informed of the rebel forces threatening to start a war during the *Enterprise*'s mission to install Gowron on the throne of the Klingon Empire. Wary of getting involved, Picard ultimately intervened when Romulan support for the Klingon rebels was uncovered.

Meanwhile, Worf resigned his commission to fight for the new leader of the Empire, and Picard met the Romulan Sela, who claimed she was the daughter of the Tasha Yar from the alternate time line seen in "Yesterday's

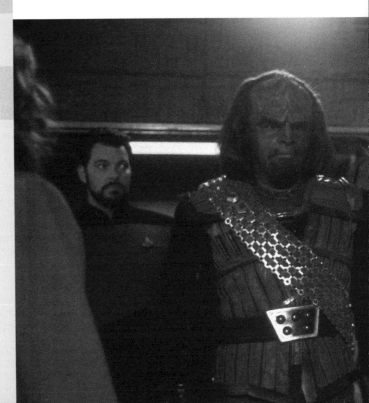

Enterprise." Tasha was captured by Romulans and given a choice: be the Romulan general's consort to spare the other survivors of the *U.S.S. Enterprise*-C or die.

Picard split his forces, and Data took command of a ship in a Federation blockade. Data's actions impressed even the prejudiced first officer, who did not believe an android should be a captain.

What was the name of the ship Data commanded?

A. *U.S.S. Drake*
B. *U.S.S. Wellington*
C. *U.S.S. Sutherland*
D. *U.S.S. Hood*

694. Which director helmed a record twenty-five *Next Generation* episodes?

A. Les Landau
B. David Carson
C. Winrich Kolbe
D. Cliff Bole

695. Whose death helped drive Ro Laren to betray Starfleet and join the Maquis?

A. Santos
B. Macias
C. Picard
D. Kalita

696. In the anti-time future, what warp factor were the ships able to achieve?

A. Warp 37
B. Warp 38
C. Warp 39
D. Warp 100

697. Which system is the anti-time anomaly in?

A. Earth
B. Farpoint
C. Devron
D. Romulan

698. What happened to Geordi during the encroachment of the anti-time anomaly?

A. He began to grow new eyes
B. His VISOR stopped working
C. He was demoted
D. His mother came back to life

699. Who was the wise gardener who advised Picard during his academy days?

A. Satelk
B. Boothby
C. Sito
D. Locarno

700. What is the registry number of Riker's *Enterprise* in the antitime future?

A. *U.S.S. Enterprise* NCC 1701-D
B. *U.S.S. Enterprise* NCC 1701-E
C. *U.S.S. Enterprise* NCC 1701-F
D. *U.S.S. Enterprise* NCC 1701-G

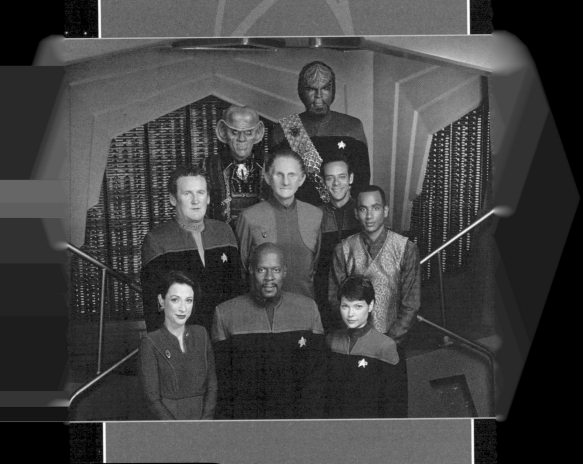

701. What was the name of Benjamin Sisko's first wife, who died during the battle of Wolf 359?

A. Felicia

B. Jennifer

C. Kasidy

D. Terri

702. What do the Bajorans call the nine Orb artifacts?

A. Eyes of the Prophets

B. The Emissary's Tears

C. Tears of the Prophets

D. Temple Crystals

703. What do the Bajorans call the stable wormhole that opened up in 2370?

A. Celestial Temple

B. Fire Cave

C. Denorios

D. Orb

704. What do the Bajorans call the aliens who live in the stable wormhole?

A. Emissaries

B. Pah-Wraiths

C. Prophets

D. Watchers

705. What is the term for the spiritual leader of the Bajoran people?

A. Vedek

B. Legate

C. Provider

D. Kai

706. What race does Odo belong to?

A. Bajoran

B. Changeling

C. Vorta

D. Jem'Hadar

707. Where did Odo normally sleep?

A. His office desk

B. In bed

C. Bucket

D. Outside the station

LEFT The crew of *Deep Space Nine*.

708. What sport did Dr. Bashir and Chief O'Brien regularly compete at?

A. Handball
B. Racquetball
C. Squash
D. Tennis

709. When he first came to Deep Space 9, whom did Dr. Bashir have a crush on?

A. Kira
B. Neela
C. Dax
D. Leeta

710. What resistance cell of the Bajoran underground did Kira Nerys once belong to?

A. Shakaar
B. Maquis
C. Paqu
D. Navot

711. What was Kira's rank upon assignment to Deep Space 9?

A. Colonel
B. Major
C. Ensign
D. Lieutenant

712. Who was the Dax host immediately prior to Jadzia?

A. Tobin
B. Curzon
C. Emony
D. Ezri

713. How many hosts did the Dax symbiont have prior to Jadzia?

A. Eight
B. Nine
C. Ten
D. Fifteen

714. In what episode did U.S.S. Enterprise crew member Lieutenant Worf join the crew of Deep Space 9?

A. "The Visitor"
B. "Way of the Warrior"
C. "Family Business"
D. "The Sword of Kahless"

715. What fundamentalist movement targeting the Federation's "decadence" did Worf briefly assist in the episode "Let He Who Is Without Sin ..."?

A. New Earthers
B. The Circle
C. Terra Prime
D. New Essentialists

716.

716.

In January of 1993, *Star Trek: The Next Generation* was at the height of its popularity, and plans were in place to shift it from a television franchise to a film series. The studio requested a companion show be produced to take *The Next Generation*'s place in syndication and thus, *Star Trek: Deep Space Nine* was born.

The producers took a twist on the original Star Trek's premise—rather than "seeking out new life and new civilizations," this show would focus on a father and son in an alien community setting. The community would be a space station, an important outpost near Bajor (introduced in *The Next Generation* episode "Ensign Ro"), as the Cardassians (also introduced in *The Next Generation* in "The Wounded") had just withdrawn from a 50-year occupation of the planet.

In the pilot episode of *Deep Space Nine*, Commander Benjamin Sisko and his son, Jake, journeyed to the ransacked mining station, now renamed Deep Space 9, and set about building up the Federation presence there. But during the episode, Sisko discovered a stable wormhole in the region that would lead him to become far more than a Starfleet commander—he would become a religious figure to the Bajorans.

What did Bajoran religious leader Kai Opaka (shown at right) name Sisko?

A. Emissary
B. Vedek
C. Prophet
D. Orb-Maker

717. What nickname does the Ferengi bartender Quark call his mother?

A. Moogie
B. Ishka
C. Nagus
D. Grand Inquisitor

718. Who wrote the first Rules of Acquisition?

A. Brunt
B. Rom
C. Zek
D. Gint

719. What position did Miles O'Brien accept at Deep Space 9?

A. Chief of Security
B. Chief Ambassador
C. Chief of Operations
D. Chief Liaison to Bajor

720. What did Keiko O'Brien establish at the station?

A. Arboretum
B. Church
C. Spa
D. School

721. What was Jake Sisko's passion?

A. Dabo
B. Writing
C. Teaching
D. Bartending

722. Who was Jake's best friend on Deep Space 9?

A. Morn
B. Molly O'Brien
C. Dr. Bashir
D. Nog

723. Who was the first Ferengi to attend Starfleet Academy?

A. Rom
B. Brunt
C. Nog
D. Zek

724. What race led the Dominion?

A. Vorta
B. Jem'Hadar
C. Wadi
D. Founders

725. What quadrant of space did the Bajoran wormhole lead to?

A. Alpha **C.** Gamma
B. Beta **D.** Delta

726. Which Bajoran religious figure ultimately turned away from the Prophets?

A. Bareil **C.** Opaka
B. Winn **D.** Sisko

727. Who were the noncorporeal enemies of the Prophets?

A. Pah-wraiths **C.** Jem'Hadar
B. Q **D.** Meridians

728. Who called himself just a "plain, simple" tailor on board Deep Space 9?

A. Gul Dukat **C.** Elim Garek
B. Enabran Tain **D.** Tora Ziyal

729. What is the name of the Cardassian secret intelligence agency?

A. Tal Shiar **C.** Obsidian Order
B. Section 31 **D.** Kanar

730. Who was the dabo girl who fell in love with Quark's brother?

A. Aluura **C.** Leeta
B. Leosa **D.** Sarda

731. Who was Quark's most frequent bar patron?

A. Jadzia Dax **C.** Benjamin Sisko
B. Morn **D.** Odo

732. What is the preferred Ferengi form of foreplay?

A. *Oo-mox* **C.** Ear-cleaning
B. Shopping **D.** Counting money

733. Instead of shuttles, the Deep Space 9 crew used what type of ship for relatively short-range excursions?
- **A.** Bajoran lightships
- **B.** Runabouts
- **C.** *Galor*-class vessels
- **D.** Freighters

734. What sports memorabilia item did Sisko keep on his desk?
- **A.** Golf tee
- **B.** Baseball card
- **C.** Baseball
- **D.** Bowling pin

735. What is the unit of exchange for the Ferengi and many other cultures?
- **A.** Credits
- **B.** Dabos
- **C.** Dom-jots
- **D.** Latinum

736. What was the *Defiant*-class starship assigned permanently to Deep Space Nine?
- **A.** *U.S.S. Saratoga*
- **B.** *U.S.S. Defiant*
- **C.** *U.S.S. Yukon*
- **D.** *U.S.S. Ganges*

737. What was the race of clones that served in the Dominion called?
- **A.** Changelings
- **B.** Jem'Hadar
- **C.** Vorta
- **D.** Tosk

738.

739. Who was the self-aware holographic lounge singer from Dr. Bashir's Vegas program?
- **A.** Louis Velvet
- **B.** Vic Fontaine
- **C.** Bobby Stardust
- **D.** Lester Crown

740. What popular 1960s singer/actor played Dr. Bashir's favorite holographic performer?
- **A.** James Darren
- **B.** Dean Martin
- **C.** Sammy Davis Jr.
- **D.** Frank Sinatra Jr.

738.

Although they never quite made the grade as villains on *The Next Generation*, the Ferengi enjoyed a natural place in the more communal setting of *Deep Space Nine* thanks to their overriding desire for wealth. Quark, the Ferengi owner of the bar, the holosuites, and the dabo tables on the station turned a tidy profit.

These profits caught the attention of the Ferengi leader, the Grand Nagus (shown at left). The Nagus decided to use Quark to test his son's worthiness of being his successor. In the episode "The Nagus," Quark thought the head of his race wanted to take over his bar. Instead, the leader died and Quark was suddenly named the new Grand Nagus—to the anger of the Nagus' son!

For the episode, the producers took pains to include homage to Francis Ford Coppola's *The Godfather*, from set dressing to lighting to dialogue, with Quark as the Godfather figure. However, Quark's tenure as a figure of power didn't last long and the real Nagus returned to take back his title from Quark.

Who stayed in power as the Grand Nagus until the end of *Deep Space Nine*?

- **A.** Krax
- **B.** Brunt
- **C.** Zek
- **D.** Rom

741. Which was *not* one of the holosuite programs Bashir frequently enjoyed?

A. Alamo
C. Vulcan Love Slave, Volume III
B. Julian Bashir, Secret Agent
D. Kayaking

742. What is the title of the head of the Ferengi Alliance?

A. Blessed Exchequer
C. Grand Nagus
B. DaiMon
D. Great Liquidator

743. How many Rules of Acquisition are there?

A. 10
C. 342
B. 285
D. 526

744. Which Klingon general led a squadron of warriors stationed on Deep Space 9 during the Dominion War?

A. Martok
C. Worf
B. Gowron
D. Kor

745. In the mirror universe, what position did Kira Nerys hold?

A. Regent
C. Vedek
B. Intendant
D. Empress

746. What was O'Brien's nickname in the mirror universe?

A. Theta
C. Yardstick
B. Smiley
D. Shamrock

747. What was Deep Space 9 called before the Federation assumed control?

A. K-7
C. Empok Nor
B. Terok Nor
D. Deep Space 17

748. What Cardassian officer oversaw the station during the occupation of Bajor?

A. Legate Damar
C. Gul Dukat
B. Garak
D. Gul Ocett

755.

Religion and politics were almost inseparable on Bajor. That's hardly surprising, given that supernatural events occurred regularly on the planet and on Deep Space 9, where its commander was named a religious icon.

The fledgling provisional government faced its greatest challenge in 2369. Religious leaders helped fan the flames of xenophobia among Bajorans already frustrated by years of Cardassian oppression. Soon, many Bajorans saw the Federation's presence as another form of oppression.

In a trilogy of episodes that aired in September and October 1993, Major Kira was caught between her newfound loyalty to Commander Sisko and the anti-Federation

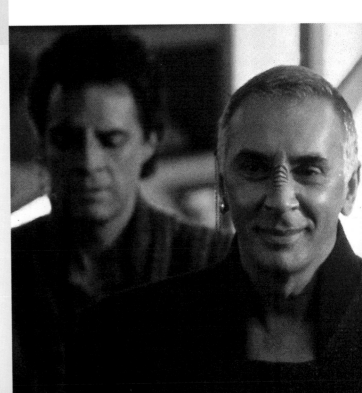

extremists of her home world whose attitude she once shared.

This extremist group had members at the highest levels of the government, including Minister Jaro Essa (shown below, center) and the church, but unbeknownst even to them, they were being used by an old enemy.

The common name for these Bajoran extremists was "the Circle," but what was their official name?

A. Alliance for Global Unity
B. Pah-wraith Cult
C. Prophets of the Celestial Temple
D. Bajor for Bajorans

749. What event did the wormhole aliens help Sisko face so he could move forward with his life?
A. Posting on Deep Space 9
C. Becoming the Emissary
B. The death of his wife
D. His son's possession

750. What was Keiko O'Brien's profession?
A. Security Chief
C. Engineer
B. Botanist
D. Astrophysicist

751. What Bajoran confection was "too sweet" for Kira?
A. *Jumja* stick
C. *Hasperat*
B. Groatcake
D. *Tuwali* pie

752. What noted Federation ambassador became attracted to Odo in "The Forsaken"?
A. Taxco
C. Lojal
B. Anara
D. Lwaxana Troi

753. Who was the head of the labor camp on Bajor known as "the Butcher of Gallitep"?
A. Aamin Marritza
C. Gul Dukat
B. Gul Darhe'el
D. Neela

754. Which Bajoran vedek was Neela ordered to assassinate during "In The Hands of the Prophets"?
A. Winn
C. Oram
B. Bareil
D. Solis

755.

756. The first-ever *Star Trek* trilogy consisted of which episodes?
A. "The Homecoming," "The Circle," and "The Siege"
C. "The Jem'Hadar," "The Search Part 1," and "The Search Part 2"
B. "Rivals," "The Alternate," and "Armageddon Game"
D. "Home Front," "Paradise Lost," and "Crossfire"

757. Who was the unwilling hero of the Bajoran resistance, rescued in "The Homecoming"?

A. Li Nalas

B. Romah Doe

C. Luson Jomat

D. Colonel Day

758. In "The Siege," who was actually supplying the Circle with weapons?

A. Klingons

B. Pah-Wraiths

C. Cardassians

D. Lurians

759. What was the Nagus's favorite inhaled delicacy?

A. Ferengi mold spores

B. Hupyrian beetle snuff

C. Tarkalean tea powder

D. Crushed lobe wax

760. Who was the Bajoran scientist assigned to study Odo when he was first discovered?

A. Mora Pel

B. Weld Ram

C. Latha Mabrin

D. Brin Tusk

761. What Cardassian pests occasionally infested Deep Space 9?

A. Tojal

B. Yamok

C. Voles

D. Beetles

762. Who was Sisko's Starfleet-friend-turned-Maquis-sympathizer?

A. Cal Hudson

B. Lieutenant Commander Eddington

C. Admiral Ross

D. Admiral Nechayev

763. What is the name of the Cardassian home world?

A. Cardassia Prime

B. Cardassius

C. Cardas One

D. Cardassia

764. What was the Jem'Hadar battle chant?

A. "To the victor, the spoils!"

B. "For the Founders!"

C. "Victory is life!"

D. "It is a good day to die!"

772.

After season two's finale introduced two-thirds of the Dominion—the Jem'Hadar and the Vorta—season three's opening two-parter, "The Search," introduced the *U.S.S. Defiant*, new combadges, and the Founders. Telepathically bound by the Great Link, the Founders were worshipped as gods by the Vorta and Jem'Hadar. After centuries of persecution, the Founders distrusted what they called "solids," life-forms unable to morph as they did.

Odo was stunned to find out he was a Founder, and desperately wanted to be part of their Link, but he was appalled at his people's xenophobia and willingness to wage war on the Alpha Quadrant. The Founders had strict tenets in their culture, and ultimately Odo would break one to help ensure his safety as he faced the Dominion's forces during the war.

Which tenet of their race did the female Founder (shown at left) tell Odo he had broken?

A. They were divine and could not die
B. No Changeling had ever harmed another
C. What hurt one Founder hurt them all
D. All the Founders were one being

765. What is the Jem'Hadar's personal "invisibility" effect called?
A. Cloak C. Shroud
B. Dagger D. Mask

766. What was the name of Kasidy Yate's freighter?
A. *Ganges* C. *Orinoco*
B. *Xhosa* D. *Batris*

767. Which episode featured the first same-sex kiss in *Star Trek* history?
A. "The Visitor" C. "Little Green Men"
B. "Indiscretion" D. "Rejoined"

768. What was Benjamin Sisko's father's name?
A. Joseph C. Jacob
B. Lafayette D. Peter

769. Which member of Security aboard Deep Space 9 turned out to be a member of the Maquis?
A. Michael Eddington C. Worf
B. Odo D. Kira

770. Which loyal Vorta appeared for the first time in "To the Death"?
A. Eris C. Weyoun
B. Yelgrun D. Deyos

771. Which Klingon did the Founders make Odo suspect had been replaced by a Changeling?
A. Gowron C. Kurn
B. Worf D. Martok

772.

773. What had the rogue Jem'Hadar found on *Vandros IV*?
A. Temporal anomaly C. Naturally occurring Ketracel-white
B. An Iconian gateway D. Imprisoned Founders

774. How long, in years, did the average Jem'Hadar soldier live?

- **A.** Ten
- **B.** Twelve
- **C.** Thirteen
- **D.** Fifteen

775. Which high-ranking Klingon turned out to be the Changeling imposter, rather than the one in Odo's vision?

- **A.** Worf
- **B.** Martok
- **C.** Kurn
- **D.** Kor

776. What is the Klingon word for "love" (albeit with more aggressive overtones)?

- **A.** *tlhIngan*
- **B.** *par'Mach*
- **C.** *hur'q*
- **D.** *tajtiq*

777. How did Worf explain the differences in Klingon cranial ridges in the twenty-third and twenty-fourth centuries?

- **A.** Viral mutation
- **B.** "We do *not* discuss it with outsiders!"
- **C.** Genetic engineering
- **D.** Family bloodlines

778. What former Miss America guest starred in "Let He Who Is Without Sin ..."?

- **A.** Gretchen Carlson
- **B.** Lee Meriwether
- **C.** Phyllis George
- **D.** Vanessa Williams

779. How did Odo regain his shapeshifting abilities in "The Begotten"?

- **A.** Dr. Mora Pel's experiments
- **B.** The Founders returned them
- **C.** Bashir cured him
- **D.** He absorbed a dying Changeling

780. Who was revealed to be Enabran Tain's son?

- **A.** Gul Dukat
- **B.** Elim Garak
- **C.** Damar
- **D.** Eddington

781.

781.

For centuries, governmental power on Cardassia had been shared between the military's Central Command and its secret intelligence agency. The official name of the governing body was the Cardassian Union, and the civilian Detapa Council served as a bridge between its two branches. However, it was little more than a figurehead for the true governmental authorities.

After the Battle of the Omarion Nebula, the first major engagement in the war between the Dominion and the Alpha Quadrant, the Detapa Council and a Cardassian dissident movement briefly took control of the government.

One Cardassian military commander secretly negotiated for the Cardassian Union to become part of the Dominion. In the episode "By Inferno's Light," he became the ruler of Cardassia.

Who was this officer?

- **A.** Damar
- **B.** Gul Dukat
- **C.** A Founder
- **D.** Mila

782. What was the secret Dr. Bashir didn't want his parents to reveal?
- **A.** He still had his teddy bear
- **B.** He loved Dax
- **C.** He'd been genetically engineered
- **D.** He was gay

783. What Klingon House did Worf join in "Soldiers of the Empire"?
- **A.** Kor
- **B.** Martok
- **C.** Duras
- **D.** Mogh

784. In "Children of Time," who was the only original Deep Space 9 crew member still alive after 200 years?
- **A.** O'Brien
- **B.** Worf
- **C.** Odo
- **D.** Sisko

785. How did Commander Eddington die?
- **A.** Plasma explosion
- **B.** Execution
- **C.** Jem'Hadar attack
- **D.** Missile launch

786. What was the Bajoran slur for Cardassians?
- **A.** "Snake-noses"
- **B.** "Cardies"
- **C.** "Gators"
- **D.** "Spoonheads"

787. What is the secret division of Starfleet Intelligence?
- **A.** Obsidian Order
- **B.** Office of Temporal Investigations
- **C.** Section 31
- **D.** Tal Shiar

788. Which Deep Space 9 crew member was recruited for Section 31?
- **A.** Odo
- **B.** Bashir
- **C.** Worf
- **D.** Jadzia

789. Who lost a leg during "The Siege of AR-558"?
- **A.** Kellin
- **B.** Larkin
- **C.** Reese
- **D.** Nog

790. What was the name of the Federation ship crewed by Starfleet Academy cadets?

A. *U.S.S. Valiant*
B. *U.S.S. Odyssey*
C. *U.S.S. Republic*
D. *U.S.S. Shenandoah*

791. Who was the captain of the *U.S.S. Olympia*, whose distress signal to the *Defiant* was shunted forward in time?

A. William Ross
B. Lisa Cusak
C. Tim Watters
D. Dorian Collins

792. What sparked Sisko's decision to leave Deep Space 9 in "Tears of the Prophets"?

A. His father's illness
B. Jake's scholarship
C. Jadzia's death
D. Post-traumatic stress

793. Who helped the depressed Nog get back to "playing the hand life has dealt him"?

A. Rom
B. Ezri Dax
C. Leeta
D. Vic Fontaine

794.

795. Which Section 31 operative did Bashir repeatedly find in his bedroom upon waking?

A. Sloan
B. Ross
C. Koval
D. Jack

796. Who did Ezri realize she was in love with during the last season of *Deep Space Nine*?

A. Bashir
B. Sisko
C. Quark
D. Worf

797. Who became Chancellor of the Klingon High Council in "When It Rains"?

A. Worf
B. Martok
C. Gowron
D. Alexander

794.

It's no secret that Dr. Julian Bashir (shown at right with Garak (left) and Kira (middle)) enjoyed intrigue. He became friends with Garak (who firmly denied any connection to the Cardassian intelligence agency), flirted with recruitment for a rogue intelligence agency, and for fun often ran his "Julian Bashir, Secret Agent" holoprogram.

One of the first times he ran this spy program, an emergency transporter malfunction retained some of the senior staff's patterns. Bashir and Garak were forced to play along to prevent any of them from being killed before their patterns could be brought out of the program.

Conceived as a tribute to various international spy thrillers of the 1960s (such as the *James Bond* series and *Our Man Flint*), the episode "Our Man Bashir" gave the holoprogram characters some genre-specific names—including genius geologist Dr. Honey Bare.

Which crew member played her?

A. Jadzia Dax
B. Kira Nerys
C. Leeta
D. Rom

798. Which of the Breen's weapons crippled Federation, Romulan, and most Klingon ships?

A. Temporal disruptors
C. Neural screamers
B. Energy-dampening weapons
D. Tricobalt bombs

799. Ironically, who had to teach the Cardassians how to be revolutionaries?

A. Garak
C. Odo
B. Kira
D. Sisko

800. Who poisoned Gul Dukat?

A. Quark
C. Bashir
B. Garak
D. Kai Winn

801. Who sold explosive bilitrium to Bajoran terrorist Tahna Los?

A. Quark
C. Ibudan
B. Lursa and B'Etor
D. Surmak Ren

802. What was the only episode of *Deep Space Nine* that featured Q?

A. "True Q"
C. "Q-pid"
B. "Tapestry"
D. "Q-less"

803. What is the name of the game-obsessed Gamma Quadrant species?

A. Tosk
C. Wadi
B. Vorta
D. Dosi

804. Who was Zek's son?

A. Rom
C. Krax
B. Stol
D. Brunt

805. Which Rule of Acquisition states, "Once you have their money, you never give it back"?

A. Fourth
C. Second
B. Third
D. First

806. Which film actor played the recurring role of the Grand Nagus?

- **A.** Christopher Lloyd
- **B.** Chris Sarandon
- **C.** Wallace Shawn
- **D.** John Larroquette

807. What was Rule of Acquisition #7?

- **A.** "Always keep your ears open"
- **B.** "A deal is a deal"
- **C.** "War is good for business"
- **D.** "Free advice is seldom cheap"

808. What is the disease only caused by the Gallitep mining accident?

- **A.** Pottrik syndrome
- **B.** Kalla-Nohra syndrome
- **C.** Dorek syndrome
- **D.** Dysphoria syndrome

809. Who was behind Neela's assassination attempt on Vedek Bareil?

- **A.** Ensign Aquino
- **B.** Tahna Los
- **C.** Vedek Winn
- **D.** Gul Dukat

810.

811. Who started the movement on Bajor known as "the Circle"?

- **A.** Winn Adami
- **B.** Bareil Antos
- **C.** Jaro Essa
- **D.** Li Nalas

812. Which Orb gave Kira a vision in "The Circle"?

- **A.** Orb of Time
- **B.** Orb of Contemplation
- **C.** Orb of Prophecy and Change
- **D.** Orb of the Emissary

813. Who was the Trill who attempted to steal Dax from Jadzia in "Invasive Procedures"?

- **A.** Vernica
- **B.** Kell
- **C.** Hanor
- **D.** Verad

814. What tea did Dr. Bashir often drink during his lunches with Garak?

- **A.** Tarkalean
- **B.** Earl Grey
- **C.** Chamomile
- **D.** Rigelian

810.

Over the course of seven seasons, the Deep Space 9 crew had numerous run-ins with their counterparts from the mirror universe. Though the first *Deep Space Nine* episode "Crossover" picked up where the original series *Star Trek* episode "Mirror, Mirror" left off, the political landscape had changed dramatically since the events of that episode. The Terran Empire had fallen when the mirror version of Spock became leader of the empire and instituted more logical and peaceful reforms.

The Klingon-Cardassian Alliance was now the main power in the Quadrant and Benjamin Sisko (shown at right with Tuvok, far left, and Bashir, middle) was killed. The mirror O'Brien brought over the "real" Sisko in an attempt to convince his wife Jennifer–still alive in the mirror universe–to stop working on an Alliance weapon that would crush the human rebellion.

"Through the Looking Glass" introduced mirror versions of Rom, Jennifer Sisko, and a "logical" *Voyager* crew member.

Who was it?

- **A.** Tuvok
- **B.** Paris
- **C.** Janeway
- **D.** Seven of Nine

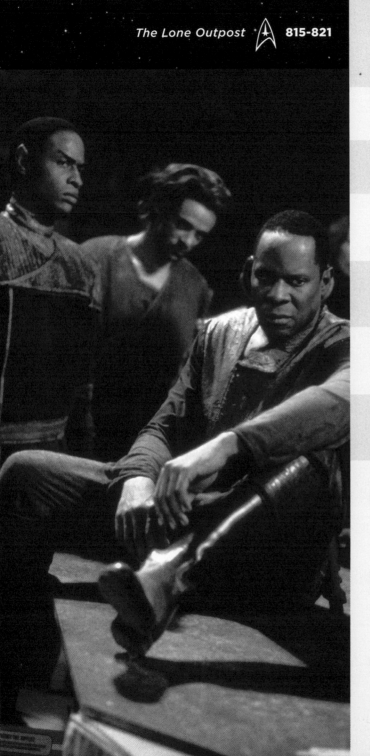

815. What was nontraditional about the Ferengi Pel?

A. Pel didn't like profit

B. Pel loved Quark

C. Pel cheated customers

D. Pel was a female who negotiated business

816. What episode first mentioned the Dominion?

A. "The Siege"

B. "Invasive Procedures"

C. "Necessary Evil"

D. "Rules of Acquisition"

817. What snack did Quark serve to induce thirst in his customers?

A. Ferengi mushroom caps

B. Gramilian sand peas

C. Salted *targ* jerky

D. Peanuts

818. What was the first episode to reveal the Cardassian name for Deep Space 9?

A. "Emissary"

B. "Cardassians"

C. "Necessary Evil"

D. "Homecoming"

819. Who was responsible for the death of the Cardassian collaborator Vaatrik?

A. Odo

B. Pallra

C. Kira

D. Bareil

820. Who was the psychoprojective alter ego of the telepath Nidell, which fell in love with Sisko?

A. Lidell

B. Halana

C. Fenna

D. Jennifer

821. What Gamma Quadrant race believed Bajor was their legendary home world?

A. T-Rogorans

B. Skrreeans

C. Dosi

D. El-Aurians

822. How did Keiko know the recording of her husband's death was a fake in "Armageddon Game"?

A. Miles wouldn't go anywhere with Bashir

B. Miles didn't drink coffee in the afternoon

C. Miles never mentioned their daughter's name

D. Miles was with her at that time

823. Whom was Jake Sisko briefly apprenticed to on Deep Space 9?

A. Odo

B. Major Kira

C. Dr. Bashir

D. Chief O'Brien

824. What did Dax and Odo discover was unusual about the population of the Yaderan colony?

A. They were Dominion hybrids

B. They were immortal

C. They were holograms except for Rurigan

D. They were unevolved Changelings

825. Who was Quark's onetime Cardassian love?

A. Zarale

B. Natima Lang

C. Tora Ziyal

D. Makbar

826. Which Klingon from the *Star Trek* original series did *not* appear in the episode "Blood Oath"?

A. Kor

B. Koloth

C. Kang

D. Korax

827.

827.

The episode "Home Front" and its second part, "Paradise Lost," were originally intended to be the season-three cliff-hanger and season-four opener. However, the studio forced a new direction on the producers, causing them to shift both episodes into production later in the fourth season.

In the episodes, the cold war between the Dominion forces and the Alpha Quadrant heated up, and Captain Sisko and Odo (shown below with Admiral Leyton, right) were recalled to Earth after a suspected terrorist attack by Changelings. As their investigation and security

828. In "Blood Oath," who was the Klingon trio's greatest enemy?

A. Martok

B. Gowron

C. Kirk

D. The Albino

829. What is a "Dahar Master"?

A. Title bestowed on the greatest Klingon warriors

B. Master of *bat'leth* combat

C. Mocking title of cowardice

D. Klingon with multiple wives

measures progressed, so did paranoia and the curtailing of civil rights. This was a huge leap from the peaceful Earth of the future that *Star Trek* had traditionally shown. Despite the lack of effects, viewers got a chilling revelation that no matter how many Changelings were on Earth, humans had the capacity to wreak more havoc on themselves through fear than the imposters could.

How many Changelings were actually on Earth at the time of the threat?

A. One
B. Four
C. Eight
D. Ten

830. What was the danger of the badlands region of space?
A. Subspace distortions
B. Plasma storms and gravitational anomalies
C. Temporal anomalies
D. The Caretaker

831. What is unusual about Gallamite physiology?
A. Four arms
B. Transparent skulls
C. Extra vertebrae
D. Tails

832. What episode first mentioned the Obsidian Order?
A. "The Wire"
B. "The Maquis"
C. "Crossover"
D. "The Search"

833. Who was the head of the Obsidian Order for twenty years?
A. Elim Garak
B. Legate Damar
C. Gul Dukat
D. Enabran Tain

834. How long is a standard day on Deep Space 9?
A. 26 hours
B. 28 hours
C. 32 hours
D. 34 hours

835. Which two powers made up the Alliance in the mirror universe?
A. Human & Vulcan
B. Klingon & Cardassian
C. Ferengi & Bajoran
D. Vorta & Jem'Hadar

836. What was different about Jake Sisko in the mirror universe?
A. He was a propaganda writer
B. He was a mine worker
C. He was never born
D. He tended bar

837. Who became kai after Vedek Bareil took the blame to protect the previous kai's involvement in a massacre?
A. Winn Adami
B. Opaka
C. Kubus Oak
D. Prylar Bek

838. How do the Cardassians achieve such swift justice in their legal system?

A. All defendants are guilty
B. The verdict is known before the trial begins
C. There are no lawyers
D. The trials only take one day

839. What *Galaxy*-class starship was destroyed during the first encounter with the Jem'Hadar?

A. U.S.S. Enterprise
B. U.S.S. Defiant
C. U.S.S. Odyssey
D. U.S.S. Orinoco

840. Who was the first Vorta encountered by Sisko?

A. Weyoun
B. Luaran
C. Kilana
D. Eris

841. How are all aspects of the Jem'Hadar controlled?

A. Mental control
B. Their wills are broken by the Founders
C. Addiction to ketracel-white
D. Loyalty oaths

842. Which Romulan was assigned to oversee Starfleet's use of their borrowed cloaking device?

A. Senator Cretak
B. General Movar
C. Karina
D. T'Rul

843.

844. Who temporarily replaced Odo as head of Security on Deep Space 9?

A. Major Kira
B. Lieutenant Worf
C. Lt. Michael Eddington
D. Garak

845. Where was the Founders' home world located?

A. Omarion Nebula
B. In the wormhole
C. Chamra Vortex
D. Idran

846. How many infant Changelings did the Founders send out to acquire knowledge of the Galaxy?

A. 50
B. 100
C. 150
D. 1,000

843.

In 1995, the studio asked *Star Trek's* producers to shake up the status quo of the series to increase ratings. The producers decided the best way to do that was to make the Klingons (shown at right) enemies of the Federation again—and to bring back one of the most popular *Next Generation* crew members.

Transferring from the *U.S.S. Enterprise*-E, Lieutenant Commander Worf (Michael Dorn) joined the crew of Deep Space 9 as Strategic Operations Officer. Story lines would be spun out of both Worf's personal history and Klingon history for the remainder of the show's run.

As Gowron, leader of the Klingon Empire, prepared to invade Cardassia, Sisko and his crew tried to prevent the deaths of Cardassia's ruling council, leading the Klingons to declare them as enemies. Gowron also stripped Worf of his house and honor—leading him to tender his resignation from Starfleet.

Who convinced Worf to stay?

A. Dax
B. Sisko
C. Alexander
D. Odo

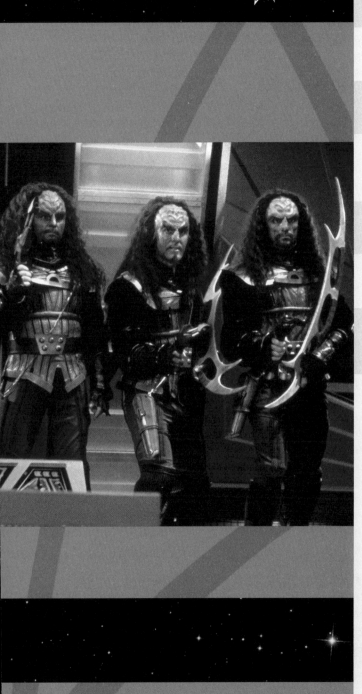

847. Which Klingon was Quark married to briefly?

 A. Lursa **C.** Doran

 B. B'Etor **D.** Grilka

848. Which Dax symbiont was a murderer?

 A. Joran **C.** Emony

 B. Curzon **D.** Ezri

849. What ship does Thomas Riker attempt to take into the Badlands?

 A. *U.S.S. Rio Grande* **C.** *U.S.S. Rubicon*

 B. *U.S.S. Ganges* **D.** *U.S.S. Defiant*

850. What were the segregated twenty-first-century holding areas for the homeless and unemployed called?

 A. Bell areas **C.** Paradise camps

 B. Sanctuary districts **D.** Home fronts

851. Who was forced to take the place of civil rights leader Gabriel Bell?

 A. Bashir **C.** Sisko

 B. Odo **D.** O'Brien

852. Why did Nog want to join Starfleet?

 A. To fight the Dominion **C.** To command Deep Space 9

 B. To gain profit **D.** To not end up like his father

853. What prestigious Federation medical award was Dr. Bashir nominated for in 2371, making him the youngest nominee ever?

 A. Carrington Award **C.** Pulaski Prize

 B. McCoy Medal **D.** Daystrom Honors

854. Whose scientific work for the Alliance did Smiley need Benjamin Sisko's help to stop?

 A. Jadzia Dax **C.** Jennifer Sisko

 B. Dr. Bashir **D.** Tuvok

855. Who joined forces to attack the Founders on their home world?

A. Tal Shiar & Obsidian Order C. Section 31 & Starfleet
B. Klingons & Romulans D. Breen & Ferengi

856. What was the first episode to feature Leeta the dabo girl?

A. "The Die is Cast" C. "Through the Looking Glass"
B. "Explorers" D. "Destiny"

857. What was Jake Sisko's first short story about?

A. The Maquis C. Ferengi
B. Deep Space 9 D. The mirror universe

858. What crime did Brunt charge Quark with in the episode "Family Business"?

A. Not recording profits from a tulaberry wine franchise C. Letting Nog enter Starfleet Academy
B. Improper supervision of a family member D. Letting dabo girls go on strike

859. What baseball team did Kasidy Yates's brother play for?

A. Cestus III Comets C. Vulcan Logicians
B. Gorn Gators D. Pike City Pioneers

860. How could it be determined if someone was being impersonated by a Changeling?

A. Telepathic scan C. Blood screenings
B. Phaser set to stun D. Ultrasonics

861. What actress, best known for her role in the soap opera *Dallas*, played Quark's Cardassian lover?

A. Barbara Bel Geddes C. Victoria Principal
B. Mary Crosby D. Linda Gray

862. Who was Gul Dukat's half-Bajoran daughter?

A. Kira Nerys C. Tora Naprem
B. Winn Adami D. Tora Ziyal

869.

Voted in 1996 by *TV Guide* as the best *Star Trek* episode ever, "The Visitor" tells the story of how Captain Sisko vanished into a temporal inversion, occasionally reappearing to his adult son, and how Jake Sisko gave up everything to return his father to normal.

The alternate time line in which Jake Sisko grows up (with the adult Jake played by Tony Todd, shown at left) shows what might have happened had Sisko vanished: the Klingons overtake the station, the Bajorans and Cardassians form an alliance, and the Dominion War never takes place. Some things do remain the same—Jake continues to write and his first novel is the same in both time lines.

What is the name of his first novel?

A. *Far Beyond the Stars*
B. *Anselm*
C. *Past Prologue*
D. *The Prophet's Call*

863. What is the Trill taboo against resuming a relationship with a lover from a past life?

A. Reassociation C. Rejoining
B. Rekindling D. Replacement

864. According to the episode "Little Green Men," who were the aliens discovered in Roswell in 1947?

A. Morn, Dax, and Kira C. Worf, Sisko, and Odo
B. Quark, Rom, and Nog D. Garak, Dukat, and Winn

865. In "Our Man Bashir," whose transporter patterns were stored as Russian spy Anastasia Komananov?

A. Dax C. Leeta
B. Major Kira D. Kasidy Yates

866. After an accident in "Body Parts," who agreed to carry Keiko's second baby?

A. Kira C. Bashir
B. Dax D. Leeta

867. How many disks do Ferengi usually need to store their vacuum-desiccated remains?

A. Ten C. Forty-seven
B. Twenty-six D. Fifty-two

868. What does the FCA stand for on Ferenginar?

A. Ferenginar Coalition of Altruism C. Ferengi Commerce Authority
B. Ferengi Chancellor's Assistant D. Ferengi Code of Assets

869.

870. In "Broken Link," who told Garak "You fight well . . . for a tailor"?

A. Omet'iklan C. Worf
B. Kira D. Dax

871. Which undercover Deep Space 9 crew member was inducted into the Order of the Bat'leth in "Apocalypse Rising"?

A. Odo C. Worf
B. O'Brien D. Sisko

872. Who helped Quark romance his Klingon ex-wife, Grilka, during her return to Deep Space 9?

A. Bashir
B. Nog
C. Worf
D. Kira

873. Who was possessed by the Pah-wraiths in "The Assignment"?

A. Morn
B. Keiko O'Brien
C. Leeta
D. Rom

874. How many temporal violations had Captain Kirk accrued during his career?

A. Twelve
B. Seventeen
C. Twenty-four
D. Forty-seven

875. What identity did Arne Darvin take on in the episode "Trials and Tribble-ations"?

A. Cyrano Jones
B. Kang
C. Barry Waddle
D. Worf's great-grandfather

876. Why did Bashir and Leeta go to Risa?

A. To get married
B. To vacation
C. To break up
D. To start a family

877. What triggered Odo's "link" with Sisko, Dax, and Garak in "Things Past"?

A. An Orb
B. A plasma storm
C. His guilt feelings
D. His morphogenic matrix

878. Despite orders from Captain Picard, who ends up preventing Bajor's admission to the Federation?

A. Sisko
B. Worf
C. O'Brien
D. Dax

879. What was the name of Miles and Keiko O'Brien's baby son?

A. Kirayoshi
B. Miles Jr.
C. Julian
D. Benjamin

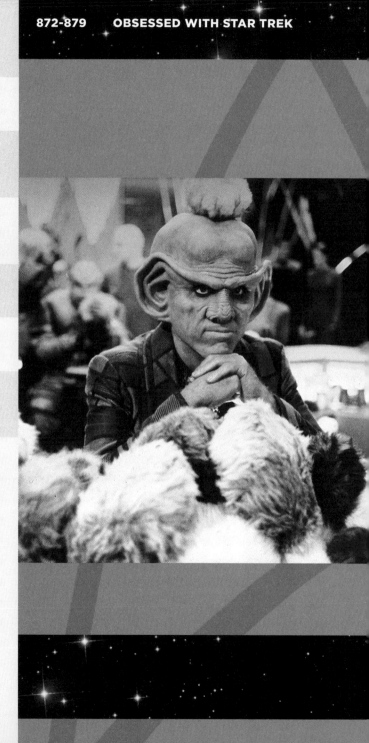

884.

To celebrate the thirtieth anniversary of *Star Trek*, the *Deep Space Nine* production staff toyed with several ideas, including having one of the seven principle actors from the original show visit the station or having Sisko and crew visit Sigma Iotia from the original series episode "A Piece of the Action." Ultimately, it was test footage of a modern-day actor inserted into footage from the original series that allowed them to craft "Trials and Tribble-ations," in which Sisko and crew visit Kirk's *Enterprise* during the time of the episode "The Trouble with Tribbles."

A lighthearted juxtaposition of the two series was highlighted by the difference in Klingon cranial ridges, the miniskirted outfits of Starfleet's female personnel, and, of course, the ever-popular tribbles (shown left with Quark). In the famous scene where Kirk was showered with tribbles falling out of a storage bin, "Trials" revealed someone (or more than one someone) was actually tossing them out onto him.

Who was it?

A. Sisko & Dax
B. O'Brien & Bashir
C. Odo
D. Worf

880. How did Sisko capture Maquis leader Eddington?
A. Infiltrating the Maquis
B. Holocommunicator trick
C. By threatening to destroy all Maquis colonies
D. Using the holosuite

881. Along with Martok, which Deep Space 9 crewman had been captured and replaced by a Changeling?
A. Bashir
B. O'Brien
C. Nog
D. Rom

882. In the episode "Ferengi Love Songs," who said, "Sometimes the only thing more dangerous than a question is an answer"?
A. Quark
B. Rom
C. Ishka
D. Zek

883. What did Sisko leave as a message to Dukat when the Dominion retook Deep Space 9?
A. A mine
B. His baseball
C. An Orb
D. A phaser

884.

885. Which *Deep Space Nine* writer left the show after season five and a cameo in "Call to Arms"?
A. Robert Hewitt Wolfe
B. Ira Steven Behr
C. Hans Beimler
D. Peter Allan Fields

886. Which Klingon ship did Alexander Rozhenko first serve on?
A. *I.K.S. B'Moth*
B. *I.K.S. Rotarran*
C. *I.K.S. Klothos*
D. *I.K.S. Toh'Kaht*

887. In the episode "Far Beyond the Stars," which friend's death caused Sisko to question if he was making a difference in the war?
A. Jadzia Dax
B. Cal Hudson
C. Captain Swofford
D. Captain Solok

888. What were the Bajoran females forced to provide company and pleasure to Cardassians called?
A. Pleasure Givers
B. Madames
C. Comfort Women
D. Companions

889. How old did Molly O'Brien become when she fell into a temporal vortex?

- **A.** Eight
- **B.** Eighteen
- **C.** Twenty-eight
- **D.** Thirty-eight

890. What did Quark agree to do to help reinstate Zek as Nagus?

- **A.** Give up the bar
- **B.** Undergo a temporary sex change
- **C.** Hand over all his savings
- **D.** Donate to the Bajoran War Orphans fund

891. What did Garak suffer from?

- **A.** Arachnophobia
- **B.** Xenophobia
- **C.** Transporter psychosis
- **D.** Claustrophobia

892. What did Ezri Dax suffer from?

- **A.** Space-sickness
- **B.** Fear of heights
- **C.** Fear of snakes
- **D.** Hypochondria

893. What did the Prophets tell Sisko in regards to marrying Kasidy?

- **A.** "That is not your destiny."
- **B.** "Your destiny is your own."
- **C.** "You're with us now."
- **D.** "Follow your heart, my son."

894. Who captured Worf and Ezri during "Penumbra"?

- **A.** Cardassians
- **B.** Breen
- **C.** Founders
- **D.** Jem'Hadar

895. Who seduced Kai Winn into finding a way to free the Pah-wraiths?

- **A.** Solbor
- **B.** Female Founder
- **C.** Damar
- **D.** Dukat

896. What did the Pah-wraiths do to Dukat to punish him for trying to read *The Book of the Kosst Amojan*?

- **A.** Made him a beggar
- **B.** Revealed his true identity
- **C.** Struck him blind temporarily
- **D.** Killed him

897. What turned the tide for the Federation/Klingon fleet during the final battle of the Dominion War?

- **A.** Cardassians changing sides
- **B.** Countering Breen technology
- **C.** Vulcan ships
- **D.** Ferengi Alliance joined in

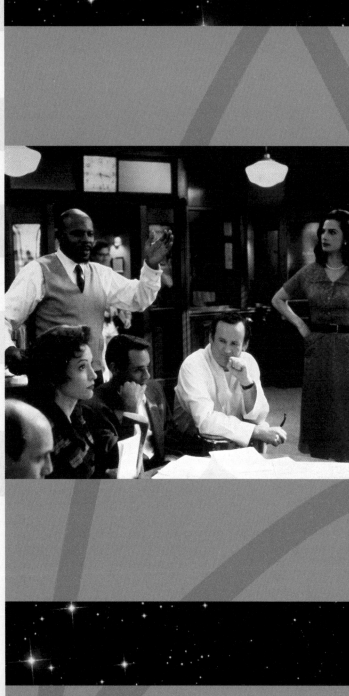

902.

In "Far Beyond the Stars," Sisko debated leaving Deep Space 9 as losses mounted during the Dominion War. The Prophets sent him a vision of Benny Russell, a science fiction writer in the 1950s struggling against racism. During the vision, Sisko lived out a crucial period in Benny's life. The vision helped him decide to stay on the station. Brooks also directed the episode, marking the first time a *Star Trek* actor played the roles of both lead character and director.

It was also the first time Sisko's alter ego of Benny Russell was seen, though he would experience another shift into Benny's life in the final season.

The episode featured another first: the first time several of the cast members who played aliens appeared on camera *without* the makeup and prosthetics typically needed for their characters. They wore no makeup because all of the characters were seen as 1950s humans in Sisko's vision (Nana Visitor, Sisko, Bashir, O'Brien, and Dax shown at left, from left to right).

Which actor got to skip his extensive makeup sessions during the production of this episode?

A. Cirroc Lofton
B. Michael Dorn
C. Colm Meaney
D. Mark Allen Shepherd

898. What was the book used to free the Pah-wraiths?
- **A.** *Pagh'tem'far*
- **B.** *Kosst Amojan*
- **C.** *Duranja*
- **D.** *Ha'mara*

899. Where were the Pah-wraiths imprisoned since their defeat by the Prophets?
- **A.** Shakaar Province
- **B.** Cliffs of Undalar
- **C.** Fire caves
- **D.** Sahving Valley

900. Why did the Founder agree to stand trial?
- **A.** She felt remorse
- **B.** She had been cast out of the Great Link
- **C.** So that Odo would return home and cure their people
- **D.** She would be returned home after serving a commuted sentence

901. How does Chief O'Brien take his coffee?
- **A.** One cream, no sugar
- **B.** Black, double sweet
- **C.** Black
- **D.** Americano-style

902.

903. How much sleep did a Tosk need?
- **A.** 17 minutes
- **B.** 17 hours
- **C.** 17 days
- **D.** 17 weeks

904. What graduate honor did Dr. Bashir achieve at Starfleet Medical Academy?
- **A.** Summa cum laude
- **B.** Valedictorian
- **C.** Salutatorian
- **D.** Magna cum laude

905. In "The Nagus," who did Nog claim stole his homework because they have "no ethics"?
- **A.** Orions
- **B.** Changelings
- **C.** Vulcans
- **D.** Breen

906. What summoned the Dal'Rok each year?
- **A.** Chief O'Brien
- **B.** Sirah
- **C.** Prophets
- **D.** Kai Opaka

907. What did Jake and Nog trade for seven tessipates of land on Bajor?

A. 100 gross of self-sealing stem bolts
B. Cardassian *yamok* sauce
C. Bajoran kilns
D. Dabo tables

908. What *Family Affair* actor portrayed the stubborn Bajoran Mullibok in "Progress"?

A. Sebastian Cabot
B. Brian Keith
C. Johnny Whitaker
D. John Williams

909. What alloy is typically used to construct *bat'leths*?

A. Duranium
B. Boridium
C. Baakonite
D. Rodinium

910. How many vedeks are there?

A. 112
B. 100
C. 56
D. 12

911. What Tony Award–winning actor played Minister Jaro Essa?

A. Jason Alexander
B. Frank Langella
C. Kevin Kline
D. Michael Crawford

912. What was the first episode to feature the future leader of Cardassia, Damar?

A. "Paradise Lost"
B. "Return to Grace"
C. "Home Front"
D. "Indiscretion"

913. Who was the young Cardassian adopted by Bajorans in the episode "Cardassians"?

A. Pa'Dar
B. Proka
C. Asha
D. Rugel

914. What low-gravity world was Melora from?

A. Elaysia
B. Clarus III
C. Altair IV
D. Amleth Prime

915.

From the beginning of the *Star Trek* series, creator Gene Roddenberry was insistent that the human characters be unerringly good and always do the right thing. He even wrote it into the production notes during the concepting of *The Next Generation*—that humans are better in the twenty-fourth century and do not come into conflict with each other over petty emotions. Some writers remarked after Roddenberry's death that they felt this hampered their ability to create dramatic interpersonal stories.

As the episode "In the Pale Moonlight" opened, Captain Sisko (shown at right with Garek, right) was shown recording a private log entry. Over the course of the episode, viewers saw that Sisko had knowingly sacrificed his Starfleet ideals and principles for the greater good—covering for Garak in the hope that it would bring the Romulans over to their side in the Dominion War. "Moonlight" became one of the most controversial *Star Trek: Deep Space Nine* episodes as a result.

What did Sisko cover up for Garak?

A. His role in leaking information
B. His sabotage of a Starfleet vessel
C. That he killed a Romulan senator who threatened to expose them
D. That he let Vulcan officers die

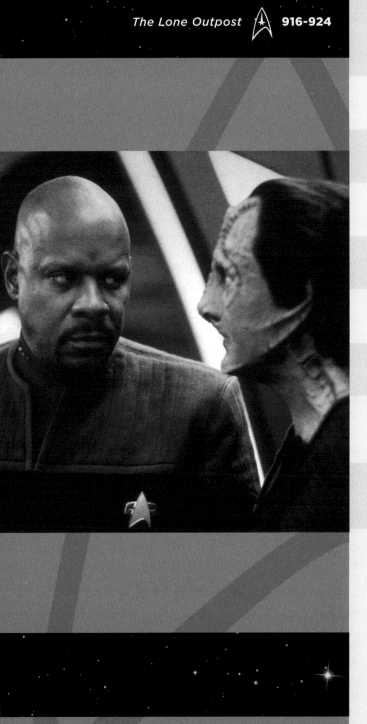

916. Who said, "I believe in coincidences. Coincidences happen every day. But I don't trust coincidences"?

A. Sisko C. Dukat
B. Garak D. Kai Winn

917. Who was the Grand Nagus's imposing yet silent bodyguard?

A. Maihar'du C. Mr. Homm
B. Pel D. Brunt

918. What race was the Grand Nagus's taciturn bodyguard?

A. Ferengi C. Dopterian
B. Hupyrian D. Breen

919. Who exposed Pel's secret in the episode "Rules of Acquisition"?

A. Zek C. Rom
B. Brunt D. Odo

920. What did the Skrreeans call their fabled home world?

A. Bajor C. Halana
B. Kentanna D. T'lani III

921. Which *Star Trek* actor's son portrayed a Skrreean male?

A. Walter Koenig C. James Doohan
B. Leonard Nimoy D. William Shatner

922. What film and TV actor played Quark's rival, Martus?

A. Johnny Depp C. Chris Sarandon
B. Brad Dourif D. Wallace Shawn

923. Which *Next Generation* character's wayward son did the producers originally want the El-Aurian con artist Martus to be?

A. Dr. Crusher C. Worf
B. Picard D. Guinan

924. Over the years, how many Trill host candidates had Curzon Dax rejected for the Symbiosis Committee?

A. 57 C. 210
B. 110 D. 347

925. Denise Crosby, Tasha Yar from *The Next Generation*, was Bing Crosby's granddaughter and the niece of which *Deep Space Nine* guest star?

A. K Callan
B. Mary Crosby
C. Vanessa Williams
D. Louise Fletcher

926. Which Academy Award–winning actress portrayed Kai Winn Adami?

A. Shelley Winters
B. Ellen Burstyn
C. Louise Fletcher
D. Faye Dunaway

927. Who was the Gallamite ship captain Jadzia had a brief affair with?

A. Boday
B. Parn
C. Gurard
D. Arjin

928. What was Dr. Bashir's middle name?

A. Siddig
B. Amsha
C. Ismael
D. Subatoi

929. What was Number 14 in the mirror universe Odo's "Rules of Obedience"?

A. "No resting during work"
B. "No joking"
C. "No congregating"
D. "No religion"

930. What mental abilities did the Vorta named Eris seem to possess?

A. Telepathy
B. Telekinesis
C. Empathy
D. Clairvoyance

931. Who was the captain of the *U.S.S. Odyssey*?

A. Captain Yates
B. Captain Riker
C. Captain Keogh
D. Captain Worf

932.

933. Which leader of the Cardassian dissident movement believed Kira was his daughter?

A. Tekeny Ghemor
B. Damar
C. Tavor Kell
D. Kotan Pa'Dar

932.

In an interview, writer Ron Moore stated he'd wanted to marry Worf and Troi on *The Next Generation*, so when the opportunity for a wedding on *Deep Space Nine* opened up, he jumped at the chance to assume writing duties for "You Are Cordially Invited …"

Weddings are often plagued with crises in the *Star Trek* universe, and newly engaged Worf and Jadzia Dax (shown at right) seemed to be headed down the same road. However, the problem they faced wasn't the Dominion, the Romulans, or even Tribbles—it was Sirella, head of Worf's adopted House. Effectively becoming Dax's Klingon mother-in-law, the strong-willed character clashed with the proud Dax, in a fight that escalated until it looked as though there would be no wedding.

What treaty had Curzon Dax, the prior host of the symbiant, negotiated that made Jadzia so unwilling to grovel before Sirella?

A. Axanar Treaty
B. Khitomer Accords
C. Tau Ceti Treaty
D. Dominion Surrender

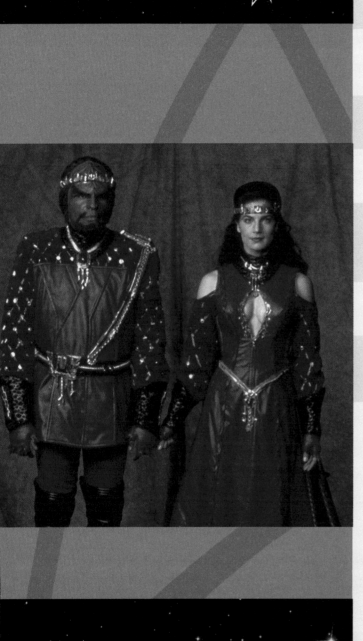

934. In which episode did Vedek Bareil die?

A. "Heart of Stone" C. "Life Support"
B. "Civil Defense" D. "Visionary"

935. Who was the thrice-mentioned but never-seen male ensign whose species gave birth by budding?

A. Morn C. Selar
B. Latara D. Vilix'pran

936. What aquatic sport does O'Brien enjoy in the holosuite?

A. Surfing C. Kayaking
B. Swimming D. Rafting

937. What were the "three vipers" from Trako's Third Prophecy?

A. Comet fragments C. Dominion races
B. Cardassians D. Federation ships

938. Under the influence of the Prophets, what did Zek change the first Rule of Acquisition to read?

A. "Latinum tarnishes, but family C. "If they want their money back,
is forever" give it to them"
B. "Greed is dead" D. "A good deed is its own reward"

939. Which Romulan turned out to be a Changeling?

A. T'Rul C. Merrok
B. Movar D. Lovok

940. What is the Trill ritual that allows a current host to meet telepathic projections of prior hosts?

A. Rite of Emergence C. The Gathering
B. zhian'tara D. Facets

941. In which episode did Sisko receive a promotion to Captain?

- **A.** "The Search"
- **B.** "Destiny"
- **C.** "The Adversary"
- **D.** "The Way of the Warrior"

942. Where was Worf immediately before coming to Deep Space 9?

- **A.** Boreth
- **B.** Son'a
- **C.** Borg Cube
- **D.** Remus

943. Why did the Klingon Empire withdraw from the Khitomer Accords?

- **A.** Sisko attacked Gowron
- **B.** Martok was a Changeling
- **C.** Worf's family was no longer in power
- **D.** Federation condemned their invasion of Cardassia

944. What actor played Worf's brother?

- **A.** Robert O'Reilly
- **B.** Tony Todd
- **C.** J. G. Hertzler
- **D.** Jeffrey Combs

945. How many actresses portrayed Tora Ziyal?

- **A.** Three
- **B.** Four
- **C.** Five
- **D.** Six

946. Which Dax host had been married to Lenara Khan?

- **A.** Curzon
- **B.** Torias
- **C.** Jadzia
- **D.** Emony

947. Who attempted a military coup of Starfleet during the threat of a Changeling invasion?

- **A.** Admiral Nechayev
- **B.** Admiral Leyton
- **C.** Captain Benteen
- **D.** Admiral Ross

948.

948.

The *Deep Space Nine* crew often complained that Morn (shown at right), the near-permanent resident of Quark's bar, talked too much, but viewers never heard a peep from the alien.

In "Who Mourns for Morn?" news broke that Morn had died in an ion storm. And when a few former "business associates" came on board claiming Morn had stolen latinum from a famous heist, viewers and crew alike realized there was far more to Morn than had met the eye.

Appearing in over eighty *Deep Space Nine* episodes, actor Mark Shepherd also played Morn in the pilot of *Voyager* and which episode of *The Next Generation*?

- **A.** "Starship Mine"
- **B.** "Genesis"
- **C.** "Birthright, Part II"
- **D.** "Ensign Ro"

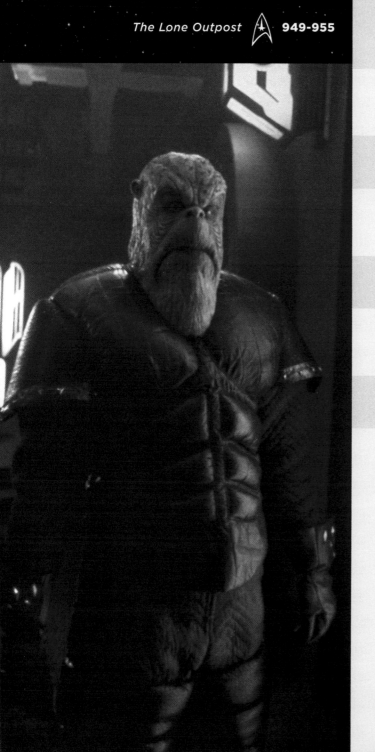

949. Which star of the TV show *Wings* played Colonel Day in "The Siege"?

A. Timothy Daly
C. Tony Shalhoub
B. Steven Weber
D. Thomas Haden Church

950. Who was the cellmate O'Brien "killed" during the twenty years of false memories implanted in him in "Hard Time"?

A. Ee'Char
C. Muniz
B. Bashir
D. Garak

951. Who was the Regent of the Alliance in the mirror universe?

A. Worf
C. Dax
B. Garak
D. Kira

952. Which episode featured Majel-Barrett Roddenberry's final on-screen *Star Trek* appearance?

A. "The Muse"
C. "Shattered Mirror"
B. "For the Cause"
D. "Body Parts"

953. In "The Quickening," what disease was Dr. Bashir unable to cure?

A. Teplan blight
C. Ketracel addiction
B. Dorek syndrome
D. Founders disease

954. What was the name of Dr. Bashir's childhood teddy bear and "first patient"?

A. Kukalaka
C. Moogie
B. Spot
D. Morn

955. What was Kasidy Yates accused of in "For the Cause"?

A. Smuggling
C. Spying
B. Collaborating with the Maquis
D. Stealing

956. As a solid, what was Odo's blood type?

A. O-negative
B. O-positive
C. A-negative
D. A-positive

957. What actor from the 1970s series *The Mod Squad* portrayed Jem'Hadar First Omet'iklan in "To the Death"?

A. Tige Andrews
B. Clarence Williams III
C. Michael Cole
D. Peggy Lipton

958. Which two cast members had a child and were married during the run of *Deep Space Nine*?

A. Avery Brooks & Terry Farrell
B. Colm Meany & Chase Masterson
C. Nana Visitor & Alexander Siddig
D. Penny Johnson & Michael Dorn

959. Which *Deep Space Nine* cast member's uncle is Malcolm McDowell?

A. Alexander Siddig
B. Colm Meany
C. Aron Eisenberg
D. Rene Auberjonois

960. What form of radiation is deadly to the wormhole aliens?

A. Eichner
B. Omicron
C. Pyritic
D. Chroniton

961. Why did the producers change the name of the Koss'moran to Kosst Amojan?

A. They didn't like the sound of it
B. The actors couldn't pronounce it
C. It meant something in another language
D. It was supposed to be a new character's name instead

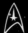

964.

The threats to Deep Space 9 increased as the Dominion War raged and an ancient war reignited. Sisko's constant Cardassian nemesis, Gul Dukat, found an ironic new path to power through the noncorporeal Pah-wraiths, enemies of the Bajoran Prophets.

The release of the first Pah-wraith collapsed the Alpha Quadrant entrance to the wormhole, changing the game for both the Federation and the Dominion forces. But the most personal loss came on board the station. Actress Terry Farrell (shown at left) was leaving the show, and to give the Jadzia character as big a sendoff as possible, she died at the hands of the Dukat Pah-wraith. Jadzia's symbiont, Dax, of course, would return in the next season in a new host.

Farrell went on to star in what CBS sitcom with Ted Danson?

A. *Wings*
B. *Cheers*
C. *Becker*
D. *It Must Be Love*

962. Temporal investigators Lucsly and Dulmur's names are anagrams for another pair of investigators from which 1990s hit show?

A. *Twin Peaks*
B. *NYPD Blue*
C. *Nash Bridges*
D. *The X-Files*

963. Why did Worf always practice restraint when living among humans?

A. He thought they were fragile
B. Klingons are always restrained
C. He accidentally killed one as a teen
D. His parents taught him

964.

965. What was the first episode of *Deep Space Nine* to feature the *Star Trek: First Contact*–style uniforms?

A. "For the Uniform"
B. "The Ascent"
C. "Things Past"
D. "Rapture"

966. Who guest-starred as the creator of his *Voyager* holographic character in "Doctor Bashir, I Presume?"

A. Ethan Phillips
B. Robert Picardo
C. Tim Russ
D. Robert Duncan MacNeill

967. Who seemed best able to keep Miles and Keiko's infant son from crying?

A. Rom
B. Worf
C. Jake Sisko
D. Leeta

968. In "Ties of Blood and Water," Weyoun revealed the Vorta are immune to most forms of what?

A. Radiation
B. Biogenic weapons
C. Poison
D. Bacteria

969. Where did Kira bury the Cardassian Tekeny Ghemor?

 A. Next to her father on Bajor
 B. On the station
 C. On Cardassia Prime
 D. In the wormhole

970. Why did the writers invent the premise of the Vorta being a clone race?

 A. To bring actor Jeffrey Combs back
 B. To save on hiring different actors
 C. To save on makeup costs
 D. To fix a continuity mistake from season two

971. What is the Ferengi equivalent of a prenuptial agreement?

 A. Ferengi Fund Release
 B. Wedding Protection Papers
 C. Bridal Noninterference Pact
 D. Waiver of Property & Profit

972. What were Jake and Nog trying to acquire to cheer up Captain Sisko during "In the Cards"?

 A. Willie Mays baseball card
 B. Pet Cardassian vole
 C. St. Louis Cardinals holoprogram
 D. Solar ship map of Bajoran system

973. What episode showed Rom and Leeta's marriage?

 A. "In the Cards"
 B. "Ferengi Love Songs"
 C. "Ties of Blood and Water"
 D. "Call to Arms"

974. Who did Jake begin working for in "Call to Arms"?

 A. Bajoran Medical Unit
 B. Starfleet Corps of Engineers
 C. His father
 D. Federation News Network

975. Which episode was *not* part of season six's six-part opening story arc?

 A. "A Time to Stand"
 B. "Sons and Daughters"
 C. "Rocks and Shoals"
 D. "You Are Cordially Invited ..."

976.

976.

Just as Sisko's actions in "In the Pale Moonlight" hinted at the darker sides of Starfleet and the Federation, Dr. Bashir's involvement with the shadowy covert group Section 31 showed that even in a utopian future, there are dirty jobs that need to get done.

In the episode "Inter Arma Enim Silent Leges," Bashir was sent on a mission to Romulus and fell victim to his own ethics. In attempting to make the Romulan Senate believe him, he unwittingly forced his sole Romulan ally (Cretak, shown at right) into a compromising position. Her downfall ensured that a Federation mole was left in a secure position high within the Romulan government—the true goal of Section 31 all along.

Who was the second person to portray the Romulan senator whose political career Bashir accidentally destroys?

 A. Joanna Cassidy
 B. Adrienne Barbeau
 C. Megan Cole
 D. Suzie Plakson

977. Which vedek's suicide prompted Kira to form a resistance cell during the second Cardassian occupation of Deep Space 9?

A. Bareil
B. Shakaar
C. Yassim
D. Winn

978. What is the name of Martok's wife?

A. Grilka
B. Doran
C. Sirella
D. B'Etor

979. Why did the mirror universe Bareil come to Deep Space 9?

A. To switch Kira with the Intendant
B. To steal an Orb
C. To escape the Intendant
D. Transporter accident

980. Which *Happy Days* actor directed two episodes of *Deep Space Nine*?

A. Ron Howard
B. Donny Most
C. Anson Williams
D. Henry Winkler

981. Which punk rock legend guest-starred as Yelgrun in "The Magnificent Ferengi"?

A. Lou Reed
B. Iggy Pop
C. Debbie Harry
D. Sid Vicious

982. Where does Morn store his secret supply of liquid latinum?

A. His second stomach
B. A glass at Quark's
C. Bank of Bolias
D. Behind the matador painting

983. What shrank the *U.S.S. Rubicon*?

A. Spiroid Epsilon waves
B. Subspace compression anomaly
C. Pym particles
D. Reduction disruptors

984. What matte painting of a planet from the original series *Star Trek* was used as a cover of the *Incredible Tales* magazine in "Far Beyond the Stars"?

A. Delta Vega
B. Eminiar VII
C. Starbase 11
D. Janus VI

985. What was Jadzia taking to increase her chances of pregnancy with Worf?

- **A.** Raktajino herbs
- **B.** Klingon fertilization pills
- **C.** Ovarian resequencing enzymes
- **D.** Nanite suspension formula

986. What ship was Ezri Dax stationed on before coming to Deep Space 9?

- **A.** *U.S.S. Destiny*
- **B.** *U.S.S. Wyoming*
- **C.** *U.S.S. Victory*
- **D.** *U.S.S. Tecumseh*

987. Why did Worf ask Martok to undertake the dangerous mission to the Monac shipyards?

- **A.** To ensure Jadzia's spirit enters Sto-vo-kor
- **B.** To restore his family's name
- **C.** To save Jadzia's life
- **D.** To make his son a warrior

988. What Romulan senator was stationed on Deep Space 9 during "Image in the Sand"?

- **A.** Tal'aura
- **B.** Letant
- **C.** Cretak
- **D.** Vreenak

989. What was the name of the Vulcan baseball team Sisko was determined to defeat?

- **A.** Sehlats
- **B.** Logicians
- **C.** Plomeeks
- **D.** Fascinators

990.

991. Who was the genetically engineered savant Bashir fell in love with?

- **A.** Lauren
- **B.** Sarina
- **C.** Laas
- **D.** Sirella

992. How did Kor enter *Sto-vo-kor*?

- **A.** Defeating a Changeling in battle
- **B.** Engaging a Jem'Hadar squadron single-handedly
- **C.** Commanding the *I.K.S. Rotarran*
- **D.** Fighting Dax

990.

Over the course of the last four seasons of *Deep Space Nine*, the war between the Federation and the Dominion sparked, ignited, and raged. Alliances shifted, relationships changed, and whole worlds were ruined by the war. Some characters died, some characters were reassigned, and one in particular would meet his destiny after seven years of prophecy.

The two-hour series finale of *Deep Space Nine*, "What You Leave Behind," aired in June 1999. While the Deep Space 9 crew would see victory on the war front, they would also suffer loss. The finale brought back most of the recurring characters from the seven-year run of the show, and just as the party had started at Vic Fontaine's holosuite casino and lounge (featuring cameos from most of the *Deep Space Nine* writing and production staff), Sisko was called by the Prophets to finish "walking the path" he'd begun seven years earlier. Sisko fought his nemesis, Gul Dukat (shown at right), and defeated the Pah-wraith possessing Dukat.

What then became of the captain?

- **A.** He died
- **B.** He joined the Prophets outside of linear time
- **C.** He joined the Pah-wraiths
- **D.** He returned to Deep Space 9 in an alternate time line

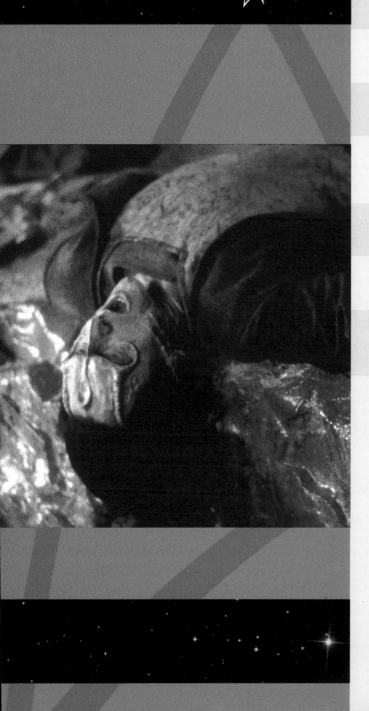

993. Which *Leave It to Beaver* actor directed "Field of Fire"?

A. Jerry Mathers C. Ken Osmond
B. Hugh Beaumont D. Tony Dow

994. What was the first place attacked by the Dominion-Breen alliance?

A. Deep Space 9 C. Earth
B. Bajor D. Betazed

995. Who engineered the disease to exterminate the Founders?

A. Section 31 C. Dr. Bashir
B. The Vorta D. Cardassians

996. How did Bashir find a cure for the disease killing Odo?

A. Blackmailed the engineer C. Tortured an operative
B. Threatened to contact the Founders D. Entered an operative's mind

997. Who became Grand Nagus after Zek retired?

A. Brunt C. Quark
B. Nog D. Rom

998. Who assumed control of Deep Space 9 at the end of the series?

A. Worf C. Odo
B. Colonel Kira D. Kai Winn

999. Who became Federation Ambassador to the Klingon Empire at the end of the series?

A. Sisko C. Quark
B. Dax D. Worf

1000. What did Chief O'Brien find on the floor of his quarters as he packed to leave?

A. His combadge from his *U.S.S. Enterprise* days C. His lucky dart
B. The model figure of Travis from the Alamo D. Kirayoshi's rattle

CHAPTER 4

A LONG WAY FROM HOME

STAR TREK: VOYAGER

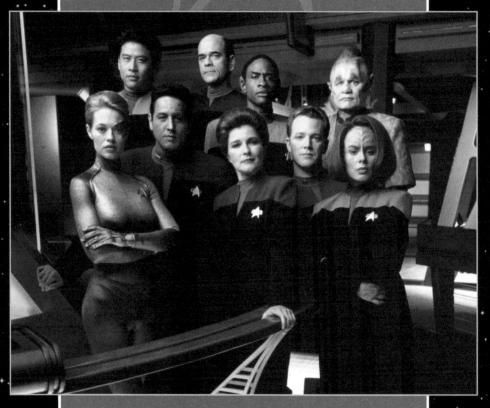

1001. What class of ship is the *U.S.S. Voyager*?

A. *Galaxy* class
B. *Nova* class
C. *Excelsior* class
D. *Intrepid* class

1002. What was the entity that displaced the *U.S.S. Voyager* into the Delta Quadrant?

A. Suspiria
B. Caretaker
C. Q
D. Kes

1003. What was Captain Janeway's preferred beverage?

A. Tea
B. Romulan ale
C. Coffee
D. Raktajino

1004. What position did Tuvok hold aboard the *U.S.S. Voyager*?

A. Tactical
B. Helm
C. Ops
D. First officer

1005. Who was the leader of the Maquis cell that joined the *U.S.S. Voyager* crew in the Delta Quadrant?

A. Seska
B. Chakotay
C. Torres
D. Carey

1006. What did the Emergency Medical Holographic Program say whenever activated?

A. "I'm a doctor, not a counselor"
B. "I am programmed with the knowledge of five million surgical treatments"
C. "Please describe all pertinent symptoms"
D. "Please state the nature of the medical emergency"

1007. What was the Emergency Medical Holographic Program's name?

A. Shmullus
B. Lewis
C. Crusher
D. Joe

LEFT The crew of *Voyager*.

1008. Who assisted the Emergency Medical Holographic Program in sick bay during the first years in the Delta Quadrant?

A. Paris

B. Kes

C. Harry Kim

D. Ensign Wildman

1009. What race is Neelix's girlfriend, Kes?

A. Talaxian

B. Vidiian

C. Kazon

D. Ocampan

1010. How long did the average Ocampan live?

A. Five years

B. Six years

C. Nine years

D. Ten years

1011. What planet was Neelix born on?

A. Rinax

B. Talax

C. Ocampa

D. The Array world

1012. Who was Neelix in love with for several years?

A. Kes

B. Torres

C. Janeway

D. Seven of Nine

1013. At the beginning of "Caretaker," who was serving time in a Federation penal colony for being a member of the Maquis?

A. Chakotay

B. Hogan

C. Tom Paris

D. Seska

1014. Who was Janeway's commanding officer aboard the *U.S.S. Al-Batani*?

A. Tuvok's wife

B. Captain Sulu

C. Torres's father

D. Paris's father

1015.

1016. How long did it take *U.S.S. Voyager* to get home?

A. 23 years

B. 7 years

C. 5 years

D. It didn't

1017. What musical instrument does Ensign Kim play?

A. Oboe

B. Trombone

C. Clarinet

D. Guitar

1015.

As Paramount launched the UPN network in 1995, it was only natural to use one of its premier properties, the *Star Trek* franchise, to headline the infant network. Thus, even as *Deep Space Nine* was hitting its stride, *Star Trek: Voyager* was born. The premise of this show was different from others in the franchise: *Voyager*'s exploration was to find its way home.

Deep Space Nine featured the first female lead in a *Star Trek* show, though female captains and admirals had been seen earlier. Captain Kathryn Janeway, played by Kate Mulgrew, would face a challenge: to consolidate two disparate crews as they began their trek back to the Alpha Quadrant.

In the pilot episode, the ship was swept into the Delta Quadrant by a powerful but dying alien called the Caretaker (shown at right with Janeway and crew, left). Janeway chose not to take the opportunity to get her ship home, in order to save the Ocampa people.

How far from home did the Caretaker bring the *U.S.S. Voyager*?

A. 20,000 light years

B. 70,000 light years

C. 100,000 light years

D. 200,000 light years

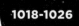

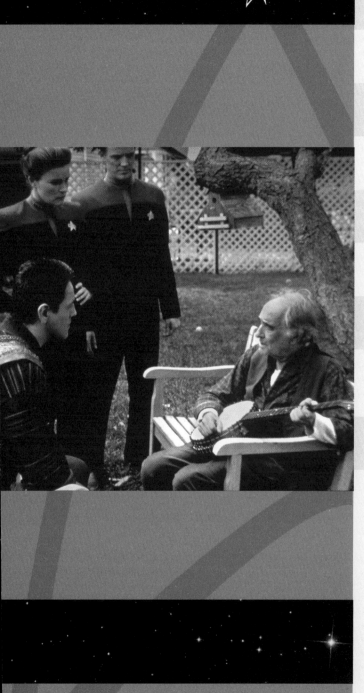

1018. What race is B'Elanna Torres's mother?

A. Klingon C. Bolian

B. Ktarian D. Bajoran

1019. Which cast member left the show during season four?

A. Garrett Wang C. Ethan Phillips

B. Tim Russ D. Jennifer Lien

1020. What actress joined the crew as the Borg drone Seven of Nine?

A. Alce Krige C. Susannah Thompson

B. Jeri Ryan D. Suzi Plakson

1021. What race did the traitorous Seska belong to?

A. Bajoran C. Cardassian

B. Human D. Kazon

1022. What sect of the violent Kazon race did Seska make an alliance with?

A. Nistram C. Halik

B. Ogla D. Relora

1023. In the episode "Basics," who played Seska?

A. Denise Crosby C. Penny Johnson

B. Chase Masterson D. Martha Hackett

1024. Who was Janeway's fiancé at the beginning of the series?

A. Owen Paris C. Michael Sullivan

B. Mark Johnson D. Jaffen

1025. What was the holodeck French bistro where the crew members relaxed and shot pool?

A. Sandrine's C. Ricky's

B. Bebe's D. Casablanca

1026. According to Dr. Chaotica, how many dimensions were there?

A. Eight C. Six

B. Seven D. Five

1027. Which historical inventor did Janeway often visit in the holodeck?

A. Thomas Edison
B. Ben Franklin
C. Leonardo da Vinci
D. Isaac Newton

1028. Who became chief engineer in the episode "Parallax"?

A. Hogan
B. Carey
C. Torres
D. Chakotay

1029. Where was the Doctor's programmer stationed?

A. Jupiter Station
B. Starfleet medical
C. Deep Space 9
D. Daystrom Institute

1030. What advanced data processing circuitry did the *U.S.S. Voyager* boast?

A. Holographic artificial intelligence
B. Bioneural gel packs
C. Nanite processing
D. Quantum level

1031. Who became the cook aboard *Voyager*?

A. Paris
B. Ensign Wildman
C. Kes
D. Neelix

1032. Who were the organ-harvesting aliens suffering from the Phage disease?

A. Species 8472
B. Hirogen
C. Vidiians
D. Sikarians

1033. Whose DNA was resistant to the Phage?

A. Ktarians
B. Klingons
C. Bolians
D. Human

1034. Who was the famous aviator encountered in the Delta Quadrant?

A. Amelia Earhart
B. Charles Lindbergh
C. Neil Armstrong
D. Red Baron

1035. What episode showed Kes's latent mental abilities expand while encountering an Ocampan colony?

A. "Parturition"
B. "Learning Curve"
C. "Cold Fire"
D. "Resistance"

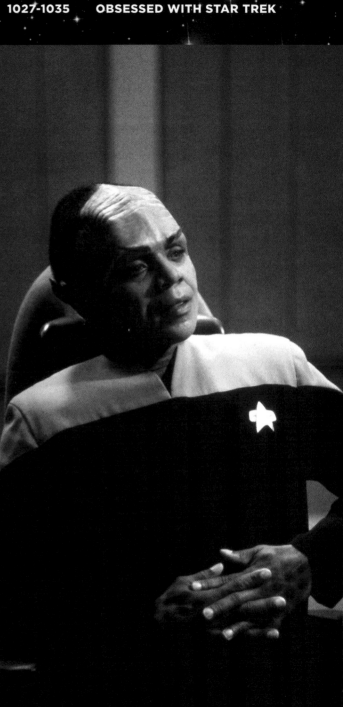

1036. Whom does Q bring to the Delta Quadrant briefly, to testify at Quinn's hearing?

- **A.** Captain Picard
- **B.** Vash
- **C.** Quark
- **D.** Commander Riker

1037. What infamously made Paris and Janeway evolve into reptilian beings?

- **A.** A Vidiian drug
- **B.** Achieving Warp 10
- **C.** Inhaling trigemic vapors
- **D.** Q

1038. Who died and was replaced from a duplicated *Voyager* in "Deadlock"?

- **A.** Chakotay
- **B.** Harry Kim
- **C.** Samantha Wildman
- **D.** Kes

1039.

Throughout the run of the various *Star Trek* series, the transporter was to blame for a long list of unwanted side effects—some of them even fatal. But it was an interesting twist on the original series *Star Trek* episode "The Enemy Within" that brought *Voyager* one of its most thought-provoking episodes on what constitutes an individual's rights.

In the original series, Captain Kirk was split into two versions of himself (one good, one evil) whereas in "Tuvix," the transporter combined two people into one, merging the unlikely pair of Tuvok and Neelix. The Tuvix character (shown at left) quickly integrated himself among the *Voyager* crew over the next month.

The crew's initial race to find a way to safely reverse the process gave way to uncertainty: Was Tuvix an individual with rights? Would splitting him be akin to murder?

Ultimately, after finding a way to de-integrate the fused Tuvix, the Doctor refused to perform the procedure, saying his ethical programming would not allow him to operate on the unwilling Tuvix.

Who actually performed the procedure?

- **A.** Captain Janeway
- **B.** The Doctor
- **C.** Paris
- **D.** Tuvix

1040. Who was Tuvok's cabinmate during his time serving aboard the *U.S.S. Excelsior*?

- **A.** T'Pel
- **B.** Chakotay
- **C.** Kathryn Janeway
- **D.** Dmitri Valtane

1041. What caused Torres to enter *Pon farr*?

- **A.** Accidental telepathic bond with Vorik
- **B.** Her Klingon ancestry
- **C.** Mind-meld gone wrong
- **D.** Mating with Vorik

1042. What did Janeway offer the Borg in exchange for passage through their space?

- **A.** To assimilate her
- **B.** Methods of fighting Species 8472
- **C.** Variable warp technology
- **D.** Bioneural gel-packs

1043. Which episode featured the first appearance of Seven of Nine?

- **A.** "Nemesis"
- **B.** "Scorpion, Part II"
- **C.** "Unity"
- **D.** "Day of Honor"

1044. Which *Voyager* crew member contacted Starfleet in the episode "Message in a Bottle"?

- **A.** Paris
- **B.** Seven of Nine
- **C.** Janeway
- **D.** The Doctor

1045. How did the Hirogen species break down the bones and muscle tissue of their prey?

A. Enzymes
B. Teeth
C. Tetryon emitters
D. Osteotomy

1046. What was the primary threat posed by an Omega molecule?

A. Destruction of planets
B. Destruction of all organic matter in a quadrant
C. Destruction of subspace
D. Merged dimensions

1047. What type of propulsion did the *U.S.S. Dauntless* possess?

A. Transwarp
B. Quantum slipstream drive
C. Spatial folding
D. Transpectral drive

1048. What did the crew call the newly created Borg in "Drone"?

A. Three of Seven
B. Hugh
C. Drone
D. One

1049. What was the name of the advanced shuttle Paris designed?

A. *Sandrine's Kiss*
B. *Delta Flyer*
C. *Raven*
D. *Proton Burst*

1050.

1051. What Starfleet figure's appearance was taken "In the Flesh" by Species 8472?

A. Admiral Nechayev
B. Ambassador Spock
C. Boothby
D. Wesley Crusher

1052. What pair of biomimetic alien crew members exchanged vows in "Course: Oblivion," with the original officers following suit in "Drive"?

A. Paris and Torres
B. Seven and Chakotay
C. Kim and Megan
D. Neelix and Kes

1053. What *Seinfeld* actor portrayed Kurros in "Think Tank"?

A. Julia Louis-Dreyfus
B. Jason Alexander
C. Jerry Seinfeld
D. Michael Richards

1054. What class of ship is the *U.S.S. Equinox*?

A. *Nova* class
B. *Oberth* class
C. *Intrepid* class
D. *Defiant* class

1050.

In *Star Trek*, holonovels competed with regular books for crew member recreation. Science fiction came full circle with Tom Paris's series of holonovel programs, *The Adventures of Captain Proton!*

Inspired by his love of black-and-white B-movie science fiction serials from the 1930s, he wrote numerous chapters featuring his alter ego, Captain Proton. Crew members taking part in the program would appear in black-and-white (as holodeck technology apparently has no problem deleting the color from living beings).

In the episode "Bride of Chaotica!" when Paris and Harry Kim re-enacted Chapter 18 (titled appropriately "The Bride of Chaotica"), they realized something was wrong when a heroine was killed. Photonic life-forms had confused the holonovel with reality, and the crew had to play along to defeat them. Even Captain Janeway (shown at right) got into the act as the titular bride, whose pheromones were irresistible to all men.

Donning an appropriately spidery outfit, what role did the captain take on?

A. Arachnia
B. Dr. Chaotica
C. Satan's Robot
D. Lonzak

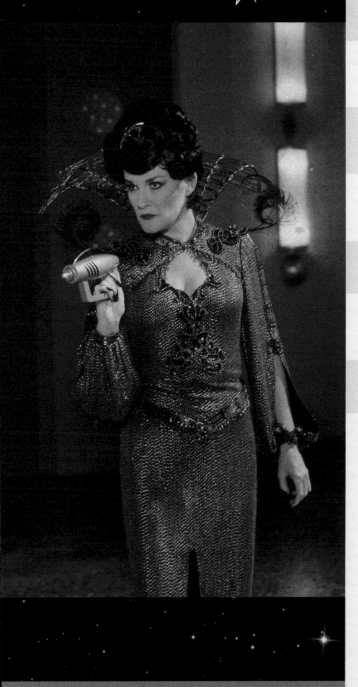

1055. Which members of Seven's Borg unimatrix stayed on board *Voyager* after being freed?

A. None C. Two of Nine
B. One of Nine D. Three of Nine

1056. What actor and WWE wrestling superstar appeared in the combative episode "Tsunkatse"?

A. Shawn Michaels C. The Undertaker
B. The Rock D. John Cena

1057. Which former crew member came back to the ship in a "Fury," attempting to travel back in time?

A. Suder C. Kes
B. Lt. Carey D. Seska

1058. What was the current version of the Emergency Medical Hologram program by the time of "Life Line"?

A. Mark-1 C. Mark-5
B. Mark-4 D. Mark-6

1059. Who was responsible for creating the Emergency Medical Hologram?

A. Reginald Barclay C. Lewis Zimmerman
B. Geordi La Forge D. Jadzia Dax

1060. What is the name of the virtual construct that only one in a million Borg drones can access and use to become individuals?

A. One of One C. Non-Collective
B. Omega Zone D. Unimatrix Zero

1061. What game did Neelix and Seven of Nine often play?

A. *Kadis-kot* C. *Kal-tot*
B. Parrises squares D. 3-D chess

1062. What species kidnapped the crew as a "Workforce"?

A. Imhotep C. Quarren
B. Antarian D. Terrelians

1063. Who were the aliens who conquered the Kazon home world?

- A. Species 8472
- B. Borg
- C. Vidiians
- D. Trabe

1064. Why was Q's son going to be banished from the Continuum?

- A. He was too mischievous
- B. He was destroying the fabric of the Continuum
- C. To get revenge on Q
- D. He was half-human

1065. Which crew member remained in the Delta Quadrant?

- A. Tuvok
- B. Seven of Nine
- C. Harry Kim
- D. Neelix

1066. What allowed the *U.S.S. Voyager* crew to return home?

- A. Slipstream drive
- B. Quantum teleport
- C. Borg transwarp conduit
- D. The writers

1067. What was the name of the daily news program started by Neelix in "Investigations"?

- A. Joe Carey
- B. Tom Paris
- C. Samantha Wildman
- D. Hogan

1068.

1069. How many times can an Ocampan woman be fertile?

- A. Never
- B. Once a year
- C. Once in her life
- D. Twice in her life

1070. Which sisters did Tom Paris repeatedly invite on double dates with himself and Harry?

- A. Torres
- B. Delaney
- C. Wildman
- D. Hansen

1068.

The two-part episode "Year of Hell" was originally intended to be season three's cliff-hanger finale but was pushed forward to season four. This explains how Kes, while in temporal flux during the season three episode "Before and After," saw a version of these events.

However, the time line apparently changed when Kes left *Voyager*. This left the crew with little hope of beating a scientist of the Krenim Imperium, Annorax (shown below), who had weaponized time itself.

While traveling through hostile territory, the *U.S.S. Voyager* was repeatedly attacked. By the time a year had passed,

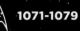
much had happened: the ship had been abandoned by all but the senior staff, Janeway was nearly relieved of command, and numerous crew members had been lost. With Chakotay and Paris kidnapped by Annorax, Janeway came to the inescapable conclusion of what needed to be done to repair history.

What did she have to do?

A. Abandon Chakotay
B. Kill Paris
C. Use the Omega molecule
D. Perform a kamikaze run into the weapon ship

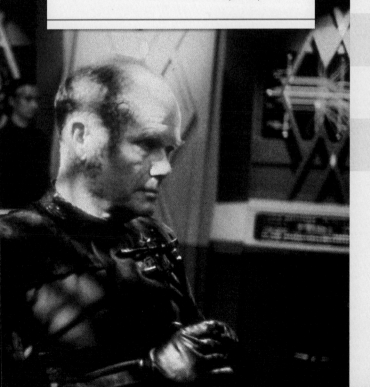

1071. Why couldn't the Romulan Telek R'Mor help *Voyager* in "Eye of the Needle"?

A. He was from twenty years in the past
B. He didn't trust the Federation
C. He was stranded
D. He was in exile

1072. What did the Vhnori call the afterlife?

A. Great Beyond
B. Final Transference
C. Next Emanation
D. Thanatologia

1073. With whom was Seska once romantically involved?

A. Tuvok
B. Paris
C. Carey
D. Chakotay

1074. Which *Deep Space Nine* cast member guest-starred as a young Kazon warrior?

A. Cirroc Lofton
B. Aron Esienberg
C. Alexander Siddig
D. Nana Visitor

1075. How were Neelix's people conquered?

A. Subterfuge
B. Phage
C. DNA weapons
D. Metreon Cascade

1076. While in the Maquis, who was Seska's best friend?

A. Tom Paris
B. B'Elanna Torres
C. Chell
D. Dalby

1077. What is the name of Suspiria's race?

A. Nacene
B. Ocampa
C. Vhnori
D. Talaxian

1078. Who was the traitor helping Seska after she left *Voyager*?

A. Crewman Chell
B. Torres
C. Paris
D. Jonas

1079. What did the news program Neelix created eventually become?

A. "Delta Quadrant Dawn"
B. "From the Bridge"
C. "Good Morning, *Voyager*"
D. "Neelix!"

1080. Which Ferengi set themselves up as gods among the people of the Takar in "False Profits"?

A. DaiMon Goss and Tog
B. Arridor and Kol
C. Quark and Rom
D. Brunt and Pel

1081. Which well-known royal figure had a nonspeaking cameo in "Investigations"?

A. Prince William of England
B. Princess Stephanie of Monaco
C. Queen Noor of Jordan
D. King Abdullah of Jordan

1082. How did Tuvok attempt to help the unstable Lon Suder?

A. Counseling
B. Medical treatments
C. Mind-meld
D. Transporter reprogramming

1083. Who did Seska claim was the father of her child?

A. Chakotay
B. Kim
C. Paris
D. Paxim

1084.

1085. In what episode of *The Next Generation* did the two Ferengi set up as gods in "False Profits" first appear?

A. "Encounter at Farpoint"
B. "Menage a Troi"
C. "The Price"
D. "The Battle"

1086. What *Star Trek* original series crew member served on the *U.S.S. Excelsior* under Captain Sulu?

A. Pavel Chekov
B. Marlena Moreau
C. Kevin Riley
D. Janice Rand

1087. What comedienne played Rain Robinson in "Future's End"?

A. Ellen DeGeneres
B. Sarah Silverman
C. Sarah Bernhardt
D. Roseanne Barr

1088. Which *St. Elsewhere* actor played 1990s computer tycoon Henry Starling?

A. Ed Begley, Jr.
B. Mark Harmon
C. Howie Mandel
D. Denzel Washington

1084.

Ever since the *U.S.S. Voyager* ended up in the Delta Quadrant in its pilot episode, Star Trek fans knew that one day the crew would encounter the Federation's greatest foe—the Borg—who had originated in that Quadrant. What fans couldn't suspect was that *Voyager* would also welcome aboard a Borg crew member: Seven of Nine (shown at right).

Producers felt Kes' arc had run its course, and they looked to find a character who would hold a mirror to humanity the way Spock and Data had done in prior series. The stoic and distant Seven filled that role perfectly. She initially resisted rejoining the human race, but eventually overcame her desire to rejoin the Borg Collective and sided with the *Voyager* team.

What was the name of the ship the Borg had assimilated the young Seven from?

A. *Horizon*
B. *Raven*
C. *Val Jean*
D. *Blackbird*

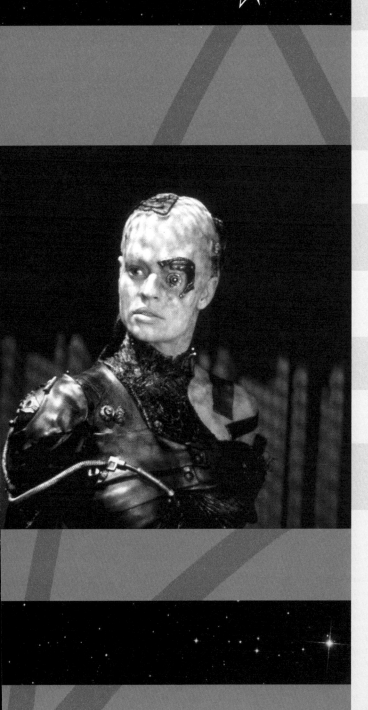

1089. What century was the timeship *Aeon* from?

A. Twenty-fifth C. Twenty-ninth
B. Twenty-seventh D. Thirty-first

1090. What caused the civil war in the Q Continuum?

A. The female Q's jealousy C. Q wanting to preserve the status quo
B. Quinn's suicide D. Q's loss of ultimate power

1091. Who became the godmother of Q's son?

A. Kes C. Seven of Nine
B. Torres D. Janeway

1092. What region of space contained a planet with a group of ex-Borg?

A. The Void C. Vidiian Sodality
B. Nekrit Expanse D. Chaotic space

1093. What was Seven of Nine's function in the Collective?

A. Speaker of the Collective C. Transwarp operations drone
B. Astrometrics coordinator D. Tertiary adjunct of Unamatriz Zero One

1094. What was the purpose of the Klingon Day of Honor?

A. Celebrate Kahless's deeds and emulate them C. Evaluate one's deeds for the year
B. Fast for a day D. Renew mating vows

1095. What was Seven of Nine's human name?

A. Riley Frazier C. Joan Hallicet
B. Kim Kellener D. Annika Hansen

1096. What was the name of the ship Seven's parents were on?

A. *Raven* C. *Crow*
B. *Exeter* D. *Poe*

1097. Which popular comedian played the Emergency Medical Hologram Mark II?

A. Andy Dick C. Conan O'Brien
B. Joe Rogan D. David Cross

1098. What did Seven do in "Prey" that consequently had her duties on *Voyager* restricted?

A. Started a mutiny

B. Beamed her enemy to a Hirogen ship

C. Disobeyed orders from Chakotay

D. Contacted the Borg

1099. What type of ore was needed to create an Omega molecule?

A. Iridium

B. Arcybite

C. Miszinite

D. Boronite

1100. What did the Silver Blood crave from *Voyager* in "Demon"?

A. DNA samples to mimic sentience

B. Souls

C. Deuterium

D. Music

1101. In "One," who was in command while the majority of the crew was in stasis during a trip through a dangerous nebula?

A. Paris

B. Seven

C. Kim

D. The Doctor

1102.

1103. What created a twenty-ninth-century Borg drone?

A. Malon technology

B. The proto-nebula's effect on Seven

C. Fusion of Seven's nanoprobes and Emergency Medical Hologram's mobile emitter

D. The Borg queen

1104. What kind of shielding does the *Delta Flyer* employ?

A. Unimatrix

B. Adaptive

C. Transphasic

D. Ablative

1105. Who was Naomi Wildman's favorite holodeck character?

A. Flotter

B. Captain Proton

C. Leonardo da Vinci

D. The Doctor

1106. What ship did Geordi La Forge captain in the future shown in "Timeless"?

A. U.S.S. Equinox

B. U.S.S. Enterprise-G

C. U.S.S. Challenger

D. U.S.S. Billings

1102.

The Hirogen race (shown at right) is fiercely devoted to the pursuit of prey. The crew of the *U.S.S. Voyager* first encountered the Hirogen in the episodes "Hunters" and "Prey," after using the Hirogen communications relay in the prior episode, "Message in a Bottle." *Voyager*'s escape in "Message" was due mainly to Seven disobeying a direct order.

In "The Killing Game," the entire ship had been turned into a holodeck and the Hirogen reenacted famous Earth battles to see how their now-brainwashed prey would react. In World War II France, Seven and the other crew members attempted to break free of their conditioning and the holodeck. When they had finally done so, Janeway entered negotiations with the surviving Hirogen.

What did she offer them in exchange for their freedom?

A. Warp drive

B. Holographic technology

C. Photon torpedoes

D. Medical supplies

1107. Who was *not* a telepath aboard the *U.S.S. Voyager*?

A. Suder
B. Vorik
C. Tuvok
D. Kashyk

1108. Who was Captain Proton's archenemy?

A. Dr. Chaotica
B. Arachnia
C. Satan's Robot
D. Buster Kincaid

1109. During "Bliss," whom does Tuvok see?

A. Captain Sulu
B. T'Pel
C. His children
D. Kes

1110. The Starfleet Handbook on Personal Relationships states that personnel cannot engage in intimate relationships with alien species without what?

A. Protection
B. Biological scans
C. Permission from alien authorities
D. Authorization from commanding officer and clearance from medical

1111. What had Seven's parents developed to go undetected by the Borg?

A. Personal cloaking technology
B. Transphasic shielding
C. Biodampener
D. Bio-echo simulations

1112. How much closer to home did the *U.S.S. Voyager* get by using the transwarp technology in "Dark Frontier"?

A. 20,000 light years
B. 10,000 light years
C. 5,000 light years
D. No closer

1113. What made the biomimetic copies of the *Voyager* crew realize that they were the duplicates?

A. They began to act too differently
B. The enhanced warp drive caused them to degrade
C. They encountered the real *U.S.S. Voyager* crew
D. They could live on Class-Y planets

1114. What did Kurros *not* demand as payment for help in "Think Tank"?

A. Quantum slipstream technology
B. Seven of Nine
C. Chakotay's Olmec figurine
D. Bioneural gelpacks

1115. Who began to develop feelings for Seven of Nine in "Someone to Watch Over Me"?

A. Harry
B. Neelix
C. The Doctor
D. Tuvok

1116. What was the name of the timeship from the twenty-ninth century encountered in "Relativity"?

A. *U.S.S. Relativity*
B. *U.S.S. Aeon*
C. *U.S.S. Dali*
D. *U.S.S. Einstein*

1117. Who was the captain of the *U.S.S. Equinox*?

A. Maxwell Burke
B. Rudolph Ransom
C. Noah Lessing
D. Marla Gilmore

1118. What was the name of the ship with a neurogenic interface that began to control Tom Paris?

A. *Christine*
B. *Sally*
C. *Alice*
D. *Georgia*

1119.

1120. What "Lost" star appeared in a "Blink of an Eye"?

A. Daniel Dae Kim
B. Terry O'Quinn
C. Matthew Fox
D. Jorge Garcia

1121. Who was *not* one of the Borg children rescued by *Voyager*?

A. Icheb
B. Naomi
C. Mezoti
D. Rebi

1122. Which *Voyager* shipmate came back from the dead in "Ashes to Ashes"?

A. Lyndsay Ballard
B. Hogan
C. Michael Jonas
D. Seska

1123. What is Dr. Zimmerman suffering from?

A. Necrobiosis
B. Subcellular degradation
C. Orkett's disease
D. Hypoxia

1124. Who had Seven had a relationship with while in the Borg's virtual construct?

A. Korok
B. Two of Nine
C. Borg King
D. Axum

1119.

During its years lost in the Delta Quadrant, the *Voyager* had an unlikely ally in its attempts to communicate back with the Alpha Quadrant: former *Enterprise*-E crew member Lieutenant Reginald Barclay from *The Next Generation* (shown below with Janeway, right).

In "Pathfinder," Barclay became obsessed with finding a way to establish regular communication with the lost *Voyager* through the Pathfinder project. The stress also triggered another of his obsessions—his holoaddiction. His holodeck simulations had again become more important than his real life. Realizing he needed help before he was removed from the project, he turned to

his old counselor and friend, *Enterprise* crew member Commander Deanna Troi.

Following that episode, actress Marina Sirtis would guest-star three more times on *Voyager* as Counselor Troi, each time helping Barclay (and the Doctor) during his attempts at closing the gap between *Voyager* and home. Troi also forced Barclay out of his comfort zone.

At the end of the episode "Inside Man," what did she convince him to do?

A. Ask for a promotion
B. Go on a date with her friend
C. Go to Holoaddicts Anonymous
D. Quit Starfleet

1125. What implant of Seven's began to malfunction in "imperfection"?
A. Optical
B. Dermal
C. Cortical node
D. Aortal

1126. Who won the Antarian Transstellar Rally of 2377?
A. Paris
B. O'Zaal
C. Assan
D. Irinia

1127. What phrase activated Teero's repressed memories in Tuvok?
A. *"Pagh t'em far"*
B. "The crow flies at midnight"
C. *"Fal-tor-pan"*
D. "Live long and prosper"

1128. Whose hologram was used to attempt to smuggle Borg nanoprobes to the Alpha Quadrant for Ferengi to sell?
A. Chakotay
B. Barclay
C. Seven
D. Doctor

1129. What was Operation: Watson?
A. New transspatial drive
B. First successful comlink between the Alpha and Delta Quadrants
C. Holographic imaging array
D. New warp engine technology

1130. What was *Voyager*'s first official Starfleet assignment in seven years?
A. Destroy a Borg transwarp hub
B. Map the Mobius Inversion
C. Retrieve Friendship One
D. Transfer holographic data to *U.S.S. Equinox*

1131. Whom did Neelix fall in love with in "Homestead"?
A. Ayala
B. Lydia
C. Seven of Nine
D. Dexa

1132. What was the name of Naomi Wildman's daughter in the time line shown in "Endgame"?
A. Sabrina
B. Miral
C. Samantha
D. Kathryn

1133. What was the name of the Maquis ship Chakotay commanded?
A. *Vetar*
B. *Liberty*
C. *Val Jean*
D. *Zola*

1134. Who was the original first officer on the *U.S.S. Voyager*, killed when it was displaced in the Delta Quadrant?

A. Chakotay
B. Cavit
C. Rollins
D. Stadi

1135. How many replacement bioneural gelpacks did Voyager initially carry in inventory?

A. 12
B. 24
C. 74
D. 47

1136.

1137. Why did Seska betray her *Voyager* and Maquis crewmates?

A. To find allies in the Quadrant
B. To steal Kazon technology
C. She loved First Maje Cullah
D. She was brainwashed

1138. What was the purpose of the movable engine nacelles?

A. To go faster than Warp 10
B. To provide power to the weapons
C. To make the ship a smaller target
D. To create variable geometry warp fields

1139. How does Chakotay facilitate his vision quests?

A. *Akoonah*
B. Psychotropic drugs
C. Herbs
D. Nuanka

1140. What holonovel, based on an ancient Earth epic, did Kim get trapped in during "Heroes and Demons"?

A. "Canterbury Tales"
B. "Beowulf"
C. "Camelot"
D. "Valley of the Dolls"

1141. Who or what created an all-Klingon version of B'Elanna?

A. The Doctor
B. Transporter accident
C. Caretaker
D. Sulan

1142. What could the *U.S.S. Voyager* do that the *U.S.S. Enterprise* could not?

A. Achieve Warp 10
B. Fly through subspace
C. Land on a planet
D. Think

1136.

While traveling back in time may not be easy for a starship crew, for TV producers it's easy—if you're traveling back to the present.

Bringing the crew of the *U.S.S. Voyager* back to Los Angeles in 1996 was the work of Captain Braxton from the twenty-ninth century. Braxton's timeship was hurled back into the twentieth century, where it allowed an unscrupulous entrepreneur, Henry Starling (shown at right with Doctor, left), to create a high-tech empire.

The crew managed to keep Starling from plundering the future for more technology, and they also acquired a device allowing the Doctor more mobility.

What was Starling's unintended 29th-century gift to the Doctor?

A. Android body
B. Mobile holoemitter
C. Plasma projector
D. Subspace manifestation device

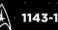

1143. What was the name of Chakotay's father?

A. Kolopak C. Surat

B. Razik D. Hogan

1144. Who was the Caretaker's mate?

A. Tanis C. Haron

B. Suspiria D. Denara Pel

1145. How did the producers visually delineate the Maquis crew from the Starfleet crew?

A. Braid on sleeve is different C. Rank pips are different

B. Colors of uniform are different D. The Maquis do not get combadges

1146. What frequent "mockumentary" actor appeared as the Clown in "The Thaw"?

A. Christopher Guest C. Catherine O'Hara

B. Eugene Levy D. Michael McKean

1147. How was the duplicated *Voyager* in "Deadlock" damaging the original?

A. Plasma leak C. Quantum reversal

B. Proton bursts D. Vidiian technology

1148. What race aged in reverse?

A. Kohl C. Drayans

B. Vhnori D. Ocampa

1149. What was Janeway's favorite way to relax?

A. Baths C. Coffee

B. Massage D. Holonovel

1150. After the Kazon takeover, who was the only (nonholographic) crewman left on board *Voyager*?

A. Paris C. Hogan

B. Chakotay D. Suder

1151. What were the names of the Delaney sisters?

A. Tara and Susan C. Megan and Jenny

B. Ellen and Karen D. Kim and Jackie

1152. How long was the EMH's program designed to run?

A. 150 hours
B. 500 hours
C. 1,000 hours
D. 1,500 hours

1153. What did 1990s astronomer Rain Robinson call the EMH?

A. "Doc"
B. "Mr. Leisure Suit"
C. "Mr. Photon"
D. "Bones"

1154. How long had Q and the female Q been involved?

A. 100 years
B. 1,000 years
C. 2,000 years
D. 4 billion years

1155. What severed the link to the Borg collective for Riley and her fellow drones in "Unity"?

A. Transphasic torpedoes
B. Electrokinetic storm
C. Plasma storm
D. Photonic distortion wave

1156. What training program did Seska reprogram to be a deadly holonovel?

A. "Tactical One"
B. "Battle of the Alamo"
C. "Insurrection Alpha"
D. "Kazon Ambush III"

1157. Which *Lord of the Rings* actor portrayed Leonardo da Vinci in Janeway's holodeck program in "Scorpion"?

A. Orlando Bloom
B. Viggo Mortensen
C. Ian McKellen
D. John Rhys-Davies

1158.

1159. What area of space was created by Species 8472's activities?

A. Northwest passage
B. Fluidic space
C. Ilarian corridor
D. Nacene sector

1160. What was Kes's final gift to the *U.S.S. Voyager* as she evolved into a noncorporeal state?

A. Gave telekinetic protection from the Borg weapons
B. Made the Doctor human
C. Repaired the structural integrity of the ship
D. Sent *Voyager* ten years closer to the Alpha Quadrant

1158.

For *Voyager*'s contribution to the thirtieth anniversary of *Star Trek*, Tuvok's (shown at right with Janeway, left) suppressed memories and a mind-meld allowed him and Janeway to relive his assignment aboard the *U.S.S. Excelsior*—under the command of Captain Sulu. The episode, entitled "Flashback," took place during one of the most famous scenes of the sixth *Star Trek* movie, *The Undiscovered Country*.

Integrating the *Voyager* actors into *The Undiscovered Country* scenes required refilming most of the *Excelsior*'s encounter with the destruction of the Klingon moon, but some external footage and one key bridge scene were reused directly.

Which bridge scene remained unaltered?

A. Dmitri's death
B. Sulu's teacup shattering
C. Rand taking the helm
D. Sulu talking to Kirk

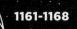

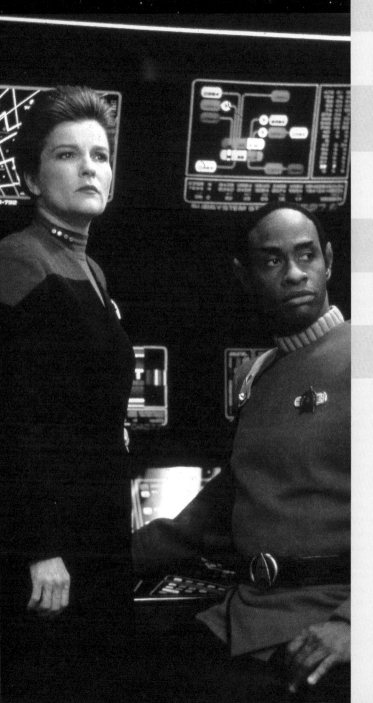

1161. What species' devastating temporal weapons forced *Voyager* to endure a "Year of Hell"?

A. Krenim
B. Zahl
C. Hirogen
D. Entharan

1162. What was Annorax attempting to do by creating temporal incursions?

A. Conquer the Borg
B. Restore his family to life
C. Destroy *Voyager*
D. Get revenge on Chakotay

1163. What was the name of the ship hijacked by Romulans in "Message in a Bottle"?

A. *U.S.S. Bonchune*
B. *U.S.S. Equinox*
C. *U.S.S. Carolina*
D. *U.S.S. Prometheus*

1164. What holographic Earth setting did the Hirogen place the *Voyager* crew in during "The Killing Game"?

A. Alamo
B. Tiananmen Square
C. World War II French Resistance
D. Vietnam

1165. What Starfleet scientist first synthesized Omega particles?

A. Allos
B. Steth
C. Cochrane
D. Ketteract

1166. What film star portrayed the unremembered, yet "Unforgettable," Kellin?

A. Virginia Madsen
B. Sandra Oh
C. Susan Sarandon
D. Whoopi Goldberg

1167. What did "Gray Mode" mean?

A. Running in stealth mode
B. Running on reserve power only
C. Operating a cloaking device
D. Command-level imposter alert

1168. What characterized a Class-Y planet's atmosphere?

A. Oxygen-nitrogen
B. Helium
C. Toxic
D. Vacuum

1169. Why did Arturis create the *U.S.S. Dauntless*?

A. To trap the *Voyager* crew
B. To help the *Voyager* crew get home
C. To escape Borg attacks
D. To fight Species 8472

1170. What message from Starfleet did Arturis translate for *Voyager*?

A. They have declared *Voyager* lost
B. Janeway has been promoted
C. A ship is coming to meet them
D. No way home has been found yet

1171. What was the officer's club near Starfleet called?

A. Admiral's Place
B. Presidio
C. Quantum Café
D. Captains Mess

1172. What position aboard *Voyager* did Naomi Wildman want to pursue?

A. Junior Security Officer
B. Captain's Assistant
C. Assistant Chef
D. Borg negotiator

1173. What caused Seven to exhibit personalities of assimilated victims?

A. Damaged Borg vinculum
B. Cortical inhibitor malfunction
C. Mind-meld
D. Holodeck malfunction

1174.

1175. What role did Harry Kim usually play in "The Adventures of Captain Proton"?

A. Satan's Robot
B. Lonzak
C. President of Earth
D. Buster Kincaid

1176. What was B'Elanna's act of courage during her "Day of Honor"?

A. Realizing she loved Tom Paris
B. Saving the ship
C. Working with her enemies
D. Reconciling with her father

1177. How many gigawatts of energy can the exoskeleton on Seven's hand withstand?

A. One million
B. Three million
C. Five million
D. Six million

1174.

Quinn's suicide in "Death Wish" sent shockwaves throughout the Q continuum and started a war among the Q. As Q (John deLancie) was on the losing side, he thought of a way to end the hostility by adding human DNA to the Q's genetic makeup. Since Janeway and the *Voyager* crew were instrumental in Quinn's decision, Q wooed Janeway with the hope of procreating with her to create this new breed of Q.

But when Q's jealous former lover, a female Q (shown at right), arrived, the *Voyager* crew was transported directly into the Q battlefield. Janeway tried to convince Q that mating with her was not an option. She suggested that, instead, Q mate with the female Q.

The actress who played the female Q had played other aliens in Star Trek universe, namely the Vulcan Dr. Selar and Klingon ambassador K'Ehleyr in *The Next Generation*, and would play the Andorian Tarah in *Enterprise*.

Who was this actress?

A. Barbara March
B. Grace Lee Whitney
C. Suzie Plakson
D. Linda Park

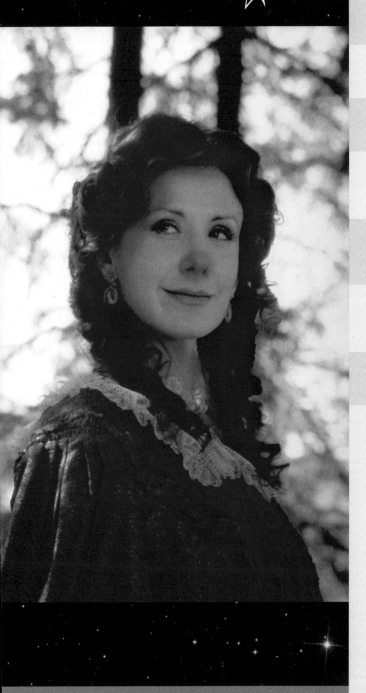

1178. Which race of aliens in "Random Thoughts" had a black market trade in illicit mental imagery?

A. Entharans **C.** Krenim

B. Mari **D.** The "Dream" aliens

1179. What was the registry number of the *U.S.S. Dauntless*?

A. NCC-72381 **C.** NCC-74656

B. NX-02 **D.** NX-01

1180. What is the sickness that afflicts crews on Malon waste export vehicles?

A. Freighter blight **C.** Plasma plague

B. Subspace poisoning **D.** Chromovirus

1181. Who was the Cardassian exobiologist whose hologram helped saved Torres?

A. Siana **C.** Crell Moset

B. Asha **D.** Evek

1182. How quickly could the biomimetic copies of the *Voyager* crew have gotten home with their enhanced warp drive?

A. Instantly **C.** Two months

B. Two weeks **D.** Two years

1183. What are the first stages of theta-radiation poisoning, as evidenced in "Juggernaut"?

A. Blisters **C.** Paranoia

B. Hallucinations **D.** Paralysis

1184. Who did Seven have her first date with?

A. Lieutenant Chapman **C.** The Doctor

B. Harry Kim **D.** Tom Paris

1185. Who was the ancestor Captain Janeway erroneously believed was a great explorer?

A. Henry Janeway
B. Phoebe
C. Martha Janeway
D. Shannon O'Donnel

1186. Who was the Starfleet officer from the twenty-ninth century who enlisted Seven's helping in capturing a version of himself?

A. Ducane
B. Captain Braxton
C. Lucsly
D. Dulmur

1187. What did the *Equinox* crew do to their Emergency Medical Hologram?

A. Deactivated him
B. Made him first officer
C. Removed his ethical subroutines
D. Downloaded him into an android body

1188. What *U.S.S. Equinox* crewman did Torres date at Starfleet Academy?

A. Ransom
B. Gilmore
C. Lessing
D. Burke

1189. What is the name of the Klingon version of Hell?

A. *paq'bath*
B. Fek'lhr
C. *Sto-vo-Kor*
D. *Gre'thor*

1190. What is the slogan of the holodeck town Fair Haven?

A. "The town of spirit"
B. "Welcome weary traveler"
C. "All are welcome"
D. "Strangers are friends you haven't met yet"

1191. How long had Barclay lived in his apartment without unpacking by the beginning of "Pathfinder"?

A. Two months
B. Six months
C. Eight months
D. A year

1200.

It is said you can't go home again, and for a while it looked as though *Voyager* might prove that saying right. The series finale, "Endgame," aired May 23, 2001 and marked the last appearance of the twenty-fourth-century era episodes (though this era would be revisited in the last *Next Generation* film, *Nemesis*, in 2002). "Endgame" showed an alternate time line in which it took the crew twenty-three years to return to Earth. The Doctor chose a name, Chakotay was dead, and Janeway (shown at left with Barclay, right) didn't want to discuss Seven.

Admiral Janeway headed back into the past, violating the temporal Prime Directive, in order to save her crew from these fates. She was met with resistance from the now-Captain Kim of the *U.S.S. Rhode Island*, the Doctor, and her nemesis the Borg queen, but managed to go back and bring *Voyager* home, as well as deal the Borg a crippling blow.

Which experimental drug did Janeway ask the Doctor for to protect her from the tachyon radiation of time travel?

A. Vasokin
B. Alkysine
C. Chronexaline
D. Tropolisine

1192. How long did Janeway have a headache after her last mind-meld?
A. A day and a half
C. Three days
B. Two days
D. A week

1193. What city was Tuvok born in?
A. Shakaar
C. Tycho City
B. Paris
D. T'Paal

1194. Who saved Seven by donating his or her own implant?
A. Icheb
C. Cody
B. Azan
D. Rebi

1195. Which *Enterprise* cast member auditioned to be Tuvok's son?
A. Dominic Keating
C. Connor Trineer
B. John Billingsley
D. Anthony Montgomery

1196. Who was Barclay's ex-dabo-girl girlfriend?
A. Hartla
C. Leeta
B. Leosa
D. Glidia

1197. What episode saw Tuvok enter *Pon farr*?
A. "Workforce"
C. "Repression"
B. "Critical Care"
D. "Body and Soul"

1198. Who played Q's son in "Q2"?
A. Keegan deLancie
C. Michael Kagen
B. Manu Intiraymi
D. John deLancie

1199. Which crew member went insane in the alternate future of "Endgame"?
A. Chakotay
C. Tuvok
B. Seven of Nine
D. Kim

1200.

1201. What was the first name of the *Enterprise* NX-01's captain?

A. Jonathan

C. Maxwell

B. Christopher

D. Travis

1202. Which of the Three Musketeers was Archer's beagle named after?

A. D'Artagnan

C. Aramis

B. Athos

D. Porthos

1203. What was Archer's father, Henry, famous for?

A. Dying of an alien disease

C. Being friends with Zefram Cochrane

B. Developing the first engine capable of Warp 5

D. Hating Vulcans

1204. What was T'Pol's rank?

A. Lieutenant

C. Consultant

B. Lieutenant Commander

D. Subcommander

1205. Who was T'Pol briefly married to?

A. Koss

C. Menos

B. Jossen

D. Trip

1206. Who was the Vulcan ambassador to Earth T'Pol worked for?

A. V'Las

C. Soval

B. Kuvak

D. Stel

1207. Where was Travis Mayweather born?

A. *E.C.S. Horizon*

C. *Columbia*

B. *Enterprise* NX-00

D. *E.C.S. Fortunate*

LEFT The *Enterprise* crew.

1208. What race was Dr. Phlox?

A. Antaran C. Denobulan
B. Xindi D. Vissian

1209. What nationality was Lieutenant Malcolm Reed?

A. Welsh C. Scottish
B. Irish D. English

1210. Which of the following was Reed *not* allergic to?

A. Wheat C. Dust mites
B. Pineapple D. Oak pollen

1211. Where was Hoshi Sato born?

A. China C. Hawaii
B. Japan D. Korea

1212. What translation matrix would Hoshi eventually develop?

A. Universal translation C. Metaphoric
B. Esperanto D. Linguacode

1213. Why was Hoshi discharged from Starfleet early in her career?

A. She broke an officer's arm C. She failed too many courses
B. Family emergency D. Gambling problems

1214.

1215. How many wives did Phlox have?

A. Two C. Four
B. Three D. Five

1216. What unusual ability do Denobulan faces have?

A. They can glow C. They are poisonous to the touch
B. They are transparent D. They can expand like blowfish

1214.

The fifth spin-off of *Star Trek* was originally titled, simply, *Enterprise*, but during the third season a decision was made to rename it *Star Trek: Enterprise*. The show's initial ratings were high, but leveled out to an average of 2.5 million viewers per week.

The show went in a different direction from prior *Star Trek* series–rather than being set in the twenty-fourth century (or even farther out), it was set in the twenty-second century and was a prequel to the original *Star Trek* series. Starring *Quantum Leap* actor Scott Bakula, the show featured the very beginnings of humanity's exploration of the stars and of interstellar politics.

The pilot episode, "Broken Bow," featured the first contact between humans and Klingons. The *Enterprise* NX-01's maiden voyage was to return an injured Klingon to his home world, and included the crew's introduction to a race of aliens who were involved in a temporal cold war, called the Suliban.

The Suliban named Silik (shown at right) would become Archer's nemesis over the three years of the Temporal Cold War—but the character was not named until which episode?

A. "Storm Front"
B. "Dead Stop"
C. "Cold Front"
D. "Shockwave"

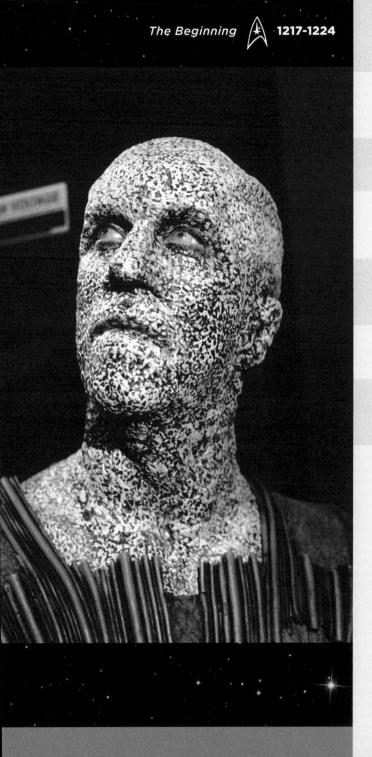

1217. Who was the Starfleet admiral that Archer reported to?

A. Michael Rostov **C.** Maxwell Forrest
B. Erika Hernandez **D.** Bryce Shumar

1218. What was the slang term for people who spent most of their lives on spaceships?

A. "Star trekkers" **C.** "Galaxy jockeys"
B. "Space boomers" **D.** "Star shiners"

1219. What was the top speed of the NX-class ships?

A. Warp 5 **C.** Warp 8
B. Warp 7 **D.** Warp 10

1220. In the episode "Broken Bow," on what planet was the away team captured by the Suliban?

A. Denobula **C.** Qo'noS
B. Vulcan **D.** Rigel X

1221. What Grammy-winning songwriter composed the theme song for *Enterprise*?

A. Joe Cocker **C.** Dianne Warren
B. Bruce Springsteen **D.** Stephen Sondheim

1222. Which actor reprised his role as Zefram Cochrane in the *Enterprise* pilot?

A. James Cromwell **C.** John deLancie
B. Glenn Corbett **D.** Dwight Schultz

1223. Which episode featured the first appearance of the Axanar, who were only mentioned in the *Star Trek* original series?

A. "Dead Stop" **C.** "Strange New World"
B. "Broken Bow" **D.** "Fight or Flight"

1224. Which crew member was fascinated by alien culture and attempted to have a relationship with Dr. Phlox?

A. Amanda Cole **C.** Patricia O'Malley
B. Elizabeth Cutler **D.** Hoshi Sato

1225. What was the name of the Vulcan monastery whose destruction caused political fallout between the Vulcans and Andorains?

A. Gol

B. Kolinahr

C. P'Jem

D. Kir

1226. Who became the pregnant "host" of a Xyrillian baby in "Unexpected"?

A. Phlox

B. Trip Tucker

C. Archer

D. T'Pol

1227. What caused the loss of contact with the Terra Nova colony?

A. They were forgotten

B. A plague wiped out the colony

C. No one knows

D. An asteroid hit the planet

1228. What type of pirates attacked the *E.C.S. Fortunate* cargo ship?

A. Orions

B. Antarans

C. Klingon

D. Nausicaan

1229. Why did the Vulcan high command want to transfer T'Pol off the *Enterprise*?

A. She was being culturally contaminated

B. They blamed her for the destruction of their spy base

C. To take her mother's place at the Science Academy

D. To command her own ship

1230. What shuttlepod were Trip and Reed trapped on when they thought the *Enterprise* had been destroyed?

A. Shuttlepod One

B. Shuttlepod Two

C. Shuttlepod Three

D. Shuttlepod Four

1231. Who is the actor who played Balok in the *Star Trek* original series, as well as Muk in the *Enterprise* episode "Acquisition"?

A. Mark Lenard

B. Joanna Linville

C. William Campbell

D. Clint Howard

1232. Who was actually responsible for the destruction of the Paraagan II colony?

A. Daniels
B. Na'kuhl
C. Suliban
D. Romulans

1233.

Throughout the four-year run of *Enterprise*, Archer (shown at left with Daniels, right) and his crew continually ran into various factions fighting a temporal cold war. The twenty-second century was an important front in this war. Two representatives of the warring factions encountered repeatedly by the *Enterprise* crew were Silik of the Suliban Cabal, and Daniels, who represented a Federation-like faction. Daniels even served on *Enterprise* for a time, before revealing to Archer that he was from the future.

After *Enterprise* was involved with the destruction of an entire colony, Daniels brought Archer forward in time to protect him, but the action had disastrous consequences: bringing Archer forward damaged the time line, so that Daniels' Earth was in ruins and he couldn't return Archer to the twenty-second century to repair the mistake.

What century did Archer get trapped in at the end of "Shockwave, Part 1"?

1233.

1234. What are the Suliban space stations called?

A. Helixes
B. Spheres
C. Complexes
D. Spiral cores

1235. Echoing the *Star Trek* original series episode "A Piece of the Action," what piece of technology did Reed accidentally leave on a pre-warp planet?

A. Photonic torpedo
B. Transporter
C. Phase pistol
D. Communicator

1236. What is the name of the Andorian military force?

A. Aenar
B. Ushaan
C. Imperial Guard
D. Andorian Militia

1237. Which role did frequent *Star Trek* guest star Suzie Plakson play in "Cease Fire"?

A. Tarah
B. Shren
C. Talas
D. Telev

1238. Who was sent to the Klingon penal colony of Rura Penthe?

A. Trip
B. Archer
C. Reed
D. Mayweather

1239. What *Star Trek* alien makes an "untroubled" cameo in the episode "The Breach"?

A. Balok
B. Gorn
C. Denebian Slime Devil
D. Tribble

A. Twenty-ninth
B. Thirty-first
C. Thirty-second
D. Fortieth

1240. Where did Borg drones from the film *First Contact* crash on Earth in the mid-twenty-second century?

 A. Africa **C.** Arctic

 B. Europe **D.** Antarctica

1241. Which actor, better known for playing a well-known Klingon on *The Next Generation* and *Deep Space Nine*, played a Tellarite bounty hunter in *Enterprise*?

 A. J. G. Hertzler **C.** Michael Dorn

 B. Robert O'Reilly **D.** Suzie Plakson

1242. What was the "602 Club"?

 A. A bar on Earth **C.** Engineers who worked on the NX project

 B. People who'd been safely transported **D.** *Enterprise* crew members

1243. What did MACO stand for?

 A. Mobile Armed Confrontation Order **C.** Modern Assault Combat Operatives

 B. Massed Alien Combat Officials **D.** Military Assault Command Operations

1244. What region of space did the Xindi inhabit?

 A. Transdimensional space **C.** Delphic Expanse

 B. Mirror universe **D.** Epsilon Quadrant

1245. What surrounded the area of Xindi space?

 A. Plasma clouds **C.** Galactic barrier

 B. Thermobaric clouds **D.** Ion storms

1246. Which Xindi race had become extinct by the time the *Enterprise* crew encountered the Xindi?

 A. Avian **C.** Insectoid

 B. Aquatic **D.** Arboreal

1248.

The *Enterprise*'s original mission of exploration changed with the season two finale that aired in May of 2003.

The producers were told to shake up the series to garner more ratings, and so the search for the Xindi super-weapon story line was developed. Partially inspired by the attacks on September 11 two years prior, the yearlong story line began with a planetary attack on Earth. A Xindi probe blasted a swath from Florida to Venezuela and the *Enterprise* was recalled to Earth to begin the search for the Xindi who had created the weapon.

As devastating as the attack was, it struck home for Trip Tucker (shown at left) more than it did for most: Trip's sister was among the innocent who died in the attack. Demoralized, he begged Archer to tell him their mission wouldn't be "tiptoeing around" with all the "noninterference crap T'Pol's always shoving down our throats."

How many died in the attack shown in "The Expanse"?

A. 7,000
B. 70,000
C. 700,000
D. 7,000,000

1247. What did the Xindi call the Sphere Builders?

A. Regents
B. Guardians
C. Makers
D. Gods

1248.

1249. Whom did Dr. Phlox often correspond with?

A. Admiral Gardner
B. Dr. Lucas
C. His wife
D. His son

1250. What military conflict in the time line was pivotal in defeating the Sphere Builders in the twenty-sixth century?

A. Wolf 359
B. Battle of Axanar
C. Battle of Procyon 5
D. Invasion of Septimus III

1251. In the alternate time line of the episode "E2," what ship did Lorian captain?

A. *U.S.S. Enterprise* NCC-1701
B. *Enterprise* NX-01
C. *Enterprise* NCC-1701-A
D. *U.S.S. Enterprise* NX-03

1252. What was the actual purpose of the spheres in the Expanse?

A. Combine to form the Xindi superweapon
B. Reconfigure space to be habitable for the Sphere Builders
C. Erect a barrier around the galaxy
D. Kill any organic being in range

1253. Which Xindi species did *not* help the *Enterprise* crew stop the super-weapon?

A. Reptilian
B. Aquatic
C. Primate
D. Arboreal

1254. Whom did the reptilians kidnap to decipher Degra's codes?

A. Trip
B. T'Pol
C. Hoshi
D. Reed

1255. In the episode "Zero Hour," who killed Degra?

A. Archer
B. The Xindi-Aquatics
C. Dolim
D. He committed suicide

1256. What position did Arik Soong once hold on Cold Station 12?

- **A.** Director of Genetic Research
- **B.** Professor of Exobiology
- **C.** Senior Medical Director
- **D.** Research Fellow in Artificial Intelligence

1257. Which Starfleet officer did Archer rekindle a romance with in "Home"?

- **A.** Ruby
- **B.** T'les
- **C.** Pierce
- **D.** Erika Hernandez

1258. What war resulted in the outlawing of the Augments?

- **A.** Romulan Wars
- **B.** Eugenics Wars
- **C.** Battle of Axanar
- **D.** Dominion War

1259. What famed Vulcan leader did Archer and T'Pol meet during the Vulcan Reformation?

- **A.** T'Pau
- **B.** Sarek
- **C.** Sybok
- **D.** Spock

1260. Which *Enterprise* crew member was recruited by Section 31?

- **A.** Trip
- **B.** Reed
- **C.** Hoshi
- **D.** Mayweather

1261. What episode explained the difference in Klingons' cranial ridges between the original series *Star Trek* and the *The Next Generation* eras?

- **A.** "Augments"
- **B.** "Demons"
- **C.** "Affliction"
- **D.** "Terra Prime"

1262. Who was *not* an Orion slave girl in "Bound"?

- **A.** Navaar
- **B.** Kelby
- **C.** Maras
- **D.** D'Nesh

1263. Which *Star Trek* alien was shown completely for the first time in "In a Mirror, Darkly"?

- **A.** Klingon
- **B.** Romulan
- **C.** Gorn
- **D.** Tholian

1266.

In the episode "Shadows of P'Jem," after the *Enterprise*'s involvement with the discovery of a Vulcan surveillance facility at the P'Jem monastery, the Andorians gave the Vulcans time to get off-planet, and then they destroyed the monastery.

In what appeared to be punishment, the Vulcan high command ordered T'Pol transferred from the *Enterprise*. As Vulcan and Andorians prepared for a showdown, Archer took T'Pol (shown at left with Archer, top) on one last away mission to the planet Coridan, where they were captured by rebels on the planet. The two were saved when the Andorian Shran came to their aid, repaying what he saw as a debt for uncovering the mystery at P'Jem.

T'pol's transfer was then forestalled after she saved the life of the captain of *Ni'Var*, the Vulcan ship sent to pick her up.

What was this captain's name?

A. Soval
B. Koss
C. Sopek
D. Syrran

1264. Which *Star Trek* original series alien got a complete CGI upgrade "In a Mirror, Darkly"?

A. Balok
B. Tribbles
C. Gorn
D. Excalbians

1265. Which *The Next Generation* character called up the final mission of the *Enterprise* NX-01 on the holodeck?

A. Picard
B. Troi
C. Riker
D. Worf

1266.

1267. How long do the Axanar generally live?

A. 40 years
B. 400 years
C. 4,000 years
D. 4 million years

1268. What was P'Jem's original function?

A. Spa resort
B. Military base
C. Spiritual retreat
D. Mining facility

1269. What was the Vulcan religious artifact presented to Archer on his visit to P'Jem?

A. IDIC medallion
B. Cup of Gol
C. Stone of J'Kah
D. Katric Ark

1270. Who was the Andorian commander who would eventually become one of Archer's allies?

A. Tholos
B. Shran
C. Keval
D. Talla

1271. What was Trip's favorite dessert, which he taught T'Pol to enjoy?

A. Pecan pie
B. Apple pie
C. Lemon meringue pie
D. Pumpkin pie

1272. According to Mayweather, how many NX-class vessels did Starfleet plan to build?

A. Two
B. Three
C. Ten
D. Twelve

1273. What was the Great Plume of Agosoria?

A. Borothan pilgrims' name for Archer's comet

B. A beverage Borothans drank

C. A neutron burst from a protostar erupting every eleven years

D. A fountain on Borotha

1274. What never-fully-seen character sometimes adopted the role of unofficial counselor on the *Enterprise*?

A. Crewman Rossi

B. Chef

C. Ensign Keely

D. Sluggo

1275. What neural disease did T'Pol contract in "Fusion"?

A. *Kir'Shara*

B. *K'oh-nar*

C. *Pa'nar* syndrome

D. Dysphoria syndrome

1276. Who was the human doctor participating in the interspecies medical exchange with Phlox?

A. Elizabeth Cutler

B. Irina Karlovassi

C. Lokesh

D. Jeremy Lucas

1277. In "The Expanse," who tells Archer why the Xindi have attacked Earth?

A. Daniels

B. Soval

C. Sillik's leader

D. Forrest

1278. What poisoned the Klingon crew of the *Somraw*?

A. Plasma exhaust

B. Xarantine ale

C. Radioactive cometary fragments

D. Andorian assassins

1279.

1280. What are the "Vulcans without logic" known as?

A. *V'tosh ka'tur*

B. *Kir'Shara*

C. *Vokau*

D. *Mal-kom*

1281. What Vulcan ambassador negotiated the territorial compromise between Vulcan and Andoria?

A. Sarek

B. Soval

C. V'Lar

D. T'Les

1279.

Trilogies and two-part episodes were the rule rather than the exception in season four of *Star Trek: Enterprise*. These multipart stories would depict pivotal events in Star Trek history. The "Vulcan Reformation" story line, for example, showed Archer and T'Pol as instrumental in events that would reshape Vulcan society.

T'Pol's involvement with the destruction of the monastery on P'Jem had personal repercussions for her on Vulcan. Her mother was forced to step down from teaching at the Vulcan Science Academy, and despite T'Pol's subsequent political marriage to Koss, her mother's place was never truly restored and she went into hiding. As T'Pol and Archer tracked her down, they not only met T'Pau (a Vulcan who would become legendary in Captain Kirk's time, shown at right with T'Pol, left), but also unraveled a secret that the Vulcan high command wanted suppressed—the ancient *Kir'shara* artifact.

The *Kir'shara* held one secret, but the head of the Vulcan high command was keeping another.

Whom was he secretly working with?

A. Suliban

B. Romulans

C. Andorians

D. Remans

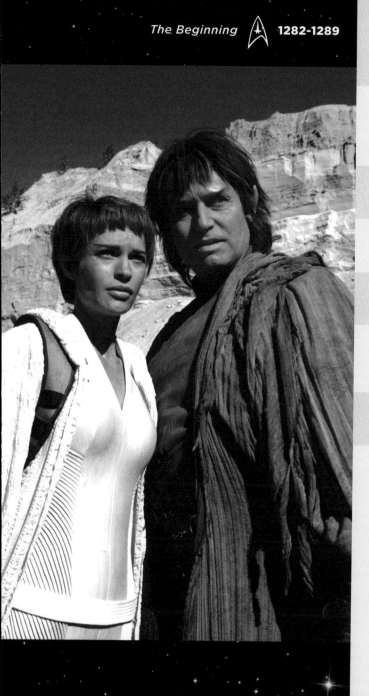

1282. Which of the following episodes showed the *Enterprise* NX-01 achieving Warp 5 speeds for the first time?

A. "Vox Sola" **C.** "Desert Crossing"
B. "Two Days and Two Nights" **D.** "Fallen Hero"

1283. What historical event was *not* supposed to occur in "Shockwave"?

A. Destruction of Paraagan colony **C.** Returning Klaang to Qo'noS
B. Archer being kidnapped into the future **D.** Trip dying

1284. Which shipwrecked Vulcan stayed on Earth in the 1950s?

A. T'Mir **C.** Mestral
B. Stron **D.** T'les

1285. What episode introduced the first encounter with the Romulans?

A. "Dead Stop" **C.** "Minefield"
B. "Marauders" **D.** "Carbon Creek"

1286. What Vulcan smuggler did the high command direct T'pol to capture?

A. Nyran **C.** Menos
B. Jossen **D.** Koss

1287. What ghost story "legend" did Hoshi conjure up while trapped in the transporter pattern buffer for 8.3 seconds?

A. Zefram Cochrane **C.** Emory Erickson
B. Cyrus Ramsey **D.** Transphasic aliens

1288. Which *Top Chef* judge played the future first monarch of Krios Prime?

A. Tom Colicchio **C.** Gail Simmons
B. Padma Lakshmi **D.** Ted Allen

1289. Where did the crew have to set up quarters during a neutronic storm?

A. Sick bay **C.** Catwalk
B. Shuttle bay **D.** Gym

1290. Which Vulcan admitted to T'Pol that he was also a mind-melder?

A. Oratt
B. Yuris
C. Strom
D. Soval

1291. According to T'Pol, which horror film was a must-see for every Vulcan newly arrived on Earth?

A. *The Wolfman*
B. *Dr. Jekyll and Mr. Hyde*
C. *Frankenstein*
D. *Dracula*

1292. Why did Tarah attack Archer and his crew?

A. She had secret orders from the Imperial Guard
B. She thought Archer was a disguised Vulcan
C. She thought Shran's inaction was a betrayal
D. She hated humans

1293. What were Archer and Tucker accused of by the Enolians in "Canamar"?

A. Spying
B. Treason
C. Smuggling
D. Murder

1294. What actor played Archer's Klingon advocate in "Judgement"?

A. Tony Todd
B. Michael Ansara
C. J. G. Hertzler
D. Michael Dorn

1295. Who was Archer's rival pilot in Starfleet, who died while climbing Mount McKinley?

A. Trip Tucker
B. Admiral Gardner
C. A.G. Robinson
D. Maxwell Forrest

1296.

1297. What *Dexter* actor played Archer's rival pilot?

A. Michael C. Hall
B. James Remar
C. Keith Carradine
D. Erik King

1296.

The Borg's appearance on *Enterprise* (shown at right) made it tricky to preserve the established *Star Trek* canon. Prior to the *Enterprise* series, Starfleet's first contact with the Borg had been shown to occur in the twenty-fourth century. So to preserve continuity (as the writers did with appearances by the Romulans and Ferengi), the *Enterprise* crew would never see the aliens directly, and would remain unaware of their identity—thus leaving the Borg unknown until the events of *The Next Generation* series.

In the case of the Borg from the episode "Regeneration," the retroactive continuity worked well—Borg from the film *First Contact* crashed to Earth and lay dormant until revived by human scientists. *Enterprise* managed to destroy the Borg, but not before the Borg sent a message—a message that T'pol theorized would take 200 years to reach the aliens' point of origin.

What was the message?

A. "Resistance is futile"
B. Earth's spatial coordinates
C. "Earth is defended"
D. "You will adapt to service us"

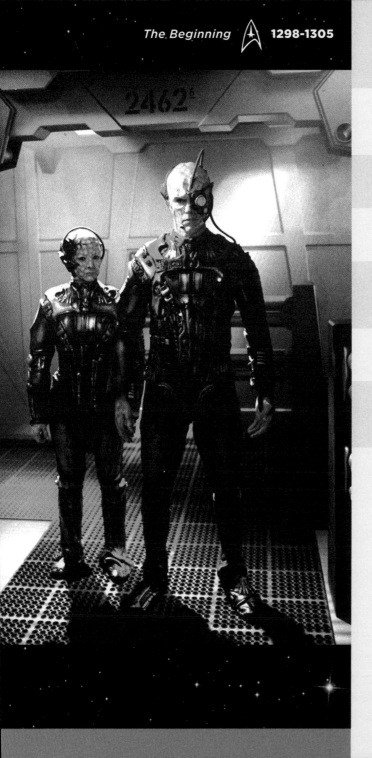

1298. What type of radiation did Dr. Phlox use on himself to destroy the Borg nanoprobes?

 A. Delta **C.** Omicron

 B. Theta **D.** Kinoplasmic

1299. The episode "Bounty" featured the first *Enterprise* appearance of what *Star Trek* original series aliens?

 A. Archons **C.** Tribbles

 B. Tellarites **D.** Gorn

1300. How many suns did Rura Penthe have?

 A. One **C.** Three

 B. Two **D.** Four

1301. Who was the leader of the MACOs on board the *Enterprise*?

 A. Major Hayes **C.** Corporal Hawkins

 B. General Casey **D.** Corporal Scott

1302. What did the *Enterprise* need on its hull to protect it from the *Expanse*'s spatial anamolies?

 A. Trellium-A **C.** Trellium-D

 B. Duranium **D.** Ablative armor

1303. What Vulcan technique did T'Pol employ to help cure Tucker's insomnia?

 A. Mind-meld **C.** Meditation

 B. Neuropressure **D.** *fal-tor-pan*

1304. Who did the Xindi send on board the *Enterprise* to acquire biometric data on the humans?

 A. B'rat **C.** Raijin

 B. Jannar **D.** Zjod

1305. What did exposure to trellium-D do to Vulcans?

 A. Made them sick **C.** Impaired motor functions

 B. Drove them insane **D.** Killed them

1306. Who abducted a group of Americans from the 1860s?

A. Xindi

B. Skagarans

C. Lyssarrian

D. Triannon

1307. What were the Xindi-reptilians doing on Earth in 2004?

A. Hiding from *Enterprise*

B. Developing bioweapons

C. Creating target info for the spheres

D. Altering history

1308. What was the name of Shran's ship?

A. *Kallisko*

B. *Lakul*

C. *Tezra*

D. *Kumari*

1309. Who was the primary designer of the Xindi superweapon?

A. Dolim

B. Naara

C. Degra

D. Piral

1310. Who was the first Xindi to believe Archer's claims that the Sphere Builders were manipulating them?

A. Gralik

B. Dolim

C. Enarchis

D. Degra

1311. Where was the Xindi superweapon being constructed?

A. Orassin distortion field

B. Muratas Cluster

C. Azati Prime

D. Calindra system

1312.

1313. What *Enterprise* did Daniels bring Archer aboard to show him the future conflict with the Sphere Builders?

A. *U.S.S. Enterprise*-D

B. *U.S.S. Enterprise*-E

C. *U.S.S. Enterprise*-J

D. *U.S.S. Enterprise*-K

1312.

Though Archer had been informed of the existence of the temporal cold war, he directly enters the fray in the episode "Cold Front." When the *Enterprise* is nearly destroyed while observing a quasi-religious stellar event with pilgrims led by Prah Mantoos (shown at right with Archer, left and T'Pol, right), crewman Daniels reveals to Archer that he is more than a mere crewman.

Attempting to capture the Suliban Silik, Daniels took Archer into his confidence and showed him evidence that he was indeed from the future, including his temporal observatory. Archer decided he needed to discuss this with several of his senior officers.

Archer's officers believed Daniel's story in varying degrees. As Daniels worked with them, Trip half-jokingly asked for advance information on an engineering betting pool. Another officer made their adamant belief clear that time travel wasn't possible.

Which officer didn't believe in time travel?

A. T'Pol

B. Reed

C. Hoshi

D. Travis

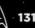

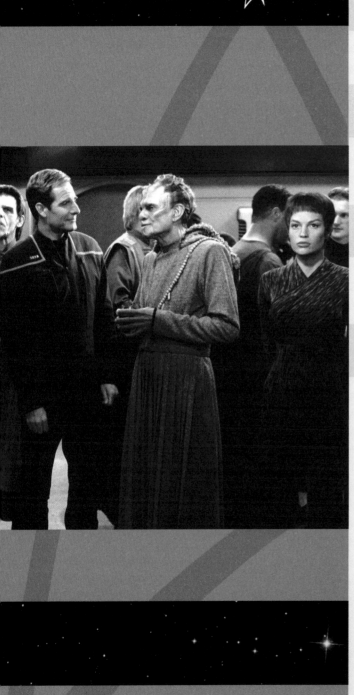

1314. How many spheres were there in the Expanse?

A. 42 **C.** 78

B. 64 **D.** 100

1315. Which MACO died in the episode "The Council?"

A. Major Hayes **C.** Corporal Hawkins

B. Cpl. Chang **D.** Cpl. Cole

1316. How old was T'Pol during the third year of the *Enterprise*'s mission?

A. 23 **C.** 72

B. 65 **D.** 112

1317. Which alien ally came to help Archer in his final showdown with the Xindi?

A. Soval **C.** Shran

B. Lorian **D.** Naarg

1318. Who was *not* a founding member race of the Federation?

A. Vulcans **C.** Klingons

B. Humans **D.** Andorians

1319. What was the name of the alien race in the temporal cold war that helped the Nazis take over the eastern coast of America?

A. Suliban **C.** Na'Kuhl

B. Procyons **D.** Sphere Builders

1320. Who on Shran's crew fell in love with him?

A. Tarah **C.** Talas

B. Jhamel **D.** Naarg

1321. Which Augment began to disobey his "father," Dr. Soong?

A. Persis **C.** Raakin

B. Udar **D.** Malik

1322. Whose Vulcan *katra* did Archer carry after Syrran mind-melded with him?

A. T'Les
B. T'Pol
C. Surak
D. Sarek

1323. What noncorporeal *Star Trek* original series aliens possessed members of the *Enterprise* crew as an "observer effect"?

A. Organians
B. Medusans
C. Dikronium cloud creatures
D. Thasians

1324. Which of the following ships did Trip temporarily transfer to?

A. *Intrepid*
B. NX-*Beta*
C. *Columbia*
D. NX-*Delta*

1325. What was the ironic twist about Orion slave girls?

A. Their green skin was cosmetic
B. They actually mastered their owners
C. They were genetically male
D. They never loved anyone

1326. What ship was Admiral Black aboard during Archer's attempt to take control of the Terran Empire?

A. *I.S.S. Revenge*
B. *I.S.S. Avenger*
C. *I.S.S. Malice*
D. *I.S.S. Invader*

1327. What *Constitution*-class ship enabled the mirror-universe Archer to nearly conquer Earth?

A. *U.S.S. Enterprise*
B. *U.S.S. Constellation*
C. *U.S.S. Defiant*
D. *U.S.S. Lexington*

1328.

1329. What was the name of the xenophobic group that attempted to destroy Starfleet command?

A. Earth First
B. United Earth Coalition
C. Section 31
D. Terra Prime

1328.

Using established events from both *Star Trek* and *The Next Generation*, as well as guest star Brent Spiner, the writers crafted not only the unexplored history after the Eugenics Wars, but also the explanation for the change in the Klingons' cranial ridges between the twenty-third and twenty-fourth centuries.

Over a trilogy of episodes, Spiner portrayed Dr. Soong (shown at right with Augments), a scientist obsessed with engineering better human beings. He had stolen augmented human embryos and raised those children as his own, until he was captured.

Thus began the Augments' quest to survive. Humanity had outlawed their very existence; they wanted to leave the planet Soong had raised them on and force humans to accept them–or be conquered by them. They eventually found their "father" and helped him escape, but even he would admit they had to be stopped.

Which of Soong's "children" helped free him—an act that cost the child's life?

A. Raakin
B. Persis
C. Malik
D. Lokesh

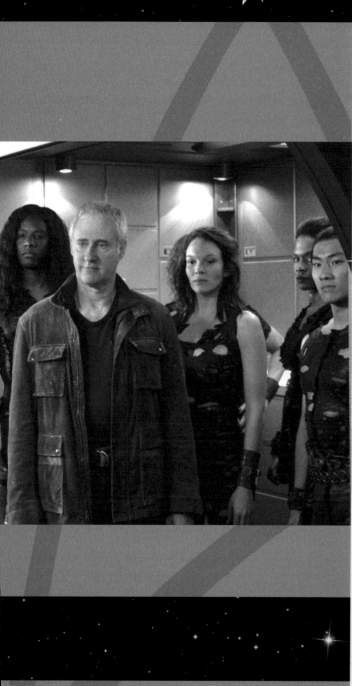

1330. What was the name of the baby cloned from T'Pol and Trip's DNA?

A. Gannett
B. Susan
C. Elizabeth
D. Maria

1331. Why did Shran need Archer's help in "These Are the Voyages ..."?

A. To stop a civil war
B. To free the Aenar
C. To form the United Federation
D. His daughter was kidnapped

1332. What did T'pol replicate to fool the pirates in the series finale?

A. Ditanium
B. Teneebian amythest
C. Falangian diamond
D. Promethean quartz

1333. What was the Vulcan insult Hoshi Sato hurled at T'Pol during the *Enterprise*'s maiden voyage?

A. *"Ish-veh ni komihn!"*
B. *"Ponfo mirann!"*
C. *"Tiamah!"*
D. *"Nirak!"*

1334. What does the "M" stand for in Class-M planets, according to Vulcans?

A. Milky Way–based
B. Metallurigical
C. Minshara
D. Meteorite-formed

1335. Why did the Xyrillians need the *Enterprise*'s plasma exhaust?

A. It was atmosphere for them
B. To breed
C. To replenish their own warp coils
D. To power their cloak

1336. What role did Jeffrey Combs *not* play in any of the *Star Trek* series?

A. Shran
B. Brunt
C. Morn
D. Weyoun

1337. What was Commander Shran's first name?

A. Thy'Lek
B. Tarah
C. Talas
D. Gral

1338. What was the name of the Vulcan ship that rescued Mayweather and Reed from a comet?

A. Ti'Mur
B. Ni'Var
C. Tal'Kir
D. Sh'Raan

1339. Who destroyed the temporal observatory in "Cold Front"?

A. Archer
B. Silik
C. T'Pol
D. Reed

1340.

1341. What was Chef's famous breakfast dish?

A. Blueberry pancakes
B. Stuffed Denobulan sausage
C. Bacon and egg pizza
D. Eggs Benedict

1342. How long was T'Pol's original assignment to the *Enterprise* supposed to last?

A. Eight hours
B. Three days
C. Eight days
D. Three years

1343. While trapped on the shuttlepod, what did Trip and Reed have to drink?

A. Tea
B. Romulan ale
C. Milk
D. Bourbon

1344. What regular *Voyager* cast member guest-starred as a Ferengi in "Acquisition"?

A. Robert Beltran
B. Robert Picardo
C. Ethan Phillips
D. Robert Duncan MacNeill

1345. Which *Deep Space Nine* cast member guest-starred as an engineer in "Oasis"?

A. Armin Shimerman
B. Rene Auberjonois
C. Cirroc Lofton
D. Colm Meaney

1340.

In the third-season finale, Archer (shown at right) and his crew were racing against time to stop a Xindi faction from taking the finished superweapon to Earth. Having made allies among the Xindi council, they also needed to defeat the Sphere Builders, transdimensional beings who had manipulated the Xindi for their own purposes.

As Archer engaged in hand-to-hand combat with the leader of the reptilian forces, T'Pol and Trip worked to destroy the spheres and defeat their creators.

With success on both fronts, the *Enterprise* headed toward Earth … but the victory was short-lived: Archer didn't appear to make it out from the weapon as it exploded, and the crew believed him dead. As the *Enterprise* approached Earth, they saw no sign of *anything* from the twenty-second century.

What holiday was it when the *Enterprise* destroyed the Xindi superweapon?

A. New Year's Eve
B. Martin Luther King Jr. Day
C. Valentine's Day
D. St. Patrick's Day

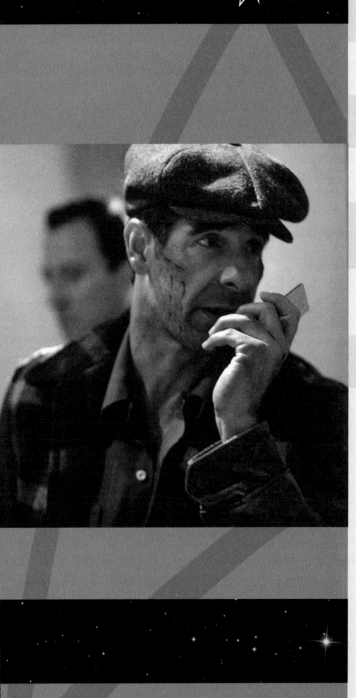

1346. Which actor, best known at the time for his role on *Quantum Leap*, guest-starred as Detention Complex 26's Colonel Grat?

A. Neil Patrick Harris C. Patrick Warburton
B. Dean Stockwell D. Jason Priestly

1347. How many days a year do Denobulans need to hibernate?

A. One C. Six
B. Three D. Nine

1348. What race was the mysterious Keyla, whom Archer met on Risa?

A. Suliban C. Torothan
B. Tandaran D. Mazarite

1349. What volatile by-product did the Paraagan II colony's mining produce?

A. Dicosilium C. Infernite
B. Tetrazine D. Hutzelite 27

1350. How did Trip and T'Pol escape from the Suliban helix in "Shockwave"?

A. Pretending to surrender Archer to Silik C. Faking a warp core breach
B. Rigging an implosion D. Impersonating Suliban

1351. How did the shipwrecked Vulcans in "Carbon Creek" acquire money at first?

A. Replicating currency C. Playing pool
B. Mining precious metals D. Stealing

1352. Who got pinned to the hull of the ship by a Romulan mine in "Minefield"?

A. Trip C. Archer
B. Reed D. Mayweather

1353. Which *Voyager* cast member directed and lent their voice to the computer in "Dead Stop"?

A. Jeri Ryan **C.** Roxann Dawson
B. Tim Russ **D.** Kate Mulgrew

1354.

1355. What Vulcan memory-suppression technique did T'Pol undergo after killing someone?

A. *Kahs-wan* **C.** Rite of Tal'oth
B. *Fullara* **D.** *fal-tor-pan*

1356. Who was the Arkonian pilot stranded with Trip in "Dawn"?

A. Zho'Khan **C.** Kaitaama
B. Khata'n Zshaar **D.** Firek Plinn

1357. Which of Dr. Phlox's wives came on board the *Enterprise* in "Stigma"?

A. Bogga **C.** Feezal
B. Yolen **D.** Zepht

1358. What act did most Vulcans consider taboo?

A. Mind-melding **C.** Living off-world
B. Praying **D.** Marrying aliens

1359. Which ship was *not* seen in Daniels's temporal database?

A. Klingon *Raptor*-class **C.** Ferengi *Marauder*
B. *Intrepid*-class ship **D.** *D'deridex*-class warbird

1360. The noncorporeal beings in "The Crossing" were unable to possess which crew member?

A. Porthos **C.** T'Pol
B. Phlox **D.** Tucker

1354.

Season four opened with Captain Archer and the crew arriving separately on Earth in an alternate time line where the Nazis had been aided by an alien faction from the temporal cold war. The Enterprise crew found history rewritten, and Germany now occupied the eastern seaboard of America.

After being captured by the Nazis, Archer escaped and met up with resistance fighters in New York City. Finally he reunited with his crew, who had thought him dead based on the events of the season-three finale. The time-traveling Daniels had also reappeared, dying as his body aged visibly at different rates. Once Archer carried out his mission, Daniels revived and showed him history returning to normal, and promised never to visit Archer again. However, one of Archer's other unlikely allies did not survive (shown at right with Archer, right), giving his life to help Archer complete his mission in Storm Front.

What did Archer's actions in the alternate past Earth cause?

A. Caused Daniels to die
B. Caused Daniels to never be born
C. Ended the temporal cold war
D. Allowed Silik's faction to win the temporal cold war

1361. What was the name of the ship that Duras, son of Toral, commanded?

A. *I.K.S. Amar* C. *I.K.S. Ch'Tang*
B. *I.K.S. Bortas* D. *I.K.S. Drovana*

1362. What was the name of Hudak's race, traditionally prejudiced against Denobulans?

A. Xantoran C. Vissian
B. Antaran D. Tarkalean

1363. Why were bounty hunters after Archer?

A. For escaping Rura Penthe C. For angering the emperor
B. For killing Duras D. For interfering in the temporal cold war

1364. How many Klingon darseks was Archer's bounty?

A. 8,000 C. 10,000
B. 9,000 D. 12,000

1365. What was Trip's sister's profession?

A. Astronomer C. Archaeologist
B. Architect D. Airline pilot

1366. Who commanded the *Intrepid* during the time of the Xindi attack on Earth?

A. Admiral Gardner C. Erika Hernandez
B. Carlos Ramirez D. A.G. Robinson

1367. In "Extinction," what was the name of the species Archer, Reed, and Sato began to mutate into?

A. Oran'taku C. Loque'eque
B. Osaarian D. Xindi-arboreal

1368. What Vulcan ship's automated distress call did the *Enterprise* respond to in the Expanse?

A. *Vaankara* C. *Seleya*
B. *Sh'Ran* D. *D'Vahl*

1369. How long was T'Pol addicted to trellium-D?

A. Three months
B. Six months
C. Nine months
D. Twelve months

1370.

1371. Who was the telepath who offered to help find the Xindi if Hoshi would stay on his exile planet with him?

A. Gralik
B. Yerdrin
C. Tarquin
D. Draysik

1372. Which *Watchmen* actor guest-starred as a Xindi-reptilian in "Carpenter Street"?

A. Billy Crudup
B. Jeffrey Dean Morgan
C. Matthew Goode
D. Patrick Wilson

1373. What did the Triannons call the spatial anomalies?

A. "Karmic upheavals"
B. "Breath of the Gods"
C. "The Maker's Breath"
D. "Eyes of the Makers"

1374. What type of aliens were the Sphere Builders?

A. Transdimensional
B. Subspatial
C. Fluidic space beings
D. Antimatter

1375. Who had to pilot the ship through a transspatial anomaly while the rest of the crew were sedated for protection?

A. T'Pol
B. Porthos
C. Dr. Phlox
D. Trip

1376. What crew member was "reverse-imprinted" by Xindi insectoid eggs to care for them?

A. Hoshi
B. Archer
C. T'Pol
D. Mayweather

1370.

In a *Star Trek* first, none of the regular characters appeared in the two-part episode "In A Mirror, Darkly"—though its cast remained unchanged. Viewers were shown the mirror-universe counterparts of the Enterprise crew, as a ship from the "real" universe's future decided the course of the burgeoning Terran Empire.

"In a Mirror, Darkly" was originally conceived as a way to bring William Shatner on as a guest star; when that didn't pan out, the writers found other ways to tie into the *Star Trek* original series history.

With the episodes "Mirror, Mirror" and "The Tholian Web," continuity was sidestepped as events were not portrayed in heavy detail. Characters were given darker roles (mirror T'Pol shown at right), and to emphasize the nature of the episode, even the opening credits were changed. Viewers also discovered that one *Enterprise* crew member rose to power and ruthlessly took control of the Empire that would later be conquered by the King-Cardassian Alliance.

Which character in the mirror universe became empress of the Terran Empire?

A. Elizabeth Tucker
B. Hoshi
C. T'Pol
D. Erika Hernandez

1377. Who was Lorian?

 A. A Xindi-reptillian in disguise

 B. Trip's son from an alternate future

 C. A MACO corporal who died

 D. Mayweather's brother

1378. How many spheres were integral to connecting all of the other spheres in the Expanse?

 A. Three

 B. Four

 C. Five

 D. Six

1379. How did the Delphic Expanse spheres connect with each other?

 A. Sphere controllers

 B. Transspatial networks

 C. Interspatial manifolds

 D. Neural nets

1380. What did Daniels show Archer about the future in "Zero Hour"?

 A. Archer getting married

 B. Archer having a son

 C. Archer helping found a United Federation of Planets

 D. Archer dying

1381. What personal information is considered intimate by Vulcans?

 A. Age

 B. Birth date

 C. Weight

 D. Sexual partners

1382. What ship did the *Enterprise* travel within to reach Earth after the final confrontation with the Xindi?

 A. Dolim's ship

 B. Shran's ship

 C. Xindi-aquatic ship

 D. *Selaya*

1383. Where did Archer show up after the superweapon exploded?

 A. Aboard the *Enterprise*

 B. A Nazi medical camp in the past

 C. The Xindi council room

 D. The twenty-ninth century

1384. Which Na'Kuhl agent gave the Nazis advanced weaponry in exchange for resources he needed to build a temporal conduit?

 A. Ghrath

 B. Vosk

 C. Kraul

 D. D'Vahl

1385. Who was the 1944 Brooklynite who helped Archer fight to restore the time line?

A. Joe Prazki
B. Alicia Travers
C. Nicky Jorjo
D. Tanner

1386. What was Silik's mission in "Storm Front"?

A. Kill Archer
B. Cure Daniels
C. Steal Vosk's technology
D. Defeat the Nazis

1387.

1388. After his failure to perfect humanity, what branch of science did Dr. Soong turn to?

A. Nanobiotics
B. Cryogenics
C. Temporal research
D. Artificial life-forms

1389. What was the Vulcan *kir'shara*?

A. A rare mind-meld
B. The writings of Surak
C. A gourmet dish
D. A band of rebel Vulcans

1390. Who was trying to provoke a conflict between the Federation and Klingons in "Babel One"?

A. Romulans
B. Tellarites
C. Andorians
D. Vulcans

1391. Which episode introduced the small community of the blind, albino Andorians?

A. "The Aenar"
B. "Affliction"
C. "The Augments"
D. "Home"

1392. What abilities did the albino Andorians possess?

A. Telepathy
B. Clairvoyance
C. Telekinesis
D. Pyrokinesis

1393. Which Andorian was being used by the Romulans to pilot their holographically disguised drone ship?

A. Lissan
B. Gareb
C. Jhamel
D. Talla

1387.

May 13, 2005 marked the end of an era: For the first time since 1987, there was no ongoing *Star Trek* series in production and no films were in the works. *Star Trek* fans were sent a "valentine" by the show's executive producers in the form of a grand series finale, "These Are the Voyages…"

The episode dealt with the events of the last mission of the NX-01 *Enterprise*, set ten years after the events of the prior episode. The events were shown as a holodeck simulation run by Commander William Riker (shown at right with Troi, right) during the events of a *Next Generation* episode, "The Pegasus," as he decided how to confront his former commanding officer.

While in the holodeck simulation, Riker interacted with NX-01 characters as another oft-referenced crew member.

Who was it?

A. Porthos
B. Daniels
C. Chef
D. Billy

1394. Why was Trip unaffected by the Orion slave girls' pheromones?

A. His insomnia

B. His psychic bond with T'Pol

C. He was allergic to them

D. The warp core shielded him

1395. In the mirror universe, what did Zefram Cochrane do when the Vulcans landed on Earth?

A. Ran from them

B. Captured them

C. Enslaved them

D. Shot them

1396. How did Porthos insult the Kreetassans?

A. "Watering" their tree

B. Biting the ambassador

C. Barking

D. Eating sacred food

1397. Who stole the mirror Hoshi from Archer when the former became captain?

A. Trip

B. Forrest

C. Reed

D. Mayweather

1398. How did John Frederick Paxton and his followers attempt to destroy Starfleet command?

A. Rogue comet

B. Hijacking *Enterprise*

C. Verteron array

D. Xindi superweapon

1399. What planet did the Enterprise crew revisit to rescue Shran's daughter in the episode, "These Are the Voyages ..."?

A. Secarus IV

B. Rigel X

C. Teerza Prime

D. Matalas

1400. What was the name of Shran's daughter in the future depicted in "These Are the Voyages ..."?

A. Jhamel

B. Tarah

C. Talas

D. Talla

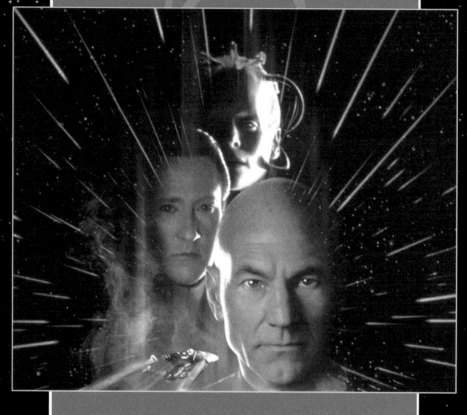

1401. What was James T. Kirk's rank at the beginning of the first *Star Trek* film?

 A. Captain **C.** Vice Admiral

 B. Admiral **D.** Major

1402. At the beginning of the first *Star Trek* film, what Vulcan ritual was Spock undergoing?

 A. *Pon farr* **C.** *Fal-tor-pan*

 B. *Kahs-woon* **D.** *Kolinahr*

1403. Who was the captain of the *U.S.S. Enterprise* prior to Admiral Kirk's return?

 A. Sulu **C.** Will Decker

 B. Spock **D.** Chekov

1404. Who was the Deltan navigator in the first *Star Trek* film?

 A. Decker **C.** Branch

 B. Ilia **D.** Nogura

1405. What station did Chekov man in *Star Trek: The Motion Picture*?

 A. Communications **C.** Weapons

 B. Helm **D.** Science

1406. Who was assigned to transporter duty aboard the *U.S.S. Enterprise*?

 A. Chief DiFalco **C.** Scotty

 B. Janice Rand **D.** Ensign Perez

1407. Where did the crew of the *Enterprise* keep their communicators in *Star Trek: The Motion Picture*?

 A. Belt **C.** Pocket

 B. Wrist **D.** Insignia badge

LEFT Movie poster for *First Contact*.

1408. What did the V'ger probe refer to humans as?

A. Inferior beings
B. Creators
C. Carbon units
D. Ugly bags of mostly water

1409. What "little known, seldom used" clause brought Dr. McCoy back into Starfleet?

A. Hippocratic retention
B. Reserve activation
C. On-call status
D. Field duty promotion

1410. Who joined with V'ger so it could evolve?

A. Ilia
B. Spock
C. Decker
D. Kirk

1411. What film introduced the Starfleet "no-win scenario" test for cadets?

A. *The Final Frontier*
B. *The Search for Spock*
C. *The Voyage Home*
D. *The Wrath of Khan*

1412. What was the name of the Starfleet Academy "no-win scenario"?

A. Genesis I
B. *Kobayashi Maru*
C. Revelations 1
D. Space Seed gambit

1413. Who was the only cadet ever to beat the no-win scenario?

A. Spock
B. Scotty
C. Kirk
D. McCoy

1414.

1415. What ship was Chekov assigned to at the beginning of *Star Trek II*?

A. *U.S.S. Grissom*
B. *U.S.S. Bozeman*
C. *U.S.S. Excelsior*
D. *U.S.S. Reliant*

1416. What form of mind control did Khan utilize?

A. Hypnosis
B. Implanted Ceti eels
C. Charisma
D. Telepathy

1414.

Star Trek creator Gene Roddenberry had been trying to revive *Star Trek* since the original series was canceled. An animated version of the series ran for a season and a half, but his plans for a *Phase II* TV show never materialized. Eventually the success of George Lucas's *Star Wars* at the box office helped convince Paramount to greenlight a *Star Trek* film. Building on what Roddenberry had planned to put into a *Star Trek Phase II* television series, the movie began to take shape.

The original cast reunited, with some new additions, and *Star Trek*'s second life began. The film was a commercial success, breaking U.S. box office records with an opening weekend of $11 million.

Star Trek: The Motion Picture (cast shown at right) was the first and last *Star Trek* film to carry which Motion Picture Association of America rating?

A. R
B. PG
C. PG-13
D. G

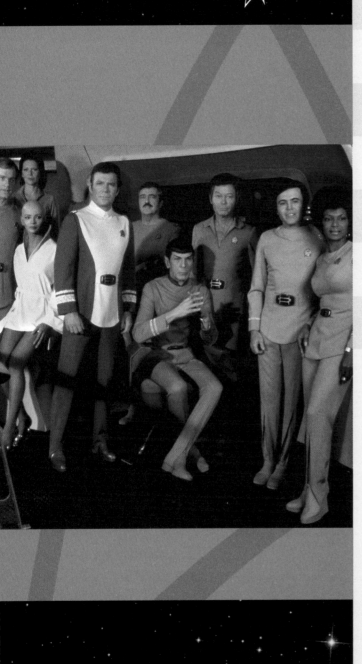

1417. Who developed the Genesis project?

 A. Khan **C.** Saavik

 B. Carol & David Marcus **D.** Terrell

1418. Whose son was David Marcus revealed to be?

 A. Chekov **C.** Spock

 B. Kirk **D.** McCoy

1419. Who first said, "The needs of the many outweigh the needs of the few"?

 A. McCoy **C.** Spock

 B. Saavik **D.** Sarek

1420. What officer gave his life to save the ship by fixing the main reactor?

 A. Scott **C.** Chekov

 B. Spock **D.** Sulu

1421. Who took over the role of Saavik in the third and fourth *Star Trek* films?

 A. Kim Cattrall **C.** Sarah Jessica Parker

 B. Robin Curtis **D.** Markie Post

1422. What actor known for his role in *Taxi* played Klingon commander Kruge?

 A. Danny DeVito **C.** Christopher Lloyd

 B. Jeff Conaway **D.** Tony Danza

1423. What type of propulsion did the *U.S.S. Excelsior* boast?

 A. Quantum slipstream **C.** Transwarp

 B. Subspace **D.** Spatial folding

1424. What furry *Star Trek* original series alien was briefly seen in the bar scene in *Star Trek III*?

 A. Mugato **C.** Horta

 B. Tribble **D.** Gorn

1425. Who directed *The Search for Spock*?

A. William Shatner
B. Gene Roddenberry
C. George Takei
D. Leonard Nimoy

1426. How did David Marcus die in *The Search for Spock*?

A. Protomatter explosion
B. Transporter malfunction
C. Protecting Saavik from Klingons
D. Suicide

1427.

1428. Who reprised his role as Ambassador Sarek in *Star Trek III & IV*?

A. Frank Gorshin
B. Mark Lenard
C. Ricardo Montalban
D. Roger C. Carmel

1429. Why did the Klingons want the Genesis device?

A. To terraform their dying moon
B. To use as a weapon
C. To ransom it for Kirk
D. To repurpose its energy supply

1430. What ship did the *Enterprise* crew use to get to Vulcan?

A. *U.S.S. Grissom*
B. *U.S.S. Enterprise*
C. Kruge's bird-of-prey
D. *Galileo Seven*

1431. What was the first Starfleet vessel seen incapacitated by the alien probe in *The Voyage Home*?

A. *U.S.S. Excalibur*
B. *U.S.S. Saratoga*
C. *U.S.S. Yorktown*
D. *U.S.S. Excelsior*

1432. What was Kiri-kin-tha's first law of metaphysics?

A. As within, so without
B. Cause follows effect, unless it doesn't
C. Nothing unreal exists
D. The good of the real outweighs the good of the unreal

1433. How did the *Enterprise* crew travel back into the past?

A. Temporal "blowhole"
B. Slingshot around the sun
C. Guardian of Forever
D. Temporal wormhole

1427.

In *The Wrath of Khan*, the past came back to haunt James Kirk from all sides. The race to stop the detonation of the Genesis device found Kirk running up against an old foe, an old flame, and a relative he never knew he had.

Project Genesis was a terraforming project on a planetary scope. By destroying and realigning existing matter on the subatomic scale, the Genesis device's preprogrammed matrix could create a habitable world. But like so many scientific inventions, it could be perverted into a weapon.

The plot elements Genesis introduced in *Star Trek II* would continue through the next two films, allowing the crew to also undergo a process of emotional rebirth (and in one officer's case, a literal rebirth).

Which officer would die (coffin shown at right with crew standing at attention) and, through the Genesis effect, be reborn in the next film?

A. Kirk
B. Spock
C. David Marcus
D. Uhura

1434. What whale species did the crew of the *Enterprise* need to answer the alien probe's signal?

A. Blue C. Gray
B. Killer D. Humpback

1435. How did Kirk explain Spock's odd behavior to Dr. Taylor?

A. He was from another country C. Too much "LDS" in the '60s
B. He was obsessed with whales D. He was a savant

1436. What futuristic material did Scotty give Dr. Nichols the formula for?

A. Dilithium C. Transparent silicone
B. Transparent aluminum D. Antigravitic steel

1437. What were the "colorful metaphors" Spock questioned Kirk about?

A. Slang C. Epithets
B. Profanity D. Pop lyrics

1438. Why did Uhura and Chekov need to collect photons from the nuclear "wessel"?

A. To recharge the temporal transport C. To heal Dr. McCoy
B. To recrystallize the dilithium D. To transport the whales

1439. How did Dr. Taylor get on board the Klingon ship?

A. She snuck in C. The hatch was open
B. She grabbed Kirk while in transport D. She was brought in while unconscious

1440. Where was Chekov taken when injured?

A. St. Elegius C. Cedars-Sinai
B. Seattle Grace D. Mercy Hospital

1441. What rank was Kirk demoted to from Admiral?

A. Lieutenant Commander C. Ensign
B. Commodore D. Captain

1442. Where did Kirk, Spock, and McCoy go while on shore leave in *The Final Frontier*?

A. Redwood National Forest
B. Risa
C. Yosemite
D. Alaska

1443. What was the name of the "Planet of Galactic Peace"?

A. Orion IV
B. Rigel VI
C. Nimbus III
D. Babel

1444.

1445. Where was *Sha-Ka-Ree* located?

A. Outside of space and time
B. The mirror universe
C. The Neutral Zone
D. Center of the galaxy

1446. What was the Romulan name for *Sha-Ka-Ree*?

A. Eden
B. *Qui'Tu*
C. *Vorta Vor*
D. *Tal Shiar*

1447. What shuttle did Kirk and crew take down to the "Planet of Galactic Peace"?

A. *Great Bird of the Galaxy*
B. *Galileo V*
C. *Copernicus I*
D. *Newton III*

1448. Who sang to provide a distraction for the *Enterprise* crew to commandeer some horses?

A. Spock
B. Uhura
C. Kirk
D. Sulu

1449. Why did "God" need a starship in *The Final Frontier*?

A. To spread his wisdom
B. To escape *Sha-Ka-Ree*
C. To wreak vengeance
D. To go home

1450. What was McCoy's secret ingredient for Southern baked beans?

A. Sugar
B. Scotch whisky
C. Fatback
D. Mint

1444.

The relationship between Spock and McCoy (shown at right) deepened over time—but never stopped being fractious. Always on opposite ends of the emotional spectrum, the passionate McCoy argued about almost everything with the coolly logical Spock.

So it came as a surprise that in *The Search for Spock*, when Spock's father asked Kirk why he hadn't brought Spock's living soul (or *katra*) back to Vulcan, it turned out Spock had transferred his *katra* to McCoy rather than his best friend.

Spock's manner, personality, and even speech patterns would sometimes eerily come through McCoy as the crew attempted to retrieve Spock's body and take it and McCoy to Vulcan. However, there was one Spock characteristic McCoy attempted but could not successfully manage.

What was it?

A. Mind-meld
B. Nerve pinch
C. Vulcan salute
D. Manning the science station

1451. What campfire song did Spock finally sing?

A. "Camptown Races" **C.** "Row, Row, Row Your Boat"
B. "Moon Over Rigel VII" **D.** "Do Your Ears Hang High"

1452. What Vulcan proverb did Spock quote to try and convince Kirk to escort the Klingon chancellor in *The Undiscovered Country*?

A. "One man can summon the future." **C.** "No good deed goes unpunished."
B. "The dream dreams the dreamer." **D.** "Only Nixon could go to China."

1453. What was the name of the Klingon moon that exploded?

A. Vixis **C.** Qo'noS
B. Praxis **D.** Remus

1454. Who became captain of the *U.S.S. Excelsior* in *Star Trek VI*?

A. Spock **C.** Scott
B. Chekov **D.** Sulu

1455. Where did the Federation-Klingon peace talks take place?

A. Camp Khitomer **C.** Camp Babel
B. Camp David **D.** Vulcan

1456. What was the name of the Klingon prison planet where Kirk and McCoy were incarcerated?

A. Rura Penthe **C.** Praxis
B. Risa **D.** Coridan

1457. Who did Martia impersonate when fighting Kirk in *The Undiscovered Country*?

A. McCoy **C.** A guard
B. Kirk **D.** A young girl

1458. How did Spock acquire the proof of the conspiracy to kill Gorkon?

A. Found the gravity boots **C.** Found West's transmissions
B. Forced mind-meld with Valeris **D.** Forced Chang's confession

1459. Who was *not* part of the conspiracy to assassinate Chancellor Gorkon and the Federation president?

A. Valeris
B. Admiral Cartwright
C. Sarek
D. Nanclus

1460. What heading did Kirk give Chekov at the end of *Star Trek VI*?

A. "That way."
B. "Once around the solar system, mister."
C. "To infinity ... and beyond!"
D. "Second star to the right and straight on till morning."

1461. Which future *Enterprise*-D crew member was rescued from the Nexus by the *Enterprise*-B?

A. Riker
B. Guinan
C. Troi
D. Data

1462. Which El-Aurian devoted his or her life to getting back to the Nexus?

A. Guinan
B. Soran
C. Martus
D. Terkim

1463. Which *Enterprise*-D crew member was promoted to lieutenant commander during the holodeck naval ceremony?

A. Data
B. Geordi
C. Worf
D. Troi

1464. Whose brother and nephew died in *Star Trek Generations*?

A. Riker
B. Guinan
C. Picard
D. Barclay

1465. In *Star Trek Generations*, why couldn't Data prevent Geordi's kidnapping?

A. His emotion chip overwhelmed him
B. He was deactivated
C. He didn't see it happen
D. He was not programmed for that

1466.

1467. In *Star Trek Generations*, whom did Picard see in the Nexus?

A. Lursa
B. A family he never had
C. Q
D. Vash

1466.

The highest grossing *Star Trek* film of the franchise (prior to the 2009 film), *The Voyage Home* made $109 million in the United States alone. Rounding out the unofficial "Genesis Trilogy" events of Spock's death and rebirth, the film found the crew headed home to Earth, to face the consequences for stealing the *U.S.S. Enterprise* in order to save Spock. They were met with a planetary catastrophe, and the only way to save Earth was to go back in time to the 1980s to retrieve whales (shown at right) that could answer a destructive alien probe's call. Kirk and Spock managed to find two whales at the San Francisco Cetacean Institute.

What were the names of the whales?

A. Lucy and Ricky
B. George and Gracie
C. Fred and Ginger
D. Sonny and Cher

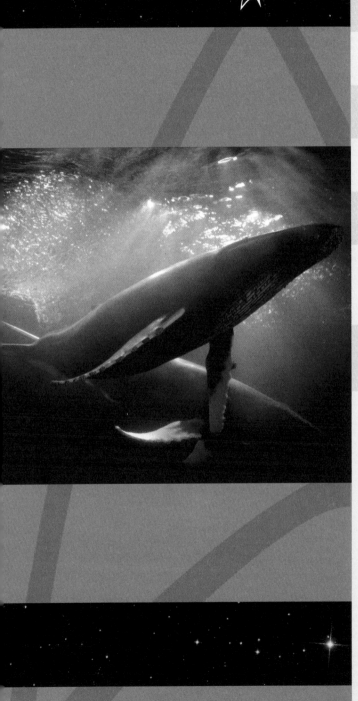

1468. What was Soran using to collapse the stars?

A. Antimatter C. Trilithium

B. Infernite D. Sorium

1469. Who killed Captain Kirk?

A. Picard C. The Klingon sisters

B. Soran D. Khan

1470. Who did Data find trapped in the *Enterprise* wreckage?

A. Guinan C. Spot

B. Nurse Ogawa D. Geordi

1471. The *U.S.S. Enterprise* NCC-1701-E is what class of ship?

A. *Galaxy* C. *Icarus*

B. *Sovereign* D. *Oberth*

1472. What did Geordi replace his VISOR with in *First Contact*?

A. Nanoprobe cortexes C. Ocular implants

B. VISOR Mark II D. Acuity lens implants

1473. Why did Starfleet order Picard to the Romulan Neutral Zone?

A. Borg were attacking there C. They didn't trust him against the Borg

B. He was the second line of defense D. To request aid from the Romulans

1474. What did the *Enterprise* crew have to travel back in time to fix?

A. Picard's assimilation C. Their first meeting with the Borg

B. Earth's first contact with Vulcans D. The Borg queen's ascension to power

1475. What historical figure did the *Enterprise*-E crew meet in *First Contact*?

A. Neil Armstrong C. Thomas Edison

B. Leonardo da Vinci D. Zefram Cochrane

1476. What holodeck program did Picard revisit during *First Contact*?

A. Sherlock Holmes
B. Dixon Hill
C. Robin Hood
D. Barclay Program 15

1477. What was the name of the first warp-capable ship on Earth?

A. *Cyclops*
B. *Phoenix*
C. *Beast*
D. *Angel*

1478. Which *U.S.S. Voyager* crew member appeared in *First Contact*, albeit holographically?

A. Chakotay
B. Emergency Medical Hologram
C. Neelix
D. Tuvok

1479. Who said, "The line must be drawn here! This far, no further!"?

A. Worf
B. Hawk
C. Picard
D. Riker

1480. How did Data destroy the Borg queen's organic components?

A. Shooting her
B. Warp plasma coolant
C. Phaser overload
D. Disruptor rays

1481. How did Picard destroy the Borg queen's synthetic components?

A. Deactivated her
B. Broke her mechanical spine
C. Downloaded and erased her memory
D. Melted her exoskeleton

1482. What is the name of the region of space where the Ba'ku planet is located?

A. Mutara sector
B. Typhon sector
C. Delphic Expanse
D. Briar Patch

1483.

1484. What did Data destroy that revealed the Federation's presence to the Ba'ku?

A. Starship
B. Duck blind
C. Tachyon generator
D. Shield generator

1483.

The Final Frontier was an ambitious look at family, death, and what lies beyond (the Vulcan Sha Ka Ree shown at right). Unfortunately, many factors contributed to its poor performance.

The writer's strike of 1988 caused the film's preproduction budget to be slashed. The studio demanded that the story be as lighthearted as the successful *Star Trek IV*, and with an untested director at the helm, the film was as shaky as the newly commissioned ship its crew traveled on.

While the previous successful installments had been directed by his costar, which *Star Trek* cast member helmed *The Final Frontier* to a rocky box office of only $17 million?

A. Leonard Nimoy
B. William Shatner
C. George Takei
D. James Doohan

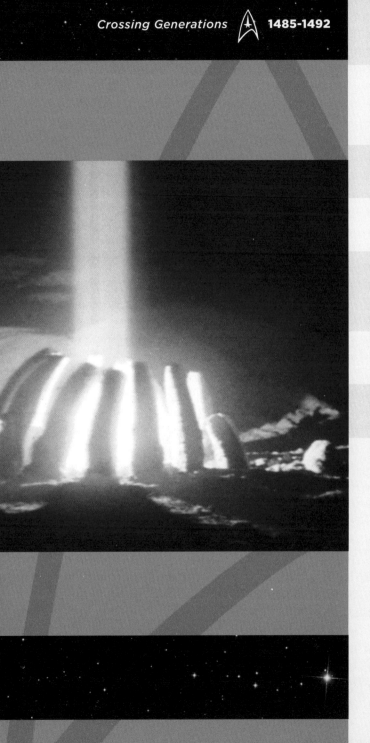

1485. Who rekindled their romance while on the Ba'ku mission?

A. Picard and Crusher **C.** Riker and Troi

B. Worf and Troi **D.** Data and D'sora

1486. In *Insurrection*, what did radiation allow Geordi to experience for the first time?

A. Puberty **C.** Love

B. Seeing a sunset with unaided eyes **D.** Singing

1487. What is the name of the captain's yacht?

A. *Kon-Tiki* **C.** *Magellan*

B. *Cousteau* **D.** *Sacagawea*

1488. Who was the ill-fated admiral who was working with the Son'a?

A. Kathryn Janeway **C.** Marcus Holt

B. Owen Paris **D.** Matthew Daugherty

1489. What was the secret behind the Son'a's hostility towards the Ba'ku?

A. They were once conquered by the Ba'ku **C.** They were banished by the Ba'ku after a failed rebellion

B. The Ba'ku blocked their entry into the Federation **D.** They thought the Ba'ku were Changelings

1490. How did Riker and Geordi defeat the Son'a's isolytic weapons?

A. Rammed the ship **C.** Photon torpedo barrage

B. Ejected the warp core **D.** Beamed the weapons array out

1491. Who betrayed Ru'afo to help Starfleet save the Ba'ku?

A. Daugherty **C.** Gallatin

B. Data **D.** The Tarlac servant

1492. What type of radiation killed the entire Romulan Senate in *Nemesis*?

A. Metaphasic **C.** Nucleonic

B. Thalaron **D.** Thermionic

1493. Shinzon was a clone of which *Enterprise* crew member?

A. Riker
B. Yar
C. Picard
D. Crusher

1494. Whose wedding reception was held aboard the *Enterprise*?

A. Lwaxana Troi & Mr. Homm
B. Picard & Dr. Crusher
C. Guinan & La Forge
D. Riker & Troi

1495. What was the name of Data's android predecessor?

A. Lore
B. B4
C. Lal
D. Datum

1496. What was the name of the four-wheeled vehicle the Captain drove in *Nemesis*?

A. *Odyssey*
B. *Troy*
C. *Poseidon*
D. *Argo*

1497. What *Voyager* crew member has been promoted to admiral by the time of *Nemesis*?

A. Paris
B. Chakotay
C. Janeway
D. Emergency Medical Hologram

1498. What was the name of Shinzon's ship?

A. *Claw*
B. *Hammer*
C. *Axe*
D. *Scimitar*

1499. Who sacrificed himself to destroy Shinzon's weapon in *Nemesis*?

A. Data
B. Picard
C. Riker
D. Shinzon

1500.

1501. When was *Star Trek: The Motion Picture* released in the United States?

A. December 20, 1977
B. January 1, 1978
C. December 24, 1978
D. December 7, 1979

1500.

The *Star Trek* film series rebounded with the last outing of the original series crew. Despite misgivings left over from the previous film, and producer Harve Bennett's desire to do a Starfleet Academy prequel, *The Undiscovered Country* made $18 million its first weekend alone. Several facts were finally established as canonical (such as Sulu's first name and Kirk's middle name), and it marked the last appearance of Dr. McCoy (shown at right with Kirk, left) and Lieutenant Uhura in the *Star Trek* franchise.

While the next film would be considered the true passing of the torch to *The Next Generation*, as it wrapped its successful television run and began its life as a film franchise, *Star Trek VI* added subtle links to the television show. Spock's comments to Picard in the opening of the episode "Unification, Part II" echoed back to the events of *The Undiscovered Country*. And a *Next Generation* actor even portrayed his own ancestor.

Who played the Colonel who defended Kirk and McCoy at their trial for the death of the Klingon chancellor?

A. Patrick Stewart
B. Jonathan Frakes
C. LeVar Burton
D. Michael Dorn

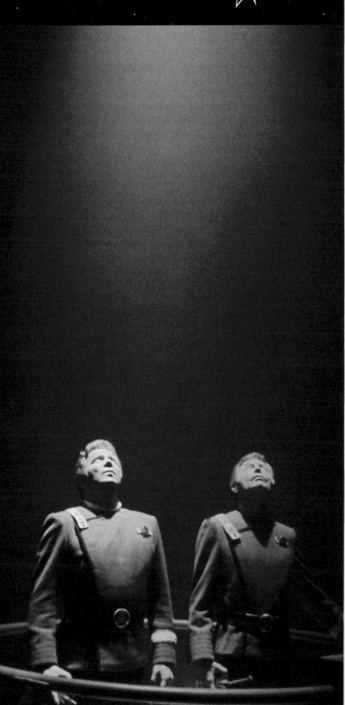

 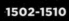
1502. Who was the Vulcan commander assigned to *Enterprise* as science officer, based on Kirk's recommendation?

A. Ilia **C.** Sonak

B. T'sai **D.** T'Pau

1503. How many months of refit had the *Enterprise* undergone by the time of the events of *Star Trek: The Motion Picture*?

A. Six **C.** Forty-seven

B. Eighteen **D.** Twenty-four

1504. What space station monitored the Klingons' attack on the cloud entity?

A. Regula One **C.** SpaceDock

B. Deep Space 9 **D.** Epsilon Nine

1505. What happened to Commander Sonak in the first *Star Trek* film?

A. Resigned in protest **C.** Recalled to Vulcan

B. Died in a transporter malfunction **D.** Reassigned

1506. How large was the intruder's cloudlike power field in *Star Trek: The Motion Picture*?

A. Eighty-two astronomical units **C.** Ten light-years

B. Galaxywide **D.** Twelve light-years

1507. What caused the wormhole that the *Enterprise* was briefly trapped in?

A. Gravimetric distortions **C.** Engine imbalance

B. Klingon weapons **D.** V'ger

1508. What characteristic was highly developed in the Deltan race?

A. Sexuality **C.** Physical strength

B. Mental abilities **D.** Immune system

1509. What was V'ger?

A. Janeway's ship from another time line **C.** Probe from the Borg home world

B. *Voyager 6* NASA probe **D.** Machine deity

1510. How did Kirk list the two "casualties" in his log?

A. Dead **C.** Killed in action

B. Evolved **D.** Missing

1511. What planet did the *U.S.S. Reliant* crew believe they were orbiting?

- **A.** Ceti Alpha V
- **B.** Regula I
- **C.** Ceti Alpha VI
- **D.** Regula IX

1512. What planet was the *U.S.S. Reliant* actually orbiting?

- **A.** Earth
- **B.** Romulus
- **C.** Regula
- **D.** Ceti Alpha V

1513. In *The Wrath of Khan*, what was the marooned ship discovered by the crew of the *U.S.S. Reliant*?

- **A.** *S.S. Botany Bay*
- **B.** *U.S.S. Enterprise*-A
- **C.** *U.S.S. Defiant*
- **D.** *Wotan*

1514. Which former *Enterprise* crew member had died while in exile with Khan?

- **A.** Janice Rand
- **B.** Marla McGivers
- **C.** Lieutenant Leslie
- **D.** Marlena Moreau

1515. What was Starfleet General Order 15?

- **A.** Formal relief of a commanding officer by his or her successor
- **B.** No flag officer shall beam into a hazardous area without armed escort
- **C.** Captain shall be relieved of duty if declared unfit by the chief medical officer
- **D.** Must assist any vessel in distress

1516. What was Regulation 46a?

- **A.** *Kobayashi Maru* simulations may not be reprogrammed
- **B.** If transmissions are being monitored during battle, no uncoded messages may be sent on an open frequency
- **C.** Evacuation is mandatory in the case of shipwide catastrophe
- **D.** Landing parties must report to the bridge at least once every twenty-four hours

1517. What nebula did the *Enterprise* fight the *Reliant* in?

- **A.** Horsehead
- **B.** Regula
- **C.** Mutara
- **D.** Genesis

1518. What *Cheers* regular portrayed Saavik?
- **A.** Shelley Long
- **B.** Rhea Perlman
- **C.** Kirstie Alley
- **D.** Bebe Neuwirth

1519. What is the old Klingon proverb about revenge?
- **A.** "Revenge is a dish best served cold."
- **B.** "Only a fool fights in a burning house."
- **C.** "4,000 throats may be cut in one night by a running man with a knife."
- **D.** "There is no victory without combat."

1520. Which actor provided the voice-over for the familiar "These are the voyages ..." credo at the end of *Wrath of Khan*?
- **A.** Leonard Nimoy
- **B.** William Shatner
- **C.** Nichelle Nichols
- **D.** William Koenig

1521. What ship are Saavik and David Marcus assigned to at the beginning of *The Search for Spock*?
- **A.** U.S.S. Excelsior
- **B.** U.S.S. Enterprise
- **C.** U.S.S. Grissom
- **D.** U.S.S. Reliant-A

1522.

1523. Who was the Starfleet commander who ordered Kirk not to go to the Genesis planet?
- **A.** Admiral Nogura
- **B.** Captain Estaban
- **C.** Admiral Morrow
- **D.** Captain Styles

1524. Who got reassigned to the *U.S.S. Excelsior* in *The Undiscovered Country*?
- **A.** McCoy
- **B.** Scotty
- **C.** Sulu
- **D.** Uhura

1525. What illegal substance did David Marcus use in the matrix of the Genesis device?
- **A.** Protomatter
- **B.** Romulan ale
- **C.** Cannabis
- **D.** Omega molecules

1526. How many different actors portrayed Spock in *Star Trek III: The Search For Spock*?
- **A.** Two
- **B.** Three
- **C.** Four
- **D.** Five

1522.

After Gene Roddenberry's death in 1995, the *Star Trek* franchise was turned over to executive producer Rick Berman. The first foray into films for the *Star Trek: The Next Generation* crew would be momentous: not only would a time-spanning villain cause Picard (shown at left with Riker, right) to meet with the legendary James T. Kirk, but the crew would get new uniforms, new combadges, and a new medium for marketing—the Internet. Appropriately enough for a film about the future, in 1994 *Generations* launched the first official film website.

The film brought back Guinan, the Duras sisters, and Data's emotion chip, and saw the death of James Kirk as well as the crash landing of the *U.S.S. Enterprise*-D.

Who was at the helm as the ship crashed into the terrain of Veridian III?

- **A.** Deanna Troi
- **B.** Data
- **C.** Worf
- **D.** Riker

1527. How did Spock's body come back to life?

A. Vulcan *kahs-woon*

B. The still-active Genesis radiation

C. Antimatter radiation

D. He was not really dead

1528. What was the Vulcan rite of refusion?

A. *Fal-tor-pan*

B. *Kahs-woon*

C. *pok tar*

D. *Tal shaya*

1529. What did Uhura call the cadet she imprisoned in a closet?

A. "Old-timer"

B. "Mr. Action"

C. "Mr. Adventure"

D. "Mr. Snitch"

1530. Who told Spock, "The needs of the one outweigh the needs of the many"?

A. McCoy

B. Sarek

C. Kirk

D. Saavik

1531. Who directed *Star Trek IV*?

A. Nicholas Meyer

B. Leonard Nimoy

C. William Shatner

D. Walter Koenig

1532. Who was the matron of Vulcan philosophy?

A. T'Plana-Hath

B. Surak

C. T'sai

D. T'lani

1533. What Klingon object did Spock recognize during the testing of his mind after his rebirth?

A. *d'k tahg* knife

B. Bird-of-Prey

C. Kahless's sword

D. Mummification glyph

1534. Who was one of the "giants" of literature Spock referred to while in the past?

A. Gore Vidal

B. Jacqueline Susann

C. Truman Capote

D. Richard Bach

1535. What was Chekov's serial number?

A. 668-1701C

B. 669-3247D

C. 665-5872B

D. 1701-222D

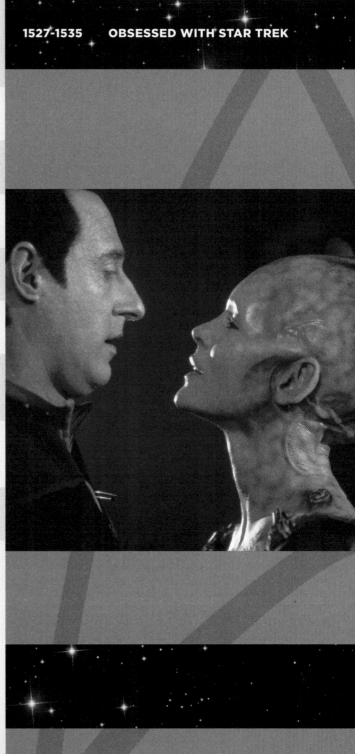

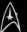
1538.

The Next Generation crew's second film outing was more successful than anyone could have hoped. Its $30 million opening box office made *First Contact* the best opening among the first ten films. Featuring time travel, the Borg, and a new ship, the sophomore film pleased almost everyone.

Picking up plot threads from Picard's assimilation in the third-season cliff-hanger, this film also had what *The Wrath of Khan* brought: a strong villain. But giving a "face" to a race of hive-mind cybernetic drones required a different approach. Thus the Borg queen was born. Inexplicably separate and yet still connected to the Borg communal mind, she tempted Data to join her (shown at left) in her quest to achieve perfection.

How long did he think about her offer?

A. 0.24 seconds
B. 0.68 seconds
C. 5 seconds
D. 5 minutes

1536. How did Kirk acquire money in the 1980s?
A. Stole it
B. Replicated it
C. Sold the antique glasses McCoy gave him in *Star Trek II*
D. Sold the secret of transparent aluminum

1537. Who said, "No, I'm from Iowa. I only work in outer space."
A. Uhura
B. Kirk
C. McCoy
D. Sulu

1538.

1539. What type of computer did Scotty use while at Plexicorp?
A. IBM
B. Dell
C. Macintosh
D. Gateway

1540. When McCoy claimed Taylor had "immediate postprandial upper abdominal distension," what was he saying she had?
A. Cramps
B. Labor pains
C. Interior bleeding
D. Hardened arteries

1541. What mountain was Kirk climbing at the beginning of *Star Trek V*?
A. Mount Everest
B. El Capitan
C. Mount St. Helens
D. Mount Diablo

1542. Who was the bored Klingon officer who wanted more of a challenge than shooting "space garbage"?
A. Korrd
B. Sybok
C. Klaa
D. Vixis

1543. Who was the Romulan ambassador to Nimbus III?
A. Vixis
B. J'onn
C. Caitlin Dar
D. Nanclus

1544. David Warner played the human ambassador in *Star Trek V*; in *Star Trek VI*, he would be a high-ranked Klingon. Whom did he play?
A. Chancellor Gorkon
B. General Chang
C. Kahless
D. Azetbur

1545. What did Sybok call his followers?

A. True Believers
B. Syrranites
C. Army of Galactic Light
D. The Fallen

1546. Whose strategies were required reading at Starfleet Academy in Kirk's day?

A. General Chang
B. General Korrd
C. General Martok
D. General Nalas

1547. What was McCoy's secret pain?

A. He cheated on his wife
B. He abandoned his daughter
C. He experimented on animals
D. He took his dying father off life support

1548. What was the name of the city on Nimbus III?

A. Paradise City
B. Eden
C. Xanadu
D. New New York

1549. Who eventually defeated the "God" entity by sacrificing himself?

A. Klaa
B. Kirk
C. Sybok
D. Spock

1550. What technology did Spock wear that was never seen again after *Star Trek V*?

A. Levitation boots
B. Phaser
C. Combadge
D. Tricorder

1551. Who was the communications officer aboard the *U.S.S. Excelsior*?

A. Uhura
B. Janice Rand
C. Chekov
D. Valtane

1552. What star of the film *Heathers* had a cameo as the *Excelsior*'s night-shift communications officer?

A. Christian Slater
B. Winona Ryder
C. Shannon Doherty
D. Patrick Labyorteaux

1553. What *Deep Space Nine* actor portrayed Colonel West?

A. Nana Visitor
B. Colm Meany
C. Michael Dorn
D. Rene Auberjonois

1555.

Star Trek fans had begun to notice that, strangely enough, the odd-numbered films didn't seem to live up to the quality (or box-office receipts) of the even-numbered films. Fresh off his success with *First Contact*, the director of *Insurrection* felt confident he could beat the curse.

Initial rumors from the producers suggested that fan-favorite Q would appear, but instead the threat came from within. The story of a Starfleet admiral breaking the

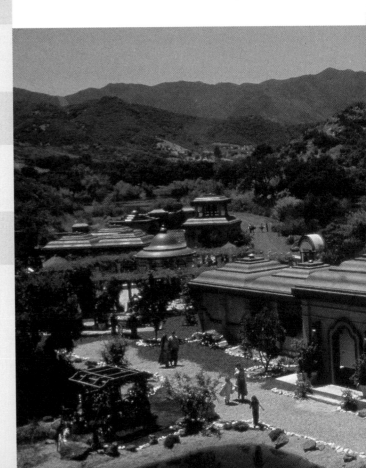

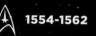

Prime Directive (with Starfleet's backing) to relocate an entire population and gain eternal youth for Federation citizens fell flat with fans; *Insurrection* ultimately fell short of its predecessor's box office. The object of Starfleet's relocation was the small community of Ba'ku villagers (shown below).

Where were the full-scale Ba'ku village sets constructed?

A. Vasquez Rocks National Park
B. Westlake Village, California
C. Yosemite National Park
D. Bozeman, Montana

1554. The actor who played Captain von Trapp in *The Sound of Music* played which Shakespeare-quoting character in *Star Trek VI*?
A. Chancellor Gorkon **C.** Colonel Worf
B. General Chang **D.** Kerla

1555.

1556. What 1980s supermodel portrayed the shapeshifter Martia?
A. Iman **C.** Christie Brinkley
B. Claudia Schiffer **D.** Paulina Porizkova

1557. What drink did Kirk order the galley not to serve at diplomatic functions?
A. Saurian brandy **C.** Romulan ale
B. Scotch whisky **D.** Klingon bloodwine

1558. What is the name of Chancellor Gorkon's ship?
A. *Kronos One* **C.** *Gorkon One*
B. *Sword of Kahless* **D.** *Azetbur*

1559. Which race was Nanclus the ambassador for?
A. Romulans **C.** Andorians
B. Tholians **D.** Tellarites

1560. Who suggested "sabotaging" the *Enterprise* to avoid being recalled to Earth?
A. Valeris **C.** Uhura
B. Scotty **D.** Chekov

1561. What star of TV's *Spin City* captained the *U.S.S. Enterprise* NCC-1701-B?
A. Michael J. Fox **C.** Barry Bostwick
B. Alan Ruck **D.** Heather Locklear

1562. Which future *Voyager* cast member portrayed an *Enterprise*-B bridge officer in *The Undiscovered Country*?
A. Kate Mulgrew **C.** Tim Russ
B. Robert Duncan MacNeil **D.** Robert Beltran

1563. What was the name of the El-Aurian ship Guinan was on?

- A. S.S. *Robert Fox*
- B. S.S. *Wotan*
- C. S.S. *Lakul*
- D. S.S. *Mazur*

1564. Why was Soran destroying stars?

- A. He was testing his weapon
- B. He was observing supernova behavior
- C. He thought it was his destiny
- D. To alter the path of the Nexus

1565. What planet did Soran set up his weapon on?

- A. Amargosa
- B. El-Auria
- C. Earth
- D. Veridian III

1566. How big was the shockwave resulting from the destruction of the Amargosa star?

- A. Level 5
- B. Level 12
- C. Level 15
- D. Level 20

1567. Who said, "I hope, for your sake, you were initiating a mating ritual"?

- A. Lursa
- B. Soran
- C. B'Etor
- D. Worf

1568. How did the Duras sisters discover the *Enterprise*'s shield modulation frequency?

- A. Spying through Geordi's VISOR
- B. Torturing Geordi
- C. Soran deduced them
- D. Data accidentally revealed them

1569. Which former lover did Kirk see again in the Nexus?

- A. Antonia
- B. Edith Keeler
- C. Miramanee
- D. Carol Marcus

1570. What were Kirk's last words?

- A. "Did we make a difference?"
- B. "Least I could do ... for the captain of the *Enterprise*."
- C. "Oh, my."
- D. "It was ... such fun."

1571.

1572. Which *Desperate Housewives* star played Cochrane's coworker Lily Sloane?

- A. Teri Hatcher
- B. Alfre Woodard
- C. Nicollette Sheridan
- D. Felicity Huffman

1571.

If *Insurrection* couldn't beat the odd-numbered curse that seemed to plague the series, hopes were high for even-numbered *Nemesis*. An Academy Award–nominated scriptwriter was hired and a new director chosen. However, *Nemesis* proved to be the last *Star Trek* film for the *Next Generation* crew.

The crew of *Enterprise*-E was heading in separate directions regardless of how many films might follow. Two

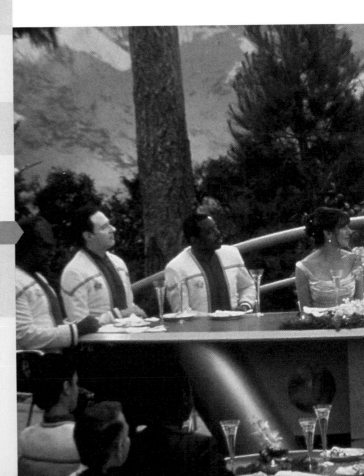

characters married (Riker and Troi's wedding shown below), one character became deactivated, and one character's destiny was filmed but cut in the final edit. Once the DVD was released, unused footage revealed Dr. Beverly Crusher's fate.

What happened to the doctor after the events of *Nemesis*?

A. Died
B. Left to head up Starfleet medical
C. Traveled with Wesley
D. Married Picard

1573. Who directed *First Contact*?
A. Patrick Stewart
B. Stuart Baird
C. Jonathan Frakes
D. LeVar Burton

1574. In *First Contact*, where did the fleet engage the Borg?
A. Typhon sector
B. Wolf 359
C. Deep Space Nine
D. Delta Quadrant

1575. What did the Borg build on the *Enterprise*'s deflector dish?
A. Assimilation beam
B. A new habitat
C. Ancillary hibernation chambers
D. Interplexing beacon

1576. Which bridge officer was assimilated while outside the ship working on the deflector dish?
A. La Forge
B. Worf
C. Hawk
D. Wallace

1577. What did the Borg queen want from Data?
A. Help reassimilating Picard
B. His positronic brain
C. Help defeating Starfleet
D. Encryption codes for the computer

1578. What Vulcan ship "noticed" Cochrane's ship and made first contact?
A. *T'Plana-Hath*
B. *Solkar*
C. *Surak*
D. *Selaya*

1579. What did Data tell the Borg queen when he intentionally missed shooting at Cochrane's ship?
A. "Watch your future's end."
B. "Assimilate this."
C. "Resistance is futile."
D. "Not so small now."

1580. What were the first words spoken by the Vulcan upon reaching Earth?
A. "Live long and prosper."
B. "Peace and long life."
C. "Greetings."
D. "Take us to your leader."

1581. What was the new Federation protectorate Picard meets with aboard the *Enterprise* in *Insurrection*?
A. Tarlac
B. Evora
C. Son'a
D. Ba'ku

1582. What song from the operetta *HMS Pinafore* did Picard and Worf sing to distract Data?

A. "We Sail the Ocean Blue" **C.** "Sir, You Are Sad"
B. "The Nightingale" **D.** "A British Tar"

1583. What weapons did the Son'a use in violation of the Second Khitomer Accords?

A. Metaphasic **C.** Biogenic
B. Subspace **D.** Temporal

1584. What was the Klingon equivalent of a pimple?

A. *qis* **C.** *gorch*
B. *qhonDoq* **D.** *Fek'lhr*

1585. Who played Ru'afo?

A. F. Murray Abraham **C.** Frank Langella
B. Alfred Molina **D.** Brock Peters

1586. In *Star Trek: Insurrection*, how did Daugherty die?

A. Injector explosion **C.** Son'a face-lift machine
B. Metaphasic radiation overdose **D.** Suicide

1587. What were the Son'a going to do with the Ba'ku people?

A. Kill them **C.** Subjugate them
B. Relocate them to a holoship **D.** Revert them into children

1588. What did the *Enterprise* crew deploy to keep the Son'a from trapping the Ba'ku?

A. Isolinear tags **C.** Shield buffers
B. Transport inhibitors **D.** Cryogenic drones

1589. When does the metaphasic radiation on the Ba'ku planet affect humans?

A. Maturity **C.** Late teens
B. Puberty **D.** Birth

1590. What was the population of the Ba'ku village?

A. 600 **C.** 100
B. 500 **D.** 1,000

1597.

In this age of Internet spoilers, it's almost hard to believe there was a time when movies were made without fans knowing intimate casting details and plot twists. But in the 1980s, some secrets could actually stay inside Hollywood. The studio worked hard to guarantee Leonard Nimoy's (shown at left with fellow actor George Takei) involvement as an actor was kept secret, so that fans would not uncover the secret of Spock's return from the dead and shy away from seeing the third *Star Trek* film. The working title for the script outline was *Return to Genesis* to avoid any mention of Spock.

To further throw anyone off the trail, a character simply called Nacluv was played *not* by Nimoy, but by whom?

A. Larry Kops
B. Joe K. Cops
C. Frank Furter
D. Frank Force

1591. How many times did Guinan claim to have been married?
A. Seventeen
B. Twenty-three
C. Forty-seven
D. Sixty-two

1592. What Irving Berlin song did Data sing at the wedding reception?
A. "Puttin' on the Ritz"
B. "Blue Skies"
C. "There's No Business Like Show Business"
D. "Say It Isn't So"

1593. What planet was B4 found on?
A. Kolarus III
B. Remus
C. Betazed
D. Celes II

1594. Who was Shinzon's accomplice in the Romulan Senate?
A. Tal'Aura
B. Hiron
C. Donatra
D. Suran

1595. Who helped Shinzon violate Troi's mind with his or her own psychic abilities?
A. Donatra
B. His viceroy
C. Valeris
D. Tal'Aura

1596. Why did Shinzon need a complete blood transfusion from Picard?
A. He needed the nutrients
B. He had cancer
C. To stop his genetic degeneration
D. He wanted to bond with Picard

1597.

1598. Who performed a Vulcan nerve pinch on a Reman guard?
A. Data
B. Picard
C. Troi
D. Riker

1599. Where did the *Enterprise* fight the *Scimitar*?
A. Neutral Zone
B. Bassen's Rift
C. Near Earth
D. Near Romulus

1600. Who switched sides to help the *Enterprise* in *Nemesis*?
A. Viceroy
B. Nero
C. All the Remans
D. Donatra

1601. Who played the Klingon commander of the *I.K.S. Amar*?

 A. William Campbell **C.** Grace Lee Whitney
 B. Mark Lenard **D.** Roger C. Carmel

1602. Who was the admiral that Kirk had to convince to give him back command of the *U.S.S. Enterprise*?

 A. Nogura **C.** Sonak
 B. Decker **D.** Laughlin

1603. Who composed the music for the first *Star Trek* film?

 A. John Williams **C.** Alexander Courage
 B. Howard Shore **D.** Jerry Goldsmith

1604. Who served as special science advisor to the first *Star Trek* film?

 A. Isaac Asimov **C.** Harlan Ellison
 B. Larry Niven **D.** Carl Sagan

1605. Which science fiction author was credited with the story for *Star Trek: The Motion Picture*?

 A. James Blish **C.** Alan Dean Foster
 B. Ray Bradbury **D.** Kurt Vonnegut Jr.

1606. What *Star Trek* books were written by the author credited with the story idea for *Star Trek: The Motion Picture*?

 A. Episode novelizations **C.** Animated series novelizations
 B. Technical manuals **D.** The Making of *Star Trek*

1607. Why did Decker countermand Kirk's phaser order while trapped in the wormhole?

 A. He was trying to show Kirk up **C.** Targeting with phasers would not be precise enough
 B. Due to the engine modifications, they were cut off **D.** The phaser banks had already drained

1608. What is Starfleet Order 2005?

 A. Salvage an alien ship **C.** Auto-destruct
 B. Quarantine from alien race **D.** Initiate planetary distress beacon

1612.

After the success of the first *Star Trek* film, a sequel was inevitable. However, Paramount and Gene Roddenberry had not seen eye-to-eye, so the studio brought in Harve Bennett to craft a story. After watching all of the original series, Bennett found what had been missing from the first film: a villain. After several rounds of script drafts, the one remaining problem wasn't with a villain, but with the fact that Leonard Nimoy—a pivotal character in film number two's plot—wasn't interested in doing a sequel. However, the idea of playing Spock's death scene ultimately lured Nimoy back into the fold.

Spock's sacrifice helped propel the film franchise forward as well as help *The Wrath of Khan* (Khan shown at left) best its predecessor.

How much more did *Khan* earn its opening weekend in U.S. box office sales?

A. $12 million
B. $14 million
C. $16 million
D. $18 million

1609. What was the first sequence of numbers in the old NASA code signal for V'ger to complete its programming and transmit its data?

A. 317 **C.** 501
B. 329 **D.** 504

1610. Who wrote the novelization of the first *Star Trek* film?

A. James Blish **C.** Isaac Asimov
B. Harlan Ellison **D.** Gene Roddenberry

1611. Who was the Captain of the *U.S.S. Reliant* in *The Wrath of Khan*?

A. Chekov **C.** Spock
B. Terrell **D.** Carol Marcus

1612.

1613. What was *U.S.S. Reliant*'s prefix code?

A. 170123 **C.** 8675309
B. 47-1981 **D.** 16309

1614. In the televised and 2002 DVD release of *The Wrath of Khan*, a restored line of dialogue indicated that injured engineer Peter Preston was whose nephew?

A. Scotty **C.** Kirk
B. Saavik **D.** McCoy

1615. What book did Spock give Kirk on his birthday?

A. *A Christmas Carol* **C.** *Moby Dick*
B. *A Tale of Two Cities* **D.** *The Complete Shakespeare*

1616. Where was the second stage of Project Genesis tested?

A. On the *Enterprise* **C.** Inside the Regula planetoid
B. On the moon **D.** In the lab

1617. Who played Dr. Carol Marcus?

A. Diana Muldaur **C.** Bibi Besch
B. Catherine Hicks **D.** Grace Lee Whitney

1618. Which of Khan's disciples manned the *Reliant*'s helm and weapons stations?

A. Joachim **C.** Beach
B. Jedda **D.** Malik

1619. What book did Khan quote from as he activated the Genesis torpedo?

A. *Moby Dick* **C.** *A Tale of Two Cities*
B. *Heart of Darkness* **D.** The Bible

1620. Which class of ship, debuting in *Star Trek III*, was the *U.S.S. Grissom*?

A. *Excelsior*-class **C.** *Hermes*-class
B. *Sovereign*-class **D.** *Oberth*-class

1621. What *Hill Street Blues* actor had a cameo as the captain of the *U.S.S. Excelsior*?

A. Daniel J. Travanti **C.** Betty Thomas
B. James B. Sikking **D.** Ed Marinaro

1622. Which star of TV's *Night Court* portrayed Klingon officer Maltz?

A. Harry Anderson **C.** Richard Moll
B. John Larroquette **D.** Charles Robinson

1623. Whom did Leonard Nimoy originally want for the role of Kruge?

A. Don Johnson **C.** Edward James Olmos
B. Michael Landon **D.** Hulk Hogan

1624. Who was Kruge's lover that died getting him the Genesis information?

A. Saavik **C.** Valkris
B. Lursa **D.** Valeris

1625. Who was the Vulcan priestess who performed the rite of fusion between Spock's body and his *katra*?

A. T'Sai **C.** T'Pring
B. T'Pau **D.** T'Lar

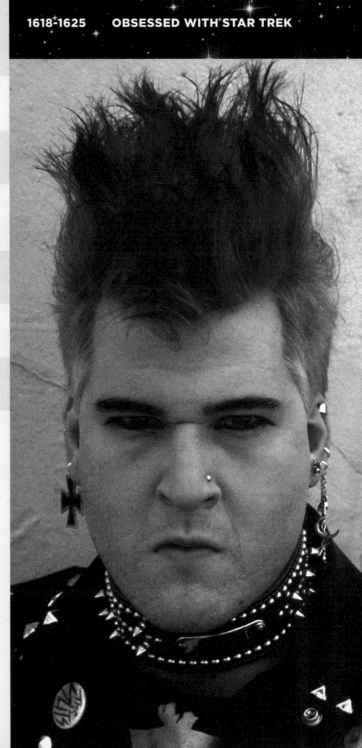

1630.

Though the Federation didn't adopt a temporal Prime Directive until the twenty-ninth century (and it wasn't mentioned until the *Voyager* episode "Future's End" in the late 1990s), Starfleet personnel were always careful about interfering in history. The *U.S.S. Enterprise* NCC-1701 crew had several experiences with time travel to various points in Earth's history before the events of *The Voyage Home*, and had been careful not to tamper with the past.

But for this trip into the past, their mission was different—and in addition to their goal of saving a species from premature extinction (and thus saving the future), they inadvertently saved a bus full of punk rockers (one shown at left) as well as garnering an extra passenger on their ride back to the future.

Who was the twentieth-century scientist who traveled forward in time at the end of the film?

A. Bob Briggs
B. Nichols
C. Dr. Gillian Taylor
D. Dr. Hastings

1626. Who played the instrumental Vulcan priestess in *The Search for Spock*?
A. Celia Lovsky
B. Dame Judith Anderson
C. Edna Glover
D. Arlene Martel

1627. Who told a security guard not to call him "Tiny"?
A. Sulu
B. Chekov
C. Kirk
D. McCoy

1628. What did Scotty always multiply his repair estimates by to keep his reputation as a miracle worker?
A. A factor of four
B. 12 hours
C. Four hours
D. At least half

1629. How did Kirk finally defeat Kruge?
A. Attacking him with his own knife
B. Beaming him into space
C. A self-destruct sequence on the *Enterprise*
D. Kicking him off a cliff into a lava flow

1630.

1631. What did McCoy rename the Klingon ship the *Enterprise* crew used to get back to Earth?
A. *S.S. Phoenix*
B. *H.M.S. Bounty*
C. *U.S.S. Enterprise ½*
D. *S.S. Lollipop*

1632. Which member of the '80s band the Go-Go's played an alien Starfleet communications officer in *Star Trek IV*?
A. Belinda Carlisle
B. Gina Schock
C. Charlotte Caffey
D. Jane Wiedlin

1633. Where was the universal atmospheric element compensator developed?
A. Loonkerian outpost on Klendth
B. Utopia Planitia
C. Mutara Sector, Grid 9
D. Amargosa

1634. What was the radio frequency of Dr. Taylor's whales' tags?

A. 47.5 megahertz
B. 401 megahertz
C. 689 megahertz
D. 1701 megahertz

1635. Whom was the part of Dr. Taylor originally written for?

A. Joe Piscopo
B. Eddie Murphy
C. Jan Hooks
D. Julia Louis-Dreyfus

1636. Whom was *The Voyage Home* dedicated to?

A. Gene Roddenberry
B. Whales everywhere
C. Crew of the *Challenger* space shuttle
D. Leonard Nimoy

1637. In *The Undiscovered Country,* Brock Peters played Admiral Cartwright; whom did he play in *Deep Space Nine*?

A. Joseph Sisko
B. An adult Jake Sisko
C. General Martok
D. Gowron

1638. What aircraft carrier were the 1980s *Enterprise* scenes actually shot on?

A. *U.S.S. Enterprise*
B. *U.S.S. Ronald Reagan*
C. *U.S.S. John F. Kennedy*
D. *U.S.S. Ranger*

1639. How many Starfleet regulations was Kirk charged with violating?

A. Six
B. Seven
C. Eight
D. Nine

1640. According to early drafts of the script, why did Saavik stay on Vulcan?

A. She had been dishonorably discharged
B. She was pregnant
C. She wanted to undergo *kolinahr*
D. She was wounded

1641. When was *Star Trek V* released?

A. June 1989
B. July 1990
C. December 1989
D. May 1988

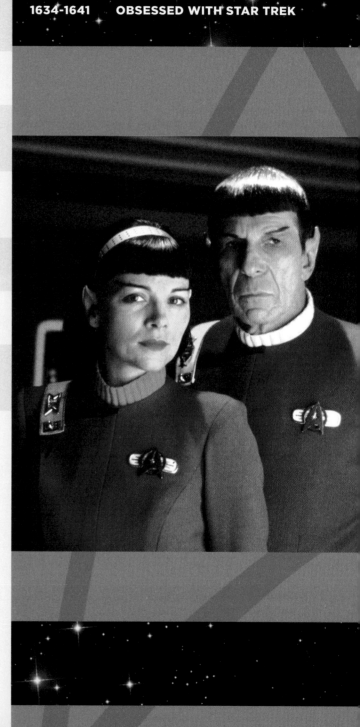

1643.

As the original crew of the *Enterprise* prepared to stand down from service (and plans for the film franchise looked towards the *Next Generation* cast), one last adventure pulled them together. Even Sulu, now promoted to Captain of his own ship, played a part in the mission during the events of *Star Trek: The Undiscovered Country*.

One character noticeably absent, however, was Saavik. Left behind on Vulcan at the beginning of *Star Trek IV*, she was never heard from again. As the script evolved and called for a crew member to become a traitor, the writers had actually suggested Saavik, but Gene Roddenberry shot this down. (The original Saavik actress would prove too costly anyway.) So to solve the problem, the writers created another Vulcan protégée for Spock (shown at left).

What was the name of this Vulcan traitor played by *Sex and the City* star Kim Cattrall?

A. T'Pol
B. T'Pau
C. Vixis
D. Valeris

1642. Who did the producers of *Star Trek V* originally want to play Sybok?

A. Sean Connery
B. Harrison Ford
C. Patrick Swayze
D. Patrick Stewart

1643.

1644. Who enjoyed a cameo as Starfleet Chief Admiral Robert Bennett?

A. Creator Gene Roddenberry
B. Producer Harve Bennett
C. Writer Nicholas Meyer
D. Composer Jerry Goldsmith

1645. In a rarity for *Star Trek* films, there were two instances of product placement in *Star Trek V*. One product was a brand of jeans; what was the other?

A. Car
B. CD player
C. Marshmallow dispenser
D. Makeup

1646. In addition to playing Korrd, Charles Cooper would play which famous Klingon in *The Next Generation*?

A. K'mpec
B. Kahless
C. Kruge
D. Kurn

1647. During *Star Trek V*, some scenes suggested Uhura was becoming romantically involved with which crew member?

A. Sulu
B. Scotty
C. Chekov
D. Spock

1648. How did Kirk think he would die?

A. In bed
B. In battle
C. From a fall
D. Alone

1649. Footage of which antagonists was not used in the film, but is available on the DVD special edition?

A. Tholians
B. Gorn
C. Rock men
D. Rigellians

1650. What was a Priority 7 situation?

- **A.** Hostages
- **B.** Invasion
- **C.** War
- **D.** Planetary destruction

1651. What was the name of Chancellor Gorkon's daughter?

- **A.** Lursa
- **B.** B'Etor
- **C.** Azetbur
- **D.** Vixis

1652. What phaser setting will trigger alarms on a ship?

- **A.** Kill
- **B.** Stun
- **C.** Heat
- **D.** Any setting

1653. Who composed the music for *Star Trek VI*?

- **A.** Jerry Goldsmith
- **B.** James Horner
- **C.** Howard Shore
- **D.** Cliff Eidelman

1654. What was Operation: Retrieve?

- **A.** Valeris's plan to find the assassins' magnetic boots
- **B.** The Starfleet plan to rescue Kirk and McCoy
- **C.** A way to recapture warp plasma
- **D.** A recruitment drive for ex-officers

1655. What did Spock place on Kirk's uniform in order to track him?

- **A.** Emergency transporter
- **B.** Nondegrading radium
- **C.** Nanotransmitter
- **D.** Veridium patch

1656. What ship did Uhura claim the *Enterprise* was as they snuck into Klingon space?

- **A.** *I.K.S. Ursva*
- **B.** *I.K.S. Kronos One*
- **C.** *I.K.S. Kahless*
- **D.** *I.K.S. Scimitar*

1657. What did Gorkon consider "the undiscovered country"?

- **A.** Death
- **B.** Peace
- **C.** The future
- **D.** The Neutral Zone

1660.

The meeting of Captain James T. Kirk and Captain Jean-Luc Picard (shown at left, from left to right) in *Star Trek Generations* was a turning point in *Star Trek* history, both real and fictional. The torch was truly passed to the "next generation" when Picard, who'd just suffered enormous personal loss, inspired Kirk to help him, and in turn inspired himself to keep going. It was also the first time the two actors playing the famous captains had appeared on screen together.

Kirk's "death" in the twenty-third century had actually transported him into the tranquil realm of the Nexus, where Picard found him. Initially Kirk was resistant to leaving, wanting to take the second chance at happiness the Nexus offered—despite the realization that he couldn't possibly be where he thought he was.

What were the two captains doing when Kirk finally agreed to come back to reality and help Picard?

A. Riding horses
B. Chopping wood
C. Cooking
D. Fencing

1658. Who directed the last film to feature the *Star Trek* original series cast?
A. William Shatner
B. Gene Roddenberry
C. Nicholas Meyer
D. Leonard Nimoy

1659. When did Gene Roddenberry see *Star Trek VI: The Undiscovered Country*?
A. Three days before his death
B. Two days before his death
C. One day before his death
D. He never saw it

1660.

1661. What is the name of Captain Sulu's daughter?
A. Nyoto
B. Demora
C. Mihoshi
D. Jacqueline

1662. When, apparently, was everything going to be installed on the *Enterprise*-B?
A. When they returned to spacedock
B. Next year
C. Stardate unknown
D. Tuesday

1663. What was Kirk's dog's name?
A. Spot
B. Butler
C. Spock
D. Jake

1664. Where did Kirk think he was in the Nexus?
A. The same future as Picard
B. Nine years prior to the *Enterprise*-B launch
C. An alternate twenty-fourth century
D. A holodeck

1665. Who told Picard, "Time is a predator"?
A. Kirk
B. Soran
C. Riker
D. Guinan

1666. What was the source of the drink that initiated Data's feeling of hate?
A. Forcas III
B. Amargosa
C. Romulus
D. Veridian III

1667. What was the shield modulation frequency of the *Enterprise*-D?

A. 112 megahertz C. 170.01 megahertz
B. 130.6 megahertz D. 257.4 megahertz

1668. Which of the following was *not* one of Picard's "children" in the Nexus?

A. Matthew C. William
B. Mimi D. Thomas

1669. How many distinct feelings had Data experienced by the end of *Star Trek Generations*?

A. 151 C. 278
B. 261 D. 312

1670. Which ship helped retrieve survivors from the *Enterprise*-D's crash?

A. U.S.S. *Farragut* C. U.S.S. *Enterprise*-E
B. U.S.S. *Stargazer* D. U.S.S. *Defiant*

1671. Who was the first person to ever say the words "star trek" in the history of the franchise?

A. William Shatner as James Kirk C. James Cromwell as Zefram Cochrane
B. John deLancie as Q D. Alfre Woodard as Lily Sloane

1672. How long had the *Enterprise*-E been in space when the Borg headed for Earth?

A. Two months C. Nine months
B. Four months D. Nearly one year

1673. What did an angry Picard listen to while patrolling the Neutral Zone?

A. Berlioz C. Beethoven
B. Bizet D. Bach

1674. What town did Earth's first contact occur in?

A. Bozeman, Montana C. Great Falls, Montana
B. Los Angeles, California D. Iowa City, Iowa

1676.

Federation history depicted warp flight pioneer Zefram Cochrane (shown below with Riker, left, and La Forge, right) as a visionary with the noble goal of ushering in a new era for mankind. Schools and museums were named after him, and statues erected.

However, Cochrane was in fact less than altruistic. A fan of classic rock 'n' roll and naked women, and actually so afraid of flying that he travelled by train, Cochrane's main "vision" was of dollar signs—particularly in a poverty-stricken America following World War III.

The cynical Cochrane became so irritated with the near hero worship of the *Enterprise* crew during the events of

First Contact that at one point he ran away in the middle of their work on his warp engines.

Ultimately, though, it was Riker quoting some "rhetorical nonsense" from ten years in the future that allowed Cochrane to reconcile his future and present status. "Don't try to be a great man," Riker said. "Just be a man, and let history make its own judgments."

Who spoke this quote originally?

A. Picard
B. Sarek
C. Cochrane
D. Riker

1675. Which *Enterprise* crew member's adulation made Cochrane so uncomfortable he tried to run away from the project?

A. Barclay C. Riker
B. Troi D. Crusher

1676.

1677. What did the Borg queen offer Data?

A. A place at her side C. Immortality
B. Organic flesh D. Control over his emotions

1678. Who portrayed the Borg queen in *Star Trek: First Contact*?

A. Anjelica Huston C. Louise Fletcher
B. Susanna Thompson D. Alice Krige

1679. Who wrote the screenplay for *First Contact*?

A. Ron Moore & Brannon Braga C. Jeri Taylor
B. Judith & Garfield Reeves-Stevens D. Jonathan Frakes

1680. What Roy Orbison song did Cochrane play for the Vulcans?

A. "Ooby-Dooby" C. "Crying"
B. "Pretty Woman" D. "You Got It"

1681. What two species did the Son'a conquer and make a worker class in its society?

A. Remans and Talaxians C. Tarlac and Ellora
B. Breen and Ba'ku D. Evora and Bajoran

1682. What did Worf crave while under the influence of the Ba'ku planet?

A. *Freash gahg* C. Prune juice
B. Blood of a live Kolar beast D. Romulan ale

1683. Where was the *Enterprise* headed when the events on the Ba'ku planet diverted them?

A. Deep Space 9 C. Earth
B. Gamma Quadrant D. Goren system

1684. What Broadway star played Anij?

- **A.** Donna Murphy
- **B.** Kristin Chenowith
- **C.** Idinia Menzel
- **D.** Jane Krakowski

1685. What was the name of Sojef's son?

- **A.** Ro'tin
- **B.** Artim
- **C.** Gen'a
- **D.** Tournel

1686. What mineral ore in the Ba'ku mountains protected the Ba'ku from transport?

- **A.** Metreon
- **B.** Ditanium
- **C.** Feldomite
- **D.** Kelbonite

1687. What was the name of the caterpillar-like creature native to the Ba'ku planet?

- **A.** Kolibri
- **B.** Ahdar
- **C.** Rhyl
- **D.** Gamera

1688. How much shore leave had Picard accumulated by the end of the Ba'ku mission?

- **A.** 210 days
- **B.** 310 days
- **C.** 375 days
- **D.** 410 days

1689. Who directed *Insurrection*?

- **A.** Jonathan Frakes
- **B.** Michael Pillar
- **C.** Rick Berman
- **D.** Brannon Braga

1690. Which Deep Space 9 resident was filmed visiting the Ba'ku planet but not included in the final cut?

- **A.** Morn
- **B.** Quark
- **C.** Garak
- **D.** Ziyal

1691. What planet's trade discussions were cut short by the sudden execution of the Romulan Senate?

- **A.** Celes II
- **B.** Tholians
- **C.** Rigel XI
- **D.** El-Aurian

1692.

1692.

At the end of *Generations*, Will Riker (shown at right with Picard, left) told Picard he'd always hoped to sit in the captain's chair of the *Enterprise* one day. However, he'd turned down the opportunity to command his own ship three times prior.

While the real-life reason behind this was that actor Jonathan Frakes had no intention of leaving the show, reasons had to be invented why an ambitious officer with a stellar career would continually refuse his own command. He cited self-interest among other reasons, and he proved right in his choices: two of the ships (*U.S.S. Drake* and *U.S.S. Melbourne*) wound up being destroyed, and the *U.S.S. Aries* remained a "relatively insignificant ship in an obscure corner of the galaxy," as Picard described it.

As the film franchise came to an end, there was no reason not to promote Riker, and so in *Nemesis*, Riker finally accepted his own command.

What ship did Riker become captain of?

- **A.** *U.S.S. Hood*
- **B.** *U.S.S. Stargazer*
- **C.** *U.S.S. Titan*
- **D.** *U.S.S. Enterprise-E*

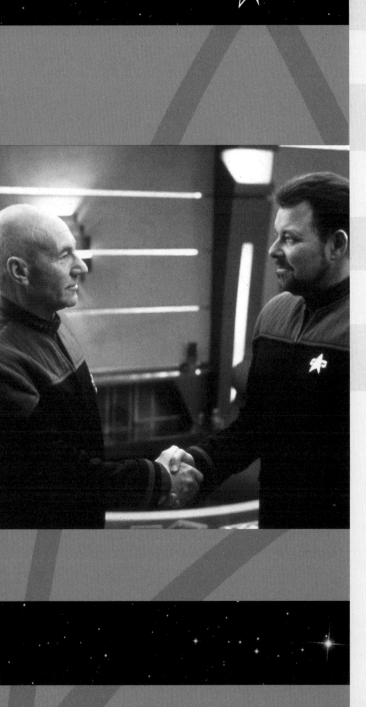

1693. Who was the best man at Riker's wedding?

A. Picard
B. La Forge
C. Worf
D. Wesley Crusher

1694. What genetic hearing ailment did Picard and Shinzon suffer from?

A. Bendii syndrome
B. Shalaft's syndrome
C. Orkett's disease
D. Potrikk syndrome

1695. How did Troi find the cloaked Reman ship in *Nemesis*?

A. She guessed
B. Its phaser spread
C. She felt Shinzon's presence
D. She used the link the viceroy established

1696. How did Picard do something unexpected to fool Shinzon?

A. Changed tactics every minute
B. Rammed the *Enterprise* into his ship
C. Let Troi navigate
D. Did the opposite of his normal tactics

1697. What brand of wine did the crew drink to toast Data?

A. Dom Perignon
B. Klingon bloodwine
C. Quark's
D. Chateau Picard

1698. What Academy Award–nominated writer penned *Nemesis*?

A. John Logan
B. Akiva Goldsman
C. Cameron Crowe
D. Ang Lee

1699. In a deleted scene available on DVD, who became the new first officer of the *U.S.S. Enterprise*-E?

A. Troi
B. Martin Madden
C. B4
D. Worf

1700. Whose cameo lines were deleted from the final cut of *Nemesis*?

A. Kate Mulgrew
B. Wil Wheaton
C. Armin Shimerman
D. Whoopi Goldberg

CHAPTER 7
STARFLEET PERSONNEL FILES
CHARACTERS, CAST & CREW

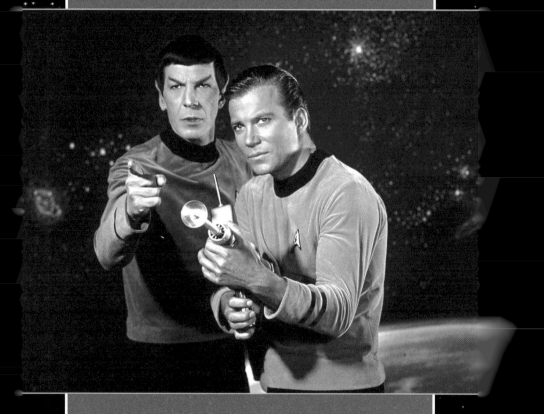

1701. How long was Kirk chief of Starfleet operations?

 A. Six months **C.** Two and a half years

 B. One year **D.** Three years

1702. What visual corrective drug is Kirk allergic to?

 A. Saline solution **C.** Retinax V

 B. VISOR fluid **D.** Optinox III

1703. What injury did Kirk suffer during the Babel conference in 2268?

 A. Broken arm **C.** Sprained shoulder

 B. Concussion **D.** Punctured lung

1704. What was Spock's mother's last name?

 A. Perrin **C.** Chapel

 B. Kalomi **D.** Grayson

1705. Spock was the object of whose unrequited love during their time on the *U.S.S. Enterprise*?

 A. Nurse Chapel **C.** Yeoman Rand

 B. Uhura **D.** Marla McGivers

1706. Who was the only *Enterprise* crew member to lose his brain *and* die ... at separate times?

 A. Kirk **C.** McCoy

 B. Spock **D.** Uhura

1707. What job did Spock take after his service on the *Enterprise*?

 A. Teacher **C.** President of the Federation

 B. Detention designer **D.** Ambassador

LEFT Spock and Kirk from *The Original Series.*

1708. What was Uhura's first name?

A. Nyota
B. Christine
C. Amanda
D. M'Benga

1709. What was McCoy's father's name?

A. Adam
B. George
C. Leonard
D. David

1710. Where was Sulu born?

A. San Francisco
B. Washington, DC
C. Los Angeles
D. Tokyo

1711. What was *not* among Sulu's many hobbies?

A. Fencing
B. Antique guns
C. Botany
D. Fishing

1712. What famous civil rights leader convinced Nichelle Nichols to continue playing Uhura after the first season, though she felt the role wasn't significant?

A. Rosa Parks
B. Malcolm X
C. Martin Luther King Jr.
D. Jesse Jackson

1713. Who played Captain Pike in the original pilot of *Star Trek*?

A. Peter Duryea
B. Jeffrey Hunter
C. Robert Bridges
D. Gary Lockwood

1714. Who played the crippled Pike in "The Menagerie"?

A. Sean Kenney
B. John Hoyt
C. Malachi Throne
D. Mark Lenard

1715. What year did Captain Kirk finally retire?

A. 2290
B. 2293
C. 2300
D. 2352

1716. Where was Captain Picard born?

A. London, England
B. Cardiff, Wales
C. LaBarre, France
D. Paris, France

1718.

William Shatner (shown at left) was not the first actor chosen to captain the *U.S.S. Enterprise*, and the character's name changed from Robert April to James Kirk along the way. Ultimately, Shatner made the part his own, becoming a television icon and making his character a legend in the process.

James T. Kirk commanded the *Enterprise* for over thirty years. His service record at Starfleet Academy was exemplary, and he studied a pantheon of military and historical figures, some of whom he would meet during his tenure. He was commended for performing with "uncommon bravery" on his first starship assignment. He soon became the youngest Starfleet captain ever promoted. Shatner was thirty-five when he portrayed Kirk for the first time.

How old was Kirk when he was named captain of the *Enterprise*?

A. Twenty-seven
B. Twenty-eight
C. Twenty-nine
D. Thirty-one

1717. What was Picard's father's name?
A. Pierre
B. Robert
C. Albert
D. Maurice

1718.

1719. Where was Will Riker born?
A. Alaska
B. Nebraska
C. Oregon
D. Pennsylvania

1720. When did Riker's father effectively abandon him?
A. Age twelve
B. Age seventeen
C. Age fifteen
D. Age twenty-one

1721. What position did Riker serve aboard the *U.S.S. Hood*?
A. Tactical officer
B. First officer
C. Security chief
D. Navigation

1722. Who was Data's "grandfather"?
A. Ira Graves
B. Arik Soong
C. Lore
D. B-4

1723. What caused Lal, Data's daughter, to shut down?
A. Insufficient memory
B. Cascade failure
C. Virus
D. Self-termination sequence

1724. What is Geordi's sister's name?
A. Gabrielle
B. Silva
C. Leah
D. Ariana

1725. What was Geordi's first position aboard the *U.S.S. Enterprise*?
A. Security
B. Conn
C. Chief engineer
D. Ops

1726. What did zero gravity do to Worf?
A. Intoxicated him
B. Disoriented him
C. Made him nauseous
D. Nothing

1727. Who was Deanna Troi betrothed to in 2364?

- **A.** Will Riker
- **B.** Devinoni Ral
- **C.** Aaron Conor
- **D.** Wyatt Miller

1728. What was Dr. Crusher's maiden name?

- **A.** Scott
- **B.** McDougal
- **C.** Connor
- **D.** Howard

1729. What was Wesley Crusher's middle name?

- **A.** Robert
- **B.** Eugene
- **C.** Rodney
- **D.** John

1730. What colony did Tasha Yar grow up on?

- **A.** Triacus
- **B.** Midos V
- **C.** Turkana IV
- **D.** Korvat

1731. Where did Benjamin Sisko first meet his wife, Jennifer?

- **A.** Bajor
- **B.** New Orleans
- **C.** Gilgo Beach
- **D.** Starbase 137

1732. What is Sisko's half-sister's name?

- **A.** Judith
- **B.** Sarah
- **C.** Zoey
- **D.** Neffie

1733. In what province was Kira Nerys born?

- **A.** Kendra
- **B.** Lonar
- **C.** Dahkur
- **D.** Tozhat

1734.

1735. How many children did Dax have over the course of the symbiont's lives?

- **A.** Nine
- **B.** Ten
- **C.** Eleven
- **D.** Twelve

1736. What Ferengi game enjoyed by Curzon Dax did Jadzia also inherit a love for?

- **A.** Dabo
- **B.** Tongo
- **C.** Jokarian chess
- **D.** Fizzbin

1734.

Casting the captain of a new generation of Starfleet officers was no easy feat. Impressed by a dramatic reading at UCLA, producer Bob Justman brought British Shakespearean veteran Patrick Stewart (shown at right) in to audition. Though Roddenberry had wanted a French actor to play Captain Julien Picard ("Julien" eventually became "Jean-Luc"), Stewart, despite being British, got the job.

At heart, Picard was an explorer, always, and at times boyishly eager to see "what's out there." Tragedy often dogged him, but it only seasoned the captain, who never shirked from taking risks in the name of exploring the unknown.

However, Ensign Picard had a life-changing moment while at Starbase Earhart, when Q showed him the life that might have been, had he not taken so many risks.

What mistake did Picard decide to keep as part of his life's "tapestry"?

- **A.** Losing Starfleet marathon
- **B.** Not loving Beverly Crusher
- **C.** Cheating the *Kobayashi Maru* test
- **D.** Nausicaan stabbing

1737. Where was the infant Odo brought when he was discovered?

A. Bajoran Institute for Science **C.** Terok Nor
B. Starfleet medical **D.** Gallitep

1738. What was Quark's father's name?

A. Beldar **C.** Rom
B. Nog **D.** Keldar

1739. What drink did Quark compare the Federation to?

A. Water **C.** Root beer
B. Romulan ale **D.** Raktajino

1740. How long did Bashir and Leeta date?

A. One year **C.** Two and a half years
B. Two years **D.** Three years

1741. What love did Jake Sisko inherit from his father and grandfather?

A. Fishing **C.** Cooking
B. Playing cards **D.** Music

1742. Where was Chief O'Brien born?

A. Scotland **C.** Wales
B. Ireland **D.** New Berlin

1743. What did O'Brien like to do while kayaking?

A. Sing **C.** Think
B. Recite poetry **D.** Imagine schematics

1744. What body part did O'Brien often injure while kayaking and playing sports?

A. Shoulder **C.** Wrist
B. Knee **D.** Ankle

1745. As revealed in "The Way of the Warrior," what race was Morn?

A. Lissepian **C.** Tosk
B. Lurian **D.** Gallamite

1746. Who was the Vulcan captain of the T'Kumbra (and the Logicians' baseball team)?

A. Sek **C.** Solok
B. Savar **D.** Sakkath

1747. Aside from being a dabo girl, what was Leeta's hobby?

A. Botany
B. History
C. Sociology
D. Archaeology

1748. Who killed Tora Ziyal?

A. Damar
B. Dukat
C. Garak
D. Ekoor

1749. Who was Kai Winn's faithful *ranjen* assistant?

A. Koral
B. Solbor
C. Telna
D. Quen

1750. How many times did the Bajoran resistance attempt to assassinate Gul Dukat?

A. Two
B. Five
C. Seven
D. Nine

1751.

1752. Where was Janeway born?

A. Idaho Falls, Idaho
B. Bozeman, Montana
C. Bloomington, Indiana
D. San Diego, California

1753. What was Tom Paris's middle name?

A. Wesley
B. Rodney
C. Owen
D. Eugene

1754. What made Chakotay decide to leave Starfleet for the Maquis?

A. Its noninterference position
B. His father's death
C. His wife's death
D. Seska's manipulations

1755. Tuvok was a prize-winning breeder of which flowers?

A. Roses
B. Lilies
C. Orchids
D. Cacti

1756. What did Tom Paris love to read books about as a child?

A. The sea
B. Dinosaurs
C. Warp engines
D. Starfleet

1751.

Certain that he would be offered a role requiring heavy prosthetics, Avery Brooks (shown at right) initially didn't want to audition for a part in *Star Trek*. However, once he read the script for the pilot, and was assured he would be portraying a human character, Benjamin Sisko, Brooks was convinced of the value of the show and auditioned for the role.

Sisko was a wounded man whose wife had died in the Battle of Wolf 359, and he was reluctant to take the post at Deep Space 9. But the events he experienced there over the course of seven years ultimately convinced him it was the right place to be: While at Deep Space 9, Sisko learned the truth about his heritage, fell in love, and was promoted to captain. He influenced galactic politics, helped end a devastating war, and defeated a race of evil noncorporeal beings. He became known behind the scenes as a builder, and this was reflected on screen as he built ships, models … and a new future.

What model was Sisko building that was "left behind" during the *Deep Space Nine* finale?

A. Deep Space 9
B. Planned home on Bajor
C. Celestial temple
D. *U.S.S. Defiant*

1757. What was the name of Neelix's cargo ship?

A. *Wixiban* C. *Kes*
B. *Dexa* D. *Baxial*

1758. What profession were Seven of Nine's parents?

A. Exobiologists C. Botanists
B. Astrophysicists D. Archaeologists

1759. How many years was Seven a Borg drone?

A. Twelve C. Eighteen
B. Sixteen D. Twenty

1760. What treat did Seven enjoy as a girl?

A. Strawberry tarts C. Chocolate chip cookies
B. Licorice sticks D. Lemon pie

1761. What was the name of the astronomy book that inspired the young Jonathan Archer?

A. *Guide to the Universe* C. *The Cosmos A to Z*
B. *Stars and Planets* D. *Light Years from Here*

1762. What was Archer's mother's name?

A. Jennifer C. Sally
B. Margaret D. Pamela

1763. What type of music elicited an emotional response in T'Pol the first time she heard it on Earth?

A. Rock C. Jazz
B. New Age D. R&B

1764. What did Trip nickname Malcolm's "tactical alerts"?

A. "Reed signals" C. "Danger signs"
B. "Reed alert" D. "Four-alarmers"

1765. What was Travis Mayweather's mother's name?

A. Rianna C. Talla
B. Danica D. Nora

1766. Where were Hoshi's quarters located on the *Enterprise* NX-01?

A. Near sickbay C. B deck
B. A deck D. C deck

1767. What year was the alternate Janeway who helped the *Voyager* find its way home from?

A. 2360 C. 2404
B. 2379 D. 2410

1768. Where were Kirk's quarters located aboard the original *U.S.S. Enterprise*?

A. Deck 5 C. Deck 13
B. Deck 8 D. Deck 19

1769. What was the name of Kirk's sister-in-law?

A. Winona C. Janice
B. Aurelan D. Carol

1770. What computer classification did Spock hold?

A. A1 C. A7
B. Alpha Level D. 1100

1771. How long did Spock serve under Captain Pike?

A. 10 years, 3 months, 1 day C. 12 years, 7 months, 6 days
B. 11 years, 4 months, 5 days D. 14 years, 6 months, 2 days

1772. Where did McCoy go to college?

A. University of Mississippi C. Duke
B. Harvard D. Georgia Tech

1773. What deck were McCoy's quarters located on?

A. Deck 5 C. Deck 10
B. Deck 9 D. Deck 12

1774. How many siblings did Chekov have?

A. None C. Two
B. One D. Three

1775. What was Pavel Chekov's father's name?

A. Andrei C. Walter
B. Ivan D. Piotr

1778.

Son of a famous warp scientist, Jonathan Archer (actor Scott Bakula, shown at left) was destined for big things. But no one could have suspected he would become one of the most pivotal figures in human history.

Though *Enterprise* lasted just four seasons, viewers saw a glimpse of what Archer's future would hold. Not only would he pave the way for what became the United Federation of Planets, be promoted to admiral, and become chief of staff at Starfleet command, he would also become an ambassador to Andoria.

Ultimately, what other position within the Federation would Archer hold?

A. Secretary of state
B. Ambassador to Vulcan
C. President
D. Vice president

1776. Which tripedal alien navigator replaced Chekov in the animated *Star Trek* series?

A. Lieutenant M'Ress
B. Lt. Arex
C. Lt. Leslie
D. Lt. Ilia

1777. Which original series actor voiced the tripedal navigator in the animated series?

A. Leonard Nimoy
B. Grace Lee Whitney
C. Nichelle Nichols
D. James Doohan

1778.

1779. What Federation undersecretary was responsible for the development project on Sherman's planet?

A. Arne Darvin
B. Nilz Baris
C. Roger Lemli
D. Cyrano Jones

1780. During the tribble infestation of Space Station K-7, who was in charge of the station?

A. Admiral Fitzpatrick
B. Roger Lemli
C. Mr. Lurry
D. Korax

1781. Which commodore was in charge of Starbase 11 during Kirk's "court-martial"?

A. Mendez
B. Stocker
C. Travers
D. Stone

1782. What musical instrument did Picard give up, even though his mother loved to hear him play?

A. Guitar
B. Drums
C. Piano
D. Flute

1783. Where did Picard first meet Sarek?

A. At the wedding of Sarek's son
B. During the Second Khitomer Accords
C. At the Starfleet Academy
D. On board the *U.S.S. Stargazer*

1784. What was Picard's first station aboard the *U.S.S. Stargazer*?

A. Ops
B. Communication
C. Flight controller
D. Security

1785. Which of Commander Riker's ancestors fought in the American Civil War?

A. Colonel Wallace T. Riker
B. General Amadeus Riker
C. Lieutenant "Buck" Riker
D. Col. Thaddeus Riker

1786. What rank did Riker graduate in his class at the Academy?

A. Fourth
B. Eighth
C. Ninth
D. Twelfth

1787. What ship did Data serve on prior to the *U.S.S. Enterprise*?

A. *U.S.S. Sutherland*
B. *U.S.S. Pegasus*
C. *U.S.S. Soong*
D. *U.S.S. Trieste*

1788. What was Data's activation date?

A. January 1
B. January 28
C. February 2
D. March 1

1789. What shipmate did Geordi serve with on another vessel prior to his *Enterprise* assignment?

A. Riker
B. Crusher
C. Data
D. O'Brien

1790. What ship did Worf's father serve on as chief petty officer?

A. *U.S.S. Intrepid*
B. *U.S.S. Hood*
C. *U.S.S. Defiant*
D. *U.S.S. Bozeman*

1791.

1792. Where was Dr. Crusher born?

A. Caldos
B. Arvada III
C. Norfolk
D. Copernicus City, Luna

1793. What was Keiko O'Brien's father's name?

A. Tak
B. Hiro
C. Yukio
D. Satoshi

1794. What traditional remedy did Dr. Pulaski prescribe for the flu?

A. Honey and tea
B. Steam bath
C. Pulaski's chicken soup
D. Salt gargle

1791.

The Soong-type android Data (actor Brent Spiner, shown at right) was activated in the Omicron Theta colony. Perpetually trying to be more human, Data provided a sharp commentary on what humanity actually meant. As Data encountered a wide range of challenges while serving aboard the *U.S.S. Enterprise*—struggling with the human concepts of art and recreation, in particular—Data's behavior was often a source of comic relief to both his shipmates and viewers.

Trouble understanding the arts was not something that Spiner, an accomplished Broadway performer, shared. While Data performed an Irving Berlin song in the final *Star Trek* film, Spiner put out an album of pop standards during the height of *The Next Generation*'s popularity. Several *Next Generation* castmates even performed backup vocals on one track. What was the name of the album?

A. *Stardust*
B. *Ol' Yellow Eyes Is Back*
C. *My Heart Belongs to Data*
D. *Sunday in the Park with Data*

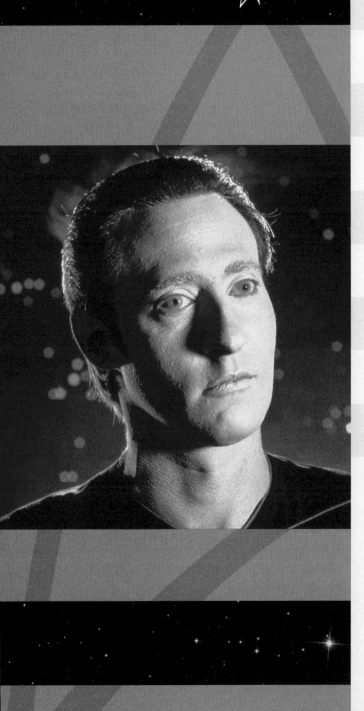

1795. What species was Chief O'Brien's pet, Christine?

A. Targ

B. Cardassian vole

C. Cat

D. Lycosan tarantula

1796. What ship did O'Brien serve on under Captain Benjamin Maxwell?

A. *U.S.S. Jenolen*

B. *U.S.S. Repulse*

C. *U.S.S. Rutledge*

D. *U.S.S. Hood*

1797. Where did Benjamin Sisko first meet Curzon Dax?

A. Pelios Station

B. Deep Space Nine

C. Starbase 137

D. New Berlin

1798. After the death of his wife, where did Sisko take a posting?

A. Starfleet command

B. *U.S.S. Enterprise*

C. Jupiter Station

D. Utopia Plantia

1799. What was the name of Kira Nerys's father?

A. Reon

B. Pohl

C. Taban

D. Meru

1800. Who was the first host of the Dax symbiont?

A. Tobin

B. Lela

C. Audrid

D. Emony

1801. What style of music did Jadzia Dax collect?

A. Lost composers

B. Klingon opera

C. Earth classical

D. Ferengi love songs

1802. Which test method did Dr. Mora *not* perform on the infant Odo?

A. Electric shocks

B. Protein decompiler

C. Vacuum chamber

D. Deep freeze

1803. How many years did Quark work as a cook on a Ferengi freighter?

A. Eight

B. Ten

C. Twelve

D. Twenty

1804. Who was the valedictorian of Dr. Bashir's graduating class?

A. Jadzia Dax

B. Elizabeth Lense

C. Palis Delon

D. Melora Pazlar

1805. Which item of Dr. Bashir's did Leeta keep after they broke up?

- A. Kukalaka
- B. His Academy pin
- C. His racquetball racquet
- D. His Alamo figures

1806. What nickname did Ben and Joseph Sisko often call Jake?

- A. "Slugger"
- B. "Pencils"
- C. "Gator"
- D. "Jake-o"

1807. What did Chief O'Brien always record for his family before going into battle?

- A. His will
- B. Where he was going
- C. A goodbye message
- D. Holiday greetings

1808.

1809. What was the name of Martok's son?

- A. Darok
- B. Alexander
- C. K'retok
- D. Drex

1810. How did Martok lose his eye?

- A. Saber bear hunting
- B. Fighting Jem'Hadar in an internment camp
- C. On his wedding night
- D. During the Cardassian invasion

1811. What medal did Martok receive from Gowron?

- A. Chin'toka Medal of Valor
- B. Koord Star Cluster
- C. Chang Commendation
- D. Order of Kahless

1812. Who did Dukat report to while he was prefect of Bajor?

- A. Legate Kell
- B. Legate Tain
- C. Legate Damar
- D. Legate Ekoor

1813. How many children total did Dukat have?

- A. Four
- B. Six
- C. Nine
- D. Twelve

1814. What Bajoran identity did Dukat take after being possessed by the Pah-wraith?

- A. Shakaar Edon
- B. Li Nalas
- C. Tahna Los
- D. Anjohl Tennan

1808.

The only character to transition from the original pilot to the aired incarnation of *Star Trek*, Spock (shown at right) was originally conceived as half-Martian—but Gene Roddenberry decided to make him half-human and half-Vulcan instead, thinking that mankind might actually make it to Mars during the space race of the late 1960s and the jig would be up.

Perhaps no other television character of the era had such an impact on popular culture. From his pointed ears to his Vulcan salute and logical outlook on life, Spock was known the world over. (And it was hardly surprising that actor Leonard Nimoy would eventually write two books encompassing his journey as the world's most famous Vulcan, titled *I Am Not Spock* and *I Am Spock*.)

What was the catchphrase fans often used during the '60s to signify how much they liked the character?

- A. "I Grok Spock"
- B. "Spock Child"
- C. "Gimme Some Spock"
- D. "Spock On!"

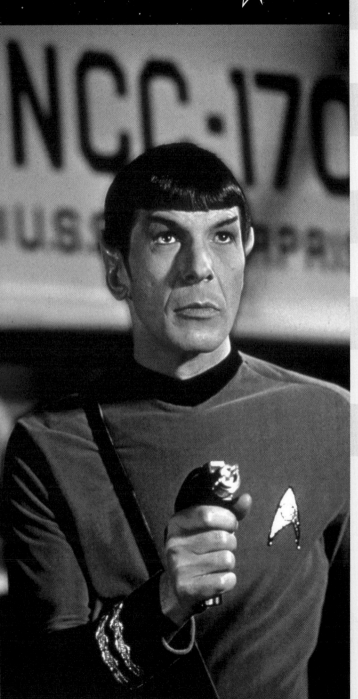

1815. What ship did Sisko serve on during the Tzen Kethi War?
- **A.** *U.S.S. Okinawa*
- **B.** *U.S.S. Saratoga*
- **C.** *U.S.S. Defiant*
- **D.** *U.S.S. Livingston*

1816. Who helped Nog recuperate emotionally from the loss of his leg?
- **A.** Ezri
- **B.** Leeta
- **C.** Rom
- **D.** Vic Fontaine

1817. What nonverbal language did Janeway have difficulty with?
- **A.** American Sign Language
- **B.** Chromolinguistics
- **C.** Tak Tak
- **D.** Leyron

1818. What rank did Janeway's father achieve in Starfleet?
- **A.** Captain
- **B.** Admiral
- **C.** Lieutenant
- **D.** Ensign

1819. Despite being a vegetarian, which vegetable did Chakotay dislike?
- **A.** Beets
- **B.** Radishes
- **C.** Mushrooms
- **D.** Carrots

1820. What scientific hobby besides anthropology did Chakotay pursue?
- **A.** Paleontology
- **B.** Archaeology
- **C.** Sociology
- **D.** History

1821. What is the name of Tuvok's youngest son?
- **A.** Sek
- **B.** Solok
- **C.** T'Men
- **D.** Asil

1822. Where did Harry Kim's parents live?
- **A.** North Carolina
- **B.** Hong Kong
- **C.** Auckland
- **D.** South Carolina

1823. How old was B'Elanna when she dropped out of Starfleet Academy?
- **A.** Seventeen
- **B.** Eighteen
- **C.** Nineteen
- **D.** Twenty-one

1824. Neelix was one-eighth what species?
- **A.** Mylean
- **B.** Ocampan
- **C.** Haakonian
- **D.** Kazon

1825. What was Kes's father's name?

A. Martis
B. Benaren
C. Elrem
D. Tieran

1826. Who was Naomi Wildman's godfather?

A. Paris
B. Chakotay
C. Neelix
D. Karry Kim

1827. What was the name of the binary clone child of T'Pol and Tucker?

A. Elizabeth
B. Koss
C. Linden
D. T'rip

1828. Where was Trip born?

A. Fort Lauderdale
B. Panama City
C. Oakland
D. New Brazil

1829.

1830. What news reporter did Mayweather have a relationship with?

A. Lana Lang
B. Jeri Pillar
C. Coral Sanders
D. Gannet Brooks

1831. What hobby did Travis enjoy that helped save some geologists?

A. Spelunking
B. Boating
C. Skin diving
D. Hiking

1832. What food did Hoshi hate as a child, but grow to love as an adult?

A. Pineapple
B. Strawberry gelatin
C. Peas
D. Soba noodles

1833. What is Captain Kirk's birthday?

A. March 22
B. April 1
C. June 23
D. October 15

1834. What was the room number of Kirk's quarters aboard the original *U.S.S. Enterprise*?

A. 5F 111
B. 6A 210
C. 3F 121
D. 2A 100

1829.

You might call Majel Barrett-Roddenberry (shown at right) the first lady of *Star Trek*.

Majel first met Gene Roddenberry while working on his TV show *The Lieutenant*; he subsequently cast her in the pilot for *Star Trek.* Though this version of the pilot was not picked up, a second one was made and *Star Trek* was born. Barrett soon returned as a supporting character and went on to make twenty-five appearances in the original *Star Trek* series.

Majel and Gene were married from 1969 until his death in 1991, and she continued his legacy by being involved in every incarnation of *Star Trek* after that, whether on screen or by providing voice-over work. One of Majel's continuing roles was to provide the voice for many of the Starfleet computers, notably the *U.S.S. Enterprise*.

Which role did she *not* play during four decades of *Star Trek*?

A. Lieutenant M'Ress
B. Christine Chapel
C. Admiral Nechayev
D. Number One

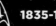

1835. From which relative did James T. Kirk inherit his famous middle name?

A. Paternal uncle
B. Paternal grandfather
C. Maternal uncle
D. Maternal grandfather

1836. What was Spock's serial number?

A. SC 1701-275-SG
B. SD 179-179 PS
C. S 279-176LN
D. S 179-276 SP

1837. What prestigious Vulcan medal was Spock awarded before the year 2267?

A. Order of *Kir-Shara*
B. Vulcanian Scientific Legion of Honor
C. Carrington Award
D. Zee-Magnees Prize

1838. What was Dr. McCoy's daughter's name?

A. Constance
B. Vanessa
C. Christine
D. Joanna

1839. During his fifty-one-year career in Starfleet, how many vessels did Scotty serve on?

A. Eleven
B. Thirteen
C. Fifteen
D. Eighteen

1840. Although not seen in the original series *Star Trek* after its first season, Yeoman Rand would later appear in the film *Star Trek VI: The Undiscovered Country*, serving under which captain?

A. Kirk
B. Sulu
C. Decker
D. Scott

1841. What ship did Yeoman Rand transfer to after the events of *The Voyage Home*?

A. *U.S.S. Reliant*
B. *U.S.S. Enterprise*-A
C. *U.S.S. Grissom*
D. *U.S.S. Excelsior*

1842. John Winston reprised his recurring role of which original series crewman in *The Wrath of Khan*, though now he served on the *U.S.S. Reliant*?

A. Leslie
B. Kyle
C. DeSalle
D. Kelso

1843. Which assimilated drone did Seven encounter in the episode "Dark Frontier"?
- **A.** Janeway
- **B.** Her father
- **C.** Her mother
- **D.** Her aunt

1844. How many episodes did Lieutenant Leslie appear in?
- **A.** Forty-seven
- **B.** Fifty-three
- **C.** Fifty-seven
- **D.** Seventy-nine

1845. Which Janus VI head of security was looking for the Horta?
- **A.** Lieutenant Galway
- **B.** Lieutenant Commander Giotto
- **C.** John Gill
- **D.** Lt. Galloway

1846. Who was the Tellarite ambassador to the Babel conference?
- **A.** Gav
- **B.** Sarek
- **C.** Shras
- **D.** Thelev

1847. What position did Kyle hold in the *Star Trek* animated series?
- **A.** Science officer
- **B.** Security chief
- **C.** Transporter chief
- **D.** Navigator

1848. Though he stopped pursuing her after his bar fight in 2327, which ensign did Picard have a crush on?
- **A.** Vash
- **B.** Marta Batanides
- **C.** Beverly Crusher
- **D.** Jenice Manheim

1849. Which of Picard's closest friends was killed after revealing his fears to Picard about a Starfleet conspiracy?
- **A.** Jack Crusher
- **B.** Tryla Scott
- **C.** Gregory Quinn
- **D.** Walker Keel

1850. What was Picard's serial number?
- **A.** JP-159-654
- **B.** FC-432-980
- **C.** SD-213-669
- **D.** SP-937-215

1851. What was Riker's mother's name?
- **A.** Wilma
- **B.** Betty
- **C.** Diane
- **D.** Kim

1858.

Garak (shown at left), the Cardassian tailor aboard Deep Space 9, had a shadowy past that often came back to haunt him. A high-ranking member of the Cardassian intelligence agency, Garak may or may not have been involved in the death of Romulan officials, and at some point he learned Klingonese (though the destruction of the Klingon moon probably wasn't his fault). He was certainly involved in the execution of Gul Dukat's father. As Garak told Worf, "Lying is a skill like any other. And if you want to maintain a level of excellence, you have to practice constantly."

Still, at heart Garak was proud of his heritage, and his work for Starfleet decoding Cardassian transmissions during the Dominion War caused him great grief.

How did this grief affect him physically?

A. Migraines
B. Debilitating claustrophobia
C. Hives
D. Cardassian shingles

1852. What was Riker's first posting?
A. *U.S.S. Pegasus*
B. *U.S.S. Hood*
C. *U.S.S. Intrepid*
D. *U.S.S. Titan*

1853. What year was Wesley Crusher born?
A. 2250
B. 2341
C. 2347
D. 2348

1854. What governed the blinking of Data's eyes?
A. Quantum calculations
B. Fourier series
C. Newton's third law
D. Random positronic algorithym

1855. How many operations per second was Data's positronic brain capable of?
A. Sixty trillion
B. Sixty billion
C. Sixty million
D. Sixty thousand

1856. What part of the electromagnetic spectrum could Geordi's VISOR *not* detect?
A. Infrared
B. Ultraviolet
C. Gamma
D. None

1857. What colony was Worf living on when he captained a soccer team at age thirteen?
A. Qu'Vat
B. Lunar One
C. Gault
D. Tendara

1858.

1859. What was Riker's nickname aboard the *U.S.S. Pegasus*?
A. "Whiskers"
B. "Mr. Regulation"
C. "Jazzman"
D. "Ensign Babyface"

1860. What was Dr. Crusher's middle name?
A. Cheryl
B. Julie
C. Sharon
D. Sybil

1861. Which paper written by Dr. Pulaski was still considered the standard in the subject during her time on the *U.S.S. Enterprise*?
A. "Comparative Alien Physiology"
B. "Nanite Organ Restructuring"
C. "Linear Models of Viral Propagation"
D. "Accelerated Aging Effects"

1862. What room housed Captain Picard's quarters?

- **A.** 1946
- **B.** 3601
- **C.** 3402
- **D.** 2133

1863. What was Sisko's favorite drink?

- **A.** Tea
- **B.** Raktajino
- **C.** Aldebaran whiskey
- **D.** Saurian brandy

1864. How old was Kira when she went on her first mission for the Shakaar resistance cell?

- **A.** Eleven
- **B.** Twelve
- **C.** Thirteen
- **D.** Eighteen

1865. What did Jadzia Dax *not* have a degree in?

- **A.** Psychiatry
- **B.** Exobiology
- **C.** Astrophysics
- **D.** Zoology

1866. Why did Curzon initially reject Jadzia as a symbiont candidate?

- **A.** He was in love with her
- **B.** He thought she was immature
- **C.** He thought she was unstable
- **D.** He was insane

1867. What type of athlete was Emony Dax?

- **A.** Swimmer
- **B.** Gymnast
- **C.** Fencer
- **D.** Horseback rider

1868. How often did Odo need to return to his natural liquid form?

- **A.** Every sixteen hours
- **B.** Every twenty-four hours
- **C.** Every thirty-six hours
- **D.** Every forty-eight hours

1869. Who was *not* a cousin of Quark's?

- **A.** Gaila
- **B.** Frin
- **C.** Barbo
- **D.** Stol

1870. Which of Bashir's ancestors was from the fifteenth century?

- **A.** Siddig
- **B.** Richard
- **C.** Watley
- **D.** Singh

1871. Who was the dabo girl Jake dated for a time?

- **A.** Leeta
- **B.** Mardah
- **C.** Sarda
- **D.** M'Pella

1872. What type of coffee did O'Brien prefer?

A. Costa Rican C. French

B. Jamaican blend D. Colombian

1873.

1874. Which of Ezri's brothers was responsible for the death of Monica Bilby?

A. Yanas C. Joran

B. Janel D. Norvo

1875. What time did Kasidy Yates normally get out of bed?

A. 0500 hours C. 0700 hours

B. 0600 hours D. 0800 hours

1876. What rank did Nog achieve in the *Deep Space Nine* finale?

A. Ensign C. Lieutenant junior grade

B. Lieutenant commander D. Colonel

1877. Which was the final Weyoun clone?

A. Weyoun 8 C. Weyoun 6

B. Weyoun 7 D. Weyoun 5

1878. What was one of Janeway's favorite dishes?

A. Beef bourguignon C. Welsh rarebit

B. Scrambled eggs D. Pizza

1879. On what ship was Janeway a command officer during the early 2360s?

A. *U.S.S. Al-Batani* C. *U.S.S. Equinox*

B. *U.S.S. Billings* D. *U.S.S. Reliant*

1880. What did the actress prior to Kate Mulgrew request as Janeway's first name?

A. Sarah C. Carol

B. Caitlin D. Nicole

1881. Who was Janeway's favorite teacher at Starfleet Academy?

A. Admiral Kirk C. Boothby

B. Admiral Patterson D. Tuvok

1873.

A fan of the original *Star Trek* and inspired by Nichelle Nichol's portrayal of Lieutenant Uhura, Academy Award–winner Whoopi Goldberg (shown at left) asked her friend LeVar Burton to tell Gene Roddenberry she'd like to be on *The Next Generation*. The producers didn't think she was serious until she contacted them herself.

Goldberg took the role of Guinan, the enigmatic and long-lived bartender of Ten-Forward. Over the course of the next six seasons, bits and pieces of her past were revealed, such as her previous encounters with the Borg, Q, and Mark Twain.

Born sometime before the nineteenth century, Guinan had a large family. She didn't always get along with them all, but she did mention one relative she liked.

Which uncle (and black sheep of her family) did she have a good relationship with?

A. Martus

B. Sam

C. Adrik

D. Terkim

1882. What was Chakotay's serial number?

A. CT-345-920
B. CC-Beta-21
C. 47-Alpha-612
D. 23-TAY-29

1883. How many wins did Chakotay have during his boxing career at Starfleet Academy?

A. Twelve
B. Twenty-three
C. Thirty-two
D. Thirty-eight

1884. What was Chakotay's boxing nickname, according to Torres?

A. "Southpaw"
B. "Eagle-Eyes"
C. "The Tattooed Terror"
D. "Chak-ka-boom"

1885. What was Tuvok's mother's name?

A. T'Pel
B. T'reel
C. T'Les
D. T'Meni

1886. After Tuvok resigned from Starfleet, where did he teach?

A. Vulcan Institute for Defensive Arts
B. Vulcan Science Academy
C. Vulcan Cultural Exchange Institute
D. Vulcan Arts and Letters Program

1887. Where was Tuvok born?

A. Andoria
B. Mount Seleya
C. Vulcanis Lunar Colony
D. Starbase 57

1888. What grade did Tom Paris receive in his father's survival strategies course at the Academy?

A. A
B. B-minus
C. A-minus
D. F

1889.

1890. What ship was Tom Paris first assigned to after graduation?

A. U.S.S. Exeter
B. U.S.S. Equinox
C. U.S.S. Bozeman
D. U.S.S. Al-Batani

1891. Harry Kim was a three-time Academy champion in what game?

A. Kal-toh
B. Lacrosse
C. Parrises squares
D. Chess

1889.

Romance often blooms in the workplace, but Commander William Riker and Counselor Deanna Troi's (shown at right) relationship started years earlier when he was stationed on Betazed. Their romance ended awkwardly and they lost touch until their separate postings drew them back together on board the *U.S.S. Enterprise*-D.

Their love affair actually began as a concept for Gene Roddenberry's unmade *Star Trek Phase II* series. He transferred the dynamic of the estranged lovers working together to the characters of Will Decker and Ilia in *Star Trek: The Motion Picture*. When *The Next Generation* was developed, he revisited the idea of former lovers working together as shipmates. However, Will and Deanna's story took much longer and had an arguably happier ending.

Though their wedding took place off screen in *Star Trek Nemesis*, it occurred as the ship was on its way to Betazed.

How were traditional Betazoid wedding ceremonies performed?

A. In antigravity chambers
B. In the nude
C. With all parties in ceremonial robes
D. Underwater

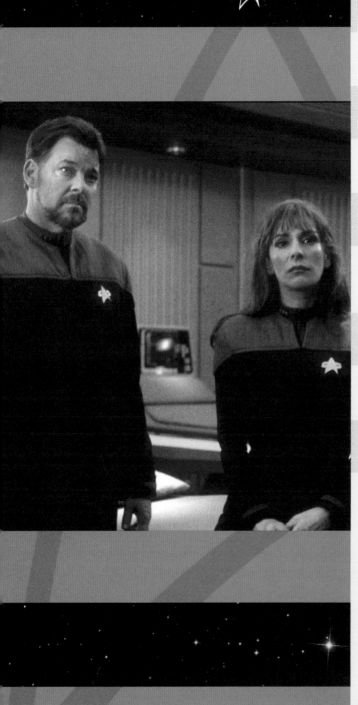

1892. What colony was B'Elanna born on?

A. Ajilon Prime C. Krios Prime
B. Kessik IV D. Runara IV

1893. What elementary school did Trip Tucker attend?

A. Zefram Cochrane C. Roosevelt Franklin
B. Bayshore D. Kennedy

1894. What was Trip's favorite dish?

A. Salisbury steak C. Catfish and hush puppies
B. Turkey and gravy D. Pizza

1895. What was Dr. Phlox's favorite Chinese dish?

A. Egg drop soup C. Chow mein
B. Sticky buns D. Lo mein

1896. How many degrees in interspecies veterinary medicine did Phlox hold?

A. Three C. Five
B. Four D. Six

1897. What waitress from the 602 Club did Malcolm Reed once have a relationship with?

A. Deborah C. Rochelle
B. Ruby D. Caitlin

1898. Who did the dying Major Hayes name as his replacement?

A. Corporal Scott C. Cpl. McKenzie
B. Cpl. Romero D. Cpl. Cole

1899. What was Shran's rank in the Andorian Imperial Guard?

A. Major C. Admiral
B. Corporal D. General

1900. How many years had Ambassador Soval served on Earth by 2154?

A. More than ten C. More than forty
B. More than thirty D. More than fifty

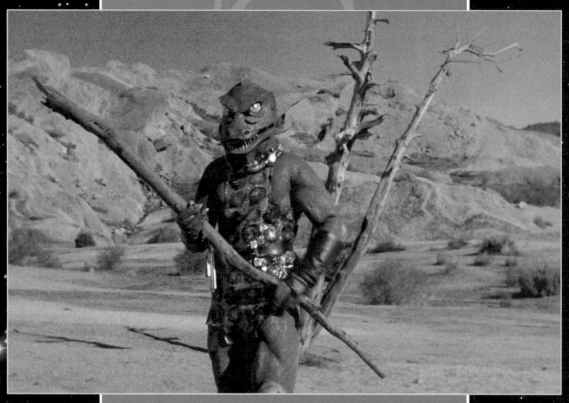

CHAPTER 8

NEW LIFE & CIVILIZATIONS

ALIEN RACES, CULTURES & PLANETS

1901. Where is the Vulcan heart located?

 A. Back of the rib cage

 B. Below the intestines

 C. Where the human liver is

 D. Where the human appendix is

1902. Where did Surak, father of Vulcan logic, die?

 A. ShiKahr

 B. Raal

 C. Vulcan's Forge

 D. Mount Seleya

1903. What did Surak's teachings bring about on Vulcan?

 A. Reformation

 B. Time of awakening

 C. Clash of the fire plains

 D. The Hundred Year War

1904. What is the ruling governmental body on Vulcan?

 A. Vulcan high command

 B. Vulcan Senate

 C. Vulcan Congress

 D. Vulcan Science Advisory

1905. Which of the following describes the Vulcan diet?

 A. Omnivorous

 B. Carnivorous

 C. Energy-based

 D. Herbivorous

1906. What mineral is Vulcan blood based on?

 A. Nickel

 B. Cadmium

 C. Tin

 D. Copper

1907. How long is a typical Vulcan lifespan?

 A. 70 years

 B. 100 years

 C. 200 years

 D. 300 years

LEFT Gorn captain in the original series episode "Arena."

1908. What race is able to shield itself from Vulcan mind-melds?

 A. Bajoran
 B. Ferengi
 C. Cardassian
 D. Human

1909. What martial arts technique was used as a form of execution on ancient Vulcan?

 A. *Suus Mahna*
 B. *Tal Shiar*
 C. *Kroyka*
 D. *Tal-shaya*

1910. What is the name of the Klingon ceremony in which an individual is stripped of honor?

 A. *Ak'voh*
 B. Discommendation
 C. *R'uustai*
 D. Rite of Dishonor

1911. How many lungs do Klingons have?

 A. Two
 B. Three
 C. Four
 D. Five

1912. What common Klingon animal did both Worf and Martok own as pets at some point?

 A. Targ
 B. Grint hound
 C. Saber Bear
 D. Sark

1913. Klingon serpent worms were the main ingredients in what popular Klingon food?

 A. *Grapok* sauce
 B. *Warnog*
 C. *Gagh*
 D. *Gladst*

1914. What is another name for the Klingon *bat'leth*?

 A. "Sword of Honor"
 B. "Death of Molor"
 C. "Spine of Kahless"
 D. "Hammer of Justice"

1915. In Klingon myth, how did Kahless come by the first *bat'leth*?

 A. Found it embedded in the Kri'stak volcano
 B. Forged it from the spine of Molor
 C. Lady of the Lake of Lusor gave it to him
 D. Twisted a burnt lock of his hair into a blade

1922.

Although best known for their logic, Vulcans have a physiology that is a study unto itself. In appearance Vulcans are similar to humans, save for their tapered ears and upswept eyebrows. Internal organs, however, are arranged differently, and some human organs, like the appendix, are absent entirely from Vulcans. The extremely thin atmosphere on Vulcan means they have a highly efficient respiratory system.

Their highly developed brain structure also allows them differing degrees of psionic ability. But those same brains that suppress emotion for a lifetime must periodically give in to the violent Vulcan mating impulses as shown in the original series episode "Amok Time" during Spock's betrothal (shown at left). Since a Vulcan's strength is greater than that of humans, they are dangerous during those periods.

How much stronger is a Vulcan than an average human?

A. Three times
B. Four times
C. Five times
D. Six times

1917. How long is the average Klingon lifespan?
A. 150 years **C.** 200 years
B. 170 years **D.** 250 years

1918. Who was the Klingon equivalent of the devil?
A. Kortar **C.** Kahless
B. *Fek'lhr* **D.** *Hij'Qa*

1919. What dish is traditionally served on the Klingon Day of Honor?
A. *Bregit* lung **C.** *Pipius* claw
B. Heart of *targ* **D.** *Rokeg* blood pie

1920. What Klingon martial art did Worf teach on board the *U.S.S. Enterprise*-D?
A. *mok'bara* **C.** *lahj*
B. *mek'leth* **D.** *Suus Mahna*

1921. What is the name of the Klingon military branch of the empire?
A. House of Kahless **C.** Imperial Guard
B. Klingon Defense Force **D.** Order of the *Bat'leth*

1922.

1923. What famous Klingon opera singer was one of Worf's favorites?
A. Keedera **C.** Barak-Kadan
B. Aktuh **D.** Gav'ot toh'va

1924. Once assimilated, what color did a Borg drone's skin become?
A. Tan **C.** Green
B. Pink **D.** Gray

1925. What was the Borg hive-mind called?

A. The Collective C. The Hive
B. The Great Link D. 10001

1926. Despite a hive-mind, who was "the one who is many" who appeared to lead the Borg?

A. One of One C. Species One
B. Axum D. Borg queen

1927. What connects drones to the Borg hive-mind?

A. Neuroprocessor C. Neurotransceiver
B. Neuropathic matrix D. Eyepiece organelles

1928. How many drones are part of the Borg?

A. Millions C. Quadrillions
B. Trillions D. Quintrillions

1929. What is the primary directive of the Borg?

A. Perfection through assimilation C. Kill all organic life
B. Obey the leader D. Conquer Earth

1930. Borg drones contain fail-safes that do what if their bodies are damaged or killed?

A. Beam them into space C. Release poison gas
B. Explode D. Vaporize them

1931. How many different words does the Ferengi language have for rain?

A. 78 C. 193
B. 178 D. 220

1932. What color are Ferengi fingernails?

A. Orange C. Blue
B. Gray D. Clear

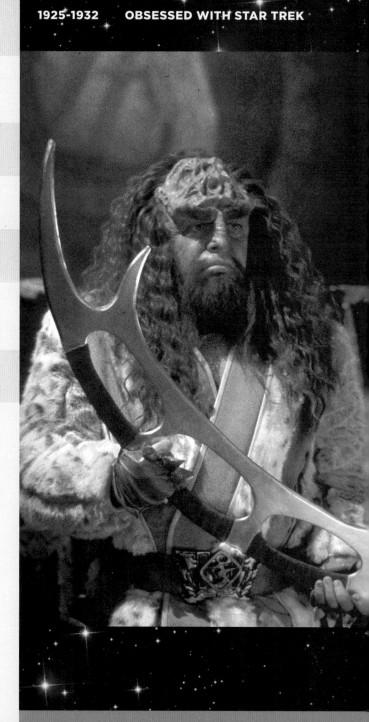

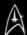

1939.

For a warrior race, the Klingons (or *thlIngan*, in the Klingonese, shown at left) could lay claim to the most developed vocabulary of all the Star Trek aliens. The original Klingonese was developed by James Doohan for the first *Star Trek* film, and only consisted of a dozen or so guttural words Doohan made up. Linguist Marc Okrand was hired to further develop the language and coach the actors in later films. Okrand wrote *The Klingon Dictionary*, and writers and fans of the show have been using it ever since. Fans have even translated Shakespeare's *Hamlet* into the original Klingonese.

Some writers have opted to make up their own words or break pronunciation rules established by the dictionary to make things sound better on television. Still, as fictional languages go, it has to be considered a success.

How would you say "Success!" in *thlIngan Hol*?

1933. What type of ear infection could be fatal to a Ferengi if left untreated?
- **A.** Canal
- **B.** Lobe
- **C.** Cochlear
- **D.** Tempanic membrane

1934. What was the first of the five stages of acquisition?
- **A.** Resale
- **B.** Infatuation
- **C.** Obsession
- **D.** Appropriation

1935. What did Ferengi call their ears?
- **A.** Moneymakers
- **B.** Cochleas
- **C.** Lobes
- **D.** Vestibules

1936. What do Ferengi usually kiss when meeting the Grand Nagus?
- **A.** His cane
- **B.** His ring
- **C.** His ears
- **D.** His robe

1937. What did the Rule of Acquisition #34 state?
- **A.** Expand or die
- **B.** War is good for business
- **C.** A deal is a deal
- **D.** Never place friendship above profit

1938. What was Rule of Acquisition #35?
- **A.** Greed is eternal
- **B.** Every man has his price
- **C.** Peace is good for business
- **D.** Knowledge equals profit

1939.

1940. Following the seemingly conflicting Rules of Acquisition #34 and #35, how did the Ferengi ally themselves in interstellar politics?
- **A.** Pro-Federation
- **B.** Pro-Dominion
- **C.** Pro-Cardassian
- **D.** Neutral

- **A.** *Mok'tah*
- **B.** *shuVak*
- **C.** *Qui'Tu*
- **D.** *Qapla'*

1941. In what quadrant was the planet Romulus located?

A. Alpha
B. Beta
C. Gamma
D. Delta

1942. What title is given to the leader of the Romulan Star Empire?

A. Praetor
B. Proconsul
C. Emperor
D. Consul

1943. What is the governing body of the empire?

A. Imperial Consulate
B. Senate
C. Imperial Council
D. Republic

1944. What governmental body on Romulus confirms any new leader?

A. Tal Shiar
B. Imperial chair
C. Romulan steering committee
D. Continuing committee

1945. What technology set the Romulans apart, especially in terms of espionage?

A. Temporal
B. Warp
C. Cloaking
D. Holographics

1946. What cultural trait did Romulans tend to possess that made them difficult to deal with?

A. Aggression
B. Xenophobia
C. Overly logical
D. Mercenary

1947. Who started a hundred year war between the Romulans and the Vulcans?

A. Female Q
B. Q Junior
C. Q
D. The Quinn Q

1948. What was the title given to the spiritual leader of Bajor?

A. Vedek
B. Ranjen
C. Kai
D. Emissary

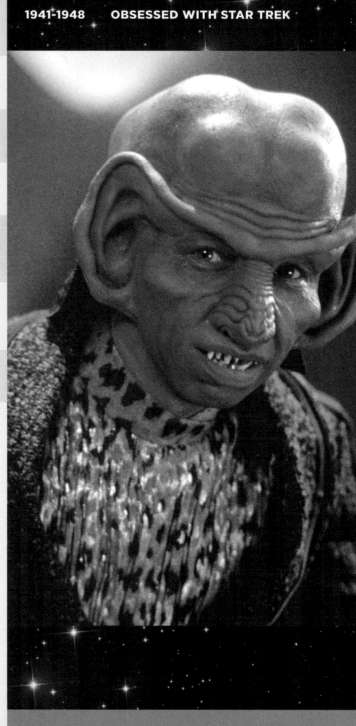

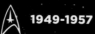

1954.

Once *The Next Generation* had introduced the Borg, the Ferengi no longer made sense in the role of villain. The small, big-eared aliens simply weren't threatening by comparison (Rom, a Ferengi, shown at left). But transforming them into a profit-driven, materialistic culture allowed the writers to redeem them, and to wring both comedy and drama out of their place in Star Trek lore.

With a Ferengi as a main character on *Deep Space Nine*, each year a Ferengi-based story would delve deeper into the alien race's culture, behavior, and myths.

As first revealed in "Little Green Men," what is the Ferengi name for the afterlife?

A. Bank of paradise
B. Great auction
C. Divine treasury
D. Vault of success

1949. Who was the chief executive of the Bajoran provisional government?
A. Vedek **C.** First minister
B. Prime minister **D.** Chancellor

1950. How long was a Bajoran pregnancy?
A. Four months **C.** Seven months
B. Five months **D.** Nine months

1951. How long did an average Bajoran live?
A. Thirty-five years **C.** Eighty-five years
B. Seventy-five years **D.** One hundred years

1952. What lamps did Bajorans light to mourn the death of a loved one?
A. Kosst **C.** *pagh*
B. *duranja* **D.** Ha'mara

1953. How did Bajorans typically clap?
A. Left palm on right wrist **C.** Right palm on left wrist
B. Wrists together **D.** Index and middle finger together

1954.

1955. What Earth food does the spicy Bajoran *hasperat* resemble?
A. Burrito **C.** Burger
B. Taco **D.** Pasta

1956. What was the unit of exchange for Cardassians?
A. Latinum **C.** Credit
B. Darsek **D.** Lek

1957. What was the civilian governing body of the Cardassian Union?
A. Detapa council **C.** Cardassian ruling council
B. Cardassian central command **D.** Cardassian Imperial court

1958. What trait did the xenophobic Cardassians value?

A. Financial success
B. Military success
C. Cleanliness
D. Piety

1959. Most Cardassians excelled in which type of memory?

A. Sensory
B. Photographic
C. Race
D. Short-term

1960. What alcoholic beverage did most Cardassians enjoy?

A. *Rokassa*
B. *Regova*
C. *Mot'lach*
D. *Kanar*

1961. What do the Vorta activate in case of capture?

A. Distress beacon
B. Emergency temporal shift
C. Termination implant
D. Emergency beam-out

1962. How do the Jem'Hadar reproduce?

A. Binary fission
B. Cloning
C. Mitosis
D. Implant eggs in host

1963. Which nuts are among the few tastes the Vorta can enjoy?

A. Kava
B. Cashews
C. Walnuts
D. Macadamias

1964. What do Jem'Hadar plasma rifles contain to ensure an enemy's slow death?

A. Poison
B. Radioactive isotopes
C. Necrosis instigators
D. Anticoagulants

1965. What weapon do the Jem'Hadar prefer in close combat?

A. Cutlass
B. Pistol
C. *Kar'tarkin*
D. Nunchuks

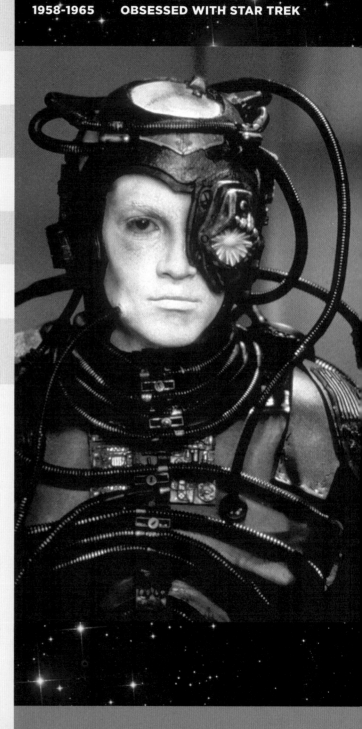

1971.

The only thing that survived the first concept of the Borg—originally conceived as an insectoid race—was the hive-mind. Budget constrictions in the early years of *The Next Generation* didn't allow for the extensive makeup or CGI technology needed for an insectoid race, but cyborgs were possible.

The implacable Borg (shown at left) were a terrifying threat to the Federation. They promised a fate worse than death: assimilation into their ranks. After Picard met this unthinkable fate, it took years for him to truly purge the effects of what he had experienced while part of the Borg.

Without a doubt one of the greatest villains in Star Trek history, the Borg have become a pop-culture symbol for any type of unstoppable juggernaut.

What is the Borg's clarion statement?

A. "All differences will be purged."
B. "Organic life must cease."
C. "Exterminate."
D. "Resistance is futile."

1966. How long had the Dominion endured before the war with the Alpha Quadrant?

A. 1,000 years
B. 2,000 years
C. 3,000 years
D. 4,000 years

1967. When did the Hundred Year War between the Romulans and Vulcans begin?

A. 1944
B. 1922
C. 1966
D. 1988

1968. What type of teeth do Vulcans have that humans do not?

A. Monocuspids
B. Bicuspids
C. Quadrocuspids
D. Tricuspids

1969. What is the three-dimensional puzzle Vulcan infants are given to learn primary logic?

A. *Kal-toh*
B. *Kadis kot*
C. *Pleenok*
D. *Plomeek*

1970. While Romulans are known for their ale, what was the *only* Vulcan spirit ever mentioned in any *Star Trek*?

A. Vulcan vodka
B. Vulcan port
C. Vulcan rum
D. Vulcan brandy

1971.

1972. What is required for a Vulcan mind-meld?

A. Physical contact
B. Familial bond
C. Training
D. *Sehlat*

1973. The Klingon saying "Today is a good day to die" actually comes from which Native American leader?

A. Sitting Bull
B. Squanto
C. Crazy Horse
D. Geronimo

1974. Where did dishonored Klingons go after death?

- **A.** *Gre'thor*
- **B.** *Sto-vo-kor*
- **C.** *Fek'lhr*
- **D.** *Ak'voh*

1975. How many members made up the Klingon High Council?

- **A.** Twelve
- **B.** Sixteen
- **C.** Eighteen
- **D.** Twenty-four

1976. How long is the average Klingon pregnancy?

- **A.** Twenty weeks
- **B.** Twenty-five weeks
- **C.** Thirty weeks
- **D.** Thirty-six weeks

1977. Which is *not* a house in the Klingon Empire?

- **A.** House of Grilka
- **B.** House of Kurn
- **C.** House of Martok
- **D.** House of D'Ghor

1978. What anatomic feature of the Klingon cranium did humans not possess?

- **A.** Mandible
- **B.** Parietal bones
- **C.** Sphenoid bone
- **D.** Tricipital lobe

1979. What branch of the Klingon military approves the applications of warriors to become officers?

- **A.** Order of Kahless
- **B.** Klingon defense command
- **C.** Klingon oversight council
- **D.** Imperial Armory

1980. Who was *not* a member of Klingon intelligence?

- **A.** Kurn
- **B.** Arne Darvin
- **C.** Bo'rak
- **D.** Atul

1981. Where did the Borg put captured children?

- **A.** Unused alcoves
- **B.** Maturation chamber
- **C.** Cryogenic stasis
- **D.** Lifepods

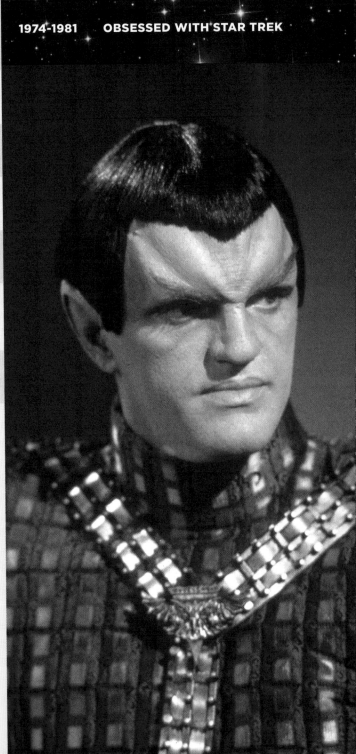

1987.

Shrouded in secrecy for eons, to the point where they fought wars and negotiated treaties without allowing their enemies to see their faces, the Romulan culture embodied paranoia, treachery, and xenophobia (Romulan shown at left).

After the Earth-Romulan War, a Neutral Zone was established between Federation and Romulan space. Entry by either side would be considered an act of war, though James Kirk deliberately entered it on two occasions.

In 2311, an incident at Tomed caused the loss of thousands of Federation lives to Romulan forces, prompting a renegotiation of the Neutral Zone as well as a stipulation that the Federation would not develop cloaking technology.

What was this famous treaty called?

A. Treaty of Armens
B. Treaty of Algeron
C. Jankata Accords
D. Tau Ceti Accords

1982. How long are captured children kept in containment by the Borg?
A. Ten cycles
B. Fourteen cycles
C. Depends on age
D. Seventeen cycles

1983. How are Borg nanoprobes injected into a target?
A. Touch
B. Surgery
C. Assimilation tubules
D. Bioneural invasion

1984. Aside from enabling a sonic interface with Borg transponders, what else could vocal sub-processors do?
A. Instigate sonic attack
B. Mask signals
C. Decode signals
D. Give users perfect pitch

1985. How big was the Borg Unicomplex?
A. 600 kilometers
B. 900 kilometers
C. 1,200 kilometers
D. 20,000 kilometers

1986. What temperature did the Borg prefer to function in?
A. 50.2 degrees Celsius
B. 17 degrees Celsius
C. 39.1 degrees Celsius
D. 24.3 degrees Celsius

1987.

1988. What did the Borg designate humans?
A. Species 180
B. Species 4339
C. Species 5618
D. Species 10026

1989. What is the tallest building on Ferenginar?
A. Sacred marketplace
B. Profit plaza
C. Latinum building
D. Tower of commerce

1990. Where was the Grand Nagus's throne located?
A. Nagal residence
B. Chamber of opportunity
C. Latinum stairway
D. Material throne room

1991. What is the ceremony in which male Ferengi are formally introduced to the world?

A. Naming Day

B. *Oo-mox*

C. Attainment Ceremony

D. Age of Profit

1992. What was the main staple of Ferengi cuisine?

A. Insects

B. Latinum

C. Scavenged food

D. Replicated food

1993. Who was Slug-O-Cola's main competitor in the 2370s?

A. Manta spray juice

B. SnailDrop

C. Dregbuie

D. Eelwasser

1994. How is Millipede juice usually served?

A. Cold

B. With lime

C. Hot

D. Sparkling

1995. What did Ferengi mothers do for their male children's food?

A. Serve them by hand

B. Pre-chew it

C. Polish it

D. Resell it

1996. By Earth's calendar, when did the Romulans leave Vulcan?

A. first century

B. second century

C. third century

D. fourth century

1997. Why did the Romulans leave Vulcan?

A. To escape oppression

B. To conquer other worlds

C. They rejected Surak's reforms

D. They thought Vulcan was doomed

1998. What color is the Romulan heart?

A. Gray

B. Red

C. Green

D. Brown

1999.

1999.

Nearly omnipotent and omniscient, and always irrepressible, Q (and his fellow Q) became a fan favorite from the moment he appeared in the pilot episode of *The Next Generation*. Named by Gene Roddenberry himself to honor a British *Star Trek* fan, Q (shown at right) would pop up in *Deep Space Nine* and *Voyager* as well.

While the threats Q could bring were real (notably, the Borg, and a civil war among the Q Continuum), actor John deLancie's comedic timing nicely balanced out the godlike abilities of the character.

However, Q's irresponsible behavior once resulted in his being stripped of his powers, which led him to seek protection from Picard against the many beings in the universe he had wronged.

Even as a mortal, Q retained an incredible intellect. How high was his IQ while he was without his powers?

A. 210

B. 1,000

C. 2,005

D. 2,500

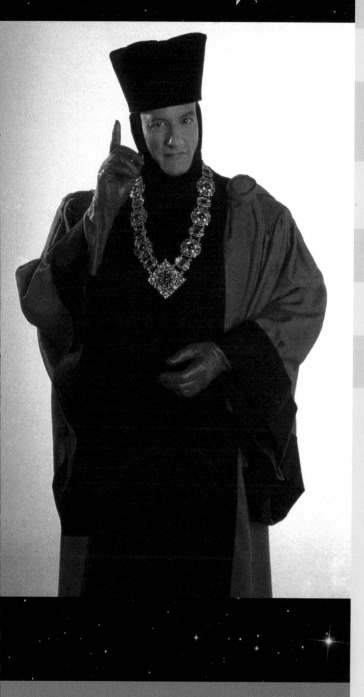

2000. What is unusual about Remus?

- **A.** Low gravity
- **B.** Totally underwater
- **C.** Tidally locked
- **D.** Dimensionally unstable

2001. What dog-sized arachnid was indigenous to Bajor's fifth moon?

- **A.** *Jeraddo*
- **B.** *Mullibok*
- **C.** *Palukoo*
- **D.** *Baltrim*

2002. What did an ancient tablet beneath the lost city of B'hala prophesize?

- **A.** An emissary of the prophets would come
- **B.** A reckoning between a prophet and a Pah-wraith
- **C.** The end of Bajor
- **D.** The end of the occupation

2003. Where did the ancient B'hala tablet pronounce its prophecy would occur?

- **A.** "Across three rivers"
- **B.** "The gateway to the temple"
- **C.** "The end of the path"
- **D.** "Below the ground"

2004. Where did the event the B'hala tablet foretold take place?

- **A.** The fire caves
- **B.** The wormhole
- **C.** The Gamma Quadrant
- **D.** Deep Space Nine

2005. Bajoran hearts were mirrored on what axis?

- **A.** Horizontal
- **B.** Diagonal
- **C.** Vertical
- **D.** None

2006. What did pregnancy often cause in Bajoran women?

- **A.** Uncontrolled eating
- **B.** Uncontrolled sneezing
- **C.** Uncontrolled drinking
- **D.** Inability to rest

2007. What traditional Cardassian morning beverage is served hot?

- **A.** *Kanar*
- **B.** *Raktajino*
- **C.** Fish juice
- **D.** *Deka* tea

2008. How many planets in the Cardassian system were mentioned in *Deep Space Nine*?

A. One
B. Five
C. Six
D. Seven

2009. What city on Cardassia Prime was obliterated by the Dominion in response to a terrorist attack?

A. Culat
B. B'hala
C. Doralis
D. Lakarian City

2010. Which of the following was *not* a system in Cardassian space?

A. Chin'toka
B. Dopa
C. Idran
D. Pelosa

2011. How long did it take Andorian antennae to grow back after a loss?

A. Nine weeks
B. Nine months
C. Nine years
D. Nine decades

2012. What color is Andorian blood?

A. Pink
B. Green
C. Blue
D. Red

2013.

2014. Where was one of the most noted art academies in the Federation located?

A. Trill
B. Tellar Prime
C. Andoria
D. Vulcan

2015. What was considered a sport on Tellar Prime?

A. Good arguments
B. Eating
C. Baths
D. Reproduction

2016. What human pet did Tellarites consider a delicacy?

A. Cat
B. Dog
C. Bird
D. Hamster

2013.

Andorians (a female shown at right) first appeared in the original series episode "Journey to Babel," and then only sporadically in the various *Star Trek* series, until a recurring role in *Enterprise* featured Jeffrey Combs as the militant Andorian commander Shran, sometime-ally of Captain Archer.

The emotional Andorians were locked in a cold war with the Vulcans. They also distrusted the Vulcans' human allies, until the *Enterprise* crew under Captain Archer unveiled a secret Vulcan surveillance facility and won the Andorians' trust in the episode "The Andorian Incident."

Meanwhile the Andorians' longtime rivals, the Tellarites, were framed for destroying an Andorian cruiser. Archer again stepped in to prevent escalation, this time by fighting Shran in the Andorian duel known as the *Ushaan*.

Hoshi and Mayweather attempted to help their captain by searching the Code of the *Ushaan* for any loophole that might prevent a combat to the death. Unfortunately, there were a lot of amendments to the Code.

How many were there?

A. 10,000
B. 12,000
C. 16,000
D. 20,000

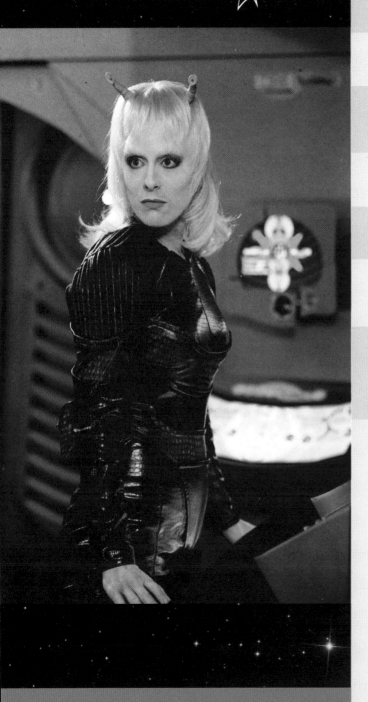

2017. How did Tellarites often begin an interaction with someone?

- **A.** Compliments
- **B.** Complaints
- **C.** Quotations
- **D.** Aphorisms

2018. How many of the noncorporeal Douwd have the Federation encountered?

- **A.** None
- **B.** One
- **C.** Five
- **D.** Ten

2019. What was Zefram Cochrane's Companion mainly composed of, besides electricity?

- **A.** Dikironium
- **B.** Ionized hydrogen
- **C.** Dilithium
- **D.** Ketrecel-white

2020. What did Clara Sutter's "imaginary friend" Isabella feed on?

- **A.** Phaser energy
- **B.** Transporter energy
- **C.** Plasma energy
- **D.** Communicator emissions

2021. What starship skills were the noncorporeal Medusans known for?

- **A.** Medical
- **B.** Cooking
- **C.** Navigational
- **D.** Command

2022. Onaya, the noncorporeal "muse" that sought out Jake Sisko, caused what type of damage to the creative people she fed off of?

- **A.** Writer's block
- **B.** Sensory overload
- **C.** Synaptic collapse
- **D.** Stroke

2023. How did the Organians test a species' level of intelligence for ten thousand years?

- **A.** Instigated a war
- **B.** Possessed them
- **C.** Observed the reactions to a silicon-based virus
- **D.** Forced them to solve unsolvable mysteries

2024. What were the prophets vulnerable to?

- **A.** Disruptors
- **B.** Chronitons
- **C.** Antiprotons
- **D.** Nucleogenix energy

2025. What was one sign of a Zalkonian evolving into a noncorporeal state?

A. Gamma emissions
B. Trianic energy readings
C. Isoelectric burst
D. Quantum flux field

2026. What did Zetarian possession of a humanoid life-form do to the host?

A. Caused a coma
B. Caused internal brain hemorrhaging
C. Caused them to spew gibberish
D. Caused them to become geniuses

2027. What is the name of the Gorn government?

A. Gorn Congress
B. Gorn hegemony
C. Gorn star empire
D. Gorn cluster

2028.

2029. What race was Mot, the barber aboard the *U.S.S. Enterprise*-D?

A. Andorian
B. Bajoran
C. Human
D. Bolian

2030. How do human females react to Orion women's pheromones?

A. Loss of motor control
B. Headaches
C. Increased serotonin
D. Lowered blood pressure

2031. What did Dr. Korby's translation of Orion medical records help revolutionize?

A. Eugenics
B. Cloning process
C. Immunization techniques
D. Neurosurgical procedures

2032. What sort of matter was left behind after the crystalline entity had converted a planet's matter to energy?

A. Lithium
B. Rhenium
C. Bitrium
D. Iridium

2033. What meal are guests in a Vulcan house expected to prepare?

A. Lunch
B. Dinner
C. Supper
D. Breakfast

2028.

Skin-color problems have plagued the Orions (shown at right) since the first *Star Trek* pilot. In test footage of the actress playing an Orion slave girl, makeup artist Fred Phillips painted her all one color. But when the footage came back from the developer, she appeared Caucasian. It happened again and again, no matter how he darkened the body paint. Finally they realized someone at the film lab had failed to understand she was playing an alien, and had been "color correcting" her each time.

The Orions next appeared in the animated *Star Trek* series, where it should have been easy to get them the correct shade … except that one of the producers was colorblind and kept steering the colorist to the wrong hue. For their *Enterprise* appearances, the characters were at last properly colored from the get-go.

What is the correct skin color for an Orion native?

A. Blue
B. Green
C. Red
D. Yellow

2034. According to creator Gene Roddenberry, what star did Vulcan orbit?

A. Antares
B. 40 Eridani A
C. Minshara
D. Epsilon

2035. What is the Vulcan ritual wherein a young adult must survive in the desert for four months with only a ritual blade?

A. *Plomeek*
B. *Tal'oth*
C. *Kal Rekk*
D. *Fal-tor-pan*

2036. What is the Vulcan holiday *Kal Rekk* for?

A. To commemorate Surak
B. Atonement
C. Presents
D. To celebrate emotions

2037. In some cases, a Vulcan nerve pinch resembles trauma to what area of the body?

A. Deltoid nerve cluster
B. Trapezius nerve bundle
C. Carotid neural pathways
D. Anterior nerve endings

2038. In *The Undiscovered Country*, the producers made Klingon blood which color to avoid getting the film being rated R by the MPAA?

A. Green
B. Lavender
C. Ochre
D. Brown

2039. What knife is used in the Klingon ritual of *Mauk-to'Vor*?

A. *gintaq*
B. *mevak*
C. *d'k tahg*
D. *mek'leth*

2040. Who was the first Klingon, according to their myths?

A. Kortar
B. Kahless
C. Molor
D. Torin

2041. How many syllables does the Klingon language contain?

A. Thirty
B. Eighty
C. Ninety
D. One hundred

2042. What vintage of Klingon bloodwine did General Martok consider the finest?

- **A.** 2209
- **B.** 2309
- **C.** 2313
- **D.** 2324

2043.

2044. What beverage was used to portray bloodwine on the *Star Trek* sets?

- **A.** Cranberry juice
- **B.** Fruit punch
- **C.** Sparkling cider
- **D.** Tea

2045. What was the Borg spatial designation for the Krenim Imperium?

- **A.** Grid 001
- **B.** Grid 005
- **C.** Grid 986
- **D.** Galactic Cluster 3

2046. What Delta Quadrant species did the Borg consider unworthy of assimilation?

- **A.** Vidiian
- **B.** Ferengi
- **C.** Voth
- **D.** Kazon

2047. What was the interlink frequency of Unimatrix Zero based on?

- **A.** Quantum variables
- **B.** Doppler shift
- **C.** Tri-axlliating modulation
- **D.** Fermat's theorem

2048. What destroyed the virtual reality of Unimatrix Zero?

- **A.** A nanovirus
- **B.** The Borg queen
- **C.** *Voyager* and a Borg sphere's deflector emitters
- **D.** Holographic disruption

2049. What did a Borg cortical array contain?

- **A.** Borg's neuroprocessor
- **B.** Borg's collective designation
- **C.** Index of a drone's memory engrams
- **D.** Self-destruct activator

2043.

The Xindi is a collective of six races, evolved from the same planet, but from different species (members of the Xindi council shown at right). While one race is extinct, the other five have one common goal: to destroy Earth. The Xindi worshipped beings known as the Guardians, who manipulated them for their own ends and primed them to destroy Earth in order to advance their own agenda in the temporal cold war.

A season-long arc that supported *Enterprise*'s almost series-long temporal cold war, the Xindi story line was generated in response to the low ratings of the second season. The producers adopted a darker tone and introduced the Xindi, who attacked Earth with a superweapon in an eerie echo of the September 11th terrorist attacks. However, in true *Star Trek* tradition, peace won out and three of the Xindi races formed an alliance with the humans of *Enterprise* to combat the Guardians' plot.

What was the home planet of all the Xindi races?

- **A.** Xindi Prime
- **B.** Xindus
- **C.** Xindithus
- **D.** Xanadus

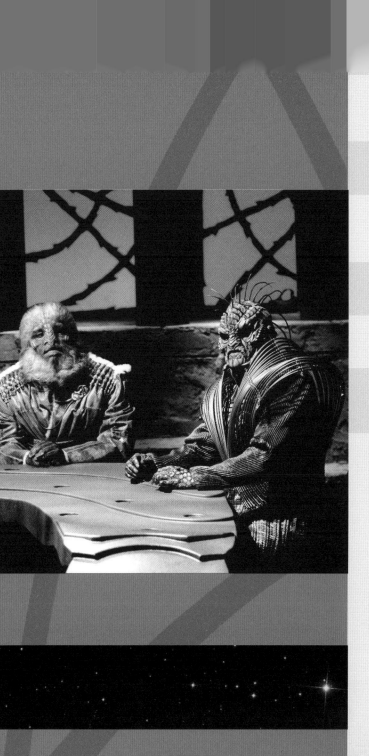

2051. What was the name of the Ferengi code that utilized patterns of light and darkness?

A. *B'Zal*
B. *Oo-mox*
C. *Yop*
D. *Gren*

2052. Who served as Grand Nagus prior to Zek?

A. Gint
B. Brunt
C. Smeet
D. Grish

2053. What system in the Ferengi Alliance is known for its arcybite mining operations?

A. Irtok
B. Clarus
C. Lappa IV
D. Zan Periculi

2054. How long is the typical Ferengi lifespan?

A. Over 40 years
B. Over 70 years
C. Over 100 years
D. Over 200 years

2055. Which Ferengi is credited with designing the first modular holosuite?

A. Gaila
B. Krem
C. Plegg
D. Qol

2056. How long did typical marriage contracts between Ferengi "lease" their daughters to a groom for?

A. Three years
B. Four years
C. Five years
D. Seven years

2057. What was the admission fee to enter another Ferengi's home?

A. ½ slip of latinum
B. ⅓ slip of latinum
C. One slip of latinum
D. One strip of latinum

2058. What Romulan animal was sometimes kept as a pet?

A. *Sehlat*
B. *Vole*
C. *Rateg*
D. *Set'leth*

2059.

2060. Who was Praetor before Shinzon?

A. Tal'aura
B. Suran
C. Donatra
D. Hiren

2061. What caste did the Remans belong to in Romulan society?

A. Untouchable
B. Slave labor
C. Merchant
D. Royal

2062. What did the complex Reman language use to represent certain verb roots?

A. Schwas
B. Pictographs
C. Sonic emissions
D. Shades of darkness

2063. What did some Romulan senators use Remans for?

A. Consorts
B. Nannies
C. Bodyguards
D. Proxies

2064. How many planets are in the Romulan system?

A. Three
B. Four
C. Six
D. Eight

2065. What mineral wealth was found on Remus?

A. Latinum
B. Benamite
C. Dilithium
D. Kemocite

2059.

"Never turn your back on a Breen," an old Romulan saying goes. This is somewhat ironic, coming from the secretive and cunning Romulans. The Romulans, like the Breen (shown at right), developed combat technology that made it difficult for their enemies to fight against them.

Rumored to come from a frozen planet, the Breen have no blood or comparable circulatory system. Like Ferengi, their brains have four lobes, making them difficult for telepaths to read. Their armored suits are refrigerated and help Breen withstand blows from even an enraged Klingon warrior.

The Breen joined the Dominion in their war against the combined powers of the Alpha Quadrant, and were promised planets like Earth and Romulus in return for their aid. Their energy-dampening weapons proved difficult for the Federation and Klingon forces to combat.

What handheld weapon was also effective against their enemies?

A. Coma blasters
B. Shock knives
C. Neural truncheon
D. Ice swords

2066. What *Star Trek* series did Bajorans first appear in?

A. *The Next Generation*
B. The original series *Star Trek*
C. *Deep Space Nine*
D. Feature films

2067. Which Bajoran peninsula's irrigation system did the chamber of ministers argue over for two days?

A. Tanis
B. Trilar
C. Perikian
D. Sahving

2068. What was the name of the greatest ancient Bajoran civilization?

A. B'hala
B. First Republic
C. Jalanda
D. First Dynasty

2069. What Bajoran musical instrument was difficult to master?

A. Bajoran lute
B. *Belaklavion*
C. Bajoran zither
D. *Cabasa*

2070. How often was the provisional government's leader elected?

A. Yearly
B. Once every four years
C. Once every six years
D. Once every ten years

2071. How did Cardassian architecture reinforce important people's place in a hierarchy?

A. By repeating their likeness
B. By placing them in physically high locations
C. By giving them tree-tiered structures
D. With freeholds above their doors

2072. What were the meticulous Cardassians known for?

A. Perfect military dress
B. Formation flying
C. Well-organized files
D. Accounting

2073. What was the Cardassian burial practice of a dying family member passing on secrets to be used against their enemies?

A. *Odo-ital*

B. *Bered Nor*

C. *Shri-tal*

D. *Nokos Nor*

2074. What replaced the Obsidian Order under Gul Dukat's Dominion Alliance?

A. Cardassian Intelligence Service

B. Onyx Order

C. Cardassian Intelligence Bureau

D. Sapphire Sovereignty

2075. What did Cardassians give to their Bureau of Identification at age ten?

A. Fingerprints

B. Molar

C. Loyalty pledge

D. Right pinky

2076.

2077. What is the Cardassian equivalent of a public defender?

A. Conservator

B. Archon

C. Tribune

D. Barrister

2078. What are most joined Trill extremely allergic to?

A. Pet dander

B. Insect bites

C. Nuts

D. Wheat

2079. On average, how many Trill symbionts are available for hosting each year?

A. 50

B. 100

C. 200

D. 300

2080. What body part of a Trill often feels cold to others?

A. Feet

B. Hands

C. Lips

D. Ears

2076.

The reptilian Cardassian race has a long and proud history. However, their xenophobic tendencies led them to commit severe atrocities, especially during their occupation of Bajor. Both their legal system and military strategies were ruthless. Gul Dukat (shown at right), like many Cardassians, believed they were superior to other races, and couldn't understand why Bajorans and other races couldn't accept that the Cardassians were better in every way.

So, when the Dominion sought them as allies in their quest to conquer the Alpha Quadrant, the Cardassians at first embraced an alliance, thinking the Dominion saw them as the rightful power in the Quadrant. Things soon turned. When the Cardassians rebelled against Dominion rule, an entire city was wiped out in retaliation. The Dominion then began a planetary bombardment in an attempt to decimate the population.

How many Cardassians died in the last brutal days of the Dominion war?

A. 1 million

B. 50 million

C. 100 million

D. 800 million

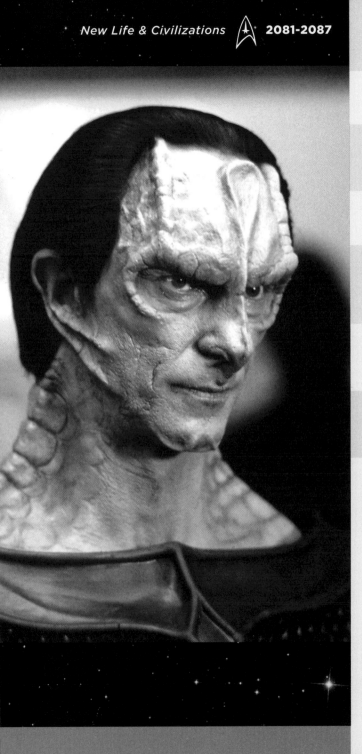

2081. What caves are the Trill symbionts born and bred in?

A. Tenaran
B. Mak'ala
C. Trillium
D. Kalandra

2082. What organization oversees almost every aspect of Trill joining?

A. Trill Science Ministry
B. Symbiosis commission
C. Ministry of Joining
D. Hosting committee

2083. Once joined, for how many hours are Trills and their symbionts dependent upon each other?

A. 24
B. 36
C. 93
D. 102

2084. What did the electromagnetic Drella of Alpha Carinae V feed on?

A. Hate
B. Warp plasma
C. Love
D. Dilithium

2085. Where did the *U.S.S. Voyager* crew keep the Class J nebula life-form it accidentally injured?

A. Deck 12, Section 42
B. Bussard collectors
C. Antimatter chamber
D. Emergency Medical Hologram's program

2086. Who gave his life to help Captain Picard defeat the electromagnetic entity on El-Adrel IV?

A. Tasha Yar
B. Sarek
C. Data
D. Dathon

2087. What did the Koinonian entity posing as Marla Aster on the *U.S.S. Enterprise*-D drain in order to sustain the replica of Aster?

A. Shields
B. Replicator rations
C. Antimatter pods
D. Dilithium

2088. Which member of the *U.S.S. Voyager* crew did the trianic energy beings known as the Komar possess?

 A. Janeway **C.** Chakotay
 B. Tuvok **D.** Kes

2089. How many years ago did the Nacene reach the Milky Way galaxy, according to the Caretaker?

 A. 1,000 **C.** 2,000
 B. 1,500 **D.** 5,000

2090. What were the Organians composed of?

 A. Silicon **C.** Emotion
 B. Pure energy **D.** Plasma energy

2091. Where did the *Pah-wraiths* once live?

 A. Celestial temple **C.** Orbs
 B. Cardassia **D.** Gamma Quadrant

2092. How long have the Q existed, according to them?

 A. Ten million years **C.** Since the Big Bang
 B. Always **D.** Since just before you thought of them

2093. How many times did the *U.S.S. Enterprise*-D encounter the xenophobic Paxan race?

 A. Twice **C.** Four times
 B. Three times **D.** Five times

2094. How often do the Horta die out and leave only one individual to protect the eggs?

 A. Every year **C.** Every 100,000 years
 B. Every 50,000 years **D.** Every 500,000 years

2098.

A philosopher within the Q Continuum, the Q who would become known as Quinn (shown at left), was imprisoned within a comet for his potentially disruptive views. When the crew of the *U.S.S. Voyager* freed Quinn, the Q first encountered by Jean-Luc Picard arrived to take him back to face the justice of the Continuum. Quinn then applied to Janeway for political asylum aboard *Voyager*.

Quinn maintained his life was no longer worth living. The Q had done and seen all of existence. With asylum granted, he became mortal and began a new life on board the ship as a human. He briefly served as a crewman, but soon realized he would never fit in and fulfilled his ambition of committing suicide. His death would cause ripples throughout the Continuum, as well as serve as an inspiration for Q.

How did Quinn end his life?

A. Blinked out of existence
B. Phaser
C. Nogatch hemlock
D. Antimatter explosion

2095. Where are Horta eggs kept?
- A. Inside the mother Horta
- B. Vault of Tomorrow
- C. Inside miners
- D. Chamber of Rebirth

2096. Which of the following was a race of well-known pirates in the twenty-second century?
- A. Andorians
- B. Nausicaans
- C. Tellarites
- D. Vulcans

2097. What did the people of Brax call Q?
- A. "The God of Lies"
- B. "The God of Humor"
- C. "The Devil"
- D. "R"

2098.

2099. How did Amanda Rogers's Q parents die?
- A. Tornado
- B. Big bang
- C. Executed by the continuum
- D. Suicide

2100. What *Star Trek* original series alien showed up as an action figure on Rain Robinson's desk in the *Voyager* episode "Future's End"?
- A. Talosian
- B. Gorn
- C. Mugato
- D. Cheron

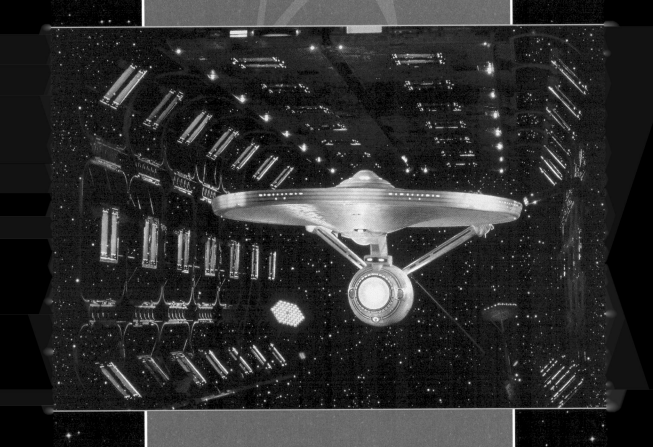

2101. How many *Constitution*-class starships were in service during the *Star Trek* original series era?

A. Five

B. Eight

C. Ten

D. Twelve

2102. What form of computer technology was employed on *Constitution*-class ships?

A. Binary

B. Bioneural

C. Duotronic

D. Multitronic

2103. Aside from warp drive, what other type of engines did *Constitution*-class ships possess?

A. Transwarp

B. Spatial trajectory

C. Impulse

D. Rocket boosters

2104. What was the standard cruising speed of *Constitution*-class ships?

A. Warp 1

B. Warp 2

C. Warp 3

D. Warp 6

2105. What station was located in the center of the bridge of a *Constitution*-class vessel, in front of the command chair?

A. Communications

B. Science

C. Engineering

D. Helm

2106. Why did the producers of the *Star Trek* original series devise the transporter?

A. To try out new special effects

B. To inspire scientists to create a real one

C. As a cost-efficient way to get crew from ship to planet

D. They were inspired by another TV show

2107. What signals did transporters usually lock on to?

A. Biosignatures

B. Communicators

C. Radioactive emissions

D. Planetary coordinates

LEFT *U.S.S. Enterprise* in *Star Trek: The Motion Picture.*

2108. What stored the matter stream of a person or object before and after a transporter beam's transmission?

A. Molecular imaging scanners **C.** Annular confinement beam
B. Heisenberg compensators **D.** Pattern buffer

2109.

2110. What happened if a person stayed in the matter stream too long?

A. They had visions **C.** They would bounce back to their origin point
B. Their patterns would degrade **D.** They would be scattered in space

2111. What are the force fields around a ship called?

A. Hull support **C.** Hull breach
B. Deflector shields **D.** Ablative armor

2112. What is used in antimatter containment to keep the matter and antimatter from exploding?

A. Ionized plasma **C.** Magnetic fields
B. Antimatter gas **D.** Antimagnetism

2113. What is the name of the main energy reactor aboard a starship?

A. Warp drive **C.** Warp core
B. Impulse engine **D.** Dilithium output sequencer

2114. What was *not* one of the three main functions of a tricorder?

A. Access ship's library computer **C.** Beam small objects
B. Scan an area **D.** Record data

2115. What class of battle cruiser did the Klingons share with the Romulans during the late 2260s?

A. D5 **C.** D7
B. *K't'inga* **D.** *K'toch*

2109.

The unique "cigar and saucer" look of the original *U.S.S. Enterprise* (NCC-1701 shown at right) quickly became as iconic a part of *Star Trek* as Vulcan ears.

Once the show had been approved to go into production, creator Gene Roddenberry needed a design for a deep space cruiser. Roddenberry insisted on believability. His art director researched both NASA ships of the time (for realism and function) and Buck Rogers and Flash Gordon (as guides for what *not* to do). For a while, the ship had a spheroid hull with twin nacelle engines (as was later seen on *Daedalus*-class ships). By flattening the sphere into a saucer, the art director made a model Roddenberry loved, and they knew they were on the right track.

Who was the art director that designed the original *U.S.S. Enterprise*?

A. Herman Zimmerman
B. Matt Jefferies
C. Rick Sternbach
D. John Eaves

2116. In addition to phasers and photon torpedos, what weapons did a Klingon battle cruiser have?

 A. Quantum torpedoes **C.** Cloaked torpedoes

 B. Disruptor cannons **D.** Laser cannons

2117. What was the maximum recorded speed of a Klingon bird-of-prey in *Star Trek IV*?

 A. Warp 8 **C.** Warp 9.8

 B. Warp 9 **D.** Warp 10

2118. Who captured the first bird-of-prey ship for Starfleet?

 A. Captain Archer **C.** Captain Picard

 B. Captain Garrett **D.** Captain Kirk

2119. What was the name of the Romulan fleet's warbird class of ship in the twenty-fourth century?

 A. *Uhlan* **C.** *D'Deridex*

 B. *Vorta* **D.** *Shiar*

2120. How many decks did a warbird typically have?

 A. Twelve **C.** Forty-five

 B. Twenty-four **D.** One hundred

2121. How many decks did a Federation *Galaxy*-class starship have?

 A. Fourteen **C.** Forty-two

 B. Twenty-four **D.** Sixty-four

2122. What type of circuitry was a *Galaxy*-class ship's computer based on?

 A. Duotronic **C.** Bioneural

 B. Isolinear **D.** Multitronic

2123. How long could a *Galaxy*-class ship maintain Warp 9.6?

 A. One hour **C.** Twelve hours

 B. Four hours **D.** Twenty-four hours

2124. What was the term for the office of a starship's commander, usually adjacent to the bridge?

A. Battle bridge **C.** Captain's mess
B. Ready room **D.** Commander's post

2125. What is the acronym for the computer operating system used aboard Federation ships and starbases?

A. LCARS **C.** CLARS
B. TCARS **D.** GRAM

2126. Where was Ten-Forward located on the *Enterprise*-D?

A. Deck one, section ten **C.** Deck ten, section ten
B. Deck ten, section one **D.** Deep Space 10

2127. Where was the *U.S.S. Enterprise*-D constructed?

A. Earth **C.** Utopia Planitia
B. Tycho City **D.** Risa

2128.

2129. On Deep Space 9, where did the residents of the station live?

A. Crew pylons **C.** Quark's
B. Habitat ring **D.** Resident quarters

2130. How many docking pylons did Deep Space 9 boast?

A. Three **C.** Six
B. Four **D.** Eight

2131. What was the main commerce area of Deep Space 9 called?

A. The Galleria **C.** The Promenade
B. The Mall **D.** The Market

2132. What was the name of the main class of Cardassian starships?

A. *Bok'Nor* **C.** *Keldon*
B. *Galor* **D.** *Hideki*

2128.

In addition to casting the crew of a ship for the twenty-fourth century, the producers of *The Next Generation* also had to catch lightning in a bottle again, design-wise, to provide a home for that crew—a new *Enterprise*. The original ship design had been modified only a few years prior as the film series began. But as the new series prepped to launch, the design of the new *Enterprise* enjoyed a relatively easy gestation.

Before he ever came to work for Gene Roddenberry on the studio lot, the ship's designer had painted a picture of what he thought a future starship could look like. And when Roddenberry saw the painting, he approved it with only minor details to refine.

Whose painting landed him the job as the designer of the *U.S.S. Enterprise*-D (shown at right)?

A. Rick Sternbach
B. Andrew Probert
C. Wah Chang
D. Mike Okuda

2133. What *Defiant*-class ship rescued Jake Sisko and Nog from the *Shenandoah*?

A. *U.S.S. Sao Paulo* C. *U.S.S. Odyssey*
B. *U.S.S. Valiant* D. *U.S.S. Defiant*

2134. What was the registry number of the *U.S.S. Defiant* first assigned to Deep Space 9?

A. NCC-75633 C. NX-01
B. NCC-26531 D. NX-74205

2135. Why was the *Defiant*-class development originally shelved?

A. A treaty with Romulans C. It was never shelved
B. In favor of *Danube*-class development D. Design flaws

2136. What type of armor was the *Defiant*'s hull equipped with?

A. Reinforced duranium C. Ablative
B. Chroniton D. Prometheum

2137. In 2373, the *U.S.S. Defiant* was equipped with what type of new communications technology?

A. Subspace filtered C. Transdimensional
B. Holographic D. Transtemporal

2138. What episode showed the destruction of the *U.S.S. Defiant* NX-74205?

A. "A Call to Arms" C. "The Changing Face of Evil"
B. "The Dogs of War" D. "Strange Bedfellows"

2139. Jem'Hadar attack fighters could detect cloaks using what technology?

A. Quantum imaging array C. Magnetic resonance
B. Antiproton beams D. Cloak dampening fields

2140. What type of shuttlepod did the *U.S.S. Defiant* have?

A. Waverider C. Runabout class-2
B. Work Bee D. Chaffee

2141. The *Delta Flyer* was a blend of Starfleet and which alien technology?

A. Species 8472
B. Borg
C. Kazon
D. Talazian

2142. When did *Voyager*'s pylons angle up?

A. At warp speeds
B. Below impulse speeds
C. When shielded
D. In battle

2143. Where was the aeroshuttle docked on *Voyager*?

A. Aft top of saucer section
B. Underside of saucer
C. Shuttle bay three
D. Secondary hull

2144. What are class-2 shuttle hulls composed of?

A. Tritanium alloy
B. Duranium alloy
C. Duritanium
D. Monotanium

2145. What was the name of the class-2 shuttle outfitted with transwarp drive by Lieutenant Tom Paris?

A. *Cochrane*
B. *Armstrong*
C. *Dawkins*
D. *Aldrin*

2146.

2147. What were the actual matter and antimatter used in the warp engines?

A. Deuterium & antideuterium
B. Dilithium & antidilithium
C. Sodium & antisodium
D. Magnesium & antimagnesium

2148. What material reinforced the *Delta Flyer II*'s hull?

A. Bakrinium
B. Duranium
C. Eisillium
D. Neutronium

2149. What powered the Caretaker's array in the Delta Quadrant?

A. Graviton generators
B. Nacene plasma engines
C. Tetryon reactor
D. Anti-energy reactor

2146.

As the *Next Generation* crew began their film series, their home of seven years, the *U.S.S. Enterprise*-D, met an inglorious end on Veridian III. The art department began crafting the next evolution in Starfleet flagships: the *U.S.S. Enterprise*-E (shown at right).

In *First Contact*, Picard told the visiting Lily Sloane his newly commissioned ship had twenty-four decks. In that same film, however, a crewman reported that decks twenty-six through eleven had been assimilated by the Borg. And in *Star Trek Nemesis*, the Remans beamed onto deck twenty-nine. Regardless of the confused crewman or the transporter-happy Reman attackers' statements, it's probably best to go by what the master systems display shows in *First Contact*.

How many decks does it show the *U.S.S. Enterprise*-E contains?

A. Twenty-one
B. Twenty-four
C. Twenty-six
D. Twenty-nine

2150. What type of atmospheric shuttle do *Nova*-class ships have docked to the ventral side of the hull?

A. *Argo*-type

B. Waverider

C. VTOL

D. Work bee

2151. What quote is featured on the dedication plaque for the *U.S.S. Relativity*?

A. "To boldly go where no man has gone before!"

B. "No matter where you go, there you are."

C. "The only reason for time is so that everything doesn't happen all at once."

D. "The night of time far surpasseth the day."

2152. As mentioned in "Relativity," where was the *U.S.S. Voyager* constructed?

A. Tranquility base

B. Copernicus shipyards

C. Jupiter station

D. Utopia Planitia

2153. In which of the following did the *U.S.S. Enterprise*-E make its first appearance?

A. *Generations*

B. *First Contact*

C. *Nemesis*

D. *Insurrection*

2154. Where was the *U.S.S. Prometheus* built?

A. Marin County Shipyards

B. Beta Antares Shipyards

C. Tycho City

D. Antares Shipyards

2155. On what stardate was the *U.S.S. Enterprise*-E launched?

A. 40759.5

B. 49827.5

C. 54868.8

D. 30620.1

2156. What new type of torpedoes did the *U.S.S. Enterprise*-E have?

A. Proton

B. Electron

C. Quantum

D. Temporal

2157. Which of the following was the second NX-class ship launched?

A. *Forrest*

B. *Cochrane*

C. *Columbia*

D. *Archer*

2158. What type of torpedoes did the *Enterprise* NX-01 initially use?

A. Warp

B. Neutronic

C. Spatial

D. Hydrogen

2159. The second type of torpedoes used on the *Enterprise* NX-01 were called what?

A. Photonic

B. Gravimetric

C. Ionic

D. Covalent

2160. What type of defense system preceded shields?

A. Ablative armor

B. Magnetic hull reinforcement

C. Polarized hull plating

D. Repulsor fields

2161. The NX-class ships initially used what type of armament?

A. Laser cannons

B. Sonic cannons

C. Electron cannons

D. Plasma cannons

2162. What type of weapons did the NX-01 upgrade to after twelve episodes of *Enterprise*?

A. Phase cannons

B. Disruptor cannons

C. Neutron cannons

D. Photonic cannons

2163.

2164. What type of weapon did Suliban cell ships use?

A. Binary plasma beams

B. Cloaking torpedoes

C. Demat emitters

D. Particle weapons

2165. How large was a Xindi-aquatic cruiser?

A. 1,500 meters

B. At least 1,800 meters

C. 2,100 meters

D. 2,400 meters

2163.

Designing Deep Space 9 (shown at right) was a big job. So big that eight artists and producer Rick Berman all assisted art director Herman Zimmerman in contributing to its development. The directive was to make it look unfamiliar and alien, a stark contrast to the familiar Starfleet exteriors and interiors the audience and fans were used to. The curved pylons and concentric ring structure were nothing like Federation bases and outposts.

Once the final concept art had been approved, the daunting task of building a shooting model six feet in diameter began.

The station came to life behind the scenes—and it must have been a relief that a full-scale model wasn't needed, because according to the show, how wide in diameter is Deep Space 9?

A. 1,025 meters

B. 1,346 meters

C. 1,451.82 meters

D. More than 2,500 meters

2166. Which Xindi race had the most advanced ship technology?

A. Xindi-primates

B. Xindi-arboreals

C. Xindi-reptilians

D. Xindi-aquatics

2167. How many science labs were on the *U.S.S. Enterprise* NCC-1701?

A. Ten

B. Twelve

C. Fourteen

D. Sixteen

2168. On a *Constitution*-class ship, which deck was sick bay located on?

A. Deck two

B. Deck three

C. Deck six

D. Deck eight

2169. Where was the *Defiant*'s production base located?

A. Luna Colony Shipyards

B. Antares fleet yards

C. Jupiter Station

D. San Francisco Shipyards

2170. How many torpedo launchers did a *Constitution*-class vessel contain?

A. Four

B. Five

C. Six

D. Eight

2171. What was the function of an astrogator device?

A. Environmental controls

B. Navigation

C. Lock weapons

D. Emergency beam-out

2172. What original series episode of *Star Trek* showed the first known use of site-to-site transport?

A. "Errand of Mercy"

B. "The Trouble with Tribbles"

C. "A Piece of the Action"

D. "The Empath"

2173. How long did a refit *Constitution*-class ship require in order to lower and raise its shields?

A. 5 seconds

B. 13.5 seconds

C. 30.5 seconds

D. 20 seconds

2174. Where are the warp coils located on a *Constitution*-class ship?

A. Engine room

B. Nacelles

C. Deuterium chamber

D. Antimatter inductor

2175. Twenty-third-century Klingon battle cruisers carried what type of magnetic armament?

A. Tractor field

B. Torpedoes

C. Repulsor blasts

D. Pulse weapons

2176. What was the approximate crew complement of a Klingon D7 ship?

A. 240

B. 430

C. 480

D. 600

2177. What was the top speed of a Klingon *K't'inga*-class ship?

A. Warp 5

B. Warp 6

C. Warp 7

D. Warp 9

2178. Who captured the first Klingon bird-of-prey for Cardassia?

A. Gul Damar

B. Gul Dukat

C. Elim Garak

D. Enabran Tain

2179. How many seconds was a bird-of-prey vulnerable while raising or lowering its cloak?

A. One

B. Two

C. Four

D. Five

2180. Why were the Klingon D12 ships retired from service in the 2350s?

A. Faulty warp design

B. Faulty plasma coils

C. Faulty cloaks

D. Faulty hull structure

2181. Which of the following was *not* a type of Klingon bird-of-prey-class ship?

A. *K'vort*

B. *B'rel*

C. D2

D. D12

2182. What type of torpedo did the Romulan bird-of-prey often utilize?

A. Quantum

B. Electron

C. Plasma

D. Photon

2183.

2183.

The *Intrepid*-class *U.S.S. Voyager* (shown at right) boasted some of Starfleet's finest technology, including an Emergency Medical Hologram that could temporarily (for a period as long as seven years!) replace a doctor and had variable warp geometry pylons and bioneural circuitry. This type of circuitry, embedded into the bioneural gelpacks, could process information faster than the duotronic or isolinear circuitry of prior starship computers and systems.

However, being organic, the gelpacks could be affected by things that attacked living tissue. In one instance, the gelpacks became infected and critical systems began to shut down.

How did Lieutenant Torres fight the virus?

A. Introduced a bioneural antibody

B. Inoculated it with the infection

C. Superheated the ship like a fever

D. Applied some antimatter "aspirin"

2184. How fast could a Romulan warbird travel while cloaked?

- **A.** Warp 3
- **B.** Warp 4
- **C.** Warp 5
- **D.** Warp 6

2185. How do isolinear chips store data within a starship's computer?

- **A.** Magnetically
- **B.** Holographically
- **C.** Plasma-encoded
- **D.** Quantum encryption

2186. Where is the battle bridge located on a *Galaxy*-class starship?

- **A.** Deck three, primary hull
- **B.** Deck five, aft saucer
- **C.** Deck eight, secondary hull
- **D.** Deck thirteen, primary hull

2187. How many holodecks did a *Galaxy*-class starship contain?

- **A.** Twelve
- **B.** Sixteen
- **C.** Eighteen
- **D.** Twenty

2188. What was the restricted area of Deep Space 9 that housed the station's deflector array controls?

- **A.** EPS1
- **B.** A51
- **C.** Computer core one
- **D.** Engineering hatch B-42

2189. How many levels did Deep Space 9 contain?

- **A.** Twelve
- **B.** Sixty-four
- **C.** Ninety-eight
- **D.** One hundred

2190. What was the name of the Bajoran restaurant on Deep Space 9?

- **A.** Quark's
- **B.** Club Martus
- **C.** Celestial Café
- **D.** The Temple

2191. What was the largest permanent set ever built for any *Star Trek* series or film?

- **A.** *U.S.S. Enterprise*-D shuttle
- **B.** Deep Space 9 Promenade
- **C.** *U.S.S. Voyager* bridge bay
- **D.** *Enterprise* NX-01 engine room

2192. What runabout were Sisko and Dax in when they discovered the Bajoran wormhole?

A. *U.S.S. Orinoco* C. *U.S.S. Rio Grande*
B. *U.S.S. Rubicon* D. *U.S.S. Volga*

2193. Which subclass was considered the top of the line of the *Galor*-class vessels?

A. Type-1 C. Type-3
B. Type-2 D. Type-4

2194. Who was the original captain of the *U.S.S. Valiant* in 2373?

A. Admiral Leyton C. Captain Ramirez
B. Captain Ferreiro D. Captain Jellico

2195. What was the registry number of the *U.S.S. Valiant*?

A. NCC-1223 C. NCC -1709
B. NCC-74210 D. NCC-19386

2196. What was the name of the Cardassian military freighter Dukat and Damar served on?

A. Groumali C. Rabol
B. Koranak D. Kornaire

2197. What was the name of the Cardassian prison transport that crash-landed on Dozaria?

A. Ziyal C. Bralek
B. Ravinok D. Reklar

2198.

2199. How many phaser cannons did a *Defiant*-class ship employ?

A. Three C. Six
B. Four D. Eight

2200. What class of warp drive did a *Defiant*-class ship boast?

A. Class-NX C. Class-7
B. Class-2 D. Class-Alpha

2198.

The *Enterprise* NX-01 (shown at right) was the fledging Starfleet's first Warp 5-capable ship, thanks largely to the work of Henry Archer and warp pioneer Zefram Cochrane. Prior to the NX program, human ships had been unable to achieve a greater velocity than Warp 1.

Under the command of Captain Jonathan Archer, this *Enterprise* made interstellar history—not only as the first true deep-space starship built by humans, but also for such missions as the destruction of the Xindi superweapon and for its role in ending the temporal cold war. It was also, of course, an integral part of the development of the United Federation of Planets.

What year was this historic ship decommissioned?

A. 2131
B. 2141
C. 2151
D. 2161

2201. How many decks did a *Defiant*-class ship consist of?

A. One
B. Three
C. Five
D. Seven

2202. What is the crew complement of a Jem'Hadar attack fighter?

A. Forty-three Jem'Hadar
B. One Vorta, forty-two Jem'Hadar
C. Two Vorta, forty Jem'Hadar
D. Ten Vorta, thirty-two Jem'Hadar

2203. What type of directed-energy weapons were used on Jem'Hadar ships?

A. Phasers
B. Tachyon spreads
C. Nucleonic beams
D. Phased polaron beams

2204. What class of warp drive did an *Intrepid*-class ship have?

A. Class Beta
B. Class-3
C. Class-9
D. Cochrane-class

2205. What is the maximum warp of an *Intrepid*-class ship?

A. 9.125
B. 9.5
C. 9.975
D. 9.98

2206. Which *Voyager* shuttle was destroyed when Harry Kim was transported to an alternate time line?

A. *Cochrane*
B. *Delta Flyer*
C. *Drake*
D. *Sacajawea*

2207. Who wrote the quote on the *U.S.S. Voyager*'s dedication plaque?

A. Shelley
B. Wordsworth
C. Shakespeare
D. Tennyson

2208. What was the *Delta Flyer*'s first mission?

A. Rescue Seven of Nine
B. Test Warp 10 drive
C. Retrieve a multispatial probe
D. Reconnoiter the Borg

2209. What type of field could Borg cubes use to disable enemy vessels' sensors and transporters?

A. Gravimetric C. Ion
B. Dispersal D. Disruptor

2210. How many bioships did a Species 8472 energy-focusing ship need to converge to fire its planet-killing weapon?

A. Four C. Eight
B. Six D. Twelve

2211. What type of armor did a Borg sphere employ?

A. Extrapolator C. Subspace shielding
B. Ablative D. Antiduranium

2212. What did the "veins" in a Species 8472 bioship carry?

A. Plasma C. Electrodynamic fluid
B. Pure liquidized antimatter D. Fluidic vacuum

2213.

2214. What sort of armor plating did Hirogen vessels use?

A. Dicyclic C. Ablative
B. Monotanium D. Duo

2215. What type of waste did the Malon transport aboard their vessels?

A. Hyperionic waste matter C. Theta radioactive antimatter
B. Radiolytic isotopes D. Kinoplasmic radioactive

2216. What technological information did *Friendship One* provide that caused a planet's nuclear winter?

A. Isolytic radiation C. Breen
B. Gamma radiation D. Antimatter

2213.

The Borg not only assimilate individuals and transform them into drones, they also assimilate the information and technology of a culture. Their hive-mind nature is reflected in the layout of their ships: With no regard for architectural aesthetics, their ships take simple geometric shapes. Cubes (shown at right) are numbered, rather than named, much as drones are named according to function and hierarchy. The layout and organization of a ship is decentralized, and the regenerative properties make a cube very difficult to destroy.

According to Commander Shelby, the cubes could still operate even if how much of one was destroyed?

A. 50 percent
B. 78 percent
C. 82 percent
D. 92 percent

2217. Who built the dreadnought that would go on to threaten *Voyager* in the Delta Quadrant?

A. Cardassians
B. Bajorans
C. Borg
D. Ferengi

2218. Which of the dreadnought's weapons, when fired, destabilized the reactor core for 30 seconds?

A. Quantum torpedoes
B. Thoron shock emitter
C. Plasma wave
D. Disruptors

2219. Which vessel class was capable of a multivector assault mode?

A. *Nebula*-class
B. *Prometheus*-class
C. *Orion*-class
D. *Nova*-class

2220. What destroyed the *U.S.S. Equinox*?

A. Nucleogenic life-forms
B. Krennim timeships
C. Self-destruction
D. Borg tractor beam

2221. How long is a *Sovereign*-class vessel?

A. 500 meters
B. 600 meters
C. Nearly 700 meters
D. 1,000 meters

2222. What is the maximum warp speed of a *Sovereign*-class vessel?

A. 9.7
B. 9.8
C. 9.9
D. 10

2223. Where did the captain's yacht dock on a *Sovereign*-class vessel?

A. Deck one
B. Deck sixteen
C. Deck twenty-four
D. Shuttle bay two

2224. How many decks did an NX-class starship contain?

A. Five
B. Six
C. Seven
D. Twelve

2225. What could an NX-class ship use to catch or hold objects in space?

A. Attenuator C. Docking beam
B. Clamps D. Grappler

2226. The Romulan drone ship possessed which of the following weapons?

A. Triphasic disruptors C. Multitronic phase cannons
B. Ionic disruptors D. Verdanic emitters

2227. What did some Xindi-insectoid ships possess?

A. Regenerative alcoves C. Quarters for visiting guardians
B. Temporal viewscreens D. Hatcheries

2228. How could Xindi ships travel interstellar distances?

A. Transwarp corridor C. Temporal skirting
B. Spatial folding D. Subspace vortex

2229.

2230. The spheres in the Delphic Expanse emitted which of the following type of energy waves?

A. Nucleonic C. Gravimetric
B. Anti-energy D. Interphasic

2231. What is the temperature of the interior of a Tholian vessel?

A. Neutronic C. 50 degrees Celsius
B. Ablative D. Interphasic

2232. What class of ship was the *U.S.S. Enterprise*-C?

A. *Oberth* C. *Constitution*
B. *Excelsior* D. *Ambassador*

2233. How many decks did the *U.S.S. Enterprise* NCC-1701 consist of?

A. Eleven C. Twenty-six
B. Twenty-three D. Twenty-nine

2234. What deck was the bridge of a *Constitution*-class ship on?

A. Deck five C. Deck eleven
B. Deck one D. Deck ten

2229.

Boasting twin wing-mounted disruptor cannons and dual-photon torpedo launchers, Klingon bird-of-prey ships (shown below) are some of the Empire's most rugged and versatile fighters. A bird-of-prey is also outfitted with a cloaking device, which allows the ship to track a target unsuspectingly until well within killing range. At least three classes of the ship exist in the Klingon fleet, with one retired in the 2350s.

2235. How many meters long was a *Constitution*-class vessel?

A. 200
B. 250
C. 289
D. 320

2236. What was the range of a *Constitution*-class phaser bank?

A. 40,000 km
B. 50,000 km
C. 90,000 km
D. 100,000 km

2237. How many ports did the *Constitution*-class impulse engine drive system contain?

A. None
B. One
C. Two
D. Four

2238. Who invented the transporter?

A. Zefram Cochrane
B. Lily Sloane
C. Lewis Zimmerman
D. Emory Erickson

2239. What was a standard transporter's range in the twenty-fourth century?

A. 10,000 km
B. 40,000 km
C. 50,000 km
D. 100,000 km

2240. How many photon torpedos' worth of damage could a *Constitution*-class ship's shields take?

A. Six
B. Eight
C. Nine
D. Twelve

2241. What do the Bussard collectors primarily collect?

A. Plasma
B. Asteroid ores
C. Deuterium
D. Pym particles

2242. What is the maximum output of a warp core in the twenty-fourth century?

A. 1 cochrane per millisecond
B. 1M koules per second
C. 4,000 teradynes per second
D. 100 teracochranes

2243. What type of warp engine did the *I.K.S. Klothos* possess in the animated episode "The Time Trap"?

A. Transwarp
B. Terawarp
C. S-2 graf unit
D. Antispatial

One of the most famous trips taken by a bird-of-prey was not only through space, but also through time. A captured ship was used to go back in time to retrieve a pair of now-extinct life-forms in order to answer a deadly probe's signal. Who captured the first bird-of-prey for the Federation?

A. Jean-Luc Picard
B. James T. Kirk
C. Benjamin Sisko
D. Spock

2244. What were some *K'Tinga*-class vessels outfitted with for long voyages?

A. Battle simulations
B. Cryonics
C. Merchants
D. Holodecks

2245. What is the average low-end crew complement of a Klingon bird-of-prey?

A. Ten
B. Twelve
C. Twenty-five
D. Thirty-six

2246.

2247. How much longer was a *D'Deridex*-class ship than a *Galaxy*-class ship?

A. It was the same size
B. Half again as long
C. Twice as long
D. Three times as long

2248. How many impulse engines did a *Galaxy*-class ship contain?

A. None
B. One
C. Two
D. Three

2249. How many transporter rooms did a *Galaxy*-class ship contain?

A. Twenty
B. Twenty-one
C. Twenty-two
D. Twenty-four

2250. Which of these was *not* a *Galaxy*-class ship?

A. *U.S.S. Challenger*
B. *U.S.S. Titan*
C. *U.S.S. Odyssey*
D. *U.S.S. Yamato*

2251. Who supervised the construction of the *U.S.S. Enterprise* NCC 1701-D?

A. Commander Orfil Quinteros
B. Dr. Leah Brahms
C. Dr. Noonien Soong
D. Lieutenant Commander Jack Crusher

2252. Who captained the *U.S.S. Yamato*?

A. Donald Varley
B. Phillip Pierce
C. Steve Gerber
D. Thomas Halloway

2253. What was the first type-6 shuttlecraft seen in *The Next Generation*?

A. *Copernicus*
B. *Curie*
C. *Magellan*
D. *El-Baz*

2246.

April 5, 2063 saw the launch of the *Phoenix* (shown at right) by its builder, Dr. Zefram Cochrane. The ship launched humanity into the age of deep space exploration by being the first manned vessel to break the warp barrier. The flight also led to the first contact with the Vulcan species.

Growing up, Jean-Luc Picard of *Next Generation* often saw the ship in a museum; in that setting, of course, the boy wasn't allowed to touch the display. Picard would finally get his chance to touch the historic ship *before* its launch, when he and the *U.S.S. Enterprise*-E crew traveled back in time to prevent the Borg from stopping the important first contact.

What museum held the *Phoenix* during Picard's childhood?

A. Cochrane Museum of Mars
B. Smithsonian
C. Louvre
D. Vulcan Science Academy

2254. After the Borg battle in "The Best of Both Worlds," where did the *U.S.S. Enterprise*-D undergo a refit?

A. Earth station McKinley
B. Utopia Planitia
C. Jupiter station
D. Tycho City

2255. According to Lieutenant Nella Daren, where was the most acoustically perfect spot on the *Enterprise*-D?

A. Catwalk above the warp core intermix chamber
B. 4th intersect of Jefferies tube 25
C. The captain's chair
D. Deck 12, behind the shuttle bay bafflers

2256. What ore did the Cardassians originally build Deep Space 9 to refine?

A. Dilithium
B. Uridium
C. Rhodium
D. Tritium

2257. Which of the following is *not* a language the Promenade directory was written in?

A. English
B. Klingon
C. Bajoran
D. Romulan

2258. What was the address of Garak's Clothiers in the Promenade?

A. 02-485
B. 01-234
C. 03-002
D. 02-664

2259. What top speed could *Danube*-class runabouts reach?

A. Warp 3
B. Warp 5
C. Warp 6
D. Warp 7

2260. What was the width of a *Danube*-class runabout?

A. Ten meters
B. Twelve meters
C. Fourteen meters
D. Fifteen meters

2261. What was the name of Gul Evek's ship?

A. *Vetar*
B. *Kraxon*
C. *Reklar*
D. *Trager*

2262. What material did Cardassian *not* use in the construction of their ships?

A. Beritium
B. Argine
C. Rhodinium
D. Dolamide

2263. Who became acting captain of the *U.S.S. Valiant*?

A. Nog

B. Tim Watters

C. Karen Farris

D. Dorian Collins

2264. How many torpedo launchers did a *Defiant*-class ship possess?

A. Two

B. Three

C. Four

D. Six

2265. What was the weakest point of a Jem'Hadar ship's shields?

A. Dorsal fin junction

B. Neck junction

C. Aft wing assembly

D. Port engine nacelle

2266. Despite their weaknesses, what were Jem'Hadar ship shields impervious to?

A. Tractor beam locks

B. Phasers

C. Photo torpedoes

D. Energy dampeners

2267. What type of life-support system did the *U.S.S. Voyager* incorporate?

A. Monocyclic

B. Duocyclic

C. Tricyclic

D. Quadrocyclic

2268. What was the total mass of an *Intrepid*-class starship?

A. 700,000 metric tons

B. 750,000 metric tons

C. 800,000 metric tons

D. 900,000 metric tons

2269. How many decks did the *U.S.S. Voyager* consist of?

A. Twelve

B. Thirteen

C. Fourteen

D. Fifteen

2270. What is the width of the *U.S.S. Voyager*?

A. 80 meters

B. 100 meters

C. 108 meters

D. Approximately 116 meters

2271. What was the name of shuttle #05 on *U.S.S. Voyager*?

A. *Cochrane*

B. *Baxial*

C. *Tereshkova*

D. *Sacajawea*

2272. Which episode saw the destruction of the *Delta Flyer*?

A. "Drive"

B. "Unimatrix Zero"

C. "Muse"

D. "Live Fast and Prosper"

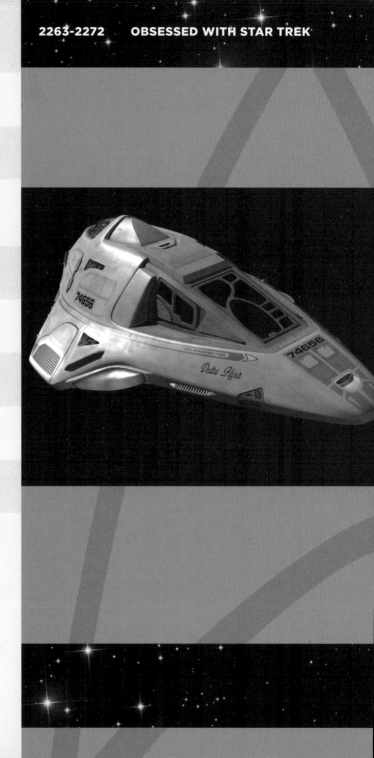

2273. What type of weaponry did the *Delta Flyer II* possess?

A. Disruptors
B. Phase pulse cannons
C. Proton torpedos
D. Borg cutting beam

2274. How large was a Borg cube ship?

A. Twenty-eight cubic kilometers
B. Thirty-two cubic kilometers
C. Thirty-six cubic kilometers
D. Forty-two cubic kilometers

2275. What spread information and communication throughout a Borg cube?

A. Alcove conduits
B. Distribution nodes
C. Neuroleptic relays
D. Cortical implants

2276. What type of guided charges did a Borg cube employ?

A. Phased pulse
B. Magnetometric
C. Antiproton
D. Antimatter

2277. What type of field kept a Borg cube in temporal sync while in a transwarp conduit?

A. Chroniton
B. Subspace
C. Structural integrity
D. Ablative

2278. What is the diameter of a Borg sphere ship?

A. 1,000 feet
B. 1,200 feet
C. 1,500 feet
D. 2,500 feet

2279.

2280. What type of circuitry did a modified Kazon raider use to confuse enemy sensors?

A. Graviton
B. Warp signature
C. Masking
D. Cloaking

2281. Where did Tom Paris acquire the sentient ship he named *Alice*?

A. Abbadon's Repository of Lost Treasures
B. Talaxian Shipbuilders Guild
C. It was derelict
D. The Nekrit Expanse of Used Starships

2279.

Designed by Tom Paris, Seven of Nine, and other members of the *U.S.S. Voyager*'s senior staff, the *Delta Flyer* (shown at left) filled their need for a ship larger than a standard shuttlecraft and was more resistant to hazardous environments.

The *Flyer* combined Borg and Starfleet technology such as a tetraburnium hull, unimatrix shielding, retractable warp nacelles, and photonic missiles. After its launch in 2375, the craft successfully completed many missions over the next two years. Unfortunately, it met an untimely end in 2377 (the crew soon constructed a new *Flyer*). The original *Flyer* had some unique design aesthetics, inspired by Paris's favorite holonovel program.

What program was it?

A. *The Adventures of Captain Proton*
B. Fair Haven
C. Sandrine's
D. Da Vinci's studio

2282. Who captained the *U.S.S. Endeavour*?

　　A. Admiral Owen Paris　　**C.** Capt. Amasov
　　B. Captain Ransom　　**D.** Captain Savage

2283. What was the cargo capacity of the larger Malon export vessels?

　　A. 500,000 metric tons　　**C.** 4 billion cubic tons
　　B. 2 billion metric tons　　**D.** 4 trillion isotons

2284. What was the registry number of the *U.S.S. Raven*?

　　A. NCC-1672　　**C.** NCC-26531
　　B. NCC-60597　　**D.** NAR-32450

2285. What did the temporal core of a Krenim ship do?

　　A. Slow down relative time　　**C.** Protect the ship from time line changes
　　B. Speed up relative time　　**D.** Open temporal warp fields

2286. Which class did the *U.S.S. Relativity* belong to?

　　A. *Akira*-class　　**C.** *Wells*-class
　　B. *Tardis*-class　　**D.** *Cordry*-class

2287. Where was the *U.S.S. Enterprise*-E built?

　　A. Utopia Planitia　　**C.** Pluto station
　　B. San Francisco fleet yards　　**D.** Copernicus shipyards

2288. Which production illustrator designed the *U.S.S. Enterprise*-E?

　　A. Andrew Probert　　**C.** John Eaves
　　B. Mike Okuda　　**D.** Rick Sternbach

2289. How many CGI models of the *Enterprise*-E were made for the *Star Trek* films?

　　A. One　　**C.** Three
　　B. Two　　**D.** Four

2290. How many shuttlepods did the *Enterprise* NX-01 carry?

　　A. None　　**C.** Two
　　B. One　　**D.** Three

2294.

Designed by Xindi-primate Degra, the Xindi super-weapon (shown at left with Archer) is a massive particle beam intended to destroy Earth. A prototype of the weapon had vaporized a huge section of the planet in 2153, destroying a swath from Florida to Venezuela. The superweapon required large amounts of kemocite, as well as an unknown material from the future, to be completed. Once the weapon was completed, an activation code from each species was required to keep the weapon from being controlled by any one Xindi species.

Which race's activation code did Dolim try to force an *Enterprise* crewman to translate?

A. Xindi-arboreal
B. Xindi-aquatic
C. Xindi-primate
D. Xindi-avian

2291. How many years was the *Enterprise* NX-01 in service?
A. Ten
B. Fifteen
C. Twelve
D. Seventeen

2292. How limited is the range of a shuttlepod's plasma weapons?
A. Less than 5 km
B. Less than 8 km
C. Less than 10 km
D. Less than 25 km

2293. What was the crew complement of an Andorian battle cruiser like the *Kumari*?
A. 72
B. 86
C. 94
D. 102

2294.

2295. What is the crew complement of a Xindi-reptilian warship?
A. Twenty-two
B. Twenty-eight
C. Thirty-six
D. Forty-two

2296. What class of ship was the *U.S.S. Bozeman*?
A. *Akira*-class
B. *Oberth*-class
C. *Soyuz*-class
D. *Ambassador*-class

2297. What ship did Arturis try to trick the *Voyager* crew into believing was a Federation vessel?
A. *U.S.S. Dauntless*
B. *U.S.S. Equinox*
C. *U.S.S. Relativity*
D. *U.S.S. Procyon*

2298. How many decks did an *Excelsior*-class ship contain?
A. Thirty-four
B. Thirty-six
C. Thirty-seven
D. Thirty-eight

2299. How many people could an Excelsior-class ship evacuate from a ship or planet if necessary?
A. 5,000
B. 9,800
C. 10,500
D. 12,000

2300. In what year was the *U.S.S. Enterprise*-C destroyed?
A. 2244
B. 2267
C. 2322
D. 2344

2301. What does the galactic barrier surround?

A. Milky Way

B. M82

C. Andromeda

D. Large Magellanic cloud

2302. What quasar-like formation flooded four sectors with ionic radiation?

A. 40 Eridani A

B. Murasaki 312

C. Omega Cygni

D. Beta Thoridar

2303. What would have happened had Edith Keeler lived?

A. America would have delayed entry into WWII and lost

B. She would have accidentally killed Roosevelt

C. She would have saved Hitler's life

D. She would have kept Kirk in the past

2304. What type of beam did the planet-killer in "The Doomsday Machine" employ?

A. Antielectron

B. Anti-neutron

C. Antilife

D. Antiproton

2305. In the mirror universe, who did Captain Kirk kill to become captain of the *U.S.S. Enterprise*?

A. Captain Spock

B. Captain Christopher Pike

C. Captain Maxwell Forrest

D. Captain Jonathan Archer

2306. What did Captain Kirk use as bait for the dikironium cloud creature on Tycho IV?

A. Antimatter

B. Copper-based blood

C. Quadrotriticale

D. Hemoplasm

2307. Which Federation ship was destroyed by a giant space amoeba?

A. *U.S.S. Constellation*

B. *U.S.S. Intrepid*

C. *U.S.S. Farragut*

D. *U.S.S. Exeter*

LEFT Sulu and Kirk in *The Voyage Home*.

2308. What was the name of the asteroid ship created by the Fabrini?

A. *Yonada*
B. *Natira*
C. *Oracle*
D. *Daran*

2309. The cosmic cloud encountered near Mantilles used what to break down the matter it consumed?

A. Gaseous antimatter
B. Antiplasma enzymes
C. Ambiplasma
D. Ionized plasma

2310. How did the V'ger entity store the information it collected?

A. Binary code
B. Trinary code
C. Holographic data patterns
D. Bioneural circuitry

2311.

2312. What did the subspace shock wave caused by Praxis's explosion damage?

A. Qo'noS' ozone layer
B. Klingon shipyards
C. Qo'noS' orbit
D. Klingon genetic makeup

2313. How often did the Nexus ribbon cross through the galaxy?

A. Every day at some point
B. Every 12.6 years
C. Every 39.1 years
D. Every century

2314. Where was the extradimensional being Nagilum encountered?

A. Morgana Quadrant
B. Delta Quadrant
C. Beta Quadrant
D. Gamma Quadrant

2315. How far could an Iconian gateway transport?

A. 7,000 light-years
B. At least 70,000 light-years
C. 700,000 light-years
D. Anywhere

2316. How far into the past did the energy vortex send Picard in "Time Squared"?

A. Six seconds
B. Six minutes
C. Six hours
D. Six weeks

2311.

Certain things symbolize *Star Trek* to the world at large—pointed ears, "Beam me up, Scotty," and … goatees.

The evil parallel universe introduced in the original series *Star Trek* episode "Mirror, Mirror" on October 6, 1967 would set the pop-culture standard for diabolical facial hair. Kirk and his crew were stunned by the appearance of a Spock with a goatee (shown at right), which made them realize they were definitely not in the right universe anymore. Uniforms, weaponry, and attitudes were all darker and more sinister in the mirror universe.

The trope has spread throughout pop culture: shows as diverse as *South Park*, *The Colbert Report* and *Codename: Kids Next Door* have all found themselves face to beard with evil twins. Another visual cue that never made it to the mainstream, but also depicted the darker nature of the mirror *Enterprise*, was a facial distinction sported by Sulu.

What was it?

A. Eyebrow piercing
B. Scar
C. Tattoo
D. Nose piercing

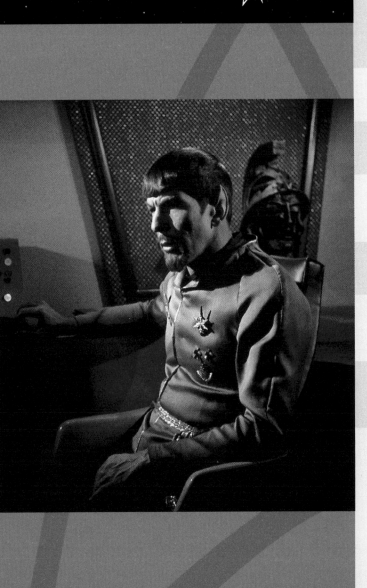

2317. How did Gomtuu, the living spaceship, plan to commit suicide in "Tin Man"?

A. Poison itself with warp exhaust

C. Ram into a Romulan warbird

B. Orbiting a star going supernova

D. Trick *Enterprise* into firing on it

2318. What aliens came back in time to steal the Tox Uthat?

A. Vorgons

C. Douwd

B. Ferengi

D. Borg

2319. How wide are cosmic strings?

A. Infinitesimal

C. 1 nanometer

B. The width of a proton

D. 1 centimeter

2320. Which Federation ship was lost while investigating the black cluster in Sector 97?

A. *U.S.S. Brattain*

C. *U.S.S. Yamato*

B. *U.S.S. Odyssey*

D. *U.S.S. Vico*

2321. What was the molecular structure of the aliens in "Schisms" based on?

A. Trilithium

C. Tetryon

B. Solanogen

D. Gravitons

2322. What is the neurophysical stress on a body entering a separate time continuum called?

A. Temporal hemorrhage

C. Tempus chondritus

B. Temporal narcosis

D. Temporal frisson

2323. What type of time discontinuity did the *Enterprise*-D crew encounter in "Timescape"?

A. Temporal fragments

C. Temporal loop

B. Temporal slippage

D. Temporal bleed

2324. What did Worf encounter in "Parallels" that made him exchange consciousness with his selves in other realities?

A. Millennial pulse weapon **C.** Uncertainty field
B. Recursive occlusion **D.** Quantum fissure

2325. What caused the antitime eruption in "All Good Things ..."?

A. Three inverse tachyon pulses in different time periods **C.** Breaking the Warp 10 barrier
B. Q **D.** Antichroniton explosion

2326. How did the U.S.S. Enterprise-D crew seal off the antitime eruption?

A. Dove through it at Warp 10 **C.** Slingshot around it
B. Simultaneously created static warp shells **D.** Locked it in a chronal loop

2327.

2328. How did the Pah-wraiths enter the Bajoran wormhole in 2374?

A. Used self-replicating mines **C.** Attacked the Orb of Contemplation
B. Possessed Benjamin Sisko **D.** Merged with Dax

2329. What type of gas was prevalent in the Chamra vortex?

A. Toh-maire **C.** Krypton
B. Helium **D.** Neon

2330. Where did an improper warp-field collapse, upon entrance to the wormhole, send Kira and Bashir?

A. Nonlinear realm of the prophets **C.** Mirror universe
B. Earth's past **D.** Edge of the galaxy

2331. What sent Quark's treasure back to Roswell, New Mexico, in 1947?

A. The Orb of Time **C.** Interphasic warp bubble
B. Kemocite reaction to warp plasma **D.** Subtime rift

2327.

The second Star Trek pilot episode, "Where No Man Has Gone Before," saw Kirk and his crew push into the edge of the galaxy, only to be driven back. The strange properties of the galactic barrier (shown below) caused two of Kirk's crew to gain nigh-godlike psionic powers. Though the U.S.S. Enterprise would encounter the galactic barrier again (as well as a possibly similar "Great Barrier" surrounding the core of the Milky Way), no one gained extrasensory powers from any further encounters.

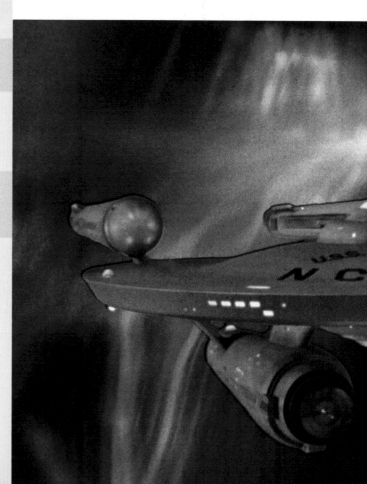

Composed of an exotic energy, the barrier was dangerous not only to human ships but to extragalactic travelers as well.

What episode of the original series featured the *Enterprise*'s final encounter with the galactic barrier?

A. "Is There In Truth No Beauty?"
B. "Spock's Brain"
C. "For the World Is Hollow and I Have Touched the Sky"
D. "All Our Yesterdays"

2332. Which disguised Klingon used the Orb of Time to go back to the events of "The Trouble with Tribbles"?

A. Kor
B. Arne Darvin
C. Koloth
D. Kang

2333. What aspect of time travel did agents Lucsly and Dulmer hate?

A. Grandfather paradoxes
B. Temporal inversions
C. Predestination paradoxes
D. Time line splits

2334. What form of radiation time-shifted the radio signals from the *U.S.S. Olympia*?

A. Tachyokinetic
B. Omega
C. Metreon
D. Eichner

2335. Who discovered the smallest microwormhole yet encountered?

A. Tom Paris
B. Tuvok
C. Harry Kim
D. Seska

2336. Why did the timeship *Aeon* come back to the twenty-fourth century?

A. To prevent Kes from leaving
B. To reintegrate the time line
C. To destroy *Voyager*
D. To find whales

2337. Who tried to fly the damaged *Aeon* back to the future to steal more technology?

A. Captain Braxton
B. Henry Starling
C. Dunbar
D. Rain Robinson

2338. How did the Q continuum's war appear to the *U.S.S. Voyager* crew?

A. As the American Revolution
B. As the Vietnam War
C. As the American Civil War
D. As the Earth-Saturn War

2339. Which original series writer and story editor wrote the second tale of the sentient time portal in the *Star Trek* animated series?

A. Rick Berman
B. Theodore Sturgeon
C. D.C. Fontana
D. Gene Roddenberry

2340. What is the only way fluidic space can be accessed?

A. Subspace rift

B. Borg transwarp corridor

C. Quantum singularities

D. Warp corridor

2341. The Krenim weapon ship fired a beam that did what to its targets?

A. Caused them to age

B. Removed them from the space-time continuum

C. Caused them to devolve

D. Caused them to lock into time loops

2342. What protected the Krenim weapon ship from its own beam?

A. Temporal shields

B. Continuum lock

C. Temporal core

D. Mannheim deflectors

2343. How many centuries did Annorax utilize the Krenim weapon ship?

A. One

B. One and a half

C. Two

D. Four

2344. Who was the Delta Quadrant scientist who tried to harness an Omega molecule?

A. Steth

B. Allos

C. Obrist

D. Ven

2345. What were the biomimetic life-forms in the episode "Demon" composed of?

A. Duridium

B. Mercassium

C. Deuterium

D. Polyduranide

2346. What killed the biomemetic life-forms in the episode "Course: Oblivion"?

A. Thermionic radiation

B. Dichromate poison

C. Enhanced warp-drive radiation

D. Deuterium radiation

2353.

Visual effects artist John Dykstra won an Academy Award in 1978 for the special effects in the original *Star Wars*. He also worked on *Star Trek: The Motion Picture*, on the exteriors of the V'ger entity. Not only was the living machine enormous in the world of the film (and that didn't include the energy field it projected, making it even larger), but the real-life model of V'Ger was 60 feet long. The model was never seen in its entirety during the film.

A separate effects team worked on the interiors of the ship. Together, the two teams created the final model for a cosmic entity in the Trek universe that dwarfed almost any other object seen on screen. The actual dimensions of the ship were never stated in the film, but when Spock (shown at left with Kirk, right) scanned it, he found that it measured what level of energy?

A. Tenth power
B. Twelfth power
C. Twentieth power
D. Thirtieth power

2347. What class of nebula did Seven and the Doctor have to fly the *U.S.S. Voyager* through alone?

A. Reflection
B. Mutara
C. Dichromatic
D. Inversion

2348. What composed the Delta Quadrant region known as Underspace?

A. 7th dimensional layers
B. Parallel layer of subspace
C. Network of subspace corridors
D. Subtime plane

2349. What type of disturbance did chaotic space create?

A. Temporal fission
B. Multiphasic tears
C. Subspatial rift
D. Trimetric fracture

2350. What created the temporal differential in the episode "Blink of an Eye"?

A. Subspace inertia
B. The planet's tachyon core
C. Warp stasis fields
D. Temporal manifold

2351. What type of life-form did *Voyager* accidentally pick up while in a Class-J nebula?

A. Multispectrum particle
B. Electromagnetic
C. Interphasic
D. Sentient plasma

2352. What did the Lokrim call the pulsar cluster in the Delta Quadrant?

A. The soul of space
B. The voice of the maker
C. The window of dreams
D. Water of life

2353.

2354. In *Enterprise*, what rule were the time-traveling races violating by altering history?

A. Temporal treaty
B. Temporal accord
C. Chronal Prime Directive
D. Chronicular law of effect

2355. What customary drink did Borothan pilgrims consume while observing the Great Plume of Agosoria?

A. *voo-sinteel*

B. Plumewine

C. Agosorian brandy

D. Nova cognac

2356. What struck Shuttlepod One, damaging its life support?

A. Microcomet

B. Microsingularity

C. Microuniverse

D. Minor asteroid

2357. What nebula did the young Jonathan Archer long to see up close?

A. Omarian

B. Crab

C. Arachnid

D. Mutara

2358. Where did *Enterprise* encounter a neutronic storm?

A. Telsia

B. Near Takret space

C. Illyria

D. Isis III

2359. Who told Archer of the Xindi plan to destroy Earth?

A. Daniels

B. The Suliban's future benefactor

C. Admiral Forrest

D. Soval

2360. What generated the Orassin distortion field?

A. Suliban helix

B. The first sphere *Enterprise* encountered

C. Temporally lost Borg

D. Xindi superweapon

2361. What ended the temporal cold war?

A. Chronal resolution treaty

B. Suliban Civil War

C. Destruction of Na'Kuhl temporal conduit

D. Destruction of Xindi superweapon

2362. What did the Triannans call the Delphic Expanse?

A. Dark region

B. Eyes of the gods

C. Chosen realm

D. Realm of fear

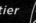

2368.

Claiming to be a historian from the future, Berlinghoff Rasmussen made a sudden appearance that disrupted life aboard the *U.S.S. Enterprise*-D in the episode "A Matter of Time." While Picard dealt with a planetary crisis, Rasmussen (shown at left with Data, right) showed his true colors, revealing that he was actually a thief from the twenty-second century who had stolen the time travel pod from a true future historian. His goal was to steal and reverse-engineer future technologies and take the credit for inventing them himself. The crew foiled Rasmussen's goal, and when the time travel pod vanished, he was stranded in the future permanently.

Actor Matt Frewer, of "Max Headroom" fame, played the thieving Rasmussen, a role that had been written for comedian Robin Williams, who backed out in order to play Peter Pan in the film *Hook*.

Which item from the twenty-fourth century did Rasmussen *not* steal?

A. PADD
B. Tricorder
C. Ressikan flute
D. Isolinear chips

2363. What type of star was Azati Prime?
A. Yellow **C.** Hypergiant
B. Red giant **D.** White dwarf

2364. What shifted the *Enterprise* temporally while in a Xindi subspace corridor?
A. Chroniton bomb **C.** Xindi superweapon
B. Damaged impulse manifold **D.** Sphere distortion

2365. Which Suliban died in the episode "Storm Front"?
A. Sarin **C.** Danik
B. Silik **D.** Raan

2366. Where was Cold Station Twelve located?
A. Luna **C.** Arctic
B. Another dimension **D.** Asteroid

2367. How many times did the *U.S.S. Enterprise* encounter the galactic barrier?
A. Never **C.** Two times
B. Once **D.** Three times

2368.

2369. What was the radiation wavelength of Murasaki 312?
A. 325 angstroms **C.** 370 angstroms
B. 213 millijoules **D.** 215 angstroms

2370. What was the *U.S.S. Enterprise* escaping when its whiplash effect sent it back in time to the late 1960s?
A. Negative quasar **C.** Black star
B. Subspace distortion **D.** Iconian gateway

2371. How did the *Enterprise* crew return to their own time after being sent into the 1960s?

A. Atavachron
B. Chronometric warp drive
C. Guardian of Forever
D. Slingshot around the sun

2372. Which *Star Trek* film featured a previously used method of time travel?

A. *Star Trek II*
B. *Star Trek III*
C. *Star Trek IV*
D. *Star Trek VIII*

2373. How old did the Guardian of Forever claim to be?

A. At least 5 billion years old
B. 6 million years old
C. 10 billion years old
D. Eternal

2374. What region of space was Zefram Cochran's non-humanoid "Companion" from?

A. Argolis Cluster
B. Orion Arm
C. Gamma Canaris
D. Kotaba Expanse

2375. What did the "Doomsday Machine" do with the planets it destroyed?

A. Created new planets
B. Used the rubble as fuel
C. Left them there
D. Used the rubble as weapons

2376. How much longer did the mirror-universe version of Spock estimate the Terran Empire would last?

A. 103 years
B. 212 years
C. 243 years
D. 340 years

2377. How long across was the giant space amoeba?

A. 1,100 miles
B. 8,100 miles
C. 11,000 miles
D. One parsec

2378. How old was Yonada?

A. 5,000 years
B. 8,000 years
C. 10,000 years
D. 25,000 years

2383.

A perennial fan favorite (and probably the closest thing to a dark "mirror universe" episode of *The Next Generation*), "Yesterday's Enterprise" showed a Federation at war, all due to an attack in the past that never should have happened.

The episode provided several groundbreaking moments in Star Trek lore. Fans got the first look at the *U.S.S. Enterprise*-C (shown at left), filling in more of the ship's illustrious history (though its predecessor, the *Enterprise*-B, would not be seen until the film *Generations*). It set up events for actress Denise Crosby to return in future episodes. And, perhaps most groundbreaking of all, Worf got his first taste of prune juice. It also garnered some of the highest ratings ever for the show.

What were the ratings for "Yesterday's Enterprise"?

A. 10.7 million viewers
B. 11.5 million viewers
C. 13.1 million viewers
D. 21.9 million viewers

2379. What was the name of the computer that controlled Yonada?

A. Vaal
B. Landru
C. Natira
D. Oracle of the people

2380. How many years prior to "Assignment: Earth" had Gary Seven's ancestors been gone from Earth?

A. 4,000
B. 5,000
C. 6,000
D. 10,000

2381. What star was the magnetic organism trapped in before the animated series episode "Beyond the Farthest Star"?

A. Beta Niobe
B. Epsilon Eridani
C. Gamma Hydra
D. Questar M-17

2382. What transported the *U.S.S. Enterprise* to Megas-Tu's universe?

A. Magic portal
B. Lucien
C. Matter-energy whirlwind
D. Orb of Amagotto

2383.

2384. How did the crew counteract the effects of the spiroid epsilon waves?

A. Phaser on stun
B. Low-frequency communicator alert
C. Transporter
D. Cordrazine

2385. What magnitude of power did the V'ger energy field generate?

A. Sixth power
B. Tenth power
C. Twelfth power
D. Eighteenth power

2386. What did the *U.S.S. Enterprise*-B use to disrupt the Nexus ribbon temporarily?

A. Quantum torpedoes
B. Electron disruptor field
C. Omega molecule
D. Resonance burst

2387. Why was the *U.S.S. Enterprise*-E unaffected by the Borg's changes to the time line?

A. It used chronal shields
B. It was too far away
C. It was in its temporal wake
D. The ship's computer stored the temporal variants

2388. Along with the *U.S.S. Enterprise*, which of the following ships experienced the time loops of the Mannheim effect?

A. *U.S.S. Hood*
B. *U.S.S. Bozeman*
C. *U.S.S. Sao Paulo*
D. *U.S.S. Lalo*

2389. What Romulan ship did Picard use an Iconian gateway to escape to?

A. *I.R.W. Navaal*
B. *I.R.W. Haakon*
C. *I.R.W. Scorpion*
D. *I.R.W. Taris*

2390. How did the crew change the time line created by the energy vortex in "Time Squared"?

A. Sent Riker off the ship
B. Steered the *Enterprise* into the vortex
C. Ejected the warp core
D. Listened to Wesley

2391. How far away did Gomtuu's energy wave send the *U.S.S. Enterprise*-D?

A. 1 million km
B. 10 million km
C. 2 billion km
D. 3.8 billion km

2392. What alien race was evolving into noncorporeal form, despite its government hunting down those who first changed?

A. Zakdorn
B. Pakled
C. Vorgon
D. Zalkonian

2393. How large was Beverly Crusher's "universe" when she was in a static warp bubble?

A. 502 meters in diameter
B. 705 meters in diameter
C. 2 light-years in diameter
D. Infinite

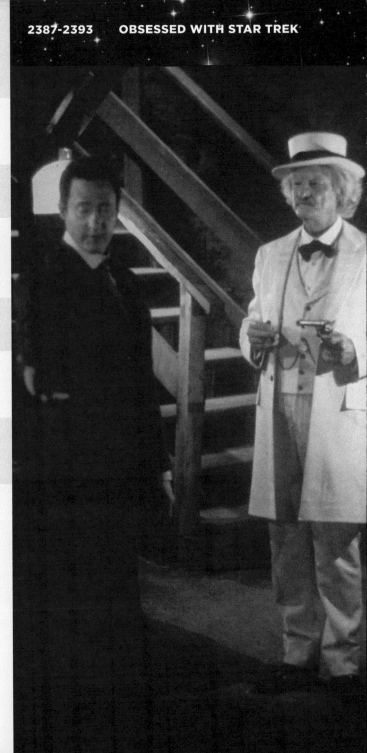

2399.

The fifth-season cliff-hanger of *The Next Generation* turned out to be a temporal mystery with very personal repercussions for Guinan, Picard, and Data, showcasing a unique method of time travel. Data's severed head was found in the twenty-fourth century after being buried 500 years prior. While investigating, the crew wound up in nineteenth-century San Francisco, where they encountered a legendary American author (Mark Twain with Data, left) and Guinan, and a previously unknown method of time travel.

In uncovering the true motives of the Devidian species, who lived out of phase with most organic life, the *Enterprise* crew discovered how they moved through time.

What was the name of the extradimensional snakelike entity that, when irradiated with the correct energy, allowed the Devidians to travel through time?

A. Serpentium
B. Cobrinius
C. Ophidian
D. Parsellium

2394. Who helped Wesley save his mother from being trapped in the static warp bubble universe?
A. Data
B. The Traveler
C. Dr. Quaice
D. Q

2395. What type of beings sometimes live in cosmic strings?
A. Four-dimensional
B. Two-dimensional
C. Plasma beings
D. Noncorporeal

2396. How large was the radiation band that "soured the milk" for the infant spaceborn creature "Junior" attached to the *U.S.S. Enterprise*-D?
A. .01 cm
B. .02 cm
C. 1 cm
D. 12 cm

2397. In "Galaxy's Child," how had "Junior's" mother trapped the *Enterprise*?
A. Energy dampening field
B. Swallowing them
C. Her tail
D. Her shell

2398. What is the name of the dark matter nebula the *U.S.S. Enterprise*-D encountered during "In Theory"?
A. Keyhole Nebula
B. Mars Oscura
C. Tibor Nebula
D. Lantar Nebula

2399.

2400. From where did the solanogen-based life-forms originate?
A. A parallel dimension
B. Tertiary subspace manifold
C. Fluidic space
D. A single proton

2401. Which Federation planet suffered violent fire storms every seven years?
A. Bersallis III
B. Ilyra VI
C. Donatu V
D. Gallos II

2402. Vilmor II contained the last fragment of a genetic code that revealed what?

- **A.** Aliens built the pyramids
- **B.** Vulcans seeded Earth with humanoid life
- **C.** All humanoid species in the galaxy shared a common genetic heritage
- **D.** Romulans were not related to Remans

2403. What type of organism did Data dream about that were actually infesting the ship?

- **A.** Astral
- **B.** Interphasic
- **C.** Neural
- **D.** Biogenic

2404. When returning the protouniverse through the wormhole, what did Dax and Arjin need to avoid?

- **A.** Microwormholes
- **B.** Verteron nodes
- **C.** Gravitational eddies
- **D.** Mobius inversions

2405. What did Bajoran ships use to navigate in the badlands?

- **A.** Radar
- **B.** Echolocation
- **C.** Ionic sensor sweeps
- **D.** Polaron field detectors

2406. What was Smiley's slave classification in the mirror universe?

- **A.** Gamma
- **B.** Theta
- **C.** Alpha
- **D.** Beta

2407. How could a Bajoran lightship travel at warp speeds?

- **A.** Through gravitational eddies
- **B.** Slingshot around a star
- **C.** Towed by a warp vessel
- **D.** If the sails collided with tachyons

2408. What caused the warp-core accident that sent Ben Sisko into temporal displacement in "The Visitor"?

- **A.** A twenty-ninth-century timeship crash
- **B.** Chroniton emitter wave
- **C.** Microsingularity
- **D.** The wormhole's subspace inversion

2416.

Throughout *Star Trek*, viewers became familiar with anti-matter, which helped power a starship's warp engines. In the series finale of *The Next Generation*, a new corollary concept was introduced: antitime. As Q bounced Captain Picard through three different eras of his life (shown at left with Data, right), Picard tried to absorb the concept that an antitime eruption was threatening not only the present, but unraveling all time itself. Perhaps even harder to accept was that he was responsible for the event that had caused the anti-time eruption. Though his crew in three eras struggled to accept Picard's unbeliev-able story, Picard ultimately managed to convince them to attempt his desperate plan to save reality.

While Picard's actions certainly made a difference, what did Q feel had *truly* saved Picard?

A. Q felt he had saved Picard
B. His crew's trust
C. Picard's trust in his crew
D. Opening his mind to the paradox

2409. Who brought the Bajoran poet Akorem forward 200 years in time?
A. Gul Dukat
B. Kai Winn
C. The prophets
D. Benjamin Sisko

2410. How did the mirror Jennifer Sisko die?
A. Saving Benjamin
B. Saving Nog
C. Saving the Intendant
D. Saving Jake

2411. How long after the tribble incident on Space Station K-7 did the temporal investigations officers visit Sisko at Deep Space 9?
A. 78 years, 2 months, 3 days
B. 105 years, 1 month, 12 days
C. 110 years, 7 months, 6 days
D. 186 years, 11 months, 1 day

2412. Who did the Pah-wraiths possess during "The Reckoning"?
A. Chief O'Brien
B. Jake Sisko
C. Molly O'Brien
D. Nog

2413. What type of particles did the Borg sphere use to generate a temporal vortex in *Star Trek: First Contact*?
A. Chroniton
B. Antichroniton
C. Chronometric
D. Fugiton

2414. What type of beam did the *U.S.S. Voyager* use to widen a breach in a quantum singularity?
A. Hyperonic
B. Dekyon
C. Pyritic
D. Antipolaron

2415. What type of energy caused a subspace temporal fracture in the episode "Time and Again"?
A. Electro-plasma
B. Omega
C. Polaric ion
D. Tetryonic

2416.

2417. What was the name of Kes's daughter during her timeshifts?

A. Miral

B. Linnis

C. Andrea

D. Kathryn

2418. What was the name of the effect created by the Krenim weapon ship?

A. Mannheim effect

B. Predestination paradox

C. Causality paradox

D. Pogo paradox

2419. What is an inversion nebula composed of?

A. Chroniton chains

B. Unstable plasma strands

C. Dark matter vacuoles

D. Subspace spirals

2420. What can omicron particles facilitate?

A. Duranium alloy

B. Fluidic biotechnology

C. Warp plasma

D. Antimatter

2421. How deep was the Delta Quadrant region known as the Void?

A. 2,000 light-years

B. 3,000 light-years

C. 5,000 light-years

D. 6,000 light-years

2422. What allowed Silik to contact his benefactor from the future?

A. Chroniton frequency radio

B. Temporal communications chamber

C. Chronal communicator

D. Subtime messages

2423. What type of light is often given off by the stars in a stellar nursery?

A. Plasmatic

B. Infrared

C. Ultraviolet

D. Ultrafluorescent

2424. What book did Archer see in the thirty-first century that he shouldn't have?

A. *Admiral Archer: A Life in the Stars*

B. *The Romulan Star Empire*

C. *These Are the Voyages…*

D. *Time Travel Made Easy*

2432.

As the last season of *Deep Space Nine* drew to a close, the writers sent viewers (and the Ferengi) into the mirror universe for one final glance at its unfolding story. Since actress Nicole deBoer had just taken over the role of Dax that season, this also provided the first and only appearance of the mirror doppelganger of Ezri Dax (shown at left). This Ezri was a ruthless mercenary who often worked for the Intendant Kira Nerys and the Klingon-Cardassian Alliance. Her mission was to steal a cloaking device from the prime universe.

While most characters' mirror counterparts were generally darker and more amoral than the original, Ezri's character differed in an additional major way.

What was this major difference between the two Ezris?

A. Mirror-Ezri wasn't Trill
B. Mirror-Ezri was insane
C. Mirror-Ezri was unjoined
D. Mirror-Ezri came from the prime universe

2425. What did the automated repair station use to improve its processing?
A. Humanoid proteins
B. Humanoid synaptic pathways
C. Vulcan cortex fibers
D. Andorian DNA

2426. What class of black hole was part of the trinary star system encountered by *Enterprise*?
A. Class IV
B. Class Alpha
C. Class Gamma
D. Class 2

2427. How did Phlox inoculate Archer for a pathogen on Paan Mokar?
A. First hypospray
B. Gamma radiation
C. Analeptic radiation
D. Hyperonic

2428. What warp calculations did the Delphic Expanse make nonconstant?
A. Fermi paradox
B. Cochrane equation
C. Newton's third law
D. Drake equation

2429. How did the Xindi open their subspace vortices?
A. Phase deflector pulse
B. Gravimetric pulse
C. Slipstream pulse
D. Quantum string resonance

2430. In "Doctor's Orders," who had to pilot the ship through a transdimensional disturbance?
A. Hoshi
B. T'Pol
C. Dr. Phlox
D. Porthos

2431. What surrounded the region of space known as the barrens?
A. Temporal barrier
B. Antimatter field
C. Negative energy barrier
D. Subspace nodes

2432.

2433. Who was able to pilot the *U.S.S. Enterprise* out of the galactic barrier in "Is There in Truth No Beauty"?
A. Spock
B. Dr. Jones
C. Larry Marvick
D. Kollos

2434. How did Lazarus describe the negative magnetic corridor between the two universes?

A. Parallel conduit **C.** Alternative warp
B. Antimatter slide **D.** Inversion field

2435. What historical act does Captain John Christopher discover his son, Shaun, will one day make?

A. Help develop warp drive **C.** Lead the first Earth-Saturn mission
B. Encounter the first Vulcans **D.** Command the *Enterprise* NX-01

2436. In which system did the "Doomsday Machine" destroy all seven planets?

A. L-374 **C.** Alpha Aurigas
B. Beta Renner **D.** L-370

2437. On which planet did the mirror-universe Kirk execute over 5,000 colonists?

A. Luna One **C.** Rigel VI
B. Vega IX **D.** Triskelion

2438. In "Assignment: Earth," how did Kirk refer to the method of time travel he and his crew used?

A. Temporal vortex **C.** Time warp
B. Light-speed breakaway factor **D.** Time wormhole

2439. During what Vulcan month of the year 2237 did Spock travel back to right his personal history in the animated episode "Yesteryear"?

A. *L-langon* **C.** *Tasmeen*
B. *ShiKahr* **D.** *I-Chaya*

2440. How large was the cosmic cloud from "One of Our Planets is Missing"?

A. 200,000 km across **C.** ½ parsec across
B. 800,000 km across **D.** 2 parsecs across

2441. How many races made up the population of the pocket dimension Elysia?

A. 100 **C.** 147
B. 123 **D.** 213

2449.

The 100th episode of *Voyager*, "Timeless," was a standout in many ways. Not only was the episode nominated for an Emmy for outstanding special visual effects for a series (losing out to another episode of *Voyager*, "Dark Frontier"), but it also featured the return of both director LeVar Burton and his character, Geordi La Forge. A temporal crossover pitted Geordi—now captain of the *U.S.S. Challenger*—against the last survivors of the *U.S.S. Voyager* crew.

Fifteen years after a mistake made by Harry Kim (shown at left with Chakotay) had caused *Voyager* to crash, Harry and Chakotay were all that remained of *Voyager*'s crew. Driven by guilt, Harry was desperate to change history and save his friends.

What did Harry and Chakotay steal from Starfleet Intelligence to use in their mission?

A. Omega Molecule Generator
B. Borg scout ship
C. Borg temporal transmitter
D. Time beacon

2442. In which of the following places did ion storms *not* strand any *U.S.S. Enterprise* crew members?

A. Mirror Universe
B. Lazarus's universe
C. Elysia
D. Murasaki 312

2443. How did the godlike entity of Delta Theta III refer to the primitives of that planet?

A. "My children"
B. "My egglings"
C. "My playthings"
D. "My inferiors"

2444. The energy field that controlled the *Enterprise* computer in "The Practical Joker" was composed of what?

A. Charged vacuum emboitments
B. Sentient ambiplasma
C. Highly charged subatomic particles
D. Reverse chronitons

2445. What intensified the effects of the Dramian II plague?

A. McCoy's mistake
B. Ionic radiation
C. Chameleon radiation
D. Dramia II's aurora

2446. What did Kukulkan's zoo provide all of its creatures?

A. Chance to feed off others
B. Docility field
C. Augmented life span
D. Virtual habitat

2447. What color was space in Karla Five's antimatter universe?

A. White
B. Blue
C. Green
D. Black

2448. What nebula did the Genesis device change into a planet?

A. Hugora
B. Mutara
C. Volterra
D. Omarion

2449.

2450. In the film *Insurrection*, where was the Briar Patch located?

A. Sector 665
B. Gamma Quadrant
C. Romulan Neutral Zone
D. Sector 441

2451. What was the original name of the Briar Patch in Klingonese?

 A. *Kortar*　　　　　**C.** *kos'karii*

 B. *Klach D'Kel Brakt*　**D.** *Mauk-to'Vor*

2452. Who took the *U.S.S. Enterprise*-D crew to "the end of the universe" in "Where No One Has Gone Before"?

 A. Q　　　　　　　　**C.** The Traveler

 B. Wesley Crusher　　　**D.** Kevin Uxbridge

2453. What happened to the crew's thoughts at the "end of the universe"?

 A. They became reality　**C.** They reverted to primitive ones

 B. They stopped　　　　**D.** They became incoherent

2454. What did the writer of the episode "Time Squared" originally envision as the cause of the vortex?

 A. Warp-core breach　　**C.** Q

 B. The Traveler　　　　**D.** The Borg

2455. What race did the superpowerful Douwd wipe out of existence?

 A. Husnock　　　　　**C.** Iconians

 B. Vulcans　　　　　　**D.** Mintakans

2456. How did the two-dimensional beings affect the *U.S.S. Enterprise*-D?

 A. Disabled transporters　**C.** Froze all systems

 B. Caused antimatter imbalance　**D.** Broke down structural integrity field

2457. What does a Tyken's Rift absorb?

 A. Emotions　　　　　**C.** Phaser energy

 B. Brainwaves　　　　**D.** Starship energy

2458. What did the *U.S.S. Enterprise*-D use to divert the stellar core fragment from Moab IV?

 A. Multiphasic tractor beam　**C.** Polarized deflectors

 B. Gravimetric charges　　**D.** Multiphasic shields

2464.

Janeway (shown at left) may not have liked time travel, but ironically, it took one more temporal journey to get *Voyager* home to Earth in the series finale. Despite James T. Kirk's record of temporal violations, viewers saw *Voyager* dealing with time travel more than any other *Star Trek* series—fifteen times in all. Several times it saved the ship completely, and by the year 2404, Janeway had cause to accept its value. If not for the intervention of her future self from an alternate time line, her crew would have made it home much the worse for the wear (and not for an additional sixteen years).

What technology did the future Admiral Janeway bring back to the past to help Captain Janeway get her crew home?

A. Interplexing time drive
B. Chronal deflector
C. Ablative generator
D. Slipstream drive

2459. Where did the first known encounter with a region of null space occur?
A. Denkir
B. J'naii systerm
C. System J-25
D. Pallas 14

2460. What caused the temporal causality loop in the Typhone Expanse?
A. Q
B. Hypergiant nova
C. *U.S.S. Enterprise*-D colliding with *U.S.S. Bozeman*
D. Subspace rift

2461. Amanda Rogers used her Q abilities to restore which planet's ecosystem to health?
A. Tagra IV
B. Bolius
C. Marlonia
D. Ligos VII

2462. What was the Hekaras Corridor composed of?
A. Geodesic radiation
B. Static warp bubbles
C. Unstable warp fields
D. Tetryon fields

2463. What did the Klingon Kor once call the Bajoran wormhole?
A. *Sto-vo-Kor*
B. *Vorta-vor*
C. The eye of destiny
D. Kahless's palace

2464.

2465. In the mirror universe, who is Sisko's mistress?
A. Kira
B. Jadzia
C. Leeta
D. Ezri

2466. What interfered with the *Defiant*'s transporters to send Sisko, Dax, and Bashir into the San Francisco of 2024?
A. Jem'Hadar sabotage
B. Kemacite explosion
C. Microsingularity
D. A particle beam test

2467. When Kira and O'Brien searched through the timestream, what year did they visit that Spock and Kirk also once visited?
A. 1921
B. 1927
C. 1930
D. 1986

2468. Who was the first Deep Space 9 resident to be possessed by a Pah-wraith?

 A. Quark

 B. Jake Sisko

 C. Leeta

 D. Keiko O'Brien

2469. Which episode featured the Intendant of the mirror universe's only visit to the "real" universe?

 A. "Resurrection"

 B. "Through the Looking Glass"

 C. "Shattered"

 D. "The Emperor's New Cloak"

2470. What type of radiation do subspace compression anomalies emit?

 A. Gamma

 B. Cosmic

 C. Spiroid Epsilon

 D. Theta

2471. Where on Bajor was the Orb of Time kept?

 A. Fire Caves

 B. Vedek Assembly Hall

 C. Temple of Iponu

 D. Jeraddo

2472. What planet contained a time portal that Molly O'Brien fell through?

 A. Mizar II

 B. Loren III

 C. Golana

 D. Potak III

2473. What was the phase variance in the "Harry Kim wormhole"?

 A. Anti-ionic particles

 B. Two-dimensional life-forms

 C. Muon radiation

 D. A temporal displacement

2474. How did the Vhnori transport their dead through subspace vacuoles?

 A. Photon torpedo tube

 B. Cenotaph

 C. Sarcophagus

 D. Dimensional pod

2475. How much information did the spatial distortion ring being leave in the *U.S.S. Voyager*'s computers?

 A. 1 billion terabytes

 B. 20 million gigaquads

 C. 3 million teraquads

 D. 500 million gigabytes

2476. What shuttle was Harry Kim aboard when he crossed into a timestream in which he had never served on *Voyager*?

 A. *Sacajawea*

 B. *Cochrane*

 C. *Tereshkova*

 D. *Drake*

2481.

During the third season of *Enterprise*, the crew of the *Enterprise* met the Triannon race. The Triannons believed that the builders of the spheres in the region known as the Delphic Expanse were gods, who were transforming the area into a paradise. In one sense they were right, but it wouldn't be a paradise for the races already existing in the Expanse.

The transdimensional sphere-building beings were known as the Makers to the Triannons, but more commonly called the Guardians by the Xindi species (shown at left), who composed the bulk of their workforce in this dimension. The Guardians were transforming the region to make it habitable for their own race. The massive artificial spheres created a dangerous barrier around the region, and the sphere's gravimetric waves created numerous spatial anomalies, making stellar travel difficult.

How long had the spheres been transforming the region?

A. 500 years
B. 750 years
C. 900 years
D. 1,000 years

2477. What was the name of the subspace layer where Suspiria existed?
A. Exosia
B. Genosha
C. Oa
D. Xhosa

2478. Where was the Q known as Quinn imprisoned?
A. Star
B. Comet
C. Nebula core
D. Subspace rift

2479. What was the range of the combined gravitational pull of the binary pulsars encountered by *Voyager*?
A. 50 million km
B. 100 million km
C. 115 million km
D. 125 million km

2480. What was the temporal variance of the chroniton torpedo?
A. 1.47 nanoseconds
B. 1.47 microseconds
C. 14.7 microseconds
D. 14.7 nanoseconds

2481.

2482. What percentage of the Krenim time line did the destruction of the Ram Izad species restore?
A. 52 percent
B. 67 percent
C. 72 percent
D. 78 percent

2483. What energy source killed Neelix while transporting it from a nebula?
A. Protomatter
B. Antimatter
C. Chroniton
D. Ion

2484. What can be generated by firing a verteron beam into a red giant?
A. Crimson corridor
B. Spatial fold
C. Geodesic fold
D. Temporal inversion

2485. What caused the warp core to split different decks of *Voyager* into temporal flux?
A. Chronokinetic surge
B. Chroniton virus
C. Mobius inversion
D. Temporal corrosion wave

2486. A second region called the Void was encountered by *Voyager* near the border of which Quadrant?

A. Epsilon
B. Gamma
C. Alpha
D. Beta

2487. What was the largest comet ever observed by humans as of the year 2151?

A. Kahoutek
B. Archer's
C. Halley's
D. Burke's

2488. What was the first Vulcan high command ship seen in *Enterprise*?

A. *Fal-tor-pan*
B. *Koss*
C. *Kir'Shara*
D. *Ti'Mur*

2489. What is the Klingon designation for a class-9 gas giant?

A. *Qapla'*
B. *Q'tahL*
C. *Qui'Tu*
D. *Soch*

2490. What was the name of the rogue planet the *Enterprise* NX-01 discovered?

A. Gothos
B. Ghorusda
C. Kataan
D. Dakala

2491. Aside from its temporal qualities, what was special about the time travel pod from "Future Tense"?

A. Larger on the inside than the outside
B. Could travel through dimensions
C. Could telepathically translate languages
D. Had extrapolator shielding

2492. Whom did Archer name the dark matter nebula after?

A. Admiral Forrest
B. His father
C. Zefram Cochrane
D. A. G. Robinson

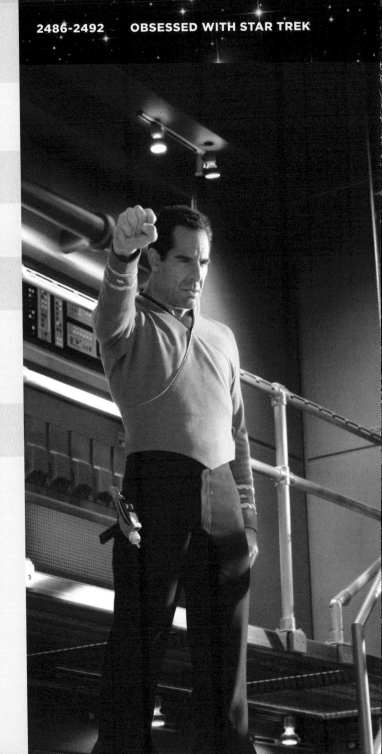

2497.

The final chapter in the mirror universe saga was actually its first: As *Enterprise* headed into its final season, the producers were close to having William Shatner reprise his role as the mirror version of Captain Kirk. That fell through, but they devised a story that still connected the *Star Trek* original series with *Enterprise*. Using events from both "Mirror, Mirror" and "The Tholian Web," they depicted the story of the *U.S.S. Defiant*'s fate and the brief rise of Jonathan Archer (shown at left) to power in the mirror universe.

The mirror universe is a dangerous place, however, and—as the *Deep Space Nine* mirror universe episodes showed—many characters don't survive. During "In a Mirror, Darkly," the *I.S.S. Enterprise* NX-01 itself did not survive.

How was it destroyed?

A. Shot by the *U.S.S. Defiant*
B. By Tholians
C. Self-destruction
D. Destroyed crossing over to prime universe

2493. How did Phlox and T'Pol destroy the interspatial parasites infecting Archer?

A. Antiproton beam
B. Chroniton purge
C. Subspace implosion
D. Quantum string resonator

2494. What trapped the Vulcan ship *Seleya* in the Delphic Expanse?

A. Plasma eddy
B. Subspace eddy
C. Astral eddy
D. Quantum eddy

2495. How did Archer and T'pol prevent the time-traveling Xindi from returning to their present?

A. Killed them
B. Surgical amnesia
C. Imprisoned them in a time loop
D. Destroyed their temporal beacon

2496. How did Archer and T'Pol retrieve all the anachronistic items from the incursion in "Carpenter Street"?

A. Chronal transporter
B. Temporal tracer
C. Chronal resolvers
D. Temporal tag

2497.

2498. What is the theoretical life span of a hypergiant star?

A. Half a million years
B. One to two million years
C. Five million years
D. Seven million years

2499. What type of cloaking device did the mirror-universe Archer have installed in the *I.S.S. Enterprise* NX-01?

A. Romulan
B. Suliban
C. Klingon
D. Denobulan

2500. What is the most cosmic phenomenon of all?

A. *Star Wars*
B. *Star Trek*
C. *Battlestar Galactica*
D. *Doctor Who*

ACKNOWLEDGMENTS

The following people receive the Starfleet Citation for Conspicuous Gallantry for their help in making this book come to life: Amelia Riedler, Amy Wideman, and Jessica Eskelson at becker&mayer!; my old arch-nemesis, John Van Citters and Marian Cordry at CBS (who also receives the Grankite Order of Tactics), Risa Kessler; and my bridge crew: Brad and Jackie Copeland, Dave and Lili Rossi, Phil and Kim Lawrence, Tara Karsian, Daniel Hastings, Ellen Hornstein, and Susan Askew.

The Palm Leaf of Axanar Peace Mission is awarded to those who kept me calm as deadlines approached: Fran Zankowski, Tim Melodick, and Shawn Ku. The Christopher Pike Medal of Valor goes to Paul Ruditis, whose experience and words of wisdom were invaluable. Finally, to John Carter, Penny Carter and my brother, David Carter—thanks for always being the closest ships in the quadrant, no matter how far I had boldly gone ...

ABOUT THE AUTHOR

The first episode of *Star Trek* that Chip Carter remembers watching is "Spectre of the Gun," which may explain a lot. From there, he parlayed watching his favorite show into a career. He worked as a project manager on numerous *Star Trek* trading card sets, and then worked in Paramount Pictures' licensing department. While there, he helped launch the Paramount Comics imprint with Marvel Comics. Chip now lives in sunny San Diego, and is really glad he doesn't have to worry about parking for Comic-Con anymore.

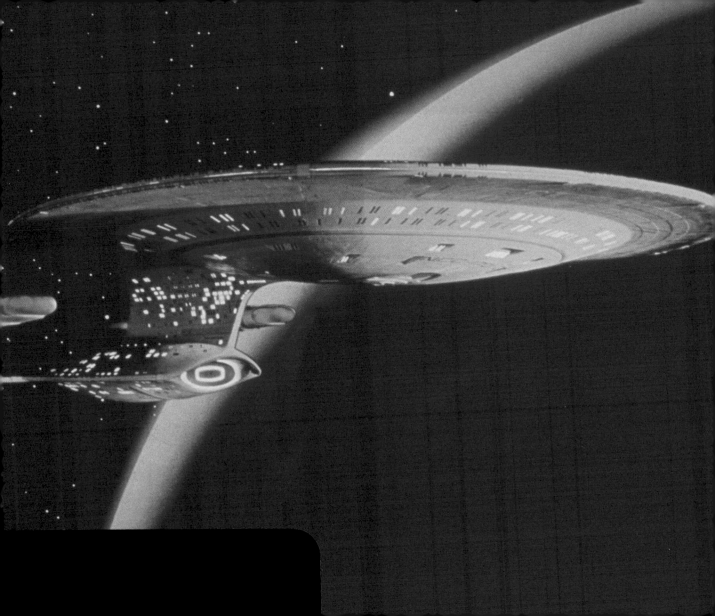